STONEHENGE

A Landscape Through Time

STUDIES IN THE BRITISH MESOLITHIC AND NEOLITHIC

Volume 2

Series Editors
David Jacques and Graeme Davis

Editorial Advisory Board
Gemma Allerton
Simon Banton
Keith Bradbury
Sophy Charlton, Natural History Museum, London
Nicholas Jones, World Heritage Trails
Bryony Rogers, Durham University
David Saunders
Christine Smith
Joshua C White, NPS Archaeology
Pauline Wilson

PETER LANG
Oxford • Bern • Berlin • Bruxelles • New York • Wien

STONEHENGE

A Landscape Through Time

David Jacques and Graeme Davis

PETER LANG

Oxford • Bern • Berlin • Bruxelles • New York • Wien

Bibliographic information published by Die Deutsche Nationalbibliothek.
Die Deutsche Nationalbibliothek lists this publication in the Deutsche
National-bibliografie; detailed bibliographic data is available on the
Internet at http://dnb.d-nb.de.

A catalogue record for this book is available from the British Library.

Library of Congress Cataloging-in-Publication Data
Names: Jacques, David, 1966- editor. | Davis, Graeme, 1965- editor.
Title: Stonehenge : a landscape through time / David Jacques and Graeme Davis
 (eds.).
Other titles: Stonehenge, a landscape through time
Description: Oxford ; New York : Peter Lang, [2018] | Series: Studies in the
 British Mesolithic and Neolithic ; 2 | Includes bibliographical references
 and index.
Identifiers: LCCN 2018050067 | ISBN 9781906165857 (alk. paper)
Subjects: LCSH: Stonehenge (England) | Megalithic
 monuments--England--Wiltshire. | Landscape
 archaeology--England--Wiltshire. | Wiltshire (England)--Antiquities.
Classification: LCC DA142 .S855 2018 | DDC 936.2/319--dc23 LC record available at https://lccn.loc.
gov/2018050067

Front cover photograph: Simon Banton.

Cover design by Brian Melville.

ISSN 2297-1068
ISBN 978-1-906165-85-7 (print) • ISBN 978-1-78707-480-4 (ePDF)
ISBN 978-1-78707-481-1 (ePub) • ISBN 978-1-78707-482-8 (mobi)

© Peter Lang AG 2019

Published by Peter Lang Ltd, International Academic Publishers,
52 St Giles, Oxford, OX1 3LU, United Kingdom
oxford@peterlang.com, www.peterlang.com

David Jacques, Tom Phillips and Tom Lyons have asserted their right under the Copyright, Designs and Patents Act, 1988, to be identified as Authors of this Work.

All rights reserved.
All parts of this publication are protected by copyright.
Any utilisation outside the strict limits of the copyright law, without the
permission of the publisher, is forbidden and liable to prosecution.
This applies in particular to reproductions, translations, microfilming,
and storage and processing in electronic retrieval systems.

This publication has been peer reviewed.

Printed in Germany

Contents

List of Figures vii

List of Tables ix

FRED WESTMORELAND
Foreword xi

Acknowledgements xiii

DAVID JACQUES
Introduction 1

GEMMA ALLERTON
1 Romano-British reactions to the Stonehenge prehistoric landscape: A re-evaluation of settlement patterns and uses of that landscape 5

NICHOLAS JONES
2 Environmental implications of Neolithic houses 35

PAULINE WILSON
3 Towards a methodological framework for identifying the presence of and analysing the child in the archaeological record, using the case of Mesolithic children in post-glacial northern Europe 71

CHRISTINE SMITH
4 The effectiveness of an enhanced grid extraction system within the context of the Blick Mead spring excavations 111

KEITH BRADBURY
5 An evaluation of the relationship between the distribution of tranchet axes and certain Mesolithic site types along the Salisbury Avon 143

DAVID SAUNDERS
6 An assessment of the evidence for large herbivore movement and hunting strategies within the Stonehenge landscape during the Mesolithic 173

JOSHUA C. WHITE
Appendix
Vespasian's Camp, Wiltshire: New insights into an Iron Age community in the Stonehenge landscape 201

Index 207

Figures

Figure 3.1:	Methodological framework for accessing the child in pre-history	87
Figure 4.1:	Site diagram showing positions of Trench 11 (the northernmost trench shown on the Lynchet), 19, 22, 23 (Jacques and Phillips 2014)	112
Figure 4.2:	North-facing section. Trench 23	118
Figure 4.3:	Positions of the bore-holes in relation to the approximate positions of the trenches at Blick Mead (*Quaternary Scientific QUEST*)	126
Figure 4.4:	Showing the deposition pattern of the Burnt Flint within the grid sections of Trench 23 98A	131
Figure 4.5:	Showing the deposition pattern of the Burnt Flint within the grid sections of Trench 23 98B	132
Figure 4.6:	Showing the deposition pattern of the Worked Flint within the grid sections of Trench 23 98A	133
Figure 4.7:	Showing the deposition pattern of the Worked flint within the grid sections of Trench 23 98B	134
Figure A.1:	Photograph of the deposits upturned by the collapse of a beech tree on the eastern ramparts of Vespasian's Camp. This photograph was taken after the removal of deposit 01 and before excavation began on 02 (looking south-east, scale 2 m)	202

Tables

Table 2.1:	Construction time for House 851	56
Table 2.2:	Models for the growth of the Durrington Walls settlement	58
Table 2.3:	Model 1 – labour and material needs of building 200 houses per year	59
Table 2.4:	Model 2 – labour and material needs of building 100 houses per year	60
Table 2.5:	Model 3 – labour and material needs of building 50 houses per year	62
Table 3.1:	Stages of a child's life	73
Table 3.2:	Child life stages recognised by the Mikea	74
Table 3.3:	Weaning ages for a selection of hunter-gatherer groups. Source Kelly, 1995:198.	90
Table 3.4:	Ethnographic communities	92
Table 3.5:	Application to the Mesolithic site of Blick Mead 5000 BPE: A children's story	104
Table 5.1:	The location of tranchet axe find spots in the Stonehenge landscape	152
Table 5.2:	C14 results from Blick Mead samples carried out by SUERC laboratory	157
Table 6.1:	Overview of species found at Blick Mead © Bryony Rogers University of Durham	176
Table 6.2:	Radio carbon dates (95% probability) from Blick Mead (after Jacques, Lyons and Phillips 2017 p. 20)	177
Table A.1:	Iron Age NISP data from Vespasian's Camp	203
Table A.2:	Iron Age MNI data from Vespasian's Camp	203
Table A.3:	Tooth eruption and wear data of the ovicaprid remains from Vespasian's Camp	204

FRED WESTMORELAND

Foreword

The first time I spoke to David Jacques he asked me what I would like from the work at Blick Mead. I asked him to fill the gap between the Stonehenge Postholes and the Neolithic. The rest, as they say, is prehistory. Working with a shoestring budget from Amesbury Town Council, Quinetiq and private donors, David's army of willing volunteers have uncovered one of the most important archaeological sites of the twenty-first century. In the process they have rewritten the history of the Stonehenge landscape and instilled a new pride and new purpose into the Amesbury community.

Having given me the Mesolithic, David has now started to read my mind and to deliver my secret desires. The introduction of the *Ancient Monuments and Archaeological Areas Act* (1979) and the *National Heritage Act* (2002) coincided with a period of rapid expansion to the south-east of historic Amesbury. Archaeology has flowed from the ground – the Amesbury Archer is only the best known of the items in a catalogue which includes Roman cemeteries, Henge monuments and (whisper it) Mesolithic postholes.

Developers are required to pay for excavations and reports, but not for the interpretation of those reports and the synthesis which creates history. Local authorities are struggling to deal with the wealth of material deriving from the Portable Antiquities Scheme. They have no mechanism at all for the systematic analysis and evaluation of the reports that accompany artefacts and planning applications. I know that, for Amesbury, there are the products of 30 years of excavation waiting to be examined, 30 years of reports which would transform our understanding of my town's history and development.

When we set out to create a History Centre for Amesbury it was intended to be a place for study, making available locally the reports on our 5,000-year history. The first step was to get the material, who would interpret it was a bit of a puzzle. Thanks to Blick Mead, those 5,000 years have now turned into 10,000 years, but also thanks to Blick Mead we may have identified a way in which the analysis could be carried out.

The six MA dissertations contained within this volume, starting from within the Stonehenge landscape, create narrative from the raw materials of archaeological investigation. Stepping out of the shadow of Trench 19, the students have set out to tell us what this all means.

Following the ordering of the book, we are invited to consider: Romano-British Amesbury; Neolithic house building practices; the role and lives of children in prehistoric societies; an excavation methodology for dealing with waterlogged deposits; the identification of new sites from the distribution of Mesolithic material, and restrictions on herbivore movement within the landscape. Six studies of six disparate subjects, united only in that they tell me more about my community, my country and my world.

I congratulate the authors of these dissertations. I hope that they have shown the way. I hope that many more will conduct their excavations in the county archives. There are still things I would like to know.

Acknowledgements

We remain extremely grateful to the Cornelius-Reid family, the Antrobus family and Amesbury Abbey residents for allowing us to work on site at Blick Mead and Vespasian's Camp. We wish to extend deep thanks to local residents Mike and Gilly Clarke, Andy and Becky Rhind Tutt, Pete and Tracey Kinge, Dave Allerton, Tim Roberts, Brian Edwards, Malcolm and Jenny Guilfoyle-Pink and Cllr Fred Westmoreland, Vera and Matt Westmoreland, Richard Crook and Mike and Rosemary Hewitt for all their hard work and keen support. We also wish to heartily thank Peter Rowley-Conwy, Bryony Rogers from the Department of Archaeology at Durham University, Nick Branch of the Department of Archaeology at the University of Reading, David John and Simon Parfitt of the Natural History Museum, Barry Bishop, John Drew and Nick James of the University of Buckingham, Tom Phillips of Oxford Archaeology, Tom Lyons, Vicky Ridgeway, Roy Froom, Mark Bush, Patricia Woodruffe, Craig and Sue Levick and everyone at Amesbury History Centre and Peter Lang for all of their support and work on various Blick Mead data which has benefited this volume. The Amesbury Heritage Trust and Amesbury Archaeology has provided much appreciated financial support to augment the University of Buckingham's generous endowment to the project and we are very grateful and wish to thank them too.

In particular we acknowledge the crucial contributions of Mike Clarke, without whom there would be no Blick Mead, and Simon Banton, whose encouragement and skill set has done so much for the authors, and whose wonderful picture of Stonehenge graces the cover of this book. The writers and editors wish to thank our families and friends; without their support this book would not have been written.

Professor David Jacques
Professor Graeme Davis

DAVID JACQUES

Introduction

The concept of this book materialised as a result of some brilliant research by University of Buckingham MA Archaeology students in 2014–2015. Each examined a feature of the Stonehenge landscape from a different space and time perspective and produced work which contained a key focus on a neglected aspect of the multiple history of the area. Their dissertations have been edited into chapters and the broad scope of the collection covers people using, building and reshaping this landscape from the end of the Ice Age to the end of the Romano British period. In doing so new detail about the richness and variety of ways generations of ordinary people understood the place is revealed.

The discovery of the internationally important Mesolithic site at Blick Mead by the University of Buckingham team, with specialist support from Durham, Southampton and Reading Universities, the Stonehenge Hidden Landscapes Project and the Natural History Museum, provides a rich data set for students interested in the Mesolithic in general and the establishment of the Stonehenge landscape in particular. Situated just over 2 km east of Stonehenge (NGR SU146417), and visited for nearly 4,000 years in the Mesolithic (7960–4041 cal BC), the most recent excavations have provided further evidence of the communities who built the first monuments at Stonehenge between the ninth and seventh millennia BC, and for Mesolithic use of the area continuing into the late fifth millennium BC and the dawn of the Neolithic period. Thirteen radio carbon dates of the sixth and fifth millennia BC are the only such dates recovered from the Stonehenge landscape and fill a crucial gap in the occupational sequence for the Stonehenge area at this time. Neolithic, Bronze and Iron Ages and Romano British artefacts found at Blick Mead offer further avenues for research.

The archaeology discovered at Blick Mead has prompted many important new questions about the Stonehenge landscape and some are addressed for the first time in this volume: How did local Romano British communities interact with the prehistoric monuments and earthworks landscape around them, including Stonehenge? What does the monumentalising of the landscape in the late Neolithic and early Bronze Age imply about resource management in the area and beyond? Was the early establishment of the Stonehenge ritual landscape invented by Neolithic farmers from nothing? How can we find the children in the archaeological record? Is there any evidence for the landscape and the Stonehenge knoll itself embodying understandings about the place that could reach back to Mesolithic? Why have spring sites and their resources been neglected for investigation? What sort of excavation methods should we employ when we are digging and recording them?

Given the importance of Stonehenge to British archaeology, it is remarkable that there has been no previous exploration of how local Romano British communities understood a landscape so vividly full of earlier monuments and earthworks. In Chapter 1 Gemma Allerton, a local resident of Boscombe Down, examines the evidence and shows we have been largely blind to its importance. The main focus is on assembling and interpreting material from Butterfield Down, the Boscombe Down cemeteries and settlement and Stonehenge itself, and what is revealed is the re-use of prehistoric places for funerary purposes, including the burial of children. The suggestion of cultural assimilation is made and set against Atkinson's arguments that Stonehenge may have been targeted for destruction during the Roman period. The choice of burying people in prominent prehistoric places is understood instead as being linked to past local connections with the landscape, with it acting as a symbolic mediator between different cultural trajectories. Stonehenge's use as a late Romano-British temple is considered for the first time. Overall the chapter assembles significant evidence for a new understanding of Romano British attitudes to the Stonehenge landscape.

In Chapter 2 Nick Jones brings together the latest information from published sources, both archaeological and ecological, as well as his practical experience of building a late Neolithic house as part of the Neolithic Houses Project, to present a time and motion study for the building of a replica of House 851 from Durrington Walls. A key question is addressed: what it would take to build and maintain up to 1,000 of these houses, the calculated maximum number for the late Neolithic village at Durrington Walls? Jones shows that previous armchair studies are almost certainly flawed, with estimates for the number of trees per hectare needing to be felled for a building project like this being well out of kilter with findings from modern ecological studies. He deduces it would require around 32 hectares of coppiced woodland and 1,200 hectares of straw to build Durrington Walls, which suggests that either the calculated number of houses is very far from the actual number; or there was far, far greater cereal cultivation and land management in the Late Neolithic than any of the latest arguments suggest. This chapter has far reaching implications for our calculations of the materials, labour, land area, and time involved in late Neolithic building projects, both in the Stonehenge landscape and beyond.

Pauline Wilson's Chapter 3 reminds us that archaeologists have often missed the presence of children in the archaeological record despite them likely to be numbering over half of the populations of prehistoric communities. Using this omission as a challenge, she carefully weaves together a variety of ethnographic, archaeological and phenomenological data to propose a new model to help relocate children in the Mesolithic record in particular. Her study involving real children at Blick Mead shows them making pretend hunting weapons, mimicking adult hunting behaviour, collecting plantain leaves, burdock leaves, clay, firewood, etc. These are all activities that (if archaeologists bothered to think about them) would be predicted and this exercise, along with a detailed review of the ethnographic evidence, displays the speed and spontaneity with which children learn such behaviours and hints at their long-term 'embeddedness'. The chapter makes clear that it is our familiarity with concepts such as 'childhood' which is so culturally loaded and that leads us away from appreciating the potential heterogeneity of communities in prehistory.

In Chapter 4 Christine Smith presents a practically based study which resulted from the need to develop a solution to a problem that actually arose during excavation at Blick Mead: how to make sense and record an exceptionally dense scatter of worked and burnt flint in waterlogged and heavy clay conditions. Faced with this challenge Smith and her partner devised an innovative method to plot the finds. The recording technique developed enabled her to interpret the distribution of finds as suggesting traces of two possible hitherto undetected Mesolithic hearths. It could be easily and cheaply applied on other sites with similar conditions too. Interpretation is always problematic, as she observes, but this new methodology enabled her to ascertain patterns within the spread of about 1,000 worked flints which would not have emerged using conventional methods.

The paucity of evidence for Mesolithic culture before the discoveries at Blick Mead has meant for an almost entirely missing chapter in the pre Stonehenge story. In Chapter 5 Keith Bradbury looks at evidence for the uses and distribution of a distinctive Mesolithic artefact, the tranchet axe, as a way of addressing some of the lack of detail. He posits that the amount of these objects found at Blick Mead provides extra insight into the site dynamics and its broader trade and exchange networks. He also examines the ways these tools may have been used to shape the local landscape. For the first time an assessment is made of where all the tranchet axes have been found within a 20 km radius of Blick Mead and Bradbury considers the evidence for them being used as symbolic markers of territory and boundaries. The finding that, despite an extensive literature and personal search, almost all the tranchets in Salisbury Plain and nearby areas come from a small radius in and around Blick Mead or Downton homebases, underlines the possibility of seeing an association between their uses and final 'resting places' with the needs of longer-term 'nexus' sites.

Using up-to-date prospection techniques and traditional field walking approaches, David Saunders argues in the final chapter that the placement of the earliest monuments on the Stonehenge knoll, the three pine posts dated to the Mesolithic between the ninth and mid-seventh millennia BC, should be

best understood in relation to the nearby movement of large herbivores, in particular aurochs. Drawing on an earlier analysis of animal movement around the Stonehenge area (Jacques and Phillips 2014) and faunal data from Blick Mead by the University of Durham, he argues that this part of Salisbury Plain was an especially good place to hunt in the Mesolithic. This is linked to recent evidence for active forest clearance by people in the area and the idea that a fully wooded landscape would prohibit intercept hunting. For the first time the Stonehenge/Blick Mead area is revealed as being connected through a natural topographic bottleneck that provided an 800-metre-wide game funnel in an otherwise difficult 26 kilometre stretch of country. Using new evidence from his Viewshed analysis and following Jacques and Phillips, the point is made that the distinction between constructed monuments (for example, the Greater Cursus) and topographic features is not so clear cut as is often implied. The fascinating question of whether the area around the Stonehenge knoll embodied some beliefs that reached back to the Mesolithic past is also posed.

The volume is completed by an analysis of the contents of a likely Iron Age midden found in a tree throw within Vespasian's Camp by Josh White. With its focus on new ways of understanding the material record in the Stonehenge landscape Josh White's piece is an appropriate one to end the volume. Like the other contributors, the emphasis is on thinking afresh about an aspect of the archaeology of the area which has been under researched and could yield exciting new data. Taken together the different scales of analysis in this collection reveal a richer, more multifaceted, nature of this landscape and it is revealed as even more special than we thought we knew it was.

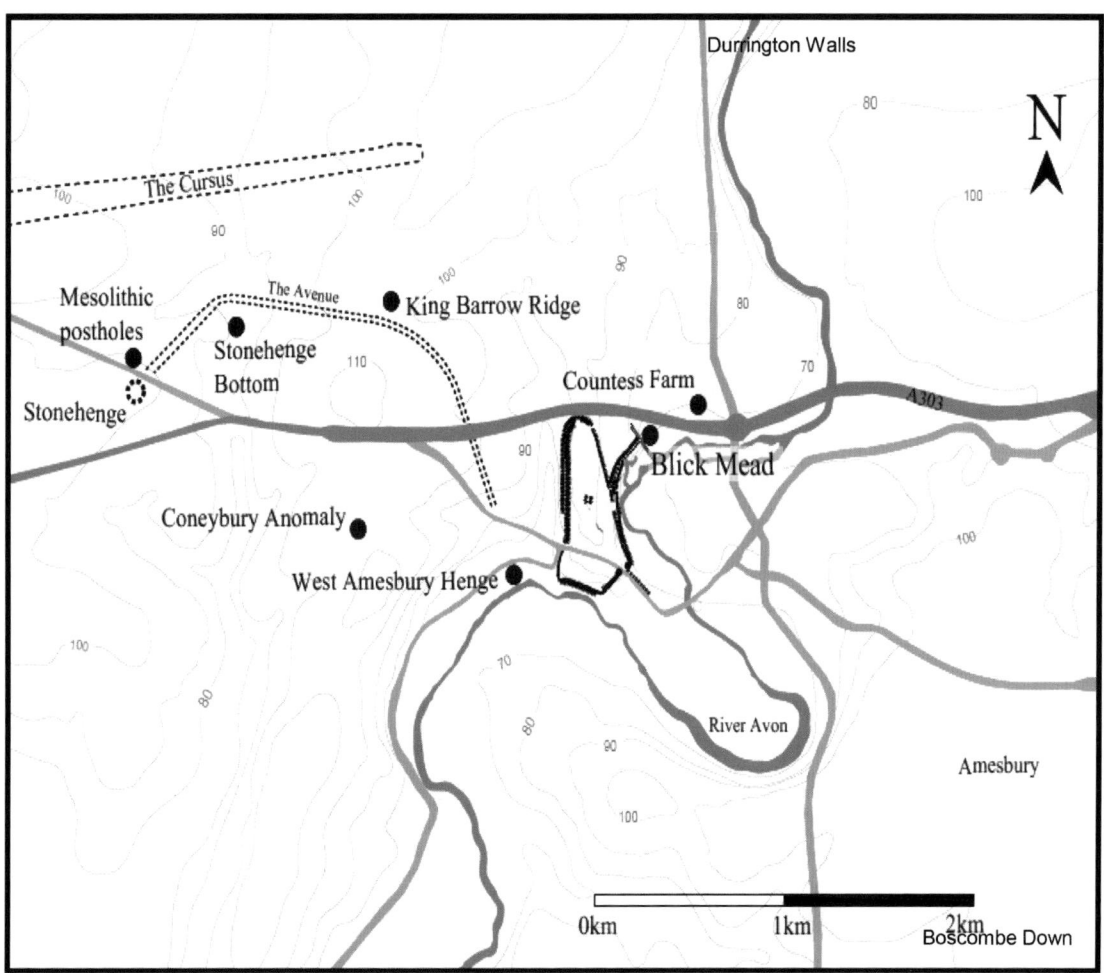

GEMMA ALLERTON

1 Romano-British reactions to the Stonehenge prehistoric landscape: A re-evaluation of settlement patterns and uses of that landscape

ABSTRACT
Studies for the Roman period of occupation within the Stonehenge landscape are minimal and under-analysed. The settlements found in the landscape have seen little scholarly attention despite increasing archaeological discoveries from that period in the location. There has been little understanding of how the Romano-British population responded to the prehistoric monuments that were found within the landscape around them and whether they assimilated their world with that of their prehistoric ancestors. With the use of a landscape archaeological survey, including phenomenological research, this research re-evaluates the Romano-British settlement patterns and the Romano-British people's attitudes towards a landscape in which the prehistoric is highly visible. The settlements of Boscombe Down West and Butterfield Down, both in the parish of Amesbury near Stonehenge, were analysed within the wider landscape. The outcome of this research shows a revised cultural process within the two settlements and that the choice of settlement location depended upon natural resources, trade routes and links to ancestral areas of significance. This research has found evidence that not only did memories of special places survive into the Roman period but that the Romano-British people were assimilating their settlements towards these places.

This research will ascertain the ways that people living in the Stonehenge landscape, during the Romano-British period (43–410 AD), assimilated the highly visible prehistoric landscape around them. For the purpose of this study the 'Stonehenge Landscape' is defined by the areas of the UNESCO World Heritage Site of Stonehenge, Avebury and Associated Sites, which lie within the parish boundaries of Amesbury, as well as associated sites within Amesbury but outside of the World Heritage Site boundaries, including Boscombe Down Ridge. Part of this study involves an assessment of whether any continuity of association with the landscape can be inferred from the material evidence. I shall also be examining the effect of Romanisation on these interactions and examining the possibility for dual identities (Roman culture with prehistoric ancestral traditions).

Since a brief period in the seventeenth century, when Inigo Jones set out the antiquarian view that the Romans built Stonehenge (Chippindale, 2012, p. 48), little attention has been paid to the Romano-British activities in this landscape or how they lived within it. For example, though it is often cited that a large amount of Roman material has been found at Stonehenge itself (Cleal et al. (1995) references 1857 sherds of pottery), this is done descriptively and there is no analysis as to why this pottery may have been there in the first place.

The lack of analysis of Romano-British activity at Stonehenge is due to the overshadowing effect of the Neolithic and Bronze Age studies. Modern scholars give a paragraph or two, of a whole book, to the Roman era of Stonehenge. The last major theory on the subject was by Collingwood and Myers (1937) in which they claim that the whole of Salisbury Plain was an imperial estate throughout the early Roman period (first to third centuries); this theory has been predominant, and although it has recently begun to be challenged, for example by Darvill (2006, p. 204), a new theory has yet to be developed. In fact, the recent investigations have focused mainly on showing that Romano-British activity at Stonehenge was scarce. Sporadic 'visits by tourists' (Cleal et al., 1995, p. 332) have been cited to explain the Romano-British artefacts found at Stonehenge and a survey of the people who work at Stonehenge found that half of the workers surveyed also held 'Picnickers' responsible for the Romano-British activity.

The lack of research, and new questions to test the data, is even more puzzling bearing in mind the increasingly significant amount of new Roman archaeological finds in the Stonehenge landscape, and

Amesbury, since the late 1990s. The most significant recent finds are found in the parish of Amesbury; firstly there is a Romano-British village, located within the Butterfield Down housing estate (Rawlings and Fitzpatrick, 1996) and there is also a large Romano-British complex of cemeteries at Boscombe Down (Wessex Archaeological Grey Reports, 2000, 2003, 2004 & 2005). Another significant archaeological excavation took place in 2008 within the stone circle of Stonehenge by Darvill and Wainwright; this too brought up some intriguing Romano-British data. Excavations when the second runway was being placed at Boscombe Down airfield in 1951 revealed intriguing Romano-British settlement discoveries which have never been placed within the context of these new excavation revelations.

The archaeological discoveries indicate that Romano-British people, in these places, would have lived within a landscape divided by Bronze Age linear ditches and surrounded by barrows. Indeed I argue in this study that they used these ditches for their own settlement boundaries and assimilated the barrows into their settlement. It is also evident that areas of ritual significance in the prehistoric period were held as ritually significant areas in the Roman period and similarly, areas held for settlement occupation in the prehistoric period were kept for the same purpose in the Roman period. However, despite this evidence, potential relationships between each individual Romano-British site and their associations with the prehistoric are yet to be examined. Dark encapsulated the point, although talking about the picture nationally – 'It is argued that the evidence for Roman period activity at prehistoric ritual monuments in Britain ... is invariably reduced to anecdotal significance, obscuring important relationships' (Dark, 1993, p. 133).

The new Romano-British archaeological discoveries in the Stonehenge area and Amesbury parish make this observation an important starting point for a new evaluation of the material culture. This study consolidates the new archaeological evidence and the outdated theories to gain a better understanding of the Romano-British period.

With the gap in the previous and current research methodologies established, I have chosen to examine a particular question. My research will evaluate the extent, and variation, over time Romano-British people, in the area, associated local, prehistoric sites as places of importance. My research concentrates on the following questions: what is the evidence for there being some form of continuity of ancestral memory in the Stonehenge World Heritage Site and Amesbury parish areas and is there evidence for a collective understanding of the area's past? Is the location of these Roman 'places' more to do with various resources, such as good soil or water supply, in the landscape? In the process of my investigation it is also necessary to re-evaluate the Roman presence in the areas under study to determine the diversity of the settlements in question and to ascertain any differences between them in relation to the above questions.

Visualising all the monuments that have been ploughed out since the Roman period, arguably it would be naïve to assume that people paid no attention to these earthworks, and the associations with them at the time. To be able to study a question such as this, a large prehistoric landscape with plentiful Romano-British finds is needed; the Stonehenge landscape provides just such things and offers an almost unique opportunity for this kind of research.

This research will focus, primarily, on three main areas; Butterfield Down Romano-British village and its possible associated cemeteries at Boscombe Down (one mile south-west of Amesbury Town Centre), Boscombe Down West Iron Age/Romano-British settlement and cemetery (located along the same ridge as Butterfield Down); and Stonehenge, within the immediate vicinity of the Stones. I will also introduce relevant small finds data from elsewhere in the Stonehenge and Amesbury landscape where relevant.

The research enclosed here is important, both on a personal level and academically. The information gained from this particular archaeological line of enquiry into the 'after story' of the Stonehenge landscape has the potential to be used in a number of ways and places. For example, it may encourage further studies of the ways Romano-British culture and religion assimilated prehistoric British cultural beliefs and also may encourage research into the other periods of Stonehenge's history which are less examined usually.

Personally, this research has been motivated by my residency in Amesbury. I moved here six years ago and was amazed by the prehistoric landmarks and astonished that there had been little effort to ascertain how they were understood in the Romano-British period. I am a native of the north-east of England and various studies of that area have made much more nuanced evidence to gauge and explain these complex cultural relationships (for example the extensive work carried out during the Hadrian's Wall research framework, with special note to the work of Allason-Jones and Hingley, 2009).

This research will also benefit Amesbury, a place which, like its Romano-British history, has been overshadowed. The new archaeological discoveries link the town with Stonehenge in a way that no other period does. The Roman finds show that Amesbury is not simply a place 'near Stonehenge' but that it has a lot more to it than its prehistory. The town has a diminished sense of itself. The economic benefits of heritage are well understood (Thurley, 2010). The past is increasingly being seen as something that can help the present. Ultimately, it is hoped that this research will go some way to bridging the gap in the knowledge base of Stonehenge itself, therefore adding to the long story of this magnificent long-duration landscape.

Wider theories of the Stonehenge landscape

The theories regarding the Roman period in this area are relatively out of date or not analysed at all. The general theory that Salisbury Plain consisted of an imperial estate first put forward in 1936 by Collingwood and Myers, 'It is on the whole most probable that, where we find large tracts of country exclusively inhabited by peasants, like Cranborne Chase and Salisbury Plain, we have to do with imperial estates' (Collingwood and Myres, 1937, p. 224) dominated for 50 years; many books published pre-1990 quoted this theory without question, for example Chandler and Goodhugh in 1989, others added their own evidence to the claim such as Wacher who notes, first in 1978 but upholds his claim despite new evidence in the reprint of the same book in 1998, that the population of Salisbury Plain were 'kept at a low subsistence level in order to provide grain for the Roman Army' (Wacher, 1998, p. 139). Recently, scholars such as Darvill have argued against this theory based on 'accumulating evidence' (Darvill, 2006, p. 204).

Other theories have been added to the Imperial Estate theory over time, Wacher (1998) argues a change in landscape use from pasture to arable in the later part of the Roman period, McOrmish et al. also argue for a change in the landscape in the later period citing a quernstone found at Chorlton Down that proves there was no imperial estate by the later part of the period (McOrmish et al., 2002, p. 107). McOrmish et al. cite soil erosion as a possible reason for a lack of villas (p. 106). Hingley also agrees with the theory that the landscape may have changed over time, he argues that the imperial land was sold off to private landowners sometime in the later Roman period and that the lack of villas is balanced by high value material goods instead (Hingley, in Rawlings et al., 1996, p. 40). This idea is contested by Rawlings et al. due to findings of luxury goods alongside villas in other areas, suggesting the two were not seen as separate; instead Rawlings draws on the work of Scott (1991) in which the question of distance from Romanisation is brought into the assessment of the lack of villa sites.

The discussions regarding villa sites in this area is important as it shows the nature of the site which is under study and, as noted by Scott above, it can also give information about the Romanisation of the people in question. A number of assumptions has been made, firstly that there are no villas in the area of Salisbury Plain (Collingwood and Myres, 1937, p. 209–210; Cunnington, 1931, p. 172–173; Goodhugh et al., 1989, p. 5) and others. Secondly there is the assumption by these same archaeologists along with others, that a lack of villas equates to a lack of lavish material culture and Romanisation, which is not the case, as seen with Hingley's argument above. The discussion as to whether a villa will be found, or ever has been found, near Stonehenge will continue until further archaeological

assessments are carried out; however, the idea that a material culture of Roman influence did not exist needs to be reassessed in light of significant finds from Butterfield Down in Amesbury.

Ritual associations

More recently work has begun to start looking at Romano-British people from the Stonehenge landscape in a more analytical way, for example Fitzpatrick (2002) has looked into the religious aspect, especially of Boscombe Down's burial grounds. He notes a very significant phenomenon of Christian burials alongside Pagan burials, showing that the two lived together in the nearby settlement. Manning (2005) also makes the link between Boscombe Down and a ritual landscape, citing that the burials here are on a landscape that has, throughout time, been ritual (note the Amesbury Archer and Boscombe Bowmen are buried here as well as Neolithic pit circles and Mesolithic postholes). In the short article by Manning, he asks the crucial question of whether the Romano-British burials are placed in this ritual landscape by coincidence or by conscious choice.

The theme of ritual is picked up, once again, in the newest (at the time of writing) book on Stonehenge, written for Heritage England in 2015. In this, they draw upon the excavations by Darvill and Wainwright and argue that they have found evidence that Stonehenge was being used 'for ritual and ceremony' in the Roman period (Barber et al., 2015, p. 79). The book also continues with reference to antiquarians' finds of a possible lead curse and votive pewter (p. 80) which may link Stonehenge to Roman religious activity further. Despite this, the book makes little attempt to further analyse these activities or link them to any of the ritual activities at Boscombe Down or to the prehistoric.

Continuation of settlement

One main question of this research is one of continuation; it was put to me by a colleague that there would have been too much time and occupation of other periods (Bronze Age and Iron Age) between the Neolithic people and the Romano-British people for there to have been any real continuity of behaviour, however, the literature suggests a great deal of habits and traditions that have been continued; Sam and Moorhead claim that Iron Age coins at Butterfield Down shows continuity of occupation (Sam and Moorhead, 2001, p. 86), as well as the nearby Iron Age settlement at Boscombe Down West which continued into the Romano-British period (Richardson, 1951). Farming traditions are also cited as continuing from the Iron Age into the Roman period (Johnson, 1987, p. 29). Collingwood and Myres claim that Salisbury Plain was subject to intensification of ancient cultivation practices (Collingwood and Myres, 1937, p. 179). Collingwood and Myres also make the important point that the inhabitants of the Roman period had 'a character which separates it from that of the modern population and assimilates it to the prehistoric' (p. 177). This point alludes to the notion of the huge changes that have taken place through the Medieval into the modern period which remove modern society further away from the Romano-British population than they were from their Neolithic ancestors.

Another theory to do with continuity is the reverting back to old traditions or Celtic revitalisation. Henig is in favour of this theory and notes items from Butterfield Down which revert back to the artistic style of the late Iron Age (Henig, 2001, p. 122); for example, he notes the artistic style of a bird figure found at Butterfield Down which may reflect native ideas and the three finger rings found at New Covert which he also believes shows Iron Age artistic qualities (p. 111). Foster also agrees that

some ancient traditions were revived in the Roman period such as the hobnail boots used by the Romano-British in their burials which, she claims, is an ancient tradition with a Roman invention (Foster, 2001, p. 168).

Stonehenge

One of the most dominant theories about Romans at Stonehenge is that of Atkinson (1956) in which he claims that the Romans saw Stonehenge as a danger from Druidism and sought to destroy it. In other scholarly work the Roman period at Stonehenge is notably absent, however it is noted by some that the Romans were present, for example Cleal et al. make a good effort to detail the mass of Roman finds from within the stone circle and around it. However, despite believing that Stonehenge may have 'remained a place of importance within folk memory, for many generations after its main period of use. ... Even though the purpose of the monument may have been long forgotten, its extraordinary structure, its obvious importance as a focus for the construction and use of other, lesser monuments, and its very strongness may have exerted considerable influence over the use of land around it' (1999, p. 332), they still regard the finds from the Roman period as picnicking or tourist activity.

Darvill, in his recent excavations, seeks a new interpretation which incorporates the site as a place of ritual and ceremony with structural evidence in the fourth century (Darvill and Wainwright, 2009, p. 15). Bowden et al. have picked up on Darvill's theories and note that, rather than destruct the monument, as Atkinson believed, instead the Roman population were adapting the monument (Bowden et al., 2015, p. 80).

The sites of Butterfield Down and Boscombe Down West

In the excavation of Boscombe Down West, Richardson notes a cultural sequence stretching from the Iron Age through the early Roman period and into the late Roman (Richardson, 1951, p. 123–168). This site is connected in many of the Wessex Archaeological grey reports as being a possible prequel to the settlement at Butterfield Down. Rawlings (1996) and Darvill (2006) agree that the Boscombe Down West settlement declined in the third century AD which corresponds with the rise of the settlement at Butterfield Down in the late second century, however Darvill does not claim that one moved into the other but that the settlements changed over time (Darvill, 2006, p. 206). No further analysis of this site has been undertaken since its discovery in 1951 in light of new discoveries at Boscombe Down airfield. Evidence recently discovered is often attributed to the settlement without analysis. In contrary to this, several pits discovered near to the settlement at Boscombe Down West (OS Grid Reference SU145412) were attributed as being contemporary with the Butterfield Down settlement (Anon, 2000, p. 255) despite its Iron Age/Romano-British dates being more in line with the Boscombe Down West settlement.

Butterfield Down is described by Rawlings and Fitzpatrick as a rural agricultural settlement in their report in the *Wiltshire Archaeological and Natural History Magazine*, volume 89, p. 1–43. Cleal et al. also cite it as a 'small town' (1994, p. 343), while Darvill describes it as a 'substantial unenclosed Hamlet' (2006, p. 205). Wessex Archaeology grey reports generally link Butterfield Down with the nearby cemeteries at Boscombe Down and with the other Romano-British discoveries at New Covert.

Environmental information

Many studies have looked at the environmental conditions of the Stonehenge landscape, however, as with other issues, the Roman period is usually considered very briefly. French et al. note that the soil condition in the Amesbury area, in the Roman period would have been 'open grassland with some relic woodland and some arable; stable wet floodplain with alder carr on margins; slow peat growth' (French et al., 2012, p. 27). This relates mainly to the Avon valley area, where as the settlements which are in this research are located mainly on the ridge above the valley, it is still important to understand the local area's environmental conditions to better understand settlement location choice.

French et al. note the strong evidence of arable farming even near to the river valley and that the valley itself is likely to have been quite stable and not prone to the constant flooding which had been evident throughout prehistory (French et al., 2012, p. 14).

Another phenomenon to do with the River Avon is the theory that some of the spring heads do not originate from the river itself, but instead come from a different source, more iron rich in content alluding to a rich colour and minerals which may have been appealing to the Romano-British population as well as their predecessors (Green, 2015, personal communication), this research is ongoing.

Assimilation

The idea of assimilation is not widely tackled; Dark argues that assimilation is done in the form of superstition (Dark, 1993, p. 133). This, Dark believes, leaves assimilation open to people who are of different religions and 'who follow different codes of action in every other respect' (p. 133). Dark's paper, interestingly, cites the countrywide presence of Romano-British activity at prehistoric sites, including the plethora of finds from Bronze Age barrows, as well as the significant Roman altars at, or near, to prehistoric ritual sites. Dark shows his own frustrations with a lack of analysis towards these finds and argues for a new interpretation; he disagrees with Atkinson's theory that Romans were destroying the stones at Stonehenge, and instead believes, in agreement with Darvill, that the Roman period saw a re-working of the bluestones and a possible large scale remodelling of Stonehenge (Darvill and Wainwright, 2009). However, Dark's paper comes at a time before the excavations at Amesbury and therefore a lot of the assumptions that he has made can be ruled out, for example, he claimed there are no votive objects near prehistoric ritual sites, but if Barber et al. are correct, and the Antiquarians found such items (2015, p. 81), as well as the eagle head sceptre found at Butterfield Down (Rawlings and Fitzpatrick, 1996, p. 21) then Dark's claim, that assimilation is down to superstition rather than religion, needs reassessing.

The Dark article is a countrywide view, aside from this there is little attempt made to assimilate the prehistoric with the Romano-British in the local area to which this research is aimed or on a countrywide basis. This fact is reflected in the absence of journal articles in this literature review. Much of the evidence obtained for this research is through unpublished grey literature and the Historic Environments Records and the Portable Antiquities Scheme. Many of the finds from this area have, frustratingly, not been published. The Rawlings and Fitzpatrick article is one exception however even this article, whilst being very detailed in description of artefacts, does not give much analysis of findings, it omits findings such as the huge amount of pottery which was not collected due to having already collected enough for studying (Jacques, 2015, personal communication) and, like so many of the other articles in this literature review, it fails to link the prehistoric landscape around it, or the prehistoric findings within it, to the Romano-British landscape.

Although this research is set within a period in the historical era, there is a lack of primary sources for this area from the Roman period. It is contested whether any primary source directly relates to Stonehenge. There is a quote from Book II.47 of Diodorus Siculus (Oldfather, 1935) which has been claimed to be referring to Stonehenge as a temple to Apollo; however, many scholars now believe this is not the case.

This research

With the problems and questions in mind, the research methodology combines several different areas of investigation within a broader landscape survey. A full survey of this nature would bring together all of the previous archaeological excavations and literature and enable a view of them in conjunction with one another as well as placing the whole area into its wider geological and environmental context. This will bring to light the ideas and thought processes behind settlement location choice and reveal if there was any connection to the prehistoric world in that thought process or whether it was clearly resource driven. Other components of the landscape survey will aid in analysing the material finds to discover any connections within their style or art.

The desk-based assessment research aims to bring together all of the past theories and also to look at the material evidence. It is the small finds of the archaeological excavations that will reveal the material culture and although this research's focus is on the placement of settlements, the particular question of assimilation needs to look at the evidence of the small finds. The desk-based assessment is vital in understanding sites which are now covered in housing estates or which are part of inaccessible military stations.

Viewsheds are carried out to assess the lines of sight between the prehistoric monuments and the location of the Romano-British settlements. Tilley argues the importance of visibility to natural features such as mountains and coasts (Tilley, 1994); however, it is also of importance, especially for this research topic, to assess the visibility that the Romano-British people had with their ancestors' monuments.

Tilley's main question in his book *A Phenomenology of Landscape* is 'why were particular locations chosen for habitation and the erection of monuments as opposed to others?' (Tilley, 1994, p. 1). Tilley believes that this question can be answered with the aid of phenomenological studies and that past archaeologists have ignored this method of research in favour of concentrating on single sites rather than their surroundings (p. 3). Tilley's criticisms of past archaeologists is certainly shown to be true of those who have excavated the Romano-British sites within this area of research and, as the questions of the research are also looking to discover why settlements were placed in a certain location, within a broader methodology of landscape archaeology, phenomenology allowed me to see the 'social memory passed down in non-textual, non-linguistic ways' (Renfrew and Bahn, 2008, p. 220).

Tilley makes the argument that landscapes can hold memories and meaning to people, that the trees and rocks and rivers become areas of recognition for the humanised places and are associated with past social actions or mythology (p. 24). If the natural land can hold such memories then the humanised monuments in the landscape can be studied to see if linking them to the Romano-British people through memory and past social actions can reveal the manner to which these monuments were assimilated into the Romano-British settlement location choices. The landscape walking was essential to the understanding of these links, if links existed.

The phenomenological method gives a great insight into the way the Romano-British people saw the landscape; however, it is important to consider the evidence alongside the environmental evidence. Natural resources may have played a vital role in the settlement location choice, just as much as the phenomenological reasons. The environmental data taken from the archaeological reports are combined with geological reports and the local information to gain an overview of the natural resources

available. Topography is also taken into consideration to ascertain any commonalities between the site locations.

This landscape has changed dramatically over the past 30 years, and most considerably in the past 10 years with the rapid expansion of new housing estates and the building of considerably large industrial estates. This makes it somewhat difficult to assess some of the environmental factors, as water tables may have been affected and natural resources covered over with buildings. There is also an issue of inconsistency between the geological reports and the local information. Placing the phenomenological data within the environmental contexts gives a much higher understanding of the landscape.

Maps were used throughout the research. Elevation profiles were made prior to conducting the practical viewsheds. This saved time on areas that were certainly not in line of sight with each other, as well as being a way of seeing the landscape bare of trees and buildings. Geological maps and old maps help with the environmental assessments, especially in locating items in the landscape which are now gone such as springs and orchards. The landscape was surveyed extensively on maps, most importantly I mapped the archaeological finds (prehistoric and Roman) from the Historic Environments Record, the National Record of the Historic Environment and the archaeological records onto an Ordnance Survey 2015 map at a scale of 1:25,000. These were colour coded by their period of occupation which allowed the view, instantly, of any correlations of settlement patterns and where occupation had continued for long periods and where it had died out. It also gives the option to see the sites as a whole rather than separately. I noted any special finds such as prehistoric monuments which enabled me to see their special relationship to their surroundings.

The results of the previous methods highlighted the importance of the location of Romano-British burials, and therefore it was felt that a case study of child burials is a good opportunity to consolidate the previous results and to test the findings against. A full investigation into the burial of children from the prehistoric through to the Roman period in this area was conducted in contrast to findings of child burials in other areas and alongside work carried out by Moore on the reasons behind the decisions surrounding child burials in the Romano-British period. Any patterns or similarities were extracted and the reasons for these were considered. This research adds to the overall questions of assimilation; if the practice of burying children could be linked to practices used in the past or linked to the prehistoric in other ways then this would add further clarity to the rest of the findings.

One of the most difficult tasks to undertake was deciding which of the Romano-British sites to include in my research. There are several other sites in the vicinity of Stonehenge which were considered; Durrington Walls has Romano-British activity very similar to the one chosen for research at Butterfield Down, it is in fact closer to Stonehenge. There are also other sites at High Post in Amesbury and at Winterbourne Stoke to the west of Stonehenge. A large Romano-British villa complex lies to the north of Stonehenge at Figheldean as well as other smaller sites at Netheravon and other parts of Durrington.

The reason why the focus was placed on Butterfield Down and Boscombe Down West is because of their close association with each other and the large presence of prehistoric monuments and activity near to them. The two sites also offer the opportunity to study sites of different time periods, one from the early Roman period and one from the late period, which were also excavated in two different times and situations; the Boscombe Down West settlement was excavated rapidly before many techniques were available where as the Butterfield Down settlement was excavated recently with more time and technique. These settlements would offer up two very different pictures of Roman Britain and how it changed over time.

Viewsheds

A set of viewsheds was conducted all on the same day, excluding the one taken from Boscombe Down airfield; this allowed consistency of light and vegetation. A clear, spring day was chosen so that vegetation was light and visibility was good. For the purpose of the viewshed, Boscombe Down that is

referred to is the cemeteries and the top of the ridge and not the Iron Age/Romano-British settlement of Boscombe Down West. The Boscombe Down West settlement is located on the south-east side of the ridge, too low down to reveal the landscape beyond to the north-west. A viewshed was conducted by Richardson during her excavations of the site in which she notes that this site overlooks prehistoric monuments to the south and east such as Ogbury Camp and Figsbury Ring (Richardson, 1951, p. 125) however, as is seen from the desk-based investigation, it is not clear to what extent this settlement reached onto the ridge, therefore it is important to include the top of the Boscombe Down ridge within the results of the viewsheds to gain a clear picture.

The elevation profile revealed that Boscombe Down and Butterfield Down are located on a plateau high enough to allow them a view of the majority of the ancient monuments on the next ridges; however the monuments west of King Barrow Ridge are obscured from view by the ridge. It was pertinent to conduct a viewshed within these 'grey areas' in order to confirm or deny the elevation profile findings.

Viewsheds were taken from nine locations looking towards the sites of Romano-British occupation. It is difficult to conduct a viewshed from the Roman Sites looking out due to the build up of houses and access restrictions. This being said, I was able to find locations within Butterfield Down where a clear line of sight was observable and I was also able to briefly take a viewshed from the top of the Boscombe Down Ridge. The practical viewshed began with the monument of Durrington Walls. Located on the edge of the ridge, this henge has clear views to the north, south and east; however, the rise of the ridge blocks the view to the west. The Romano-British settlement of Butterfield Down and the cemetery and ridge of Boscombe Down are easily visible; also visible is Vespasian's Camp Iron Age hill fort and the Avon valley towards to the location of a possible Roman-British villa complex. The viewshed was taken from the most northerly point of the henge; however, the view was noted to be very similar the whole way around the henge.

Woodhenge offers similar views to that of Durrington Walls; however, some trees directly south-west of the monument block an otherwise clear view of the Romano-British occupation location. Vespasian's Camp and King Barrow Ridge come into view as the southern end of the ridge is approached.

Slightly west of Woodhenge is the Cuckoo Stone and location of a Neolithic long barrow; this is also the location of the Romano-British settlement that is comparable to Butterfield Down settlement. This location was used for ceremony from the Neolithic through to the Roman period shown by a coin hoard discovered at the Cuckoo Stone. The views from this location are, again, comparable to the previous two; it is on the southern edge of the ridge, un-obscured by the trees that covered the views from Woodhenge. The Romano-British settlement would have been visible as would Vespasian's Camp, Coneybury Anomaly and King Barrow Ridge, as well as being inter-visible with Durrington Walls and Woodhenge. This shows us that the Romano-British settlements at Butterfield Down and Boscombe Down were not only inter visible with the prehistoric sites and monuments but also with other Romano-British occupation sites.

The next area of investigation is the Cursus; visibility towards the Romano-British settlements varies across the 3 km length of the Cursus monument and it was unclear if it was visible at all. Starting with the most easterly point, the viewshed was taken from the site of the Neolithic long barrow (Amesbury 42) at the end of the Cursus. This area is slightly too low for the next ridge, containing the Romano-British settlements, to be visible, however, this long barrow is now ploughed out and, had it stood to its full height, it is certainly plausible that it would have formed a horizon point for the Romano-British settlements in Amesbury especially as a few feet south of this long barrow the Amesbury settlement locations are clearly visible. It does, however, confirm that the end of the Cursus itself would have been out of sight of the Romano-British settlements.

The western end of the Cursus is also out of sight, hidden by King Barrow Ridge. It is debatable whether the landscape would have been visible had there not been trees on the ridge. If this was the case then possibly the large barrow (Winterbourne Stoke 30) may have formed a horizon point similar to the long barrow (Amesbury 42) at the opposite end. The elevation profile (which can show us beyond the King Barrow Ridge trees) shows us that although it is plausible that the western end

of the Cursus may have been visible to the Boscombe Down cemeteries, had there been no trees on King Barrow Ridge, it is not possible that it would have been visible from the settlement location at Butterfield Down. It is difficult to determine whether there would have been trees on King Barrow Ridge during this time period and despite there being the possibility of line of sight between the two areas of Boscombe Down and Cursus west, it is over 5 km away, therefore would have been difficult to see with the naked eye regardless.

King Barrow Ridge was examined in three separate locations; the Old King Barrows to the north, the New King Barrows further south and the point at which the Stonehenge Avenue crosses the ridge. This ridge is important, archaeologically, not just for its barrows but for the Neolithic finds, especially important for this research is the chalk plaques from this area that are comparable to those found at Butterfield Down. From the northern end of the ridge, Boscombe Down and Butterfield Down are clearly visible, however, as we move further south, the trees from the top of Vespasian's Camp begin to block the view, first of Butterfield Down and then of the higher Boscombe Down. It is debatable whether there would have been trees on the Iron Age hill fort at the time of Roman occupation, it is unlikely that they were due to the recent settlement occupation of the hill fort at that time, or how good visibility would be had there not been trees. The elevation profile, once more, is useful here; it can tell us that from no location is Vespasian's Camp large enough to obscure the view from Boscombe Ridge to King Barrow Ridge without the trees on the top of it. It is highly likely that the huge barrows of King Barrow Ridge would have been another feature on the horizon, especially those furthest north. The Avenue crosses the King Barrow Ridge between the Old King Barrows and the New King Barrows, therefore we gain a mixed sight line of the Romano-British settlements, however, as above, if the trees of Vespasian's Camp were gone there would be a clear line of sight, this is the only part of the Avenue which is visible to settlements beyond Vespasian's Camp.

Stonehenge itself is also out of view of the Romano-British settlements. Although the large aircraft hangar of the Boscombe Down military base is visible from within the stone circle, it is unlikely that smaller buildings, such as those used by the Romano-British population, would be in line of sight of the stones. Both Stonehenge and the Cursus are placed at a lower elevation than the surrounding ridges, possibly so that the ceremonial landscapes are hidden from the settlement locations. It is not within the remit of this research to ascertain the reason for the placing of Stonehenge and the Cursus, however it is worth noting that the Romano-British settlement pattern have adhered to the Neolithic concept of keeping one area for settlement and another as a hidden landscape. It is interesting, following on from this point that the settlement at Durrington Walls is also out of sight of Stonehenge and the Cursus.

The final two areas of investigation, looking towards the Romano-British settlements, are the Coneybury Anomaly and the south-west edge of Vespasian's Camp Iron Age hill fort. Both of these have exceptionally good views of both Butterfield Down and Boscombe Down; however, interestingly, they have no sight lines towards Stonehenge.

Looking from the Romano-British settlements, out into the landscape, beginning with the commanding view from the top of the ridge of Boscombe Down; this view is clear in all directions. Line of sight to the north and west reaches to the next ridge with the King Barrows, Vespasian's Camp, Coneybury Anomaly and Durrington Walls, it also stretches to the next ridges, possibly to the location of Robin Hoods Ball but confirmation of this would be needed. To the south there are the views, mentioned above, of two further Iron Age hill forts of Ogbury Camp and Figsbury Ring.

Butterfield Down also offers clear views of the monuments to the north-west, Durrington Walls is especially prominent. As the settlement is slightly down the ridge there are no long distance views to the south. The barrows seen on the ridge to the north, on the hill towards Bulford, become focal horizon points compared to the view from Boscombe Down which is very much above them.

Boscombe Down shows a commanding view of the landscape where as Butterfield Down appears more within the prehistoric setting. It is interesting, then, that the main occupation level is within the prehistoric setting, this will be explored further in the next section.

Phenomenological observations

Butterfield Down was completely surrounded by prehistoric ancestral monuments; from the point at which the viewshed was taken there would have been a full 360-degree view of the prehistoric landscape if the modern houses were not there. To the north-east, as mentioned above, is Bulford hill and Earl's Farm Down, both areas have huge barrows and the barrows on the hill form a spectacular horizon. To the south-east are more barrows running along the top of Earl's Farm Down, these would have been on the horizon in this direction. Looking to the immediate south-west there are the burials of the Boscombe Bowmen and further barrows, and to the farther south-west the Amesbury Archer burial and other Neolithic and Bronze Age features which will be discussed further below in the desk-based survey. Finally to the north-west is the valley containing Vespasian's Camp and the Mesolithic Spring at Blick Mead. All of these prehistoric ancestral monuments lie within no more than a one mile radius of Butterfield Down with the exception of Vespasian's Camp, which is a little over a mile, therefore the close proximity of the barrows gives a feel of being within the ancestral memory rather than opposed to it or commanding it. There are also, as noted in the viewsheds, the monuments further into the landscape, such as Durrington Walls and Coneybury Anomaly, which also enclose the settlement. Placing oneself into a landscape devoid of its modern buildings, with all the extant monuments back in place is an imposing and impressive view, not to be ignored in the study of the landscape and certainly not something that could have been ignored by the population inhabiting the area in the Roman period. The ancestors are 'in your face', and, to build a settlement within this landscape, would have required their inclusion.

Traditional view of the Romano-British period would assume a settlement location of power and security; however, as we see with both the Butterfield Down settlement and the Boscombe Down West settlement they have chosen a site which is not strategically located for defence, with the top of the ridge open. In fact, both settlements seem to have avoided the strategic location in favour of one more within the ancestral boundaries (this is further clarified with findings from the Wessex Linear Ditch in the desk-based assessment and map reading below). There is equality with the ancestor's monuments rather than animosity or superiority.

There are several areas of noticeable interest within the Butterfield Down settlement, the first being the possible temple location as described by Rawlings and Fitzpatrick (1996). They describe the temple with its opening facing north west which, when analysed further correlates with the Mid-Summer sunset which sets in the direction of Stonehenge. The cemetery are also placed in an interesting location, my research took me there many evenings and there are amazing sunsets all year round, however, the best are enjoyed near the Midwinter sunset. At this point of the year the sun setting over Coneybury Anomaly spreads across the vast horizon spectacularly. This amazing view from the cemeteries is intriguing, however if we look at it the other way round it shows that the sun rises behind the Amesbury Archer and the graves of the Romano-British people on the mid-summer solstice. There is new, intriguing evidence for Roman buildings to be aligned with the sun (De Franceschini and Veneziano, 2011) but further investigation into the reasons behind this architectural style are still ongoing.

As well as the sunsets, other natural phenomenon that occur on the ridges near Salisbury Plain is the micro-climate of weather. This plays an important role in this landscape; the winds from Salisbury Plain are infamous and the Romano-British settlements are open to this wind coming west to east. On the top of Boscombe Ridge it is extremely open to the elements. The Boscombe Down West settlement was perhaps a little more sheltered, being on the western side of the ridge. Another weather phenomenon encountered during this investigation was that of fog. There are intense and regular fogs in this landscape but usually only in the valleys. Quite often the tops of the ridges, including the barrows, are still inter-visible with each other despite the presence of blinding fog a few metres down the slope. Previous generations may have been aware of the emotional impact this view had.

It was difficult to conduct a phenomenological survey in an area that is now very altered from the Romano-British period, had it been conducted just 20 years ago the land would have still been very similar. The landscape is also very familiar to me in my own daily context which created problems, and coupled with the issue that the Romano-British buildings are lost to us differs from usual phenomenological studies where there is usually a basis to start from. This research had to determine the location of the buildings based on archaeological reports, this occasionally made correlations in the landscape hard to determine and the correlation between buildings of the Romano-British period impossible as many of them were not excavated to their fullness. The majority of these issues are irresolvable and work progressed as best as possible around them, however, the issue of familiarity to myself was one that I was able to tackle by including others in the landscape walk who were not familiar with the landscape at all. This involved some bias from myself still, as I had to communicate to these people where in the landscape certain buildings had been and what monuments they were looking at in the distance. The colleagues noted the barrows on the horizon and their relevance to the Romano-British settlement location. They were shocked at the clarity to which the next ridges are visible; the monuments which are usually mentioned in their singularity are all together in the view from these Romano-British settlements.

Environmental observations

It is widely accepted and so far undisputed that the area around the Roman settlements were arable farming land. French et al. have samples taken from the Avon that show an arable landscape (French et al., 2012, p. 26). The question that arises is not of the land use but of water.

It is clearly seen on maps where the River Avon runs; the next nearest river is the River Bourne to the east of Boscombe Down. The settlement at Boscombe Down West, with its slightly lower altitude down the ridge would have been 609 metres from the River Bourne, indeed this is where Richardson believes they obtained their water; however, there is a steep drop down this side, not unmanageable but not easy. The Butterfield Down site is also located high up on the ridge 836 metres from the River Avon and, again there is quite a sharp decent near the river. Both of these sites are located on the Seaford Chalk Formation leading to the Newhaven Chalk Formation but, as is clear from geological maps, there are heads of gravel, silt and clay leading down these ridges to the valley bottoms. The heads may release water that has been percolated through the chalk, and it is on one of these heads that there was an orchard placed slightly north of the Butterfield Down settlement in the twentieth century. The presence of an orchard being able to grow signifies more water in this land than is usual on chalk formations. Whilst these heads may hold and release water, it is not evidenced that these would have produced enough to suffice a settlement's sole water source. Leading geologist Don Aldiss believes that these heads could, arguably, have created springs but that these springs would have survived for only short periods, perhaps days or months at most, they would have been too unpredictable to rely on as a water source (Aldiss, personal communication). The local knowledge of these unpredictable springs may have given rise to well building to extract the water located in the chalk. This is a feasible assumption because possible well structures have been found at Butterfield Down (Rawlings and Fitzpatrick, 1996, p. 17) and also at New Covert (Wessex Archaeology, Report 43193.1). There is evidence for the practical possibilities for wells in this area from a recent British Geological Survey of test pits on the ridge at Boscombe Down when one of the pits filled up with water from the water table (Clarke, 2015, personal communication). There are also reports of this nature from slightly down in the valley of Boscombe Down to the south-west of the Boscombe cemeteries at Stockport Bottom, where businesses have reported flooding from spring like eruptions. This area has not been investigated, however this would agree with the theory of the clay heads producing short-lived springs. It

is worth noting there is a valley which runs across the Boscombe Down Ridge near to the Boscombe Down West settlement, this may have been formed by the spring heads and therefore would have been an indicator for a water source, the valley does not reach to the Boscombe Down cemeteries or the Butterfield Down settlement.

Some of the weather features of this landscape were mentioned in the previous section; however it is worth adding here that the Butterfield Down settlement lies on the south-west facing of the Boscombe Down Ridge and therefore enjoys plentiful sunshine, although it is faced with the Salisbury Plain winds. A mixture of sunshine and the water in the chalk would have produced excellent growing conditions, as exampled by the chosen orchard site in the recent past. The Boscombe Down West site would not have enjoyed the long sunshine, being on the north-east side of the ridge; however, it would have been more protected from the elements.

Both settlements would have benefitted from being away from the floodplains, which, although less prone to flooding, as noted by French et al., would not have provided a good settlement location.

Desk-based survey

The desk-based survey researched all of the archaeological records for the area including Historic Environment Records, Archaeological Grey Reports from, as yet, unpublished sites, and excavations noted on the National Record of the Historic Environment. The full details of the excavations can be found through all of these means, therefore it is not within this research to repeat all that has been previously said.

The survey begins with the settlement at Butterfield Down, based on the findings by Rawlings and Fitzpatrick in 1996. The round structure, noted as a possible temple site (observed in the phenomenological survey) is a main point of interest, especially with the nearby findings of a pit with a crow and also the find of one of the latest Roman coin hoards in Britain, dating into the fifth century (Rawlings, 1996, p. 19). Trench 23 of the Rawlings excavations is of particular interest; within this trench is found the temple and coin hoard as well as archaeological finds from a wide range of periods. There is evidence of a Neolithic ring pit surrounded by Neolithic and Bronze Age pits as well as a Bronze Age crouched burial. It is of great significance that just outside the boundaries of the Rawlings excavation there was the discovery of a Bronze Age cemetery which included the multi person Boscombe Bowmen grave. These graves would have been in the right position to complete the circle of burials and pits around the Neolithic ring pit. Also in Trench 23 was the pit or well as discussed in the environmental survey, which included a horse skull and sheep skeleton, possibly ritually placed within. This trench was also the location of the find of a copper bird figure, possibly an eagle from a sceptre. Other figures found in this location include animal feet, the figure of a woman and, just outside the boundaries of Trench 23, a metal detector found a figure of woman attributed to that of the goddess Cybele (HER no SU14SE333). There was a significant amount of pottery found at this location, it has been noted that so much pottery came out that it was no longer collected and people who live in the houses on that site still report finds of pottery. Most importantly there was some shards of jars which had bead rims, a style influenced by the Iron Age (Rawlings and Fitzpatrick, 1996).

Most of the pottery and coins from this site date to the late Roman period although there are some early artefacts, and there is also some high status pottery from all periods. Other high status objects include amulets, brooches, a stylus and some glass objects indicating that this was an area that was frequented by some high status and educated people. Also found at this location are items indicative of the type of activities that were carried out, for example there is evidence of metal working, animal husbandry, flintknapping and farming as well as the corn drying kilns and a spindle whorl. This

indicates a wide variety of activities and a self-sufficient settlement. Extensive evidence of buildings comes in the form of stone tiles, cob walling and ceramic building material, a well preserved corn drying kiln was also found.

The Roman material is vast, however this site did stretched across periods. There are Neolithic finds, mainly flint tools and evidence of flintknapping which is found to the north east of the site, however, near to the centre of the Roman activity a stone axe and a chalk plaque was discovered, similar in style to those found at King Barrow Ridge. It is also worth noting that slightly west of this location, on the same ridge, a tranchet axe was found by a metal detector (Historic Environments Record HER no SU14SE051). Bronze Age flintknapping is also found, as well as beakers, urns and incense cups. There is also many Bronze Age burial mounds in this location however many of them are now lost and appear only as crop circles or evidenced in antiquarian finds which can not be verified today.

New Covert excavation site, excavated by Wessex Archaeology as the first part of their housing development excavations which later revealed the cemeteries (Report no 43193.1) is across a modern road from the Butterfield Down settlement, therefore it is widely agreed upon that this formed another part of that settlement. The Wessex Linear Ditches alongside Roman dated ditches are found to the north-east (Wessex Archaeology, 2000, Report 48522) and west of Butterfield Down (Rawlings and Fitzpatrick, 1996). These ditches also appear to enclose the New Covert site making it within the Butterfield Down site, further to this there are trackways which appear to run from the New Covert site into the Butterfield Down site location. More evidence for this comes from the archaeological excavation which took place next to a shop which is directly between Butterfield Down and New Covert (Wessex Archaeology, 1999, Report 47351.1); this excavation revealed a tile from a heating system (very similar to one found at Butterfield Down), other finds were similar also; this site would link the two together. It is probable that this site extended further north-west as archaeological excavation undertaken by Terrain Archaeology in 2005 at Beaulieu Road, Amesbury (Report no. 53203/2/1) found contemporary Romano-British artefacts as well as prehistoric which corresponds with the evidence from around the location.

The New Covert site is also shown to have similar activities to those at Butterfield Down, for example corn drying kilns and ovens are found. The pottery is of contemporary age and the distribution and type of building material found is similar to Butterfield Down. The pattern of high status items is also continued into this area with the discovery of three silver rings and a coin hoard all found in the 1800s. As noted in the literature review, there is contestation over what these rings depict, Henig offers the argument that they revert back to an Iron Age artistic style, showing images such as deers and griffins, and that they come from a period after central power was diminished (2001, p. 122). These rings are important to this research and the theory of assimilation and will be discussed further in the discussion section. The Romano-British child burials found in this location are also of interest to this research and are discussed further in the case study section.

Several pits are also found at the New Covert site, as mentioned in the environmental review, these were possibly shafts or wells similar to the one found during the excavation of Butterfield Down, these pits also contained possibly ritual animal deposits similar to that at Butterfield Down (for example the crow). There is also a Neolithic pit which contained votive offerings. The Bronze and Iron Ages are represented in this location by minimal pottery finds.

The further excavations by Wessex Archaeology for the new housing estate at Boscombe Down were conducted in several stages, New Covert being the first. For this results section I have included everything from the Wessex Archaeology Grey Reports from each of the excavations into one location (Report numbers: 36875.1, 43193.1, 56240.02, 50875.2 and 36871.1). Of particular relevance from this whole location, beginning with the Neolithic finds, is a Late Neolithic/early Bronze Age pit circle, the circle is 63 metres in diameter and contains up to 32 pits. There are several Neolithic and Bronze Age pits nearby, although one pit has been dated to the Mesolithic period indicating a long period of activity and importance of this ridge. The pits contained a variety of items including burnt flint, cremations and animal bones; in fact the deposits within these pits has been compared to the deposits

found at Coneybury Anomaly and Robin Hoods Ball causewayed enclosure, both of which are the next visible ridges in the distance from this site. Other Neolithic finds are comparable to those found at King Barrow Ridge which are a direct link to the chalk plaques found at Butterfield Down.

From the Bronze Age there is a cemetery, a settlement and other scattered burials within the Romano-British burials, two of these separate burials are that of the Amesbury Archer, the richest beaker burial in Britain, and that of his companion. Also from the Bronze Age and of particular significance to this research is the great Wessex Linear Ditch, with adjoining ditches dated to the Roman period. Evidence that this ditch was still large and used in the Roman period comes from postholes indicating a bridge put up to cross the ditch, and, as all the Roman dated graves are located on the south-west side of the ditch, we can ascertain that the ditch was being used to separate the living, settlement area from the cemetery area.

The Romano-British cemeteries, six in total, are separated into different groups/enclosures indicating perhaps separate families, groups or beliefs; the styles and orientation of the burials differed between the enclosures. Some of the burial practices show uniformity and offer high status goods, while others are more haphazard and poor in grave goods. In some of the cemeteries there is a high proportion of child burials while in others there is a very low proportion, this is evaluated further in the case study. Also of note is the use of hobnail boots: in many of the cemeteries there is evidence of boots in nearly all of the graves, but in one cemetery only 27% of graves contain hobnail boots. There are certainly patterns of behaviours throughout the cemeteries which indicated differing beliefs or status. Some of the burials are found running along the Wessex Linear Ditch; these are, for the most part, poorly furnished graves. There are also graves running alongside a trackway which runs from the cemeteries to the north-west probably towards the Butterfield Down settlement. One grave in particular was of significance: this was the grave of a woman and child buried within a stone coffin; it was a very high status and unusual burial. What makes it all the more unusual is that it is one of the earliest graves in all the cemeteries, dating to around the second century (Barclay 2010); this corresponds with the believed beginning of the settlement at Butterfield Down. The possibility of this being a foundation deposit for the cemeteries (due to the child burial) is noted in the case study.

The Boscombe Down West settlement site dates from 300 BC to 300 AD and full excavation and finds are presented by Richardson in Volume 54 of the *Wiltshire and Natural History Magazine*. The extent of this settlement was not able to be distinguished because, at the time of excavation, machinery for the building of the Boscombe Down runway had already begun to strip away features, and the boundaries of the excavation plot were limited. Richardson found evidence of a later Iron Age/Roman Age settlement enclosed by ditches; however, she was unable to plot where the ditch ran to. Further excavations have revealed a ditch along the western side (HER no SU13NE319) which may be part of the ditch enclosure which was missing.

Richardson notes the location of the site as being lower in position than the land to its north-east, however, if the site extended further in that direction than previously thought, which is plausible, then it would quickly take position upon the higher part of the ridge. As noted above, the settlement here is on the south-east side of the ridge and is unable to see any of the features in the landscape which Butterfield Down can see, however it does overlook Ogbury Camp and Figsbury Ring. The majority of finds comes from pits with pottery dating from the whole period of the settlement, there was also evidence of crows being deposited in the pits which Richardson believes was due to the left over of stew (Richardson, 1951, p. 129); the evidence obtained from the other sites in this location, such as the pit containing the crow at Butterfield Down, may point to a more ritual conclusion for the presence of animal bones in pits.

A Roman dated cemetery was also discovered at this location (third to fourth centuries); this is contemporary with the cemetery at Boscombe Down. The graves in this cemetery were not as rich as those found at Boscombe Down, with only three in coffins (Boscombe Down had almost all in coffins) and of the 15 graves only three had hobnailed boots. Some Roman period building material has also been found at this site indicating there was buildings and, in more recent excavations, there has

been found more evidence of this settlements size and stature. Pottery has been found to the north of the dig limits (HER no SU14SE336) and coins and a box flue tile was found to the west of the excavation site (HER no SU13NE315 and SU14SE315). In addition to this, at the bottom of the ridge where the Bourne valley is nearest to the site, and also the location of many springs in the river valley, a fourth-century pottery and a coin hoard were discovered (HER no SU13NE303). This indicates that the settlement was larger than first assumed by the first excavations, and that the Bourne River was as sacred a place to them just as the Avon was to the settlement of Butterfield Down.

The Roman and Iron Age periods are not the only ones represented on this ridge, alongside the Bronze Age barrows there are also some interesting finds of Neolithic age. The Richardson excavations did not reveal as rich Neolithic finds as we find at Boscombe Down cemeteries and Butterfield Down; however, this may be due to the rapid excavations not picking up on subtle pit formations. Richardson did detail some Neolithic ditches and a very interesting green stone axe was found alongside the Roman settlement debris (Richardson, 1951, p. 162–164).

Earl's Farm Down, very close to the settlement at Boscombe Down West, also houses many Roman finds, mainly of the early Roman period; aerial photos have revealed extensive field systems and possibly building locations which have yet to be analysed. There is also the potential for a major Roman road to have passed through this location going from Sorviodunum (Sarum) to Cunetio (Mildenhall). This road has been picked up at both of these locations but its course between the two is unknown, it is probable that this is its location. Earl's Farm Down is home to many Bronze Age barrows, many ploughed out now but easily recognisable on the aerial photos, as well as Neolithic pits and the Bronze Age Wessex Linear Ditch which boundaries the Butterfield Down settlement, causing this location to be outside its territory, although this does not rule out the possibility that the field systems were part of Butterfield Down. There is also limited Iron Age activity in this location.

Stonehenge and its immediate landscape have revealed no evidence of settlement in the Roman period, although some field systems have been noted. Sporadic pieces of pottery and coins have been discovered in large quantities within the stone circle, attributed to 'picnickers' however more recent discoveries have shown there was possibly more to the activity here in the Roman period. Darvill and Wainwright believe they have discovered a Roman shaft within the stone circle alongside a possible grave dated by coins to the fourth century (Darvill and Wainwright, 2009). It is clear that there is more going on at Stonehenge during the Roman period than previously believed.

The lead curse, noted by Bowden et al. (2015) is not verified and no longer available to study; however, if this is a true account of a find then there is an added ritual element to Stonehenge in the Roman period. There is definite evidence of a lead curse at the nearby excavation site of Blick Mead. A lead curse which I have been able to study was found within the iron rich spring associated with the River Avon near Blick Mead and Vespasian's Camp hillfort. The lead curse found here did not have anything written on it but the act of throwing it into the spring may have served its purpose, it is believed that the lack of writing on the curse shows a later date (Jacques, personal communication), a point by which writing had possibly began to decline in use, by this period the verbal curse may have been used instead. If this is correct then the act of lead curses, as well as the location and special meaning of the spring, has been remembered, even when the form of writing has been forgotten. This spring has a long history of use for ritual offerings dating from the Mesolithic and Neolithic (flint offerings) and also offerings made into the Bronze Age and post-Roman periods; it is believed this area was of significance to people because of the unusual make up of the water. Green believes that this spring is not, in fact, connected to the River Avon and it instead comes from an iron rich deposit which would have placed special minerals in this water which may have given it mysterious connotations or presumed health benefits to prehistoric and Romano-British people (Green, 2015, personal communication). Roman coins have been found on the next bend of the River Avon towards Butterfield Down, in total 27 coins have now been found in this location (HER no SU14SE304) possibly indicating more ritual activity similar to that found at the Cuckoo Stone and that at the River Bourne.

There are other finds of interest in the Amesbury area, especially that around Countess Road and Farm where a villa perhaps once stood, the publication of these finds are eagerly anticipated as they may hold valuable information about the Romano-British occupation of the landscape. There are finds from elsewhere in Amesbury town which indicates a villa complex such as a tile found within the walls of the church in Amesbury and by high status pottery from around Countess Farm. This possible villa, situated 1 km away from Stonehenge in the valley bottom from Butterfield Down, would have been connected to the springs at Blick Mead.

Mapping the landscape

If we plot the archaeological finds onto a map of the landscape it shows there are separate pockets of activity and these patterns persist throughout all periods; each period from the Neolithic up to the Roman is represented in each area. There is a large gap on the very top of the ridge which is void of activity. This may be due to a lack of archaeological excavation in this location or it may be due to some practical and environmental reason such as exposure to wind. The Boscombe Down West settlement lies to the south-east of the ridge where as the rest of the Romano-British activity is to the north-west. The barrows repeat the same pattern with barrows disappearing towards Boscombe Down West. The archaeology at Earl's Farm Down may also suggest another separate group taking the northern end of the area.

The archaeology at Butterfield Down and Boscombe Down cemeteries is shown to be one large area; they are too close together to be separate. It is interesting to note that where, for example, a Roman cemetery lies, there are also graves of Iron Age, Bronze Age and Neolithic Age. Similarly where settlements took hold in prehistory there is settlement (not necessarily continued) in the Roman period. This shows that the locations of certain events were remembered even if not marked on the ground. Some of the prehistoric areas that would have still been visible on the ground are shown to be used in the Romano-British period especially that of the Wessex Linear Ditches. It also becomes evident just how empty of activity the Stonehenge immediate landscape is in the Roman Period; west of King Barrow Ridge and up to Stonehenge there is no archaeological finds from the Romano-British period, except for some small finds in a barrow; this highlights the amount of pottery found within Stonehenge as an anomaly in comparison with the surrounding landscape. It is interesting that the Stonehenge landscape had no settlements throughout all periods.

Case study

The case study centres on infant burials. There are many different styles of child burial in the Stonehenge landscape, ranging from the Neolithic through to the Roman period. From the Neolithic period there is evidence of child burials within Stonehenge, with children's bones coming from stone hole two dated to 2900–2400 BC (Cleal et al., 1995, p. 453). This is contemporary to the settlement at King Barrow Ridge from whence the chalk plaques originated. Hawley noted a possible child burial from the same period and also near the stone circle, in the counterscarp of the ditch (Cleal et al., 1995, p. 453). Two bones of a child were found by Hawley in the ditch (Cleal et al., 1995, p. 454).

From the dawn of the Bronze Age there is the grave of the Boscombe Bowmen, within which was the inhumation of two children aged five to six and six to seven, as well as a cremation of a child aged two to four (Anon., 2008). A matching pair of beakers were buried near the inhumation child burials,

one inside the other and approximately 700 years after the first burials into this grave there was a boy of about 14–15 placed intentionally into the barrow ditch of the grave. This grave is of significance as the additional burial boy, named the Amber Boy due to his amber necklace, may not have been local to the area (Barclay, 2010) and he was buried with the knowledge of where the Bowmen were. The initial children in this burial are also of interest, it is worth asking why one child was cremated and the others were given inhumation burials and pots; perhaps, as we see in the Roman period, there were differences in attitudes towards children of certain ages, perhaps until a certain age the child was not seen as a person and so not afforded the same burial practices (Moore, undated).

There are other child burials in this location from the Late Neolithic/early Bronze Age which are quite often buried under piles of flint nodules perhaps to prevent spirits from wandering (Barclay, 2010); it is interesting that this is rarely seen with adult burials. A child crouched inhumation burial was found, very near to the Boscombe Bowmen, within the excavation area of the Romano-British settlement at Butterfield Down and more Bronze Age child burials are found at Boscombe Down in the barrow group (Wessex Archaeology, 2004, Report 56240.02).

The Iron Age presents less evidence of the practices surrounding child burials however there are some interesting finds from the palisade ditch next to Stonehenge. Three children were found within Iron Age pots and buried with them were chalk figurines of either hedgehogs or pigs. These items have been described as toys (Pitts, 2008) however, this study shows there may be more to them than that.

The burials from the Roman period are more plentiful and can be separated into two groups: those incorporated into cemeteries, and those buried at other locations. Of those buried in cemeteries, each cemetery enclosure is different; at Boscombe Down there are six cemeteries dating to the Roman period, Phase V of Wessex Archaeological excavations (Report 56240.02) revealed three cemeteries which, together, had 8% child burials whilst the New School site excavations (Report 50875.2) revealed two more cemeteries with a consolidated 22% child burials; the last cemetery found (Report 36875.1) had 26% child burials. This presents the question of why the three cemeteries from Phase V had such a small percentage of child burials? Wessex Archaeology has put this phenomenon down to poor fertility or cultural reasons (Wessex Archaeology, Report 56240.02). Crummy may shed more light on this issue with her research into the inclusion of jet stone bears into child burials in a cemetery in Cambridge. She notes that status or cult differences may have played a part in whether a jet bear was included in the child's burial or not (Crummy, 2010, p. 79). We know we have both Christian and Pagan burials at this site (Fitzpatrick 2002) so we can already recognise two different cultures. One other child burial of interest from Boscombe Down is that of the woman and child mentioned in the desk-based assessment, this early burial may have been chosen to symbolise the start of the cemetery, its unusual stone coffin and early date may signify a foundation burial for the cemetery. The Boscombe Down West settlement also contained a cemetery, one child was found in this location out of the 15 burials equating to approximately 7%, this one burial cuts through an earlier Iron Age pit but no other notes of interest have been picked up on here.

Of the burials away from cemeteries there are two children found in a domestic setting from the Wessex Archaeology New Covert excavations (Report 43193.1); both of which date to the third or fourth century, one is six months old and was found in the fill of a threshing floor and the other was found near an oven. Moore discusses the large presence of Romano-British child burials near to fires and ovens. She believes that children in the Romano-British period were treated differently to adults (similar to the Bronze Age cremation burial discussed above); that they were liminal beings, between the physical and spiritual world (Moore, undated, p. 6). For this reason, Moore believes their burials may have been used as conduits between worlds and that channelling the power of the fire would have been seen as most useful (p. 7). Other foundation deposit child burials from the Romano-British period in this area are two children from Butterfield Down, located very near to the Bronze Age child crouched burial and also near to the temple and ovens (Rawlings, 1996).

Another burial, out of cemetery context is that of a child from Woodhenge. Bowden et al. note this burial as not reflecting significance in the henge but 'were placed in normal fashion on the periphery

of the settlement' (Bowden et al., 2015, p. 80); however, the standard practice of burying children was to place them within the settlement, not outside of it (Moore, p. 1). The burial location at Woodhenge was a conscious choice, as was the other burials noted above. Moore discusses this phenomenon, she states that 'it is not random disposal of unwanted but the result of careful decisions relating to concepts bound up with the physical remains of the infant' (Moore, p. 9). To decide to place a child within Woodhenge, surrounded by the giant henge of Durrington Walls and overlooked by the ritual Cuckoo Stone shows a deliberate choice of location of the burial, perhaps displaying a remembered association of the site as a special place. Moore notes the possibility that children were buried within the building foundations so as to constrain the ghost of the child (p. 8) who could not pass into the next world until they had come of an age appropriate to death (*mors inmatura*) (Crummy, 2010, p. 79). This is linked to the Bronze Age practice of burying under flint nodules and the stone coffin of the child at Boscombe Down.

Another way to look at these burials is one of protection of the child rather than the benefit of those living. Crummy notes that in the child burials she studied, the grave goods of a stone jet bear were placed in the graves of children to help guide them to Hades so they did not have to wait at the gates until an adequate age of death was reached. Perhaps what is occurring at Stonehenge is a way of passing the child to the ancestors for protection and guidance or, alternatively, to harness the power of the ancestors through the child just like the fire. Similarly the burials at Boscombe Down lay very close to the Neolithic pit ring; those cemeteries closest to the pit ring contained the most child burials, indicating that the inhabitants of Butterfield Down chose to bury their children within the ritual prehistoric landscape. The connection between child burials and ancestors is also shown in the Amber Boy Burial, buried so long after the others in that grave, within an ancestral site of importance, perhaps to give him guidance. The amber placed around his neck may have served as a token for the next place; amber is often used throughout history for its healing and protective associations. Pliny the Elder devotes two sections to the phenomenon of amber in his *Naturalis Historia*, sections 36 and 37.

The idea of burying a child with a protective item is one that can be seen throughout the ages; Crummy notes the Neolithic habit of including noise-making items in children's graves (p. 53) and also that the practice was ongoing through into the Roman period to drive away evil. It is interesting to note the presence of the goddess Cybele at Butterfield Down who is often associated with this noise-making ritual (Crummy, 2010, p. 53). This burial ritual is also evidenced with the Iron Age burials, noted above, from the palisade ditch at Stonehenge. Rather than just being toys perhaps the chalk hedgehog/pigs items found with the child burials, were used for some other purpose, the picture becomes clearer if the items are thought of not as nice toy pigs but of wild boars. The Roman iconography of the jet bears, researched by Crummy, is comparable to that of the wild-hog in the Iron Age. Just as the bear was a powerful beast, to be feared (Crummy, p. 57) so too was the wild-boar important in Iron Age iconography, often appearing on helmets and battle standards (Green, 1992, p. 46). Also worth noting is that Crummy cites the appearance of bears teeth and claws in burials from the Iron Age and Neolithic (p. 56) and that one particular jet bear figure found within a Romano-British child burial is seen as shining a light, complementing the theory that these burial goods were used as a guide for the child.

The examples used in this case study reveal a long tradition of treating child burials differently to adults. All reveal an uneasy attitude towards the death of children who perhaps should not have died before maturity. The Neolithic buried children with noise-making instruments and they used Stonehenge as a place of burial in the same fashion that the Bronze Age children were being buried with flint above them to stop their ghosts escaping. The Romans buried their children within foundations to constrain them and control their conduit power. The pattern of children being sent with protective items is a long-enduring tradition ranging from the Neolithic to the Roman period be it with a ritual guide or a children's toy item or buried with the ancestors within an ancestral landscape. The fears and traditions have persisted throughout the ages despite new rituals and cultures; the burials from the Boscombe Down landscape and Woodhenge provide evidence that the memory of the

significance of these places were still in the minds of the Romano-British people despite the physical remains of the place perhaps not surviving.

Re-assessing the Romano-British settlements in the Amesbury and Boscombe Down landscape

The assumptions made by Collingwood and Myers, that the area around Salisbury Plain was occupied only by peasants, leading to the conclusion that it was an imperial estate, is contested by the pattern of settlements that have been shown, by this research, to be more complex and high status than originally thought. The cultural processes occurring around these settlements have wider connections with the countrywide issues and events and there is a division of cultural behaviours based on new religious ideas and practices; these have effects on the patterns of settlement.

What is evidenced in this area is not, as believed by Darvill, Jacques and Wessex Archaeology, one settlement moving into another settlement location, but instead there are two completely different settlements, one at Butterfield Down and the other at Boscombe Down West, with different trades and different levels of wealth and religious practices. The Butterfield Down settlement is noted as beginning around the second century AD; however, there is evidence of it continuing from an Iron Age settlement. This settlement was in use up until the very late Roman period (fifth century), whereas the Boscombe Down West settlement has evidence dating only up to the early fourth century, although it is true that the majority of evidence for Butterfield Down is from the late Roman period where as the opposite is true of the Boscombe Down West settlement which would appear to agree with the argument that one moved into the other. The main evidence against the theory comes from the two cemetery locations, one just outside of the Boscombe Down West settlement and the other at Boscombe Down, which was used by the Butterfield Down settlement, although separated into six cemeteries. Both of these cemetery complexes are dated to the third-fourth centuries AD therefore are contemporary with each other, further to this, one of the most lavish burials associated with Butterfield Down is dated to the second century, a period when Boscombe Down West was most prominent. To place one cemetery so far away from the other six, nearly 3 km away, indicates that it was used by a different settlement at the same time. The burials themselves show us a major difference also; the burials at Boscombe Down, associated with the Butterfield Down site, have a much higher proportion of burials with hobnail boots, indicating a known ritual in that area compared with the Boscombe Down West settlement. There is also a large difference in the wealth of the graves; the Butterfield Down graves are mostly buried within coffins and have a high percentage of grave goods within them where as the Boscombe Down West burials show the opposite.

The type of activities present at each location was also different, there is no evidence of corn drying or iron working at Boscombe Down West as well as a lack of education evidenced there compared with the finds from Butterfield Down which represent a wide range of these activities. It is plausible that this may represent the changes in the land use over time and reflect the fact that Butterfield Down appears to have flourished into a small town when Boscombe Down West was declining.

With the conclusion that the area can be divided into two separate settlements, they can begin to be explored separately and it is possibly to see how each one fits within the wider landscape and with each other. The Boscombe Down West settlement stood on the south-east side of the Boscombe Down West Ridge, its main water source was either through the natural springs under the ground that we see exploited at Butterfield Down or from the River Bourne. The unpredictable springs would almost certainly have existed near to this settlement, and may have been more predictable near to the valley on the top of the ridge which is next to the settlement location; however, there is no evidence found at this site which indicates that wells were being used to collect water. Gaining water from the

River Bourne would have encountered a steep downward slope in the land which means it would have proved difficult to take a direct route to the river, a longer route would have been necessary. There is evidence of ritual activity through the discovery of a coin hoard at the Bourne river valley at the nearest point to the Boscombe Down West settlement; this coin hoard is probably connected to the settlement. There is also a villa and more Romano-British activity at Allington which is located slightly north along the Bourne River; this is also connected to the Boscombe Down West settlement, more so than the Butterfield Down settlement would be. These sites were out of the boundaries of this research; however this is an area where more research will be needed to corroborate this theory.

The assumption that Boscombe Down West was a small settlement that declined in use as the occupants moved to Butterfield Down, is one that needs to be contested; the settlement boundaries have been shown, by this research, to extend further than the 1951 excavations by Richardson revealed and a lot of the evidence available regarding this site was lost with the hasty redevelopment of the airbase, therefore a full analysis was not available. Evidence from the Bourne valley below may indicate a much more complex pattern of settlement than was evident from the excavations in 1951 and may give insight into how this settlement adopted more Romanised traditions and changed over time.

The settlement at Butterfield Down is certainly more complex than has previously been expressed. When placed within the context of the surrounding excavations and the small finds noted on the Historic Environments Record, that were not evident in the Rawlings and Fitzpatrick Report, it becomes clear that the evaluation made by Rawlings and Fitzpatrick was much too simple, and, for the want of categorising the settlement, it became boxed in to fit a standard. Darvill is also is seen to be fitting a standard when, as noted in the literature review, he puts it into a class of an 'unenclosed hamlet'; we now have evidence that it was enclosed by prehistoric linear ditches. Rather than a simple settlement, this site boasts a rich and varied ritual progression, which includes Pagan and Christian beliefs as well as a Roman temple perhaps to the goddess Cybele, representing the Mother Earth and agriculture, and aligned with the movements of the sun. The evidence of the eagle head staff used to bless the crops also shows the importance of ritual to the agricultural needs. This is a reflection on how important the agriculture was at this site.

The people of this settlement are not, as Wacher (1998) described, peasants being kept at subsistence level to feed the troops, but instead are educated people, evidenced by the stylus, and people of great wealth as indicated by the silver rings, coins, grave goods and small ornamental finds. The people of this settlement did not need to live at subsistence level as they produced enough crops to sustain themselves and to trade; this is evidenced by the many corn dryers found throughout all of the excavations; it is possible that these corn dryers served different functions, with some used for malting (Rawlings and Fitzpatrick, 1996). This was most likely the source of the wealth in this location, aided by the close proximity to the trade route from Sorviodunum to Cunetio which passed close by the settlement, possibly between Butterfield Down and Boscombe Down West settlement; the two settlements may have shared this trade route. Butterfield Down was not just an agricultural settlement, there is evidence of skilled trades in this settlement including iron working evidenced by numerous iron objects found in the Rawlings and Fitzpatrick excavation, and the spindle whorl and stylus which represent other town trades, this was a self-serving settlement with all it would need to survive.

The Butterfield Down settlement was served by the River Avon, however, as also shown at Boscombe Down West, there is a steep falling gradient in the land to get to the river. Putting this together with the evidence of at least three wells in the vicinity of Butterfield Down this indicates that the natural springs in the chalk were being utilised for water rather than the river. There is a similar coin hoard found at the nearest point of the River Avon to Butterfield Down as we see at the Bourne river next to the Boscombe Down West settlement, there is also a similar pattern of villa location along the River Avon, this is probably associated with the ritual finds of a lead curse near Vespasian's Camp and the ritual behaviour found at Stonehenge. The villa and Butterfield Down are more than likely connected with each other and give evidence of how the Romano-British occupation changed over time, and how Romanisation began to play a bigger part in everyday life towards the late Roman period.

Both of the settlements on the Boscombe Down Ridge were situated far enough out of the valley to avoid the harsh fog that is found here as well as avoiding the flood plains which, although stable, would still have been prone to flooding, as they are still today, especially in the natural spring areas of the Avon and Bourne rivers. Whilst Butterfield Down would have benefitted from the long sunshine hours, being on the south west face of the slope, the Boscombe Down West settlement would have been more protected from the strong Salisbury Plain winds. Both would have benefitted from well-drained soil able to sustain both arable and pasture farming, although chalky.

The last area of interest, which was not previously in the plan of this research to discuss, is Earl's Farm Down. This is an area of immense interest and one of little research. The site is located in an area between Boscombe Down West and Butterfield Down, and lies on the path of the road from Cunetio to Sorviodunum. The field systems seen in aerial photos, although undated, may be part of either of the settlements, or both, however they do lie outside the ditch boundaries of the Butterfield Down settlement, though no field systems have been located for this settlement therefore these are a good candidate. The structures seen on aerial photos may represent the location of trade networks for both settlements, almost like a trading post. The main thing to be noted, at this location, is the need for more research.

Overall the pattern of settlements in this area is much larger and more complex than previous evaluation has estimated. The settlements are located on ridges, including these on the next ridges at Durrington and High Post; this takes them out of flooding and gives a clear view across the valleys even through harsh fog conditions. The choice of location for settlements was based on good soil, water resources and also the important memories of the landscape's past and the ancient ways of life, which are explored further in the next section.

How assimilation with ancient traditions affected Romano-British settlements

Firstly, it must be made clear that assumptions made previously, such as Atkinson, looked at the Romano-British people as invaders and do not associate them with the people who were living in Britain prior to the invasion. It is now well recognised that the people living near Stonehenge were not foreign invaders but were, in fact, the same people that inhabited the area for centuries before the invasion; their ancestors would have inhabited the Iron Age settlement at Boscombe Down West and the hill fort at Vespasian's Camp. Data recovered by Collingwood and Myers confirms that most of the population of Britain was from native stock, therefore the people encountered near Stonehenge would have held their ancestry within the ancient landscape. For this reason it is absurd to think, as Atkinson does, that Stonehenge was being torn down for religious reasons by the Romans. This research shows that the next nearest and biggest settlement of Butterfield Down was including the prehistoric monuments and traditions into its settlement; therefore, it is reasonable to argue that they would also hold Stonehenge in reverence.

The assimilation that is evidenced at the sites in Amesbury and Boscombe Down is based on a continuation of traditions and knowledge. Many of the locations within this area have seen continual use and even those which have not, there is evidence of occupation coming back over and over again; to continually use a landscape is to assimilate the land use at that time to whatever has come before it; if the land is continually changing with past occupation the act of placing a settlement within a previously used landscape is automatically assimilating with what has come before. The landscape in this research would have been scattered with very obvious ancient monuments, however it is the nature of the assimilation that is of interest. If Atkinson were to be correct then the archaeological evidence would show a hesitancy towards ancient traditions being within a Romanized settlement and disrespect towards the ancient monuments. If the Romano-British people were scared or hostile

towards the ancient landscape then the settlement location would be shown to take a commanding stance over the landscape. What actually happened is neither of these theories. The Romano-British people at Amesbury and Boscombe Down were bringing the ancient traditions and memories of their ancestors within the settlement and working alongside them as part of the settlement, on an even stance with them and with respect for them.

In order to work with the ancient landscape there must have been evidence of the ancient landscape left, as noted previously the barrows and henges would have still been in view; many of the barrows are still in existence now and many have only been cleared in the past 20 years as part of building work. There is evidence that the Wessex Linear Ditches were still in use in the Roman period as shown by the postholes for a bridge to cross it at Boscombe Down. These sites were not only visible but also still had meaning; ancient names of landscape features would have been passed along through memory and stories so that even the less obviously visible ritual places, such as Woodhenge, would have still been known about. The case of the Amber Boy being placed within the Boscombe Bowmen burial 700 years after they were buried shows the power of the memory of such important people; arguably this memory may have survived into the Roman period for them to build their temple next to it.

Other, more day-to-day necessities were passed down through memory; the natural springs that may have appeared on the Boscombe Down Ridge would have been known about, despite the short life of most of them. The knowledge that water could be reached on this ridge without the steep walk to the river would have attracted settlement here time and time again; there is evidence of occupation from the Neolithic through to the Roman period. This area would have been recognised as a place for habitation although there may not have been continual use, the memory of the places and knowledge of the living necessities was passed down through folk stories and place names.

Reconsidering Manning's question on whether the Romano-British utilised a prehistoric landscape for their burials by coincidence or by conscious choice, this research has begun to answer this question. If a settlement was utilised, as suggested above, throughout many periods because of the knowledge of water, then, also noted above, it is conceivable that knowledge and memory of ritual, such as the Boscombe Bowmen or the Neolithic pit rings or the Amesbury Archer burial could have continued from one period to the next and been used by the Romano-British population by conscious choice. There was a reason why the important Neolithic and Bronze Age people of Stonehenge, such as the Boscombe Bowmen and Amesbury Archer, were buried in Amesbury rather than nearer to Stonehenge; a though this reason may be lost to the modern world, it is likely that it was remembered by the inhabitants of this location in the Romano-British period.

The most interesting point to come from this research is the difference in assimilation patterns between the settlement of Boscombe Down West and Butterfield Down. Whilst both of these settlements have relied upon the water source on the ridge and on the good agriculture and pasture soil found on the chalk downs, they both follow a different attitude to the prehistoric landscape. The settlement at Boscombe Down West is assimilated firmly within the Iron Age traditions; it is a continuation of an Iron Age settlement and overlooks the neighbouring, possibly rival, Iron Age hill forts of Ogbury and Figsbury. The cultural progression from Iron Age to Roman shows little change and there is no evidence of the assimilation with the prehistoric further back than the Iron Age; there is also no evidence of 'Celtic revitalisation'. This may have been the reason for the settlements decline in the fourth century; however, this point is explored further below.

The settlement at Butterfield Down is very different; there is much evidence that this settlement was built with the ancient landscape in mind. The phenomenological studies showed this area to be situated within a prehistoric landscape on an even level not a dominating one. If anything it is the opposite that is true and the prehistoric takes a dominating effect on the settlement with the barrows on the horizon looming above. Each direction is surrounded by the prehistoric landscape and the features of the settlement were situated so as to take advantage of the views and the topography of the land, for example, the huge sky available from the cemetery location gives impressive setting suns throughout the year, but especially at midwinter, a phenomenon embraced by both the Neolithic and

Bronze Age people when building their pit rings and burying the Amesbury Archer, and used again by the Romans for their own cemetery. The prehistoric was allowed to be included and involved in the settlement; a Bronze Age child (much like a foundation deposit) is found within the ritual area of the site, near to the site of the Boscombe Bowmen and a Neolithic pit ring. That the Romano-British chose to use this side of their settlement for their ritual temple and pits is a conscious choice based on the prehistoric ritual element found here; interestingly the Neolithic flintknapping evidence, for domestic use, is found on the opposite side of the Butterfield Down excavation site meaning that the domestic and ritual are split similarly in the Neolithic as they are in the Roman period. The whole site is situated within a Bronze Age feature of the Wessex linear ditch to the extent that the cemeteries of Boscombe Down are separated from the Butterfield Down settlement by the ditch itself. The impression of walking within an ancestral landscape is still felt today, the feeling would have been hugely increased in the Roman period before the many burial mounds and ditches were ploughed out in the Medieval period and the new modern buildings were put up.

Using ancient landmarks within a settlement was not a new idea in this landscape, the Iron Age hill fort at Vespasian's Camp has two Bronze Age barrows placed one either side of the entrance, this gives a sense of protection and reverence from the ancestors. The tradition moved to Butterfield Down, so possibly did the people from Vespasian's Camp as there is nothing similar to this at the Iron Age and Romano-British settlement at Boscombe Down West.

The ridges themselves were linked ritually throughout the Neolithic, Bronze Age and Roman period; the viewshed, which showed that Butterfield Down and Boscombe Down were inter-visible with much of the surrounding monuments, does not only provide evidence for the Roman period but also of the extent that these ridges were connected in the prehistoric period. Evidence for this comes from the pits at Boscombe Down where the fills are very similar to those on the following ridges and also with the chalk plaques found on both King Barrow Ridge and Boscombe Down Ridge. The choice of cemetery location was also continued on these ridges with both Durrington and Boscombe Down cemeteries, from the Neolithic and into the Roman period, sharing a similar view of the Avon valley and overlooking each other. The Neolithic burials at Durrington Walls, near to Woodhenge, would have had a direct line of sight with the burial of the Boscombe Bowmen and Amesbury Archer; it is worth noting also that the henge at Durrington Walls was in direct line of sight with the Neolithic pit rings at Butterfield Down and Boscombe Down.

It can be argued that the Romano-British were keeping up the tradition of location choice that had been evident since the Neolithic, however, it is possible that the choice of cemetery location for the Romano-British settlement may have been to do with logical choice rather than any continuity of location choice, there was a ridge to the south and field systems to the east, the drop into the valley to the north which leaves only the west available, this may also have been the reason for the Neolithic and Bronze Age burial location choice; however, the views from this area and the sunsets, as noted above, would have been an appealing reason for choosing this site for their dead. The passing road may also have contributed to the location of the Romano-British cemetery; it may have travelled through the cemetery location, or alongside it, which was a common trend in Romano-British culture. These factors would have had a huge impact on the location of the cemeteries just as much as the natural resources, discussed below, would have had a huge impact on the settlement location; the knowledge and memory of the areas past would have had a significant impact on the location choices.

It has been established that the ridges were all connected and held significance for each other. Away from the ridges there is also continuity of land use. At Stonehenge there is a repeated pattern of lack of settlement activity. The viewsheds have shown the area between King Barrow Ridge and Stonehenge, and also the area of the Cursus, to be in a bowl in the landscape, not the lowest point in the land but far enough down so as to not be viewable from any place of settlement. Whatever the reason for this, perhaps because the area was reserved for the dead, it is something that was carried on in the Roman period. There may be many reasons for this continuity, there may have been myths and legends about the location and it may have been feared or revered. The area was not totally devoid

of any activity however, Cleal et al. have shown the immense number of artefacts found within the stone circle from the Roman period, and the work carried out recently by Darvill and Wainwright has begun to help understand the activity in a more ritual context. Rather than simply placing activity as tourist litter there is now evidence enough to argue that the activity at Stonehenge was part of a complex behavioural pattern by the Romano-British population in reaction to prehistoric monuments and the changing Roman environment. This is similar to the pattern of behaviour in the Neolithic period, where the settlement was out of site, most likely at Durrington Walls, and the activity within the stones themselves was reserved for ritual or special activity. Overall, there is evidence of a pattern of important places, all linked together throughout the prehistoric and Roman period and which have remained places of importance, perhaps through practical reasons but this does not diminish the ritual significance of the places.

Not only does the landscape and environmental issues continue from one period to another, but there are instances where the traditions themselves have continued or been reapplied in a new Romanised fashion; for example, as has already has been noted, Foster identifies the hobnail boot phenomenon to be an ancient tradition but with a Roman invention. There is evidence of hobnail boots throughout the more assimilated Butterfield Down settlement cemeteries, where as at Boscombe Down West where the ancients were not so assimilated with, there are only three of the 15 inhumations with hobnail boots. Other traditions that have continued were shown in the child burial case study, such as burying a child with a guide to the next world. In fact, there is evidence that the ancestors were sometimes used as a guide for Romano-British children such as the child burial within Woodhenge. Ritual traditions were also continued; evidence for this comes from the lead curse deposited in the natural spring at Blick Mead in Amesbury. This spring has seen ritual offerings throughout prehistory so once again an ancient belief and tradition was being utilised by the Romano-British people but in a Romanised fashion by using the lead curse. The Roman coin hoard found next to the Cuckoo Stone near Woodhenge also signifies the importance of linking Roman ritual with the ancient ritual places; however the coin hoards may possibly have more to do with the easily identifiable places for ease of finding them again (Moorhead, 2001).

Material goods were also assimilated with the prehistoric; there is evidence that culture reverted back to ancient ways in the late Roman period. This phenomenon has been termed the 'Celtic revitalisation' by historians and archaeologists and is something that is seen in many areas of Britain. Celtic revitalisation is the act of Roman art and culture taking on an ancient pattern or style. This revitalisation is another difference between the two settlements in Amesbury. At Boscombe Down West there is no evidence of Celtic revitalisation, perhaps because the settlement never moved very far from Iron Age culture or perhaps because the settlement was coming to an end as this phenomenon was beginning; maybe this was the reason why this settlement came to an end. At Butterfield Down there are several exceptional instances of Celtic revitalisation; firstly there are the bead rimmed jars, as referenced earlier, decorated in a late Iron Age fashion, another example is the three finger rings from the New Covert excavations. These were late Roman period elite items which show us the dual identity of the person who owned them; the rings themselves would have shown the status of the individual, where as the images on the rings would have shown this individual's connections to the ancient traditions and linked to their own ancestry.

The Celtic revitalisation was emerging at a period in which the Roman central government was beginning to fail and the towns had already succumbed to collapse. Tensions were high with ever increasing invasions by the Saxons on the shores; people would have been scared and confused. Using old traditions, such as the lead curse at Blick Mead, and harking back to ancient cultures with the Celtic revitalisation, such as the finger rings, shows their fears and their need to communicate and assimilate themselves with their ancestors for protection and security. If the Roman way was not working anymore then they reverted back to what they knew before. Butterfield Down was in a good position to renew ancient ways of life and communicate with the ancestors. It was already connected to the landscape around it in all the ways mentioned in the phenomenological survey and it is clear

from the archaeological evidence that this settlement thrived in a period where others declined, to the extent that this settlement was in existence still after Romano-British culture is thought to have been extinguished, evidenced by the very late coin hoard found dating to the fifth century. Perhaps Butterfield Down was a settlement that people turned to whenever they felt the need to be closer to their ancestors, people left their settlements and made their way to places like Butterfield Down. This settlement had the means to adapt to the changing Romano-British environment and was able to embrace old traditions still within a Romanised way.

Boscombe Down West was not well placed to adapt to these changes, it has not shown itself to adapt to the changing times. It is reasonable to assume that the Boscombe Down West settlement did not adapt to the changes in culture and it was not well suited within the landscape to offer the security which people were seeking; this is perhaps the main reason for its demise and, as was discussed by historians in the literature review, it is possible that the inhabitants of this settlement may have made their way over to the Butterfield Down settlement in the late fourth century, although it is likely to have happened at a later date than historians have previously believed.

So overall, we see two separate settlements, dependant on the local water sources, which was known about from prehistory onwards, and on the local trade route which was conveniently close to both settlements. The local micro-climate of weather patterns played a vital role in settlement location, with the persistent fog and the need for good sunshine and soil. As the British culture changed and new ways of life and different religions began to grow people may have found comfort in the ancient ways and it is at this point that they may have returned to activity at Stonehenge and increased Celtic revitalisation at Butterfield Down indicating that memories of the ancient past lived on and could be relied upon when needed. Dark's argument that assimilation is more to do with superstition than religion is evidenced at these settlements, a plethora of religions was to be found here yet the assimilation with the prehistoric was evident throughout, evidenced by the presence of both Christians and Pagans being buried at the same prehistoric ritual landscape.

The Boscombe Down West settlement was not always assimilated with the prehistoric therefore struggled in the late Romano-British period, however the Butterfield Down settlement was always assimilated and therefore greatly expanded when Celtic revitalisation peaked.

Conclusion

Towards the end of the Romano-British period there were a lot of changes; new religions such as Christianity were being introduced and the new Saxon culture was spreading into Britain. The Roman way of life had begun to collapse as towns and order collapsed. At this point Britain saw a rise in new cultures coming from the Picts in the north and the Saxons from the south. These events were leading the people of the Stonehenge landscape to move away from Romanised culture and move back to ancient traditions; this had significant influence over the settlement patterns and culture of the Romano-British people.

The three areas of study here: Boscombe Down West, Butterfield Down and Stonehenge have, in the past, not been adequately analysed and this research has shown that the new theories such as that of Darvill and Wainwright, better reflects the archaeological material and the changing period in question. The pattern of settlement in Amesbury and Boscombe Down has revealed a large amount about the wider events in Britain than it was once given credit for; where previously it was assumed there was a simple town at Butterfield Down preceded by a basic Iron Age settlement at Boscombe Down West has given way to a complex pattern of settlements, separate from each other in terms of size, manufacturing and culture and assimilation to the prehistoric ancestors. Each settlement made separate decisions which determined their future, decisions that led to the changing culture and flourishing of one site and the demise of another.

These settlements, and the activity at Stonehenge has yielded information which shows that the Romano-British people were able to live with, and alongside, many different identities, for example they could be a Roman making an offering of a lead curse into a prehistoric spring or they could be a Christian worshiping Mother Earth for a good harvest. They have shown themselves to reuse the ancient landscape for their own purposes whilst keeping the ancient traditions and sacred places alive through memories. The people were Romanised, they possessed Roman luxury items, worshipped Roman deities, embraced Roman cultures but remained bound to the memories that survived within the landscape; memories of sacred places and memories of who their ancestors were. They tailored their settlement and their everyday life and death to these memories and ancestors and sought the solace of the ancestral places and traditions.

This research has focused in depth on two of the settlements near to Stonehenge and has produced a mass of new information, a few of the other settlements such as that at Durrington Walls and Earl's Farm Down have been touched on briefly but these are areas which require a lot more attention to build a better picture of Roman settlement within the Stonehenge landscape. This study has shown there to be a lot more to the story of Romans at Stonehenge, and as archaeological excavations continue in the Boscombe Down area, with the next phase of building construction starting at the time of writing this, it is clear that further information will become available and future research will be necessary.

Bibliography

Amesbury Phase 1 Housing Boscombe Down (2000). *Wiltshire*, Wessex Archaeology, report 43193.1.
Atkinson, R. J. C. (1956). *Stonehenge,* London: Hamish Hamilton.
Barber, M., Bowden, M., Soutar, S., and Field, D. (2015). *The Stonehenge Landscape*. Swindon: Historic England.
Barclay, A. (2010). 'Excavating the living dead', *British Archaeology*, issue 115, <http://www.archaeologyuk.org/ba/ba115/feat4.shtml>, accessed 16 September 2015.
Beaulieu Road, Amesbury, Wiltshire Archaeological Excavation (2005). Terrain Archaeology, report 53202/2/1.
The Boscombe Bowmen (2008). Wessex Archaeology, <http://www.wessexarch.co.uk/projects/wiltshire/boscombe/bowmen>, accessed 12 September 2015.
Boscombe Down Phase V Excavations, Amesbury, Wiltshire, 2004 (2005). Wessex Archaeology, report 56240.02.
Bowden, M. (ed.) (2013). *Unravelling the Landscape An Inquisitive Approach to Archaeology*. Stroud: The History Press.
Bradley, R., Entwistle, R., and Raymond, F. (1994). *Prehistoric Land Divisions on Salisbury Plain*. Swindon: English Heritage.
Branigan, K. (1973). 'Vespasian in the South-West', *Proceedings of the Dorset Natural History and Archaeology Society*, vol. 95.
Butterfield Down from Prehistory to the Present Day (1990). Wessex Archaeology.
Chandler, J., and Goodhugh, P. (1989). *Amesbury history and description of a south Wiltshire town*. Salisbury: Salisbury Printing Co. Ltd.
Chippindale, C. (2012). *Stonehenge Complete* (4th edn). London: Thames and Hudson Ltd.
Clarke, B. (1999). *Watching Brief and Excavation of a Romano-British Field Boundary at NGR SU 18573956*, Boscombe Down Conservation Group, Archaeological report 4.
Clarke, B., and Kirby, C. (2002). 'A Newly Discovered Round Barrow at Proposed Dispersed Linear Cemetery at Boscombe Down West', *Wiltshire Archaeological and Natural History Magazine*, vol. 96, p. 215–218.
Cleal, R. M. J., Walker, K. E., and Montague, R. (1995). *Stonehenge in its Landscape*. Swindon: English Heritage.
Collingwood, R. G., and Myres, J. N.L (1937). *Roman Britain and the English Settlements* (2nd edn). London: Oxford University Press.
Crummy, N. (2010). 'Bears and Coins: The Iconography of Protection in Late Roman Infant Burials', Britannia, Vol. 14, p. 37–93, *Society for the Promotion of Roman Studies*, <http://www.jstor.org/stable/41725157>, accessed 7 July 2015.
Cunnington, M. E. (1931). 'Romano British Wiltshire', *Wiltshire Archaeological and Natural History Magazine*, vol. 45, p. 166–216.

Dark, K. R. (1993). 'Roman-Period Activity at Prehistoric Ritual Monuments in Britain and in the Armorican Peninsula', in Scott, E. (ed.) (1993), 'Theoretical Roman Archaeology: First conference Proceedings'. *Worldwide Archaeology Series*, Vol. 4, p. 133–146.

Darvill, T. (2006). *Stonehenge The Biography of a Landscape*, Stroud, Tempus Publishing Ltd.

Darvill, T., and Wainwright, G. (2009). 'Stonehenge Excavation 2008', *The Antiquaries Journal*, vol. 89, p. 1–19.

De Franceschini, M., and Veneziano, G. (2011). 'Villa Adriana: Architettura Celeste: I Segreti dei Solstizi in Hadrian's Buildings Catch the Sun', *Nature*, <http://www.nature.com/news/2011/110616/full/news.2011.372.html#comments>, accessed 21 August 2015.

'Excavation Fieldwork in Wiltshire 1998' (2000). *Wiltshire Archaeological and Natural History magazine*, vol. 93, p. 255.

Fitzpatrick, A. (2002). *Christians and Pagans at Amesbury in Roman times?*, Wessex Archaeology, <http://www.wessexarch.co.uk/book/export/html/602>, accessed 24 March 2015.

Fleming, A., and Hingley, R. (2007). *Prehistoric and Roman Landscapes: Landscape history after Hoskins*, Vol. 1. Cheshire: Windgather Press Ltd.

Foster, A. (2001). 'Romano-British Burials in Wiltshire' in Ellis, P. (ed.) (2001), *Roman Wiltshire and After*. Devizes: Wiltshire Archaeological and Natural History Society (Wiltshire Heritage).

French, C., Scaife, R., Allen, M. J., Parker Pearson, M., Pollard, J., Richards, C., Thomas, J., and Welham, K. (2012). 'Durrington Walls to West Amesbury by way of Stonehenge: a major transformation of the Holocene landscape', *The Antiquaries Journal*, vol. 92, p. 1–36.

Geology of Britain Viewer (2015). British Geological Survey, <http://www.Mapapps.bgs.ac.uk/geologyofbritain/home.html>, accessed 16 September 2015.

Google Maps, Map data © 2015, <https://www.google.co.uk/maps/@51.1738609,-1.7524275,16z>, accessed 16 September 2015.

Green, M. (1992). *Animals in Celtic Life and Myth*. London: Routledge.

Henderson, J. (ed.) (2001). *Pliny Natural History X*, books 36–37. Bury St Edmunds: St Edmundsbury Press Ltd.

Henig, M. (2001). 'Art in Roman Wiltshire' in Ellis, P. (ed.) (2001), *Roman Wiltshire and After*. Devizes: Wiltshire Archaeological and Natural History Society (Wiltshire Heritage).

Hingley, R. (1989): *Rural Settlement in Roman Britain*. London: Seaby.

Hingley, R., and Allason-Jones, L. (2009). 'Life and Society', in Symonds, M. F. A., and Mason, D. J. P. (eds) (2009), *Frontiers of Knowledge, a research framework for Hadrian's wall, part of the Frontiers of the Roman Empire World Heritage Site*, Vol. 1, p. 147–166.

Johnson, S. (1987). *Later Roman Britain*. London: Paladin Books.

Land adjacent to the Spar Supermarket, Boscombe Road, Amesbury, Wiltshire (2005). AC Archaeology, report 9002/2/0.

Land South-East of Amesbury: Archaeological Evaluation of Phase I Housing Area (1995). Wessex Archaeology, report 36871.1.

LIDL, Porton Road, Boscombe Down, Amesbury (2000). *Wiltshire*, Wessex Archaeology, report 48522.

McOrmish, D. Field, D., and Brown, G. (2002). *The Field Archaeology of the Salisbury Plain Training Area*. Swindon: English Heritage.

Manning, A. (undated). *A ritual Landscape at Boscombe Down*, Wessex Archaeology, <http://www.wessexarch.co.uk/book/export/html/75>, accessed 24 March 2015.

Moore, A. (undated). *Hearth & Home: The Burial of Romano-British Infants within Domestic Contexts*, Unpublished Thesis, University of Southampton.

New School Site, Boscombe Down Wiltshire, Archaeological Excavation (2003). Wessex Archaeology, report 50875.2.

No. 1 Boscombe Road, Amesbury Wiltshire (1999). Wessex Archaeology, report 47351.1.

Oldfather, C.H (1935), *Diodorus Siculus: Library of History*, Books 2.35–4.58, Cambridge, MA: Harvard University Press, Book II.47.

OS County Series: Wiltshire 1877–1879 1:2,500, Historical Mapping © <http://www.old-maps.co.uk/#/map/416433/141325/12/101156>, accessed 9 August 2015.

OS Explorer Salisbury & Stonehenge 1:25 000, Ordnance Survey (2004), © Crown Copyright.

Pitts, M. (2008). 'Child buried with unique carved pig', *British Archaeology*, issue 103, <http://www.archaeologyuk.org/ba/ba103/news.shtml>, accessed 12 September 2015.

Rawlings, M., and Fitzpatrick, A. P. (1990). *A Ring-Ditch and Related Features, and a Romano-British Settlement at Butterfield Down, Amesbury, Wiltshire*, Wessex Archaeology.

Rawlings, M., and Fitzpatrick, A. P. (1996). 'Prehistoric Sites and a Romano-British Settlement at Butterfield Down, Amesbury', *Wiltshire Archaeological and Natural History Magazine*, Vol. 89, p. 1–43.

Remarkably preserved Roman remains from grave, Wessex Archaeology, <http://www.wessexarch.co.uk/book/export/html/651>, accessed 3 June 2015.

Renfrew, C., and Bahn, P. (2008). *Archaeology: Theories, Methods and Practice* (5th edn). London: Thames and Hudson.

Richardson, K.M (1951). 'The Excavation of Iron Age Villages on Boscombe Down West', *Wiltshire Archaeological and Natural History Magazine*, vol. 54, p. 123–168.

Robinson, P. (2001). 'Religion in Roman Wiltshire' in Ellis, P. (ed.) (2001), *Roman Wiltshire and After*. Devizes: Wiltshire Archaeological and Natural History Society (Wiltshire Heritage).

The Roman cemeteries at Boscombe Down, Wessex Archaeology, <http://www.wessexarch.co.uk/book/export/html/654%20>, accessed 3 June 2015.

Sam, T., and Moorhead, N. (2001). 'Roman coin finds from Wiltshire' in Ellis, P. (ed.) (2001), *Roman Wiltshire and After*. Devizes: Wiltshire Archaeological and Natural History Society (Wiltshire Heritage).

Scott, E. (1991). 'Animal and Infant Burials in Romano-British Villas, A Revitalisation movement', in Gorwood, P., Jennings, D., Skeates, R., and Toms, J. (eds) (1991), *Sacred and Profane*, Committee for Archaeology, Monograph 32, p.115–121.

Thurley, S. (2010). *Heritage tourism and the post-recession economy,* in *Investing in Success,* Heritage Lottery Fund.

Tilley, C. (1994). *A Phenomenology of Landscape*. Oxford: Berg Publishers.

Wacher, J. (1998). *Roman Britain,* Sparkford: J. H. Haynes & Co. Ltd.

NICHOLAS JONES

2 Environmental implications of Neolithic houses

ABSTRACT

Early Neolithic houses represented new technologies and practices, and the enculturation of the wild, but their consumption of substantial timbers, set deep into postholes, was faster than the regeneration rate of mature trees. By the Late Neolithic a shortage of large timbers may have led to changes in house-building practices, and the management of trees for monument building. Late Neolithic houses were less substantial, and have been described as flimsy and temporary, but the use of lighter materials, including hazel coppice, which regenerates quickly, exhibits a capacity of human beings to adapt to their non-human environments.

The Late Neolithic settlement at Durrington Walls may have been where the builders of Stonehenge lived. An experimental archaeology project to reconstruct some of the houses provided data on materials and processes, enabling growth models to be used to explore how such a large settlement may have developed within the time-frame, and what the implications for the Stonehenge landscape may have been. Early Neolithic houses were based on environmental degradation, whereas Late Neolithic houses were based on environmental management. The change in design from Early to Late Neolithic might be an example of sustainability in action. As well as thinking about the ancestors, this requires thinking about the needs of future generations.

Introduction

The Stonehenge landscape is only one part of a much wider area of north European chalk geology which, in England, runs diagonally from Yorkshire to Devon (Lawson, 2007: 3). It may have been a typical chalkland landscape and habitat in the pre-agricultural Holocene (Svenning, 2002), although evidence from Blick Mead suggests that continuous human activity began in the Early Mesolithic (Jacques and Phillips, 2014), continued through the Neolithic, and by the Early Bronze Age it had become a vast sacred landscape. In 2006 the Stonehenge Riverside Project uncovered evidence of seven Late Neolithic houses at Durrington Walls. The settlement was estimated to have contained 500 to 1,000 houses, and up to 4,000 people, making it potentially the largest settlement found in northern Europe. Not only that, but 'unusually precise' carbon dates (Parker Pearson, 2012: 110) indicated that it existed for only 40 years and coincided with the building of Stonehenge, just over a mile away. The suggestion was that this may have been where the builders lived.

In 2012 English Heritage commissioned an experimental archaeology project to reconstruct House 851, one of the seven houses found at Durrington Walls, using archaeological and environmental evidence. The Neolithic Houses Project, managed by the Ancient Technology Centre, Cranborne, constructed a prototype of House 851 at Old Sarum, and subsequently five Neolithic houses, based on this prototype, were built at the new Stonehenge visitor centre. The project also produced data on the quantities of materials and time taken to build such houses, and this began to raise new questions. If the carbon dates for the Durrington Walls settlement, its estimated size, and the way House 851 had been reconstructed were all correct, how did Neolithic builders obtain enough building material for such a large settlement within the time-frame? And what were the environmental implications for the Stonehenge landscape?

These questions raised others about the difference between Early and Late Neolithic houses. Early Neolithic houses were much more substantial structures than those found at Durrington Walls. They were supported by large timber posts set into deep postholes, and they consumed large quantities of timber from mature trees. Late Neolithic houses, such as those found at Durrington

Walls, were much lighter structures. Why, in the Late Neolithic, when social groups were supposed to have adopted farming and become more settled, did houses appear to be flimsy and temporary compared with those of the Early Neolithic, when the transition from hunter-gathering was taking place? One might expect Early Neolithic houses to be more temporary and Late Neolithic houses to be more permanent.

All human activity, including building houses and settlements, has implications for the environment, both locally and globally, through the procurement and consumption of materials, and the production of waste. This dissertation considers whether wider environmental change may be reflected in the differences between Early and Late Neolithic houses, and their respective environmental implications. It then focuses on the building of the Late Neolithic settlement at Durrington Walls, and the local environmental implications for the Stonehenge landscape.

During the Neolithic, trees were felled for a variety of reasons. They were felled to make way for causewayed enclosures and other earthen monuments, and for farming. They were also felled to build palisade enclosures, track-ways through wetlands, and houses. It seems unlikely that Neolithic societies shared our current concerns about environmental footprints, or the consumption of critical natural capital, such as ancient woodlands, but is it possible that diminishing resources led them to develop more efficient building techniques?

One interpretation of the change in the way houses were built is that social groups returned to mobile pastoralism and, being constantly on the move, they chose to build fewer permanent houses. But might there be other interpretations? Might a shortage of timber have forced a change in building practices? Might there have been recognition, perhaps, that, by managing the woodlands, lighter, more easily workable materials could be obtained, and houses built more quickly and efficiently? Or might there even have been a realisation that the consumption of natural material at a rate faster than its ability to regenerate is unsustainable?

Literature review

To shed light on these questions from a range of angles, the review brings together literature from different fields. It looks at the environment of Neolithic Britain, the setting for Early and Late Neolithic houses, and at the buildings themselves including some contemporary reconstructions. It then focuses on the environment of the Stonehenge landscape in the third millennium BC, the setting for Stonehenge and the settlement at Durrington Walls. It then looks at woodland management, and finally at relationships between people, nature and buildings.

The environment of Neolithic Britain

Neither the environment, nor the culture, of Neolithic Britain stood still, and the building of houses was part of the co-evolution of an arboreal cultural landscape. Early Neolithic houses were cut from Mesolithic 'climax'[1] woodlands and 'provinces' (Rackham, 2003: 37) which had spread across the British Isles, except in some small areas of moorland and grassland on high mountains. By 5000 BC most of the woodland cover in what is now England was lime, with oak/hazel in the south-west and north. Wales was predominantly oak/hazel, with hazel/elm in the south-west. Southern Scotland was predominantly oak/hazel, with pine in the central Highlands and birch in the north. Ireland

1 'Climax' can be a controversial term in that it implies an end-point in the process of woodland succession.

was predominantly hazel/elm, with some oak/hazel and pine in the far west (Rackham, 2003: 37, derived from Huntley and Birks, 1983). However, pollen evidence is hard to identify, and certain species produce more pollen than others, which may mask areas of open ground (Bradley, 2007: 15–16). Regional pollen diagrams lack sufficient spatial resolution (Brown, 1997).

Cunliffe (2006: 26) observes that a common assumption, embedded in archaeological thought for more than a generation, was that the whole of Britain was forested simultaneously in a consistent developmental sequence. Vera's hypothesis, that the picture was much more varied, contradicts this:

> The natural vegetation consists of a mosaic of large and small grasslands, scrub, solitary trees and groups of trees, in which the indigenous fauna of large herbivores is essential for the regeneration of the characteristic trees and shrubs of Europe. The wood-pasture can be seen as the closest modern analogy for this landscape. (Vera, 2000: 9)

This mosaic of natural vegetation may have been a product of varying rates of post-glacial soil development which created lags of 500–1,500 years in the adjustment of vegetation to climate amelioration (Pennington, 1986).

Mesolithic hunting and gathering involved clearances of wildwood (Rackham, 2003: 37), and Mellars (1976) suggests that systematic policies of forest burning by hunting and gathering populations led to more complex patterns of man-animal relationships such as mobile pastoralism. The benefits of burning wildwood included increased human mobility, improvements in the economic potential and carrying capacity of the environment, improvements in the quantity and quality of food for herbivores, and their increased growth and reproductive rates. Burning may have increased the overall productivity of ungulate populations tenfold. Castledine (1990) and Moore-Colyer (1996) claim that charcoal in Welsh wetland deposits is evidence of such uses of burning. The results of a review of wood charcoal and macrofossil data from 47 Mesolithic sites in Scotland (Bishop et al. 2015) suggest that: hazel and oak were the main trees exploited for fuel and hazel for nut-gathering; humans influenced woodland ecology by using wood for fuel and construction; and the use of wood for these purposes may reflect deliberate or inadvertent coppicing. Pollen evidence for management is equivocal, but clearings may reflect human use. But Rackham (2003: 37) maintains that it would seldom have been possible to set fire to 'incombustible British wildwoods', and that the only native British tree that can be burnt standing is pine, which can spring up abundantly again afterwards anyway. Perhaps wildwood was first felled and then burned? Either way, the regrowth from the stumps attracted grazing herbivores such as aurochs and deer, persistent grazing maintained the open space, and the resulting increases in the productivity of populations led to further felling and/or burning.

Evidence of feasting in Yorkshire showed the presence of cattle, pigs and sheep (Rowley-Conwy and Owen, 2011), and similar evidence has been found at Durrington Walls (Craig et al., forthcoming). Serjeantson (2014) noted that from 90 assemblages from southern Britain, nearly all included sheep. If the controversial view that cereal agriculture failed in mainland Britain from 3300 BC to 1500 BC, and that social groups became mainly pastoral (Stevens and Fuller, 2012) is correct, then the opening up of the landscape may have had more to do with creating space for grazing herbivores than for planting crops. Indeed, it seems that, if burning and felling failed to inhibit the regeneration of most British trees, the only thing likely to have done so was persistent grazing.

Whilst the Early Neolithic may appear to have offered a seemingly endless supply of large trees for house building (although location played an important part in which species were available), fire, felling and grazing, along with increasing ungulate populations, continued to enlarge areas of open space. This was a product of both natural change and human activity; the latter having both deliberate and inadvertent impacts (Brown, 1997). The development of farming during the Neolithic would have increased the demand for open space for planting crops. Once felled, mature trees (e.g. oaks take 300–400 years to reach maturity) would be unlikely to regenerate unless their regrowth could be protected from grazing.

Early Neolithic houses

Evidence of Early Neolithic houses is important in understanding domesticity, and in debates on the Mesolithic-Neolithic transition from hunter-gathering to farming (Thomas, 2004). There is more evidence from northern Europe than from Britain, to the extent that Thomas argues that, 'Evidence for the existence of permanent domestic structures in Neolithic Britain is scanty', and that, 'the majority of the population lived for most of the time in rather flimsy and temporary dwellings' (Thomas, 1996: 1–2). Thomas questions whether some structures found in Britain were domestic dwellings, or even roofed buildings at all. Evidence from exposed sites, or where there are associations with monuments such as tombs, standing stones and graves, suggests that some of the structures may have had more to do with funerary practices than housing the living (1996: 7). Barclay (1996: 70–71) captures both the inconclusive and confusing nature of evidence in north-east Scotland: 'only Balbridie represents the domestic architecture of the period, and there is doubt that the structure is a normal house'. All of which raises questions about the meanings of the words *permanent, normal* and *house*.

Early Neolithic houses in northern Europe were long timber-framed structures, sometimes referred to as longhouses. At up to 5 m in height, they stood out against their natural surroundings and hunter-gathering life-styles. They represented new technologies and practices, such as clearing forests, cutting and splitting large trees and managing animals for transport. They also represented new uses of materials, new levels of organisation and co-operation, and were, 'a distinct expression of changed values and beliefs, especially with respect to nature and the enculturation of the wild' (Amkreuz, 2014: 231).

It is clear from archaeological evidence, notably at Durrington Walls (Wainwright and Longworth, 1971), that large, timber-built structures depended for their stability on deep set posts (Richards, 2007: 141). The distribution patterns of postholes of Early Neolithic houses usually show symmetrical alignments indicating lines of support for roof beams and side walls (e.g. Darvill, 1996: 86; Last, 2013: 272). The simplest structures had a row of posts supporting a central ridge beam. The rafters spanned from the ridge to the side walls, which meant that the walls were load-bearing (or structural). In wider buildings the ridge beam was flanked by parallel rows of posts supporting purlins (beams running parallel to, but lower than, the ridge). The rafters were supported on the ridge and purlins, which meant that the side walls need not be structural. Sidewalls, therefore, could be formed in different ways. If they were structural, the walls might be made of rows of close-set vertical posts, or vertical planks, carrying a wall plate (a horizontal beam to support the rafters). If they were non-structural, the walls might consist of widely spaced posts with panels of woven wattle and daub in between. Hearths required a full-height space to allow smoke to rise to the apex of the roof. Some buildings may have had upper floors or platforms, but, with smoke and exhaust gases filling the roof space, it is unlikely that these were used for anything other than storage.

Early Neolithic British houses have long been associated with the Linearbandkeramik (LBK) tradition of the later sixth millennium BC, but Last (2013: 263) describes this as a 'longstanding and not altogether helpful connection', which is attributable to an 'inferiority complex on the part of the British' brought about by the excavations at the LBK settlement of Koln-Lindenthal in 1936. Coles et al. (1978) point to the difficulties of dating timber, notably the, 'conflict between the age of the timber (possibly oaks 300–400 years old when felled) and the age of the structure to be dated; clearly, radiocarbon dating of the innermost rings of such a tree would seriously distort the result', but Last claims that a point has now been reached when, '[t]he increased precision of British Neolithic dates and improved understanding of the fifth millennium sequences in Northern France and the Rhineland allow us finally to sever the connection between the LBK longhouse and the north-western cultural milieu around 4000BC' (Last, 2013: 278). Despite this lack of cultural connection, there are similarities in the design and construction of Early Neolithic houses on both sides of the Channel which makes a consideration of environmental implications worthwhile.

In northern Europe, evidence of some extremely large longhouses may represent competition between various households within the settlement (Benesa et al., 2014). One example is the Hrdlovka

settlement (north-west Bohemia, Czech Republic) where 58 houses have been detected. The largest, House III, is 47.5 m long and (due to its slightly trapezoidal plan) varies in width from 8.6 to 9.5 m. The structure was based on three fairly regular rows of posts set in postholes up to 1.25 metre in diameter and 1 metre deep. The internal structural posts vary from 40–45 cm in diameter, and the external wall posts vary from 15–20 cm in diameter. The plan shows the building had three distinct sections, each with a different type of external wall construction: the central section had a double row of vertical posts, and the southern section a single row of vertical posts. The walls of the northern section were defined by a trench, but the construction material was unclear. Radiocarbon dating was unsuccessful, but relative chronology puts the building in the middle of the fifth millennium BC, at the transition between LBK and SBK (Stroked Pottery Culture).

Danubian longhouses from the Polish lowland are interesting because they are seen as the prototype of earthen long barrows of the Funnel Beaker Culture (TRB), and because they exhibit variations in structural design. LBK longhouses (from the second half of the sixth millennium BC) were designed to take the weight of the roof on three rows of posts, and therefore had non-structural side walls. The buildings are trapezoidal in plan and, at the settlement of Ludwinowo 7, vary in size from 12–47 m in length with an average floor area of 117 m^2. By contrast, BKC (Brzesc Kujawski) longhouses (from the second half of the fifth millennium BC) were designed to take the weight of the roof on fewer internal posts and on structural walls, which had foundation trenches up to 1.5 m deep. The buildings are shaped like an elongated trapeze and, at the settlement at Kujawski 4, vary in size from about 12–40 m in length with an average floor area of 111.46 m^2 (Pyzel, 2013a: 183–188). The development in Danubian architecture appears to reflect attempts to reduce material consumption and maximise interior space. The environmental trade-off appears to be a reduction in the number of large wooden posts (and all the chopping, trimming and hauling and erecting involved) against the need to dig trenches to take much sturdier walls, which may have been built using the branch-wood trimmed from the large trees, or the trunks of younger trees.

LBK houses appear to have had a short life-span (possibly about 40 years) with each generation building a new house (Pyzel, 2013a: 189) despite the old one still being sound. Few houses in LBK settlements overlie each other, and so Pyzel argues that older houses were not demolished but left to decay in remembrance and respect. After a time, settlements consisted of both the houses of the living and the houses of the dead. The environmental implication here is that substantial timbers, along with any other potentially re-useable materials, were not salvaged and incorporated into new buildings, but that more mature trees had to be felled. A felling rate of about 40 years is around one tenth of the time it takes for an oak to reach maturity, and about one quarter of the time for a Scots pine.

However, this rate of felling is relatively infrequent compared with some examples from Amazonian vernacular architecture. The Yanomami build large, round, communal courtyard shelters called Yanos, and the Yucunas build large, round, communal houses called Malocca. These are re-built every few years, due to the speed at which the buildings are overcome by rot and insect infestation. According to Hugh-Jones, 'When the leader dies, the house and community die with him; he is buried in the centre of the floor, the malocca is abandoned, and the community either reforms or divides' (Hugh-Jones, 1995: 228).

According to Last (2013a: 261), after 5000 BC the longhouse structure begins to change with the Blicquy/Villeneuve-Saint-Germain (BQ/VSG) Culture in Belgium and northern France, and then disappears in the mid-late fifth millennium with the Bischheim and Cerny cultures which have much more variable architecture and new types of enclosure. That most settlement sites lack evidence of houses, as in Britain, 'demonstrates that the house, though not without cultural significance, no longer had the central place in the reproduction of cultural identity that it possessed in the preceding millennium' (Last, 2013a: 278). After 4800 BC house plans in Europe become 'rare and highly diverse' (Amkreuz, 2014: 229–230). Bickle (2008) sees the death of the longhouse being due to social change – smaller communities and different social relations.

Darvill (1996: 85–88) argues that Neolithic buildings in Britain are more numerous and widespread than commonly believed. He categorises Early and Middle Neolithic buildings into four types of

structure – post-framed, ridge-roofed, post and wall-slot, and stake-walled, and identifies approximately 37 from the Early and Middle Neolithic across England, Wales and the Isle of Man. Three have been found in Scotland – at Claish Farm, Stirlingshire, and at Balbridie and Crathes, Aberdeenshire. Others have been found at White Horse Stone in Kent, Yarnton in Oxfordshire, Lismore Fields in Derbyshire, Horton in Middlesex, and Llandygai in Gwynedd. In Ireland, a link to the timber longhouses of Europe was declared to have been found in the late 1960s at Ballynagilly, County Tyrone, and since then the boom in infrastructural development in Ireland has revealed a total of 82 houses from 52 sites. Most are rectangular, 6–12 m long and 4–8 m wide, some are rectangular, and some have curving end-walls. Walls are made of split oak planks and posts, posts and wattle, or a combination of both, set in slot trenches (Smyth, 2013: 301–302).

More recent discoveries have, according to Sheridan (2013: 283), allowed us to 'expose the canard' that Early Neolithic groups in Britain and Ireland continued a form of Mesolithic hunting and gathering. They have also confirmed similarities in house design throughout Britain and Ireland, and advances in dating have confirmed that they belong to the earliest period of the Neolithic. In Ireland, the spread of timber houses takes place with a narrow date range of c.3715–3625 BC (based on over 100 dates from one third of known sites) a few centuries after those in England (Smyth, 2013: 306).

There is little literature on the environmental implications of Early Neolithic houses. Coles (1987: 54) notably estimates the number and size of trees required to build different sizes of LBK (and other) buildings by taking three sizes of trees known from the Somerset Levels and calculating the yield of each in terms of its round-wood and timber for making posts, walls and floors, etc. Darvill (1996: 97) suggests the decline of the Early Neolithic longhouse may have been due to 'the dwindling availability of suitable timbers, or perhaps the reluctance on the part of the builders … to spend time felling large trees and working them into usable planks and beams'. Startin (1978) notes a reduction in the number of posts and suggests this may indicate a move to more efficient construction techniques. Tipping et al. (2009) use pollen analysis to model land use around the large timber hall at Warren Field, Crathes, Scotland. The building measured 24 m x 9 m and had a life-span of up to 90 years during the period 3820–3700 BC before being burned. The outer walls were of large oak timbers set in foundation trenches, and the burnt post-pipes showed that both round and split timbers were used. The internal partitions were of lighter timbers and there was evidence that some of them had been replaced or augmented. Oak trees had gone from the immediate surroundings of the building, and some had clearly been used in construction. The pollen assemblages probably reflect land uses adjacent to the 'hall' and up to 2.5 km around. Cereal cultivation was the most important land use immediately around the building, possibly grown between stands of hazel woodland.

Reconstructions of Early Neolithic houses

Some longhouses have been reconstructed in northern Europe and Britain, most recently on Jersey, although none have been placed within a reconstructed landscape of cereal and stands of hazel woodland, as suggested by pollen evidence at Warren Field. In this sense, all reconstructions lack the authenticity of environmental context. Whether in actual, virtual, paper-based or model form, they are all based on archaeological evidence of postholes and wall alignments, etc. Some actual reconstructions have been built at open air museums, including at Oerlinghausen and Herxheim in Germany, at Biskupin in Poland, and at the Parc Archeologique Asnapio in France. One was built (July 2015) at Butser Ancient Farm in Hampshire, England, and another (September 2018) is being built at La Hougue Bie, Jersey. Virtual reconstructions include one found at Horton, Berkshire (dated to 3750 BC) by Foster and Goskar for Wessex Archaeology, and Building 32 at Elsloo in the Netherlands, by Geoff Carter. Paper-based reconstructions include House 1 at Ballygalley, County Antrim, Ireland by Derek Simpson (Simpson, 1996: 126, Figure 8.4).[2]

2 Oerlinghausen, Germany: <http://www.afm-oerlinghausen.de/>; Herxheim, Germany: <http://www.museum-herxheim.de/>; Biskupin, Poland: <http://www.thenews.pl/1/11/Artykul/144785,Neolithic-settlement-

Even with the clearest of floor plans, it is impossible to know exactly what any building looked like above ground floor level, inside or outside. The alignments and dimensions of postholes give indications of structure and the sizes of timber. Pitched roofs are highly likely in a northern European climate, and environmental evidence can suggest possible building materials. But beyond that, all reconstructions are conjectural. The dangers inherent in reconstruction include mis-reading archaeological evidence and underestimating the sophistication of Neolithic builders. For example, the evidence is clear at Ballygalley that the structure was based on 'six substantial post-holes', and Simpson reasonably suggests a rectangular framework of posts and tie-beams. However, he then goes on to suggest that, 'While this forms a strong framework, it does not require a knowledge of joinery, as all the joints could be lashed together with rope.' It seems unlikely that such a risky approach would have been used given the time and effort involved in erecting six substantial posts and the potential for disastrous collapse. Debert neatly sums up the significance of Early Neolithic houses:

> These structures may simply be seen as an amalgamation of timber, thatch, wattle and daub, possibly collected from great distances. But the collection of these resources would have brought people together over vast areas. At the same time, if the timbers retained the essence of their location or the memory of their felling and transport then, the timber structure is their world concentrated in one transmorphic place. In other words, the erection of a timber structure is a physical manifestation of the building of a new Neolithic community. (Debert, 2013: 85)

The Stonehenge landscape in the third millennium BC

The Stonehenge landscape is just one area of Salisbury Plain, which in turn forms one part of a much wider surface expression of north European chalk geology. In England, this runs diagonally from Yorkshire to Devon (Lawson, 2007: 3). In a review of palaeoecological evidence regarding vegetation openness before the onset of strong human impact, Svenning (2002) finds that, 'open vegetation would be frequent on floodplains, infertile soils, chalklands', and that '[l]arge herbivores and fire emerge as likely potential key factors in creating open vegetation in north-western Europe.' But by the middle of the third millennium BC human impact on this area of chalkland had been felt for 1,000 years, and it was becoming mostly grassland (Allen, 1997). It contained an extraordinary assembly of Neolithic monuments, earthen, timber and stone, and a large settlement at Durrington Walls. Any timber needed for construction, whether used directly as elements of structures such as Woodhenge, or indirectly as levers, rollers, sleds, rails and platforms and so on for building the Stonehenge monument, is likely to have been sourced either locally or along the stone transportation corridors which may have existed between Avebury and Stonehenge. However, the majority of round-wood coppice used in house-building is likely to have come from the immediate landscape. Given the quantities of materials needed for such extraordinary projects, the effect seems likely to have been what might be described as the enculturation of an arboreal landscape, in which it is interpreted, shaped and given meaning, rituals and practices are derived from it and established within it, and it becomes an embodiment of culture, rather than simply the accidental setting of a monument.

The extent and nature of this enculturation process continue to be revealed. Colt Hoare's map (The Ancient History of Wiltshire, 1812) saw the boundaries of the Stonehenge landscape as the valleys of the River Avon and River Till, and most subsequent maps have followed a similar format (Richards, 2005: 155; Darvill, 2006: 94). The UNESCO World Heritage Site (Stonehenge, Avebury and Associated Sites) shows Avebury and Stonehenge as separate sites, omitting significant features in between them at Marden, and at Stonehenge its boundary favours the A360/B3086 to the west, rather than the River Till. Just east of the River Avon, at Boscombe Down, there is a wide distribution of Late Neolithic/

reconstructed>; Parc Archeologique Asnapio, France: <http://www.villeneuvedascq.fr/asnapio.html>; Butser Ancient Farm, England: <http://www.butserancientfarm.co.uk/>; Horton, Berkshire: <http://www.wessexarch.co.uk/blogs/news/2013/03/07/making-neolithic-house> and <http://willfosterillustration.squarespace.com/illustration-portfolio/interpretation/10298624>; Elsloo, Netherlands: <http://structuralarchaeology.blogspot.co.uk/2013/02/understanding-neolithic-longhouse.html>.

Early Bronze Age features, including 'rich deposits of artefacts and ecofacts' (Archaeology, Wessex, 2005: 7), and more recently, evidence of further substantial Neolithic monuments has been found by the Hidden Landscapes Project. At Blick Mead, 'radiocarbon dates include every millennium in the range and present the longest sequence of any Mesolithic site nationally' (Jacques and Phillips, 2014: 7–27). This suggests that maps and tightly defined world heritage boundaries may be both helpful and unhelpful. The Royal Commission on Historical Monuments (1979), and Richards and Allen (1990), offer a less rigid, and more fluid, way of thinking about this by using the term environs. And in setting out ideas of social territories across a wider Wessex, Renfrew (1973) suggests that Neolithic perceptions of landscape boundaries may have owed more to social contact than topography.

Insect fossils from the Sweet Track and other English Neolithic sites suggest that, by 3800 BC, summers had become 2–3 degrees Celsius hotter, and winters 2–4 degrees cooler (Wilkinson and Straker, 2007: 63). It is possible that some areas of chalkland were never colonised by woodland (French and Lewis, 2005), but those that had been were further reduced by woodland clearances for farming, felling trees for building houses and monuments, and the introduction of grazing animals. By 3000 BC, the Stonehenge landscape was open:

> Stonehenge and the monuments round it were not constructed in the midst of wildwood. Until this century Stonehenge was surrounded by a great tract of chalk grassland, part of which had existed for at least 5,000 years. (Rackham, 2003: 123)

Rackham also argues that the placement of barrows (so that they can be seen from a distance) and the astronomical relationships of Stonehenge (presumably requiring an unobstructed sky-line) prove that the landscape must have been open no later than the Bronze Age (Rackham, 2003: 122). Allen (1997) also describes an increasingly open landscape of cultivation and settlement. Darvill (2008: 93) also concludes that the landscape changed quickly, woodland was cleared, and grassland came to dominate for the first time. There was a range of grasses, and some wheat and barley were cultivated. Pastoral farmers, and their cattle, may have rejoiced in flowery meadows with rampion and oxeye, scabious, cranesbill and orchids, which were better for bovine consumption (Rackham, 2003: 120).

Richards (2005: 155) maps an area of 10 km by 5.5 km (5,500 hectares) around the Stonehenge monument and illustrates the changes in the landscape between around 3000 BC and 2300 BC. By 3000 BC, the Cursus and the first Stonehenge monuments were sitting in a semi-open landscape. This was dotted with a few small arable plots, and surrounded by areas of oak, hazel, and elm wood, and secondary open woodland, with some floodplain along the valley bottoms. Taken on average across these 5,500 hectares, the Stonehenge landscape was approximately 50% open grassland and 50% woodland. By around 2300 BC 80% of this woodland had gone, and the landscape was now 90% open grassland and 10% woodland. The number of arable plots had increased from 15 to 28, although between them they still only amounted to about 100 ha. Most of the increase in arable plots took place to the west and south-west of Stonehenge, whereas the number of arable plots adjacent to Durrington Walls declined from four to two, and, '[b]y the Late Neolithic the area of pasture had been expanded, although there is only limited evidence for a corresponding expansion of arable agriculture. Cultivation only seems to have been carried out on a large scale in the Early Bronze Age' (Webster, 2007: 68).

The findings of French et al. (2012) are that there appears to have been a major hiatus around 2900 BC, coinciding with human activities at Durrington Walls, but slightly after activity began at Stonehenge. The evidence includes: tree and shrub clearance leading to more open downland, and increasingly wet floodplain with sedges and alder along the river's edge; localised woodland cover near Durrington Walls, perhaps on higher parts of the downs, with stable grassland predominating on downland slopes; and alder-hazel Carr woodland and sedges fringing the floodplain. And recent evidence from nearby Avon House, Amesbury (Green, forthcoming) supports this indication of a stable and managed landscape. Environmental evidence (seeds and pollen) indicate relatively open environments on both wetland and dryland surfaces, at the latest from the Late Neolithic (2405–2155

BC) onwards. The wetland was dominated by sedges, grasses and aquatic taxa, perhaps forming sedge fen and meadow-type communities, and grassland dominated the dryland, forming a suitable habitat for animal grazing. Most significantly, within the Late Neolithic pollen evidence for trees including oak, ash, elm and hazel, were values of up to 20% pine.

Scots pine grows faster, taller and straighter than other trees, and would have been ideal for large timber structures, such as Woodhenge, the timber circle around Durrington Walls and its Northern and Southern Circles. Pine thrives in heathland, and the semi-natural pinewoods of Scotland. The species is now planted commercially for timber on rotations of 50–120 years, and it is one of the strongest softwoods available, used in construction and joinery, and for telegraph poles, pit props, gate posts and fencing (Woodland Trust, 2015).[3] Pine grows rapidly for about 50 years, after which it slows down, and the height of mature trees is generally in the range of 20–25 m. Rope can be made from the inner bark, and tar from the roots, which is a useful preservative for wooden objects. The high resin content of the sap makes it a good tree for being in contact with water, so it has been used to make ships, masts and water wheels (Forestry Commission).[4]

Pine fibres can also be used to make 'vegetable flannel' and its resin can be burned as incense. What is believed to be an incense burner was found in 1803 by Cunnington in Golden Barrow (Upton Lovell G2e), south-west of Stonehenge, and some might see the burner's knobbly exterior as resembling a pine cone. Pine is 'monoecious' – that is, both male and female flowers grow on the same tree. After pollination the female flowers turn green and develop into cones which mature the following season, and so there are always cones of different ages on the same tree. Dry cones can be used as kindling and boiling them produces a reddish/yellow dye. Pine products, then, would have been ideal for large building projects and handy around the house. Cones may also have been symbolic stimuli for mathematics and mythology, although it is important to beware 'the imposition of preconceived ideas from another society with a very different system of thought' (Butt, 1961). The spiral patterns visible on pine cones are an example of Fibonacci numbers in nature, and the builders of Stonehenge were nothing if not mathematically minded. If Darvill (2006: 137) can hint at there being a grain of truth in Geoffrey of Monmouth's seemingly bizarre claim that Merlin transported Stonehenge from Ireland (the west of Wales is certainly in the right direction), it is tempting to wonder whether any echoes of pine's place in Neolithic/Bronze Age cultures may have been passed down into more recent folklore. For Romans, pine was an object of worship during the spring equinox festival of Cybele and Attis, and as an evergreen it symbolised immortality. Worshippers of the cult of Dionysus carried pine-cones as fertility symbols (King, 1991: 150).

For pine to be growing in southern England at all contradicts Rackham's view that, by 5000 BC, it was restricted to Scotland. For it to be growing on Salisbury Plain, at what might be called 'peak construction' time for Stonehenge and Durrington Walls, is significant. It was growing no more than a mile away from what Parker Pearson has estimated to be a settlement of up to 4,000 people. During the Neolithic Houses Project, Luke Winter, Director of the Ancient Technology Centre and Project manager, commented that 'from the varying sizes of the stake holes, it looks like they were using all sorts of material for the wall verticals, like the tops of pine trees.' But from the perspective of genuine Late Neolithic house-builders, faced with the task of constructing large numbers of houses, it may have been the river that was very much at the centre of things. Given the woodland clearances that appear to have been taking place on the downland, further supplies of timber, coppice and thatch may have been sought upstream or downstream, where the banks and floodplains held useful supplies of reed, rush, alder, hazel and willow.

Today, the Stonehenge landscape is protected, and planning authorities use 'landscape character assessment tools' to prepare policies and guidance. In its quest for high quality design in new development, Salisbury District Council advises developers that '[m]any areas of the chalk downlands

3 Woodland Trust, <http://www.woodlandtrust.org.uk/>.
4 Forestry Commission, <http://www.forestry.gov.uk/forestry/infd-5nlfap>.

are characterised by archaeological features including barrows and Stonehenge. These are important features which the district aims to protect and enhance' (Salisbury DC, 2006: 2). Denton Corker Marshall's Stonehenge Visitor Centre won an RIBA Award in 2014 and its architectural imagery was lyrically praised for being a 'forest of thin square columns dancing at different angles like tree trunks, supporting a curvy canopy roof, which has fretted edges like leaves meeting the sky ... A building that takes the Australian aboriginal dictum of 'touching the earth lightly' to perch on this archaeological landscape'.[5]

Touching the earth lightly (Drew, 2001) includes fitting into the landscape visually, and paying attention to aspects of sustainability (social, economic, environmental). As we have seen, significant changes took place in the wider environment of Neolithic Britain, and particularly in the Stonehenge landscape. Might this have been reflected in the design and construction of Late Neolithic houses?

Late Neolithic houses

Compared with those of the Early Neolithic, Late Neolithic houses are much less substantial, although Thomas sees them as 'rather flimsy and temporary' (Thomas, 1996: 1–2) rather than more sustainable. Darvill categorises them into four types: post-framed; post and wall-slot; stone and turf walled; and stake-walled. And in reference to their environmental implications he observes that '[t]wo of the types rely heavily on the availability of substantial timbers, the other two are more economical in their use of such resources and involve the greater use of stakes for support' (Darvill, 1996: 92), and that '[l]ess use of wood in some areas ... may be related to the dwindling availability of suitable timbers, or perhaps the reluctance on the part of the builders of these structures to spend time felling large trees' (Darvill, 1996: 97). It seems the absence of 'substantial timbers', and the use of stake-walled alternatives, are the bases for Thomas' 'flimsy and temporary' view, and Darvill's suggestion of a timber shortage. On the face of it, this is hard to reconcile with sites such as Durrington Walls and Woodhenge where there is clear evidence of the use of large quantities of substantial timbers and the construction of (possibly) hundreds of stake-walled houses. However, a shortage of timber would seem likely to lead to the reservation of dwindling stocks for use only in special circumstances, and the increasing use of alternative materials. A shortage might also lead to the deliberate planting and management of new stocks.

'As the natural woodland was cleared, the wind could penetrate among the surviving trees, thus affecting further growth' (Wickham-Jones, 2015: 34). Pollen records from Mainland, Orkney, suggest such a course of events, and illustrate the importance of human activity in the development of the treeless, varied landscape seen today. Vegetation developed from the late glacial until after the arrival of Neolithic people. There was extensive woodland, predominantly birch, willow, alder, oak and occasionally Scots pine. This was locally affected by Mesolithic human activity, and finally lost at around 3700 BC partly due to Neolithic human activity. Evidence of Early Neolithic timber houses has been found at Wideford and the Braes of Ha'Breck, but by the Late Neolithic the tradition of building in stone had developed. The transition from timber to stone (rather than to the use of coppiced wood, as in southern Britain) seems to indicate that Orkney's delicate arboreal balance was tipped over the edge. Farrell et al. (2014) suggest that the reasons behind the shift from timber to stone are more complex, and encompass social, cultural and environmental factors, but in the face of a timber shortage, with coppice regrowth inhibited by grazing fauna and winter gales, the inexhaustible supply of layered sandstone was a good choice, as was external insulation with mounds of midden. The survival of these houses, such as the Knapp of Howar (occupied c.3500–3000 BC) and Skara Brae (occupied c.3100–2500 BC) is testament to the durability of their walls, if not their roofs. The deforestation of Orkney may have been similar to that experienced on Easter Island, where it led

5 RIBA Awards, <http://www.architecture.com/StirlingPrize/Awards2014/SouthWestWessex/Stonehenge.aspx>.

Environmental implications of Neolithic houses

to 'losses in raw materials, losses of wild-caught foods, and decreased crop yields' (Diamond, 2005: 107). Neolithic Orcadians 'trod a fine line between starvation and life' (Wickham-Jones, 2015:46), but they did learn how to maintain the fertility of their soils (Wickham-Jones, 2015:4). And because of the warm Gulf Stream, they enjoyed a moderate climate for the latitude and received occasional deliveries of North American pine drift-wood.

Further south, stone and turf-walled buildings are confined to the north and west of England and Wales, and stake-walled buildings appear throughout southern England and Wales. Examples of the latter include Trelystan Long Mountain in Powys, Gwithian Site XV in Cornwall, Chippenham 5 in Cambridgeshire (Darvill, 1996: 93), and Durrington Walls (Parker Pearson, 2012). Whilst the use of different building materials may be due to cultural preferences, it may just be an adaptive approach to the use of locally available materials – stone in the Dales, chalk in the Chalk-lands.

Gibson (1996: 134, Figure 9.1) describes two houses found at Trelystan, Powys, as 'small flimsy stake-built structures'. Structure A measured 4 m x 4.5 m and dated to c.2574–2462 BC. Structure B was slightly smaller at 3.9 m x 4.2 m and dated to c.2865–2589 BC. Each had a central hearth, and the walls were defined by stake-holes, which indicate where pointed stakes were driven into the ground – in the case of structure B, the stake-holes were up to 130 mm deep. The existence of a central hearth means the roof had no central support post, and so the Trelystan structures are similar in plan to those excavated at Durrington Walls – small wattle and daub structures with chalk floors and central hearths surrounded by stake-holes. It seems that similarities in size and plan, rather than similarities in building materials, are the indicator of cultural change. Some rectangular buildings did exist, but most were trapezoidal, sub rectangular or circular, although there is disagreement as to whether some of the larger, circular structures (e.g. Woodhenge) were roofed buildings at all (Darvill and Thomas, 1996: 90; Parker Pearson et al., 2007). Darvill notes that 'the majority of houses of the LN are more or less square or round in plan' (Darvill, 1996: 93–97). Some of the structures illustrated do not display some of the domestic characteristics we might associate with the idea of 'house'. For example, some of those Darvill refers to as LN Type E buildings (e.g. Northern Circle Phase 2, Durrington Walls; Durrington 68; Structure F, Redgate Hill; Structure D, Willington) lack hearths and appear to have very wide, seemingly draughty, doorways. And most of those referred to as LN Type Ei buildings (e.g.Site IV, Mount Pleasant; Woodhenge; Southern Circle Phase 2, Durrington Walls; The Sanctuary, Avebury) have so many postholes that the creation of usable floor space seems not to be a priority, particularly in comparison with later round-houses. The buildings which seem more plausibly to be houses – not too big, not too small, and with a hearth – are those referred to as LN Type F, G and H buildings (e.g. Little Cheney, Dorset; Phase 2, Gwithian, Cornwall; Structures A and B, Trelystan, Powys; and Hockwold-cum-Wilton, Norfolk). What is striking is the similarity in scale and plan of Late Neolithic houses from Gwithian to Hockwold, and from Trelystan to Skara Brae and Durrington Walls.

Reconstructions of Late Neolithic houses

Very few Late Neolithic Houses have been reconstructed, whether in actual, virtual or model form. Gibson (1996: 134, Figure 9.1) offers three possible reconstruction ideas for stake-walled houses based on Trelystan. However, all these ideas appear to be problematic in practice: idea A sensibly uses a ring beam on top of the walls to resist the outward thrust of the roof, but the lack of additional support (purlins) for the rafters in-between the top of the walls and ridge means the roof would be likely to bear little weight or wind-loading; inherent in idea B is the difficult problem of how to drive long, flexible stakes deeply enough into the ground to retain the tension on the rafters – a compression ring beam would be needed; and idea C also lacks purlins, and would require the rafters to be anchored to the ground.

Reconstructions based on House 851 at Durrington Walls have been built at Butser Ancient Farm in Hampshire, and at Old Sarum, Wiltshire. The latter was built during the first phase of the Neolithic Houses Project and became the prototype for five similar buildings constructed in 2013 at

the Stonehenge visitor centre. The Neolithic Houses Project was able to experiment with the kinds of ideas put forward by Gibson. Of his three ideas, C turns out to be the closest to the workable solution found by the Project. To avoid the problem of driving long, flexible stakes into the ground, short stakes were driven in and wattle walls were woven up to a height of about 60 cm. Full height wall stakes were then inserted into the weave, next to the short stakes, and the weaving continued to the top of the wall. Long, flexible rafters were then inserted deep into the top of the weave, again next to the wall stakes, and then bent over and tied together along a ridge pole. The weave was then continued up the roof to the ridge creating a form of inverted basket structure with a domed, pre-stressed roof able to bear considerable loads (the weight of at least six volunteer builders).

Data from the Neolithic Houses Project (Winter and Grigsby, 2015) suggest that stake-walled houses were neither flimsy nor temporary. They were not overnight shelters that could be erected in a matter of hours, like a yurt. Reconstructed House 851 took several weeks to build, and research into its thermal properties helped determine that they are 'valid structures for habitation' (Storm-Clifton, 2014).

There is also an actual reconstruction at Skara Brae visitor centre of House 7, which was the best preserved of the houses found at the settlement, with all walls standing at more than 3 m high, and only missing a roof, of which no evidence remained. Early attempts to both protect it and allow visitors to access it led to damage to the archaeology, and so Historic Scotland has created a 'replica', with a roof which is 'based on careful research, though modern materials have been used' (Clarke, 2012: 12). Whilst reconstructions contribute to the safeguarding of the archaeological evidence, they also raise questions as to how that evidence is interpreted. According to Watterson et al. (2014), this originates at the point where the sensory experiences of archaeologists are mediated through technologies such as cameras, survey machines or scanners: 'This influences and even constrains the kinds of information that is observed and recorded, effectively distancing the field worker from their material.' Their experimental film, 'Digital Dwelling at Skara Brae', 'moves from the present day to the imagined past', and 'explores the potential of layered multimedia as an archaeological field method; capturing and communicating very different qualities of the archaeological record to systematic and objective techniques of data collection alone.'[6]

Reynolds makes an important point in relation to the learning to be derived from reconstructions: 'Most information, though not necessarily the most valuable information, is achieved in the construction and immediate post-construction phase. Critically, there are secondary and tertiary peaks which occur when the structure reaches a stage when repair or refurbishment become necessary ... long-term study and observation bring more significant and telling results' (Reynolds, 1987: 67).

It seems fair to conclude that, while sets of objective archaeological plans, photographs, etc, are essential, all reconstructions owe something to the imagined past. Watterson warns that comparative materials provided by contemporary ethnography can never simply be imposed on archaeological data, and to be aware of 'unexamined assumptions that lie behind our own view of the world.' In relation to the transition from Early to Late Neolithic houses, Watterson also observes that 'the direction of developments is not consistently toward a larger and more solid architecture' (2014: 374–376).

The settlement at Durrington Walls

The Stonehenge Riverside Project (2003–2009) uncovered the remains of seven Late Neolithic houses, outwardly a similar sized settlement to Skara Brae, which is a cluster of eight houses. The population of Skara Brae seems likely to have been about 50 at any one time (Hedges, 1984), but Parker Pearson has proposed that the houses found at Durrington Walls formed part of a much larger settlement of up to 1,000 houses. 'With a nuclear family occupying each dwelling, this village could have housed a population of more than 4000' (Parker Pearson, 2012: 109–110). This was clearly no ordinary

6 Digital Dwelling at Skara Brae, <https://digitaldirtvirtualpasts.wordpress.com/skara-brae/>.

settlement, and 'the Durrington Walls village was the hub of a network that stretched across southern Britain to provide supplies to feed an army-sized population' (Parker Pearson, 2012: 121).

The solid chalk floors, with circular central fire dishes, were edged with beam slots where timbers had been set into the ground to provide edgings to the floors and, probably, to support furniture. Wear patterns on the floors suggested where doorways had been, and the surrounding stake holes revealed where uprights had been driven into the chalk to create walls. Small pieces of chalk daub revealed what had been used to clad them, and curved imprints in the daub indicated the size of the wattle rods it had been pressed against. The varying sizes of the stake-holes indicated that a random mixture of stakes had been used for the verticals, whereas the more regular spacing of the stake holes indicated the use of similar sized/aged material for the horizontal wall weaving. The spacing of the stake holes was consistent with the use of seven- to nine-year-old coppiced hazel (Winter and Grigsby, 2015). No evidence was found indicating how the roofs had been constructed, but the existence of a central hearth, and the absence of stake-holes within the buildings, indicated that the roofs had no central support post and were self-supporting. Environmental evidence (Allen, 1997) suggests that local materials offering options for roof coverings included domesticated cereal straw, reed, rush and grass, but the absence of grain on the site (Parker Pearson, 2007: 142) suggests that cereal straw was not used for thatching. The lack of grain may be consistent with the argument of Stevens and Fuller (2012) that cereal farming failed in the Neolithic, and Britons became largely pastoral. Certainly, it was a place of feasting, and large quantities of Grooved ware, animal bones and stone tools have been found (Wainwright and Longworth, 1971).

At nearly 500 m across, Durrington Walls is one of Britain's largest henge monuments. It also contains two other timber circles, including the 40 m diameter Southern Circle, a monument of six concentric rings of substantial timber posts. The significant aspects of the Durrington Walls settlement are its size, its proximity to Stonehenge and its short habitation dates. It was probably occupied within the years 2500–2460 BC, which is the same time as the great Sarsen stones were being assembled at Stonehenge. 'These dates are unusually precise – it's rare to end up with a timespan as short as forty years for the date of any event in prehistory' (Parker Pearson, 2012: 110).

Parker Pearson has subsequently clarified his estimate of the possible size of the settlement as follows:

> I'd adjust it to 500–1000 houses (1000 is the upper estimate). I'd estimate 300 houses surviving under the banks of the henge and a further 200–700 houses depending on how full the middle of the area would have been. Remember also that at least one of our houses at the east entrance was an outhouse and not a dwelling. (Parker Pearson, personal communication, 16 January 2015)

Whether the number of houses was 500 or 1,000 is a significant difference, but even the lower figure would still make Durrington Walls by far the largest settlement ever found in northern Europe. Parker Pearson's original estimate was for up to 1,000 houses, each with a nuclear family making a total population of 4,000 This pre-supposes that all the houses stood at the same time (Parker Pearson, 2012:109), but questions must remain over this and the actual number of houses. Skara Brae, with fewer than a dozen houses, and at most 100 people farming the land around them (Wickham-Jones, 2015: 9), seems relatively tiny. But large Neolithic settlements are not unknown in southern Europe. If sociologically not comparable with Durrington Walls, Vinca-Belo Brdo, a Vinca culture (5700–4500 BC) settlement, covered 29 ha and had an estimated population of up to 2,500 people (Chapman, 2000). Sesklo in central Greece (c.5000BC) covered about 20 ha, included 500–800 houses, and had a population of up to 5,000 people (ESREA, 2006). And in 2015 the remains of 60 houses, some two storeys high and built of wattle and daub along pre-planned streets, were found at Mursalevo, Bulgaria. They have been dated to 6000 BC, and the inhabitants were pastoralists and hunters.[7]

7 Mursalevo, <http://archaeologyinbulgaria.com/2015/04/15/bulgarian-archaeologists-find-ancient-thracian-child-sacrifice-during-excavations-of-early-neolithic-city-at-mursalevo/>.

These settlements are similar in size to the claims made by Parker Pearson for Durrington Walls, but even if they were sociologically comparable, Durrington Walls would remain outstanding due to its very brief dates. If it was a settlement, it wasn't very 'settled', and seems more likely to have been a temporary camp for the builders of Stonehenge, or some form of festival site (a Neolithic Glastonbury?). But whatever its purpose, it required unprecedented quantities of materials to build and maintain, most of which came from woodland.

Woodland management

'By the earliest Neolithic period, someone had discovered that regrowth shoots from a stump are of more use than the original tree' (Rackham, 2003: 38). This discovery may have been an unintended consequence, either from felling individual trees for timber, or from the deliberate creation of forest clearings to create habitats that attracted grazing fauna. But if the regrowth from trees such as hazel could be protected, after several years the long, bendy rods proved useful for other purposes. Woodland management, like forestry, is a form of farming, but necessitating longer-term forward planning than arable crops. One crop is coppice – the roundwood re-growth, which is often harvested on a five- to 10-year rotation – and a large number of tree stumps, or stools, are required to produce a useful amount. To create a concentrated area of new stools, they have to be grown: 'On unwooded sites new stools are best established from robust transplants planted at 1.5–2.5m spacing. The initial cut to stimulate formation of coppice shoots can be made after 1–2 seasons' growth but it may be better to allow 5–6 years for establishment' (Harmer, 1995). It should be noted that this advice presupposes the use of modern, metal tools. It is possible that prehistoric harvesting tools (e.g. flint axes) may have induced different rates of re-growth.

There were only two methods of creating coppice available to Neolithic woodsmen – planting, or layering. Planting involves growing saplings from seed, then planting them out and managing them (protecting, watering etc). Layering involves bending an existing shoot (rod) over, pegging it to the ground and covering it with 10–15 cm of soil. It should then take root and, with appropriate management, eventually create a new stool. This form of 'leap-frog' technique gradually extends the area of the coppice, or coupe. Having nurtured the new growths for five to six years, a first cut is then carried out to stimulate multiple re-growths. Common rotation periods vary from three to seven years, or longer, depending on the size of the material required, and so establishing a coupe from an unwooded site takes anything from eight to 13 years or more before the first useful crop is harvested. This is evidence of forward planning which takes into consideration the future needs of the current generation. However, if the pollen evidence from Avon House, Amesbury, is evidence of pine trees being managed, it suggests the needs of future generations being taken into consideration. Attempts at the management of valuable natural resources do not always end well, as demonstrated by the Pine Tree Riot of 1772 at Quimby's Inn, South Weare, New Hampshire. The riot was precipitated by men illegally cutting pine trees reserved for masts for the Royal Navy. 'In short, timber was to the world at that time what oil is to the world today – a finite resource for which nations competed' (Weare Historical Society).[8]

The earliest archaeological evidence of woodland management comes from the Somerset Levels, where the pollen record shows ancient wildwood trees, such as oak, ash and lime, existing c.4000 BC. By 3000 BC managed woodlands containing coppiced hazel were long-established and still existed c.2000 BC (Coles, 1987: 51). 'The archaeological record from the Somerset Levels and elsewhere speaks of managed woodlands from the Early Neolithic onwards, and of the fact that many trees were coppiced' (Coles, 1987: 55). The development of a dendrochronology for the British Neolithic

8 Weare Historical Society, <http://www.wearehistoricalsociety.org/pineriot.htm>.

(Hillam et al., 1990) enabled the dating of the Sweet Track (3807–3806 BC), which shows the earliest instance of woodland management in Europe, and the wide variety of wood being used – oak, ash, elm hazel, lime, holly, hornbeam, alder, willow, birch and apple. Rackham (2003:38) claims that, 'Many of the poles were grown for the purpose in a mixed coppice-wood', and, whilst the large amount of cut wood does suggest this, Boyd (1988: 614) points to, 'the incorrectness of the hypothesis that the fossil assemblage represents the composition of the surrounding woodland', and suggests that the management process 'probably does not represent highly organised cyclical woodland management characterised by coppicing of even-aged stands at set time intervals.'

However, evidence from the Walton Track, the earliest example of hurdle-work, appears to confirm both a woodland management system and a pre-fabrication process using a single species (Coles et al., 1978: 19). Two-metre-long hurdles had been produced using 'sails', or verticals, cut from 10-year-old growths, and weaving rods of three to five years old. Such pre-fabricated hurdles are likely to have been used for fencing (including protecting areas of coppice from grazing) and for house-building. The diversity of material used in the Sweet Track suggests that, although there were quantities of managed coppice that could be used for construction purposes, there was not enough of one species for such a large project, and that a wide area of diverse woodland was felled or stripped of its upper branches. Another possibility is that different species of trees were deliberately being coppiced as part of another process, such as growing leaf-laden branch-wood to provide winter fodder for animals.

In areas such as the Somerset Levels one might expect a predominance of alder and willow, which prefer moist soils, but pollen evidence (Coles, 1987) shows that the dominant woodland species here in the Late Neolithic were hazel and oak. Conspicuous by its absence here is pine.

People, nature and buildings

The human relationship with nature is co-evolutionary: 'society adapts to its environment; the environment responds to human activity and both shift over time' (Scott and Gough, 2004: 253). The process of co-evolution throughout the British Mesolithic, in which nature's trajectory towards 'climax' woodlands was modified by human hunting and gathering activities, created the landscapes to be inherited by Early Neolithic communities. A further 1,500 years of forest clearances, farming, mobile pastoralism and grazing, house-building and firemaking created the landscapes inherited by Late Neolithic and Early Bronze Age communities.

Humans dwell in a material world and 'in the course of this dwelling an accommodation is made between the rhythms of social reproduction and the seasonal rhythms by which the organic world renews itself' (Thomas, 1996: 5). Whilst one cycle of seasons may be enough to renew grasses, cereals, reeds and rushes for thatching purposes, other materials take longer to become useful building materials. Hazel coppice, for example, is commonly cropped on a cycle of seven years. Oak can also be coppiced, and a 15-year cycle is needed for extracting tannin from bark, a 20-year cycle for producing pit-props, and a 120-year cycle for construction timber (Shire and Martin, undated). An oak takes about 400 years to reach full maturity and its maximum yield of timber. These are some of the natural rhythms that Neolithic house-builders, 'working with the grain of nature' (DEFRA, 2011), may have learned to work within. Ignoring them is ultimately unsustainable.

Another form of co-evolution characterises our relationship with buildings. When Winston Churchill said, 'There is no doubt whatever about the influence of architecture and structure upon human character and action. We make our buildings and afterwards they make us. They regulate the course of our lives' (Speech to the Architectural Association, 1924, in Brand, 1995: 3), he was referring to the confrontational nature of British politics, the design of the House of Commons, and a two-party system kept more than two sword lengths apart by red lines in the carpet. If tradition can control the way we conduct politics, it can also control the way we build:

> Vernacular building traditions have the attention span to incorporate generational knowledge about long-term problems such as maintaining and growing a building over time ... When the standard local roof design works pretty well, and the materials and skills are readily available for later repair, why would you mess with that? (Brand, 1995:132)

Indeed, why would you mess with any design that works well, given all that it embodies – pragmatic responses to local climate, geology, ecology and topography, and the cultural requirements and technological abilities of the builders and users? Watterson asks what it takes to transmit an architectural tradition: 'How much is needed in the way of visual images, technical knowledge, plans, memory, or the persons of skilled craftsmen?' (Watterson, 2014: 374). The weight of tradition, and not solely within the context of building houses, can hinder adaptation and change, and, in some cases, contribute to societal collapse. Diamond (2005) sets out a number of case studies exploring how societies choose to fail or survive, including the case of Easter Island: 'people see the collapse of Easter Island society as a metaphor, a worst-case scenario, for what may lie ahead of us in our own future. Of course, the metaphor is imperfect' (Diamond, 2005: 119). Imperfect metaphor or not, according to Diamond the outcome of the over-use of mature timbers for moving and erecting large stone statues was that 'Easter ended up with no tree species standing and with about 90% of its former population gone.'

The FRAGSUS (Fragility and Sustainability) project (Queen's University Belfast, Cambridge and Malta) is studying sustainability and change amongst Maltese Temple Building populations in the fourth and third millennia BC. Questions include: Why do some cultures sustain their civilisation for centuries or millennia, while others collapse in response to changes in the wider environment? How did humans interact with, and impact on, the changing natural environment? Was there ever a 'forest', and was it human impact on the environment, or climate and weather, or an unfavourable combination of the two, that led to the demise of the Neolithic culture (Fenech et al., 2015)?[9] Initial findings of the project suggest that radical change may have been brought about by major natural events, such as mega-storms and tsunamis. Whether it was human impact or natural events, between 3000 BC and 2300 BC the woodland cover in the Stonehenge landscape was reduced by about 80% (from 50% cover to 10%), leaving its monuments in predominantly open grassland. And after little more than 40 years, the occupation of what may have been the largest Neolithic settlement in northern Europe came to an abrupt end.

Questions of sustainability are a matter of contemporary debate. In addition to the complexities and contradictions of many competing definitions, one problem is that sustainability is often mistaken for some past or future Golden Age. But for Hamm and Muttagi (1998: 2) '[s]ustainability is not a concept referring to some static paradise, but rather a capacity of human beings to continuously adapt to their nonhuman environments by means of social organisation'. One question in relation to the change that takes place in house-building from Early to Late Neolithic is whether it reflects an adaptive shift to more sustainable use of natural resources – a use which better accommodates the rhythms by which the organic world renews itself – notably, wood.

'Wood was one of early man's most valuable and important raw materials', and 'yet wood hardly figures in the minds of archaeologists, and it plays no part in the traditional, outmoded, but convenient Three Age system of European Prehistory: Stone-Bronze-Iron' (Coles et al., 1978: 1). The output of flint axes from Grimes Graves has been estimated at several millions, and from mines in north-western Europe at over 400,000 per year. Millions of axe-heads needed millions of wooden handles, and then there was wood for posts, beams and planks, fences and palisades, cooking and metal-smelting, timber circles, boats, mortuary houses, houses for living in, and furniture. Perhaps the important use of wood in the Neolithic Stonehenge landscape was for building Woodhenge, the Northern and Southern Circles at Durrington Walls, and the huge wooden circle erected around it. Some of these timbers had trunks over a metre in diameter and may have been up to 15 m in length (about 14 m³ of

9 FRAGSUS, <http://fragsusuom.weebly.com/scientific-investigations-into-maltarsquos-past-environment.html>.

timber). If they were pine (about 500 kg/m³) they would have weighed about 7 tonnes, and if they were oak (about 700 kg/m³) they would have weighed about 10 tonnes. Raising much smaller posts than these proved too much for Time Team in 2006. Despite the help of 20 soldiers, machines had to be used (Parker Pearson, 2012: 83).

Methodology

To consider the environmental implications of Neolithic houses, both at the scale of individual buildings and a whole settlement, this dissertation draws on evidence and ideas from a range of disciplines, including archaeology, experimental archaeology, woodland management, people, nature and buildings. This is a form of triangulation, or consilience, 'the linking of facts and fact-based theory across disciplines to create a common groundwork of explanation' (Wilson, 1998: 6).

Experimental archaeology draws upon both processual and post-processual archaeologies, in that it is based both on scientific evidence and interpretation:

> Experimental archaeology should be defined as a scientific method that follows the principles of research, and a hypothesis concerning a physical process in the past should be proved or disproved using a technology appropriate to the task. However, the difficulty with this scientific method is that one has to deal with human-social data and factors that do not have a parallel in other sciences. Prehistoric people, the lack of data and finally the researcher him or herself become overly dominating factors. (Hansen, 2014: 167)

However, its advantages include deeper insights into prehistoric processes and issues, and public engagement with archaeology. In the case of reconstructed Neolithic houses, floor plans, pollen evidence, and other associated finds are interpreted to create seemingly plausible buildings. This dissertation compares the environmental implications of Early and Late Neolithic houses and uses the data from a seemingly plausible reconstructed Late Neolithic house to explore the environmental implications of a large settlement.

The methodology is to bring together archaeological evidence of Early and Late Neolithic houses (Darvill and Thomas, 1996; Hofmann and Smyth, 2013) and the Late Neolithic settlement at Durrington Walls (Parker Pearson, 2012, 2013), with the experimental archaeology work of the Neolithic Houses Project (Winter and Grigsby, 2015) and the work of Coles (1987) on prehistoric timber. Literature on the environment of Neolithic Britain is used to provide a context for the changes taking place in the construction of houses from the Early to Late Neolithic, and to provide a context for the more localised changes taking place in the environment of the Stonehenge landscape in the third millennium BC.

Literature on Early and Late Neolithic houses, and their reconstructions, in conjunction with literature on experimental archaeology, enables comparisons to be made between methods of construction, and types and quantities of materials, at the level of individual buildings. To aid this comparison I have developed an instrument, which I term the Consumption/Regeneration Ratio, which expresses the extent to which construction types are sustainable or unsustainable. Data on labour and materials from the Neolithic Houses Project, in conjunction with literature on woodland management and archaeological evidence from Durrington Walls, are used to calculate the quantities of materials, labour, areas of land and time-scales needed to produce enough materials to build and maintain a settlement of up to 1,000 houses. Growth models are then used to explore the requirements for labour and materials of building the settlement over different hypothetical timescales within the range of the settlement's occupation dates, and to consider the environmental implications for the Stonehenge landscape. This has not been done before.

Early Neolithic houses

This section considers the materials required to build Early Neolithic houses, and their environmental implications. It draws on the work of Coles (1987) who calculates how much timber, and therefore how many trees of particular sizes, are needed for various types of timber houses, including LBK longhouses. It also uses a tool of my own invention called the Consumption to Regeneration Ratio (Con/Reg Ratio), which is explained below.

Coles (1987: 54) takes three sizes of trees known from the Somerset Levels and calculates the yield of each – that is, how many large timbers for house posts, and how much round-wood for walls and floors etc, each size of tree produces. The trees are labelled 'A', 'B', 'C':

- Tree 'A', the largest, existed in primary or long-established woodland, with a stem diameter of about 100 cm, and clear stem length of 12–15 m; if oak, about 400 years old; other species, such as pine, less old. Such a tree might yield approximately 90 m^2 of planking, or the stem could be used as a heavy roundwood post. Useful lengths of branchwood total about 50 m.
- Tree 'B' existed in secondary woodland, with a stem diameter of 40–50 cm, and stem length of 10–12 m; if oak, about 100 years old. Such a tree might yield about 20 m^2 of planking, or 10 m of thick stem and about 100 m of useful (but short) lengths of branchwood.
- Tree 'C' existed in secondary woodland, possibly coppiced oak, ash, lime or pine; with stem diameter of 20–30 cm, and stem length of 3–5 m; if oak, 40–50 years old. Such a tree might yield 4 m^2 of planking, or the stem could serve as a heavy roundwood post, but the branchwood would be rather weak.

By using archaeological evidence of the footprint of a building (i.e. overall dimensions, number and size of timber posts) and evidence of wall type (e.g. continuous line of posts, split planks, or wattle and daub), and assuming a wall height of about 2 m, it is then possible to estimate how many trees of which size might have been used to build it. Coles does this to estimate the number and size of 'A', 'B' and 'C' trees required to build different sizes of timber buildings.

Consumption to Regeneration Ratio

The consumption of one, huge 400-year-old 'A' tree may have miniscule implications for global water and carbon cycles and climate. Locally, it may also have minor implications for habitat and landscape. However, continuous consumption of such trees at a rate faster than their ability to regenerate would have more serious implications and eventually lead to deforestation and soil erosion. For my purposes, Consumption is the length of time a piece of felled timber lasts before it needs to be replaced, and Regeneration is the length of time an equivalent piece of timber would take to grow. For example, if a 100-year-old tree is felled, made into a post, and it only lasts 50 years before it needs to be replaced, the Con/Reg Ratio is 50/100, or ½. A Con/Reg Ratio <1 might be deemed 'unsustainable' in the long term because consumption is faster than regeneration and leads to a net loss of trees. A Con/Reg Ratio >1 might be deemed 'sustainable' because the timber post lasts longer than it takes to grow. The length of time it takes for timber to decay and need replacement depends on several variables, including: the species of tree, size and quality of the timber; the voracity of local insects, and environmental conditions favouring decay – for example, water, humidity, temperature and lack of ventilation; whether or not it has been treated in some way (e.g. burning the end put into the ground). The other important variable is the scale of consumption relative to available stocks.

Here is an example which appears to show a shift from sustainable to unsustainable practice. Estimates from the Southern Circle at Durrington Walls (Parker Pearson, 2012: 83) suggest that the

life-span of the Phase 1 posts (around 20 cm in diameter) was a minimum of 60 years. These would have been 'C' trees – if oak, then 40–50 years old, younger if pine. This would give a Con/Reg Ratio of >1 (sustainable). The Phase 2 posts, however, were 'A' trees, over 1 metre in diameter. If oak, they were about 400 years old, if pine less old, and estimated to have lasted for the best part of 200 years, giving a Con/Reg Ratio (oak) <1 (unsustainable). If pine was a very suitable building material for these structures, and the size/age of the trees were of cultural significance, then it would seem sensible to manage their use. This would match with the pine pollen evidence found a short distance downstream at Avon House, Amesbury (Green, forthcoming).

Materials, time and space

One of Coles' (1987: 54–57) examples is House 5, an early LBK longhouse, which measures 30 m long and 8 m wide (240 m^2). Its timber components comprise: 40 wall posts, 2 m long; 56 planks, 50 cm wide; 30 heavy posts, 10 of which are 5–6 m long; 20 posts, 4 m long; 90 m roofing members. This translates into 9 'A', 5 'A/B', and 19 'B' trees – a total of 33 trees of varying sizes that were needed to build it. In addition, some 5,000 m of rods from about 250 coppice stools were also required for the walls and roof (Coles stops short of estimating how much thatching material might be needed). Coles' suggestion is that all of the material – 33 trees and 5,000 m of coppice rods – might be contained within 1,000 m^2 (0.1 ha) of managed woodland, or 'coppice with standards'. The implication, therefore, is that one hectare of coppiced woodland would contain up to 330 standards. This is questionable.

Let us first consider the production of the 5,000 m of rods. According to Harmer (2004), 'A typical crop from 1 acre of good hazel coppice would have yielded around 10,000 rods', which equates to 25,000 rods/ha. So, an area of 1,000 m^2 would easily produce 2,500 x 2–3 m rods in three to five years (i.e. at least 5,000 m of rods). But what is 'good' hazel coppice, and what about the 33 standard trees? According to Fuller and Warren (1993: 20), the typical number of standards for the purposes of wildlife conservation is 30–80 per hectare, and that 'the lower is the overall number of standards that is compatible with good underwood'. Simply put, the more standards, the more shade, the poorer the underwood and the poorer the wildlife. Coles' estimate of the amount of managed woodland required to provide good coppice and large timbers appears to be very low. By claiming that 33 trees might come from 1,000 m^2 of managed woodland (30.3 m^2 per tree) Coles is implying that Neolithic managed woodland was approximately 10 times more densely wooded than is good for underwood and wildlife. It seems more likely that the 33 trees came from 0.4 ha to 1.1 ha of woodland (between 121 m^2 and 330 m^2 per tree).

If we take 0.75 ha of woodland as a reasonable compromise, and House 5 covered 240 m^2, then each square metre of the building required approximately 31 m^2 of managed woodland to provide enough large trees, or standards, as well as good coppice and healthy wildlife. This may have left plenty of coppice wood unused, although some would have been damaged in the process of felling and extracting the timber. As previously noted, there are structural (if not sociological) similarities between LBK and British longhouses, the footprints of which range from the smallest at Trelystan B (16.3 m^2), through Llandygai (78 m^2), up to the largest, Balbridie (329.6 m^2) (Topping, 1996: 158). If we take Coles' estimate of the materials required for LBK House 5, and apply it to these British examples, we can estimate the area of managed woodland needed to build them: Trelystan may have consumed up to 525 m^2, Llandygai up to 2,400 m^2, and Balbridie up to 10,200 m^2, or 1.2 ha.

The regeneration time for usable coppice is three to five years, whereas the regeneration time for 'A' trees is 200–400 years, assuming, of course, that generations of woodland managers protect the early re-growth from grazing fauna, and resist their own temptations to cut it down. Whilst plenty of coppice material would soon become available again, large timbers would need to be sourced from further and further away. An illustration of this might be Coles' description of how, at the Neolithic settlement of Hornstadt-Hornle in Switzerland, tree-ring analyses indicated the variety in age and

size of oak timbers used in a succession of house-building episodes, spread over a period of 80 years. The first episode used 100-year old 'B' trees. The second (15–20 years later) used a mix of 'B' and 'C' trees 50–80 years old. And the third episode (30 years after the second), used 'C' trees from regenerated woodland started at the same time as the first episode. The final episode (15 and 30 years after the third) used 'B' trees over 100 years old, believed to have come from different woodland from that which had been felled in the first episode of building (Coles, 1987: 55). Given Pyzel's (2013) estimate that the life-span of some LBK longhouses was approximately 42 years (because each generation built its own new house, leaving the old ones to decay) the conclusion is that this contributed to a net loss of mature trees. Even the youngest trees used (50–80 years) took longer to grow than the house was used for, giving a Con/Reg Ratio of 42/50–80 = <1 (unsustainable).

Materials, time and effort

To obtain and erect the substantial materials required to build Early Neolithic houses, much time and effort was needed. Coles (1987:56) refers to experimental work which suggested that an 'A' tree might take one hour to fell, and a 'B' tree 20 minutes. However, during the harvesting for Phase 1 of the Neolithic Houses Project a group of 10 volunteers, equipped with four flint axes, cut down a pine tree to make the furniture for the prototype house. This was what Coles classifies as a 'B' tree. It was 30 m tall with a 40 cm diameter trunk, and to chop through approximately 5,000 cm^2 of timber took two hours and 42 minutes, or eight times longer than Coles' estimate (see Neolithic Houses blog).[10]

For safety reasons, the volunteers took it in turns, one at a time, as flint axe-heads have a habit of flying off. But let us suppose that two Neolithic axe-men had worked together, at the same time, on opposite sides of the tree, and that they were twice as effective as twenty-first-century volunteers, it would still have taken them about 40 minutes to fell the tree, or twice as long as Coles' estimate. At this 'expert Neolithic' rate, an 'A' tree of 100 cm diameter (31,400 cm^2) would take about four hours to chop down, rather than Coles' estimate of one hour.

Had the volunteers been building House 5 (above) they would have needed: 40 wall posts 2 m long; 56 planks, 50 cm wide; 30 heavy posts, 10 of which 5–6 m long; 20 posts 4 m long; 90 m roofing members. The estimated total requirements are 9 'A', 5 'A/B', 19 'B', which amounts to 33 trees of varying sizes, plus coppice material for 76 m of walling and roofing, which is about 4.5 times the amount of coppice material needed for the walls and roof of House 851 (see below) which took 23.5 hours to harvest.

Leaving aside the trimming of branches, each tree would have needed at least two major cuts – one through the bottom of the trunk to fell the tree, and another through the top of the trunk to trim it to the right length. This is an estimate of how much harvesting time (rounded to the nearest hour) this may have taken:

9 'A' trees	=	9 x 4hrs x 2 cuts	=	72hrs
5 'A/B' trees	=	5 x 3.5hrs x 2 cuts	=	17hrs
19 'B' trees	=	19 x 3hrs x 2 cuts	=	114hrs
Coppice	=	4.5 x 23.25hrs	=	105hrs
Total time harvesting structural components =				308hrs

This represents, perhaps, four people chopping solidly for eight hours per day, for nine days. It also represents a harvest time per m^2 of usable floor space (240 m^2) of about one hour 15 minutes.

10 Neolithic Houses blog, <https://neolithichouses.wordpress.com/page/14/>.

Environmental implications of Neolithic houses

Added to this must be construction time, which included: split 56 planks; cut 70 posts to length; dig postholes. Early Neolithic timber houses represented a considerable investment in materials, time and energy, and contributed to a net loss of mature trees. The builders would have been forgiven for wondering if there might be a better way. However, Coles helpfully puts this into perspective: 'Norwich cathedral is estimated to have required almost 700 A/B trees. But an ordinary, large, three-decker ship of the line in the 17th century needed 3,500 A/B trees, from about 900 acres [364 ha] of woodland' (Coles, 1987: 57).

Late Neolithic houses

This section looks in detail at House 851, which was built by The Neolithic Houses Project (2012–2014), commissioned by English Heritage, and managed by the Ancient Technology Centre. The project generated quantitative data on building materials and processes based on the prototype phase at Old Sarum (Winter and Grigsby, 2015), and the work was carried out by English Heritage volunteers under the supervision of staff from the Ancient Technology Centre. A glossary to aid the reader with terms used in this section is in Appendix 1.

The archaeology at Durrington Walls indicated that the walls of the houses had been built with woven wattle, daubed with crushed chalk (mixed with water, and probably hay). The varying diameters of stake holes suggested a random mixture of materials, including, perhaps, pine for the sails. The spacing of the stake-holes suggested that the wall weavers may have been five-to seven-year-old hazel coppice. House 851 was sub-rectangular (curved corners) and approximately 5 m x 5 m. Its crushed chalk floor was approximately 2.5 m x 3.5 m, with a central, circular hearth. This implied that there could have been no central post to support the roof, which therefore must have been self-supporting. There was no other indication of the roof structure or materials used to cover it. Whilst no evidence of grain was found at the site, on the basis of pollen evidence in the wider landscape of domesticated cereal, it was decided that the roof would be thatched with wheat straw. The materials required to build House 851 included:

- 40 pine and hazel wall stakes (70–170 mm diam.)
- 500 hazel wall weavers (30–40 mm diam.)
- 50 wall binding weavers (10–20 mm diam.)
- 30 hazel rafter poles (50–70 mm diam.)
- 200 hazel purlins (10–30 mm diam.)
- 7,200 bundles of knotted straw (thatch)
- 11.6 tonnes of crushed chalk (floor and walls)
- One medium-sized tree, plus assorted hazel, willow and cord to make furniture

The archaeology offered no evidence of wall height or roof shape. However, there are few options for strong, self-supporting roofs and so the reconstruction of House 851 may have used only marginally more or less material than the original. In summary, then, the main material components needed to build one house amount to:

- 800 rods of coppice (or the yield of approx. 0.032 ha)
- 7,200 bundles of straw (or the yield from approx. 1.2 ha)
- 11.6 tonnes of chalk
- One medium-sized tree ('B')

Construction time for House 851

The figures for the time taken to build House 851 include harvesting the coppice and timber and completing the building (see Table 2.1). They do not include harvesting straw, digging chalk, or transporting materials to the site.

Table 2.1: Construction time for House 851

Construction Processes	Time taken hrs:mins
Harvesting structural components	23:25
Building walls	566:50
Building roof	379:12
Laying floor	50:18
Making furniture	99:00
TOTAL	1,218:45

The harvesting time (for structural components) per m² of useable floor space (25 m²) is about 55 minutes, which is a saving of about 25% in human energy and effort over House 5. The other advantage of House 851 over House 5 is that there are no postholes to dig, no large posts to cut, and very few planks to split. All that is needed is to hammer a few stakes into the ground and start weaving. In terms of its environmental implications, the reliance of this type of construction on coppice wood, rather than mature timber, produces a much more favourable Re/Con Ratio. The coppice takes no more than seven years to regenerate, but the houses would last 15–20 years (Winter and Grigsby, 2015:4), giving a Con/Reg Ratio of 7/15–20, or <1.

The project identified the most effective number of builders per house was four to six (any more than that get in each other's way), which assuming eight-hour working days gives a total construction time of 25–38 days. With more people, division of labour is possible, and some tasks might be carried out in parallel (e.g. harvesting and building). It seems likely that the original Neolithic housebuilders, given millennia of inherited experience and expertise, were much more effective than today's experimental archaeologists and English Heritage volunteers. Neolithic house-builders seem likely to have developed ways of working that suited their context and didn't need to 'go home' each evening. Once built, houses require maintenance, the extent of which depends on a number of factors, not least how well they were built in the first place, and the weather. We have no idea how Neolithic houses performed, but hopefully they were as good as, if not better than, the five Neolithic houses built by volunteers at the Stonehenge Visitor Centre. In 2015, annual maintenance amounted to approximately 14 days per house. This figure is made up of regular six days involving 1 ATC staff member and +/- six EH volunteers (42 days), plus 15 additional days 'to fix some of the major issues' involving two ATC staff members (30 days) – a total of 72 days (Grigsby, personal communication, 9 September 2015). This amounts to 350 days, or one full-time maintenance worker for every 25 houses.

Materials for 1,000 houses

The following quantities are based on data from the Neolithic Houses Project (Winter and Grigsby, 2015). Quantities of crushed chalk (daubing walls and making floors) are given by weight, in tonnes, whereas quantities of coppice (weaving walls and roof) and cereal straw (thatching) are given by area, in hectares. The figures for coppice (25,000 rods/ha) are based on post-Medieval crop yields (Harmer, 2004), and it is possible that Neolithic coppice and cereal growing may have been less efficient, and yielded less per hectare, which means that estimates of how much land was required may be conservative. The following figures simply multiply the data from House 851 by 1,000, which is

to assume that all the houses could be built simultaneously (I challenge this assumption in the next section). To aid some readers' conceptualisation of the areas of land involved, I have converted some figures from hectares into more recognisable units based on the dimensions of the Wembley Stadium football pitch and the Stonehenge Greater Cursus. Thus:

- 1 Wembley = 0.725 ha (7,250 m^2)
- 1 Cursus = 32 ha
- 1 Cursus = approx. 44 Wembleys

The quantities needed for 1,000 houses are:

- Coppice: 800 rods per house x 1,000 houses = 800,000 rods At 25,000 rods/ha this equates to the yield from 32 ha (1 Cursus, or 44 Wembleys)
- Straw: 1.2 ha per house x 1,000 houses = 1,200 ha (40 Cursuses, or 1,760 Wembleys)
- Crushed chalk – 11.6 tonnes per house (walls and floor) x 1,000 houses = 11,600 tonnes

To put the amount of chalk into context, the volume of the henge ditch at Stonehenge ditch is approximately 1,500 m^3 (Richards, 2007: 15). 1 m^3 of solid chalk weighs approximately 2.5 tonnes, and so the weight of excavated chalk was approx. 3,750 tonnes. Therefore, the amount of chalk needed for 1,000 houses is the equivalent of about three henge ditches. Hypothetically, if all 1,000 houses were built at once, the settlement at Durrington Walls would have required an area of land the size of one Cursus to be covered in coppice, and another area the size of 40 times Cursuses to be covered in cereal (wheat straw) for thatching. Whilst there may have been some managed woodland in the area, the likelihood of such large quantities of coppice being immediately available seems small. And 40 Cursuses of cereal bears little resemblance to the pollen record, and the fact that no grain was found at Durrington. If the settlement was built very quickly it would have been necessary to forage widely for material, and woodlands searched and stripped. Unmanaged woodland is far less productive than managed woodland. If, for example, the unmanaged woodland was only 10% as productive as managed woodland, then 320 ha (10 Cursuses / 440 Wembleys) of woodland would have been needed to produce the necessary amount of coppice. And if the landscape was only 50% wooded (as appears to have been the case in 3000 BC), then the necessary woodland material may have been spread over an area of 640 hectares (20 Cursuses / 880 Wembleys). To build 1,000 houses in one year would also require 415 English Heritage volunteers working eight-hour days, although as previously noted their Neolithic ancestors probably worked much more efficiently. For this amount of material, and this size of workforce, to be available all at once seems improbable. So how might the settlement at Durrington Walls have developed?

The settlement at Durrington Walls

This section explores alternative models for the development of the settlement and uses hypothetical timescales to estimate resource needs and their environmental implications. Parker Pearson's estimate of 500–1,000 houses, in conjunction with the unusually precise occupation dates (probably between 2500 BC and 2460 BC), raises logistical questions about resources. If this is where the builders of Stonehenge lived, it seems likely that the growth of the settlement reflected the needs of the monument's construction stages, which are likely to have included:

- planning and designing;
- finding and fetching the stones;

- shaping the stones and digging the holes;
- erecting the stones.

The first stage would have needed only a few people, but the second stage would have required teams of up to 200 people to move the large stones (Richards, 2007: 205). However, they would have spent most of their time away from Stonehenge, turning up briefly to deliver a stone and have a rest, before setting off to fetch another one. It is only during stages three and four that large numbers of people would have spent any length of time 'on site'. Nearly 80 pieces of stone amounting to over 1,000 tonnes needed to be shaped using Sarsen stone hammers. Some stones weighed up to 60 tonnes, and were reduced to about 40 tonnes, as demonstrated by the shape of Stone 55, the fallen upright of the Great Trilithon (Richards, 2007: 194–214).

There was a lot going on in the Stonehenge landscape in the middle of the third millennium BC. Remarkably similar carbon dates indicate that, in addition to the construction of Stonehenge Phase 2, this period also included the building of the Stonehenge Avenue (2505–2465 cal BC) and Phase 2 of the Southern Circle (2490–2460 cal BC) (Parker Pearson, 2012: 110). And around the Durrington Walls settlement as many as 300 large wooden posts were erected, evenly spaced 5 m apart in a ring almost 450 m across. But within 50 years the timbers were removed, the postholes filled in and covered by the henge bank, which also covered the remains of some Neolithic houses. All of this activity supports the case for a large settlement and its contribution to changes in the landscape (Neubauer and Gaffney, 2015).[11]

Models for the development of the settlement

The data from the Neolithic Houses Project shows an overall construction time of about 1,200 hours, and therefore a group of about five builders working eight-hour days would take about 30 days (or one month) to build one House 851. Theoretically, then, they could build about 10 houses per year and 1,000 houses in about 100 years. But the carbon dates indicated that the settlement was occupied for only 40 years, so there must have been considerably more than five builders.

It seems more likely that the settlement grew incrementally. It could have grown slowly, at perhaps 50 houses per year, or it may have grown more quickly, at perhaps 200 houses per year. But if this was where the builders of Stonehenge lived, it seems more likely that the rate of growth of the settlement was driven by the labour requirements of each phase of the project.

Table 2.2 sets out some models of how the settlement may have grown to a maximum of 1,000 houses over periods of five, 10 or 20 years, and how many builders this may have taken. Each builder group consists of five people, and each group can build 10 houses per year:

Table 2.2: Models for the growth of the Durrington Walls settlement

Model	Years of growth	Houses/year	Builder groups	Total builders
1	5	200	20	100
2	10	100	10	50
3	20	50	5	25

I now consider each of these models in more detail. Once built, the houses would also have needed regular maintenance. Daub and thatch would need to be patched, roofs re-thatched after about five years, and after about 15 years the whole house would need to be rebuilt (Winter and Grigsby, 2015:4).

11 Neubauer and Gafney, press release, 7 September 2015, <http://lbiarchpro.org/cs/stonehenge/durringtonwalls.html>.

Environmental implications of Neolithic houses

If the settlement was occupied periodically, rather than permanently, the length of time during which houses were unoccupied would also have had a bearing on dilapidation. Using the basis of the English Heritage maintenance contract for the Neolithic houses at the Stonehenge Visitor Centre, I have allocated two full-time maintenance workers per 50 houses, which is the equivalent of about 40 people engaged full-time in maintaining a settlement of up to 1,000 houses. How much material was needed to maintain each house per year is probably unknowable, but the Neolithic houses at the Stonehenge Visitor Centre should provide some idea over the coming years. In the meantime, an estimate of 1% of the fabric of each house to be replaced annually has been allowed. This would suggest that the material needed annually for maintaining 100 houses would be the same as for building one House 851. However, it seems more likely that the main materials needed are thatch and daub. Chalk can be obtained at any time, but thatch can only be harvested at certain times of the year and needs to be stored.

Model 1: 200 houses per year for five years

This model requires an initial group of 100 house-builders, and as the settlement grows so too does the need for maintenance. The settlement reaches its maximum size of 1,000 houses in year six, and this number is maintained for a further 34 years before the settlement is abandoned or demolished. Houses need to be re-built after 15 years.

Key to Table 2.3, 2.4 and 2.5
b = builder
m = maintenance worker
x = amount of material needed to build one House 851 (see above)

Table 2.3: Model 1 – labour and material needs of building 200 houses per year

Years of settlement duration	Houses to build/re-build	Total houses	Houses to maintain	Builders and maintenance workers	Total workforce	Building + maintenance materials
1	200	0	0	100b	100	200x
2	200	200	200	100b+8m	108	200x+2x
3	200	400	400	100b+16m	116	200x+4x
4	200	600	600	100b+24m	124	200x+6x
5	200	800	800	100b+32m	132	200x+8x
6–15	0	1,000	1,000	40m	40	10x
16–20	200	1,000	800	100b+32m	132	200x+8x
21–25	0	1,000	1,000	40m	40	10x
26–30	200	1,000	800	100b+32m	132	200x+8x
31–35	0	1,000	1,000	40m	40	10x
36–40	200	1,000	800	100b+32m	132	200x+8x

LABOUR AND MATERIAL NEEDS

The total labour force increases from 100 to 132 by year five. It then drops to 40 for the next nine years, during which only maintenance is required. But from year 16 the whole building process needs to be repeated, with up to 200 houses needing to be re-built each year, and repairs being carried out on the remaining 800. This requires the labour force to increase from 40 to 132. During the period of the settlement the process of building/re-building may need to be carried out four times. During building the annual material needs rise to a maximum of 208 times those of House 851.

ENVIRONMENTAL IMPLICATIONS

As previously noted, the material needs of House 851 ('x') amounted to 800 rods (0.03 ha of managed coppice), 7,200 bundles of straw (1.2 ha of domesticated cereal), 11.6 tonnes of chalk and one 'B' tree. Therefore, the maximum annual needs would be:

- Coppice: 0.03 ha x 208 = 6.24 ha (8.6 Wembleys)
- Straw: 1.2 ha x 208 = 249.6 ha (7.8 Cursuses)
- Chalk : 11.6 tonnes x 208 = 2,412 tonnes
- Trees: 200 'B'

- Coppice: supplies of suitable coppice would be problematic. Assuming a minimum five-year rotation, five areas of 6.24 ha, making a total of 31.2 ha (approximately 1 Cursus, or 43 Wembleys) of managed coppice would be required, or possibly 10 times this area being stripped of usable material.
- Straw: about 250 ha would need to be under cultivation. Whilst the number of arable plots doubles from 15 to 28 between 3000 BC and 2300 BC, Richards (2007: 155) shows only two near Durrington Walls. Assuming all were cereal, all 28 plots amount to barely the area of one Cursus, or one eighth of what was needed. Therefore, cereal straw seems unlikely to have been the main thatching material. The other options included reed, sedge and grass.
- Chalk:supplies of chalk were unlimited.
- Trees: the renewal of 'B' trees takes around 100 years, depending on species, so there could be no renewal within the time frame of the settlement. A total of 1,000 'B' trees would need to be felled. According to Coles' estimate (30.3 m^2 of woodland per tree) 1,000 trees might be found within an area of 3 ha of woodland. However, as previously noted, if the woodland was being managed efficiently (for both coppice and wildlife), this could have been much higher higher, or 12–33 ha.

Summary: the intense, repetitive nature of Model 1 sees large quantities of material being needed for relatively short periods, which is not compatible with the gradual development of woodland management, and therefore the impact on existing unmanaged woodland would have been severe. It is likely that reed, sedge and grass were used for thatching.

Model 2: 100 houses per year for 10 years

This model requires an initial group of 50 house-builders, and as the settlement grows so too does the need for maintenance. The settlement reaches its maximum size of 1,000 houses in year11, and this number is maintained for a further 29 years before the settlement is abandoned or demolished. Houses begin to be re-built after 15 years.

Table 2.4: Model 2 – labour and material needs of building 100 houses per year

Years of settlement duration	Houses to build/ re-build	Total houses	Houses to maintain	Builders and maintenance workers	Total workforce	Building + maintenance materials
1	100	0	0	50b	50	100x
2	100	100	100	50b+4m	54	100x+1x
3	100	200	200	50b+8m	58	100x+2x
4	100	300	300	50b+12m	62	100x+3x
5	100	400	400	50b+16m	66	100x+4x
6	100	500	500	50b+20m	70	100x+5x
7	100	600	600	50b+24m	74	100x+6x
8	100	700	700	50b+28m	78	100x+7x

9	100	800	800	50b+32m	82	100x+8y
10	100	900	900	50b+36m	86	100x+9x
11	100	1000	900	50b+36m	86	100x+9x
12	0	1000	1000	40m	40	10x
13	0	1000	1000	40m	40	10x
14	0	1000	1000	40m	40	10x
15	0	1000	1000	40m	40	10x
16	100	1000	900	50b+36m	86	100x+9x
17–40	ditto	ditto	ditto	ditto	ditto	ditto

LABOUR AND MATERIAL NEEDS

In Model 2, the labour force increases from 50 to 86 by year 11. The work force reduces to 40 maintenance workers from year 12 to year 16 when, if the settlement is to be maintained, up to 100 houses may need to be replaced each year, and repairs carried out on the remaining 900 houses. The annual material needs rise over the first 11 years to a peak of 109 times the needs of House 851. After a four-year maintenance period, they resume at the maximum level for the next 25 years.

ENVIRONMENTAL IMPLICATIONS

Based on the quantities for House 851, the maximum annual needs would be:

- Coppice: 0.03 ha x 109 = 3.27 ha (4.5 Wembleys)
- Straw: 1.2 ha x 109 = 130.8 ha (4 Cursuses)
- Chalk: 11.6 tonnes x 109 = 1,264.4 tonnes
- Trees: 109 'B'

- Coppice: providing enough supplies of coppice would be problematic. Five areas of 3.27 ha, making 16.3 ha (22.5 Wembleys), of managed coppice would be needed, or possibly 10 times this area of woodland being stripped of usable material.
- Straw: supplies of cereal straw (130.8 ha, or four Cursuses) are also problematic, being only about a quarter of what was needed. Alternatives would be needed for thatching.
- Chalk: Supplies of chalk are unlimited.
- Trees: again, there could be no renewal of trees within the time frame of the settlement. A total of 1,000 'B' trees would need to be felled in the first 10 years. These may have been spread over 12–33 ha of woodland.

Summary: Model 2 would have less initial impact on existing unmanaged woodland than Model 1, and new areas of coppice could be developed over the first 15 years to support the rebuilding and maintenance programme from year 16. Again, it seems likely that straw could only have played a small part in thatching, alongside reed, sedge and grass.

Model 3: 50 houses per year for 20 years

This model initially requires a group of 25 builders. As the settlement grows, so too does the amount of maintenance required. Houses begin to be re-built after 15 years. The settlement peaks at 20 years and is maintained for a further 20 years before being demolished or abandoned.

Table 2.5: Model 3 – labour and material needs of building 50 houses per year

Years of settlement duration	Houses to build/ re-build	Total houses	Houses to maintain	Builders and maintenance workers	Total workforce	Building + maintenance materials
1	50	0	0	25b	25	50x
2	50	50	50	25b+2m	27	50x+0.5x
3	50	100	100	25b+4m	29	50x+1x
4	50	150	150	25b+6m	31	50x+1.5x
5	50	200	200	25b+8m	33	50x+2x
6	50	250	250	25b+10m	35	50x+2.5x
7	50	300	300	25b+12m	37	50x+3x
8	50	350	350	25b+14m	39	50x+3.5
9	50	400	400	25b+16m	41	50x+4x
10	50	450	450	25b+18m	43	50x+4.5
11	50	500	500	25b+20m	45	50x+5x
12	50	550	550	25b+22m	47	50x+5.5x
13	50	600	600	25b+24m	49	50x+6x
14	50	650	650	25b+26m	51	50x+6.5x
15	50	700	700	25b+28m	53	50x+7x
16	100	750	750	50b+30m	80	100x+7.5x
17	100	800	800	50b+32m	82	100x+8x
18	100	850	850	50b+34m	84	100x+8.5x
19	100	900	900	50b+36m	86	100x+9x
20	100	950	950	50b+38m	88	100x+9.5x
21–30	50	1000	950	25b+38m	63	50x+9.5x
31–36	100	1000	900	50b+36m	86	100x+9x
37–40	50	1000	950	25b+38m	63	50x+9.5x

LABOUR AND MATERIAL NEEDS

In Model 3 the labour force rises gradually to 53 in year 15 but increases suddenly in year 16 to 80 people. This is because, in addition to the continuing need to build 50 new houses each year (to reach a total of 1,000), the houses built in year one are now 15 years old and need to be rebuilt, thus doubling the work. The workforce rises to 88 by year 20, and then drops to 63 after the settlement peaks in year 21. For the next nine years, 50 houses per year need to be re-built, and repairs need to be carried out on the remaining 950. By year 30, the 100 houses built/rebuilt in year 16 will now be 15 years old and will need to be replaced. The renewal rate of 100 houses per year continues for the next five years, almost to the end of the settlement period. The annual material needs of Model 3 rise to a maximum of 109.5 times the needs of House 851, which is little different from Model 2.

ENVIRONMENTAL IMPLICATIONS

As previously noted, House 851 required 0.03 ha of coppice, 1.2 ha of cereal straw, 11.6 tonnes of chalk and one 'B' tree. Therefore, the maximum annual needs would be:

- Coppice: 0.03 ha x 109.5 = 3.2 ha (4.5 Wembleys)
- Straw: 1.2 ha x 109.5 = 131 ha (4 Cursuses)

- Chalk: 11.6 tonnes x 109.5 = 1,270.2 tonnes
- Trees: 109 'B'

- Coppice: assuming a minimum five-year rotation, five areas of 3.2 ha, making a total of 16 ha (approximately half a Cursus, or 22 Wembleys) of managed coppice would be required, or possibly 10 times this area of unmanaged woodland being stripped of usable material.
- Straw: about 130 ha (4 Cursuses) would need to be under cultivation, which is still four times more than what appears to have been the case. Again, cereal straw cannot have been the main thatching material.
- Chalk: supplies of chalk were unlimited.
- Trees: A total of 1,000 'B' trees would need to be felled. These may have been spread over 12–33 ha of woodland.

Overview

Whilst the maximum material needs of Model 3 are similar to those of Model 2, Model 3's much slower growth considerably reduces the initial demand for coppice and straw, thus giving more time for larger crop areas to be developed. This is more consistent with the gradual development of woodland management and arable farming, but Model 3 fits less well with the idea of the settlement being built quickly to suit the purposes of large-scale monument building. All three models suggest that domesticated cereal straw can only have amounted to a small proportion of the overall thatching materials needed.

Conclusions

The literature indicates that co-evolution of Britain's arboreal landscape in the Mesolithic and the Neolithic created a varied environment with declining woodland cover. The growth of farming and, perhaps, a later return to mobile pastoralism, further reduced woodland cover. In the Stonehenge landscape, from 3000 BC to 2300 BC, woodland cover declined from 50% to 10%, and pine may have been managed for monument building. Woodland management and hurdle weaving date to the earliest Neolithic. Evidence from the Somerset Levels suggests that, where there was insufficient coppice material for a large project, a wide area of woodland may have been felled, or stripped of its upper branches.

Early Neolithic longhouses were timber-framed structures, depending for their stability on substantial posts set deep into holes. Late Neolithic houses were much less substantial and have been described as flimsy and temporary. The changes may have been brought about by shortages of large timber, the labour involved in obtaining it, and increasing availability of lighter materials, such as hazel coppice, which also provided food crops. Architectural development does not move consistently towards larger and more solid buildings. Early and Late Neolithic houses have been reconstructed at open air museums, and evidence from Durrington Walls has been used to reconstruct Neolithic houses at the Stonehenge visitor centre. All reconstructions are conjectural, and most learning takes place during construction and maintenance.

The estimated size of the settlement at Durrington Walls would make it the largest settlement in northern Europe. It would have required a large workforce, large quantities of materials, and would have made a substantial impact on the surrounding landscape.

Tradition guides the making of buildings, which, in turn, influence the ways in which people live. When buildings work well there is little motivation to build differently. But weight of tradition can also hinder adaptation and contribute to societal collapse. Sustainability is not some form of static paradise, but rather the capacity of human beings to continuously adapt in response to wider environmental change.

Environmental implications of Early Neolithic and Late Neolithic houses

Early Neolithic houses had a Con/Reg Ratio >1, i.e they consumed natural resources (in this case, large trees) at a faster rate than they could regenerate. This was unsustainable, and would have played a part, along with the construction of large timber monuments and forest clearances for farming, in the net loss of mature trees and the opening up of the landscape. By contrast, Late Neolithic houses (certainly those found at Durrington Walls) had a Con/Reg Ratio <1, that is, the regeneration rate of the natural resources consumed (in this case, coppice) was faster than the rate at which it was consumed. The construction of Early Neolithic houses was based on environmental degradation, whereas the construction of Late Neolithic houses was based on sustainable environmental management. Coppicing is a form of farming within which the farmer chooses when to harvest, depending on the use to which the crop is to be put. It encourages the re-growth of trees and woodland, and, if done well, has benefits for wildlife. In the case of hazel, it also produces a useful food crop. The change from Early Neolithic to Late Neolithic house design may be an example of sustainability in action.

Domesticated cereal straw was unlikely to have been a significant thatching material, therefore other materials, such as reed, sedge or grass, must also have been used. Given the difficulties of protecting large areas of grass from grazing fauna, it seems likely that reed and sedge were the main thatching materials. The stake-hole evidence suggesting that a variety of materials was being used for sails, such as the tops of pine trees, would be consistent with unmanaged woodland being stripped of useable material in the absence of sufficient managed coppice. Further experimental archaeological work in relation to House 851 might explore the environmental implications of using materials which only come from unmanaged woodland, rather than from managed coppice, and the use of reed or sedge from the River Avon valley.

Environmental implications of the Durrington Walls settlement

The estimate of 500–1,000 houses is possible within the 40-year time-frame. House-building would have been a virtually full-time activity for 25–130 people, and the growing, managing, harvesting and transporting of large quantities of materials would have occupied many more. Models suggest that rapid growth, where the settlement bursts into life in response to the building of a Stonehenge, would have had a dramatic impact on surrounding unmanaged woodland. Slow growth of the settlement would be more consistent with the development of managed coppice, but it seems highly unlikely that sufficient domesticated cereal was being grown to make straw the main thatching material.

A lot was happening in this landscape in the middle of the third millennium BC. At some time between 3000 BC and 2300 BC woodland cover declined from 50% to 10%, and major soil and vegetation changes took place from c.2850 BC onwards. The carbon dates for the Durrington Walls settlement coincide with those for the building of the Southern Circle, Stonehenge Phase 2 and the Avenue, and the erection of a huge circle of 300 wooden posts around the settlement at Durrington Walls.

If the settlement grew gradually, over a period of 20 years, it would be possible to establish new areas of coppice to meet its maximum consumption requirements. However, if it grew quickly, over a period of five years, it would be impossible to create new areas of coppice, and each year, for five

years, an area of up to 10 Cursuses (430 Wembleys) of unmanaged woodland would need to be felled or stripped of upper branches. This would not re-grow in time for the following year, and therefore an area of woodland equivalent to 50 Cursuses may have been destroyed. This process would also have provided timbers for construction purposes, and firewood. This is consistent with the decline of woodland cover from 50% to 10%, and it seems likely that much of this took place during the occupation dates of the settlement, between 2500 BC and 2460 BC.

It also seems likely that new areas of coppice were created, probably along the sheltered sides of the River Avon valley, and that reed and sedge were harvested annually along the river corridor for thatching. Pine may also have been managed for monument building. As well as thinking about the ancestors, this requires thinking about the needs of future generations: planting coppice is thinking 10 years ahead; planting pine is thinking 50–100 years ahead. Whether deliberate or accidental, the opening up of the chalk downland around Stonehenge reached a point where a holistic, sacred landscape emerged. And if the plan was for Stonehenge, and other monuments, to sit in a wide-open landscape, to be admired from every horizon, and for there to be space for hundreds of Early Bronze Age burial mounds, then it could hardly have been a more successful marriage of policy and practice.

Bibliography

Allen, M. J. (1997). 'Environment and land-use: the economic development of the communities who built Stonehenge (an economy to support the stones)', *Proceedings of the British Academy*, 92, 115–144.

Barclay, G. (1996). 'Neolithic buildings in Scotland', in Darvill, T., and Thomas, J. (eds), *Neolithic houses in Northwest Europe and beyond*, Neolithic Studies Group Seminar Papers 1. Oxford: Oxbow.

Beneša, J., Vondrovskýa, V., Kovačikováa, L., Šídab, P., and Divišováa, M. (2014). 'Decoding the Neolithic Building Complex: the Case of the Extraordinarily Large House III from Hrdlovka, Czech Republic', *Interdisciplinaria Archaeologica*, 5, 2. <http://www.iansa.eu>, accessed 29 July 2015.

Bickle, P. (2008). 'Life and death of the longhouse: daily life during and after the early Neolithic in the river valleys of the Paris basin.' Unpublished doctoral thesis, Cardiff University. <http://orca.cf.ac.uk/54344/1/U584326.pdf>.

Bishop, R., Church, M., and Rowley-Conwy, P. (2015). 'Firewood, food and human niche construction: the potential role of Mesolithic hunter-gatherers in actively structuring Scotland's woodlands'. *Quaternary Science Reviews*, 108, 51.

Boyd, W. (1988). 'Methodological problems in the analysis of fossil non-artifactual wood assemblages from archaeological sites.' *Journal of Archaeological Science*, 15(6), 603–619.

Bradley, R. (2007). *The Prehistory of Britain and Ireland*. Cambridge: Cambridge University Press.

Brand, S. (1995), *How Buildings Learn, What Happens after they're Built*. New York: Penguin.

Bunting, M. J. (1994). 'Vegetation history of Orkney, Scotland; pollen records from two small basins in west Mainland', *New Phytologist*, 128 (4), 771–792.

Burl, A. (2006). *Stonehenge, A New History of the World's Greatest Stone Circle*. London: Constable and Robinson.

Butt, A. J. (1961). 'Symbolism and ritual among the Akawaio of British Guiana', *Nieuwe West-Indische Gids/New West Indian Guide*, 41, 141–161.

Carsten, J., and Hugh-Jones, S. (eds) (1995). *About the House: Levi-Strauss and Beyond*. Cambridge: Cambridge University Press.

Canti, M., Campbell, G., and Greaney, S. (eds) (2013). *Stonehenge World Heritage Site Synthesis: Prehistoric Landscape, Environment and Economy*. Research Report Series No 45. English Heritage. <http://services.english-heritage.org.uk/ResearchReportsPdfs/045_2013WEB.pdf>.

Castledine, A. (1990). *Environmental Archaeology in Wales*. Cadw Welsh Historical Monuments and Department of Archaeology, St David's University College, Lampeter.

Chapman, J. (2000). *Fragmentation in Archaeology: People, Places, and Broken Objects*. London: Routledge.

Children, G., and Nash, G. (2008). *Neolithic Sites of Cardiganshire, Carmarthenshire and Pembrokeshire*. Glasgow: Logaston Press.

Clarke, D. (2012). *Skara Brae: the Official Souvenir Guide*. Historic Scotland.

Coles, J. (1987). 'Ancient wood, woodworking and wooden houses'. Paper presented at a workshop on 'The reconstruction of wooden buildings from the prehistoric and early period', Aarhus, Denmark, May 1987. Re-published in *EuroREA, Journal of (Re)construction and Experiment in Archaeology*, 3 (2006), 50–57.

Coles, J., Heal, V., and Orme, B. (1978). 'The Use and Character of Wood in Prehistoric Britain', *Proceedings of the Prehistoric Society*, 44, 1–45.

Council, Salisbury District (2006). *A guide to achieving high quality design in new development*. <http://www.wiltshire.gov.uk/creating-places-design-guide-spg-adopted-april-2006.pdf>.

Craig, O., Shillito, L-M., Albarella, U., Viner, S., Chan, B., Cleal, R., Ixer, R., Marshall, P., Simmons, E., Wright, E., and Pearson, M. P. (forthcoming). *Feeding Stonehenge: cuisine and consumption at the Late Neolithic site of Durrington Walls*.

Cummings, V., and Whittle, A. (2003). 'Tombs with a view: landscape, monuments and trees', *Antiquity*, 77(296), 255–266.

Cunliffe, B. (1993). *Wessex to A. D. 1000*. New York: Longman.

Cunliffe, B. (2006). *England's Landscape: The West*. English Heritage. London: Collins.

Cunliffe, B. (2011). *Europe Between the Oceans, 9000 BC-AD 1000*. New Haven, CT and London: Yale University Press.

Cunliffe, B. (2012). *Britain Begins*. Oxford: Oxford University Press.

Darvill, T. (1996). 'Neolithic buildings in England', in Darvill, T., and Thomas, J. (eds), *Neolithic houses in Northwest Europe and beyond*. Neolithic Studies Group Seminar Papers 1. Oxford: Oxbow.

Darvill, T. (2006). *Stonehenge. The Biography of a Landscape*. Stroud: The History Press.

Darvill, T., and Thomas, J. (eds) (1996). *Neolithic houses in Northwest Europe and beyond*. Neolithic Studies Group Seminar Papers 1. Oxford: Oxbow.

Davies, S. (2009). 'Location, Location, Location: A landscape-based study of early Neolithic longhouses in Britain', *Rosetta* 7, 57–101.

Debert, J. (2013). 'Looking through the glass', in Larsson, M., and Debert, J. (eds), *NW Europe in Transition*. Oxford: Archeopress.

DEFRA (Department for the Environment, Food and Rural Affairs) (2011). *Working with the grain of Nature: a biodiversity strategy for England*. London: Defra Publications.

Diamond, J. (2005). *Collapse: How Societies Choose to Fail or Survive*. London: Penguin.

Drew, P. (2001). *Touch this earth lightly: Glenn Murcutt in his own words*. Duffy and Snellgrove.

Edmonds, M. (1999). *Ancestral Geographies of the Neolithic, Landscapes, Monuments and Memory*. London: Routledge.

ESREA (European Society for Research on the Education of Adults) Conference (2006). *Transitional Spaces, Transitional Processes and Research*. Volos, Greece, 2–5 March. <http://esrea2006.ece.uth.gr/en/local.php>.

Fairweather, A., and Ralston, I. (1993). 'The Neolithic Timber Hall at Balbridie', *Antiquity*, 67, 313–323.

Farrell, M., Bunting, M., Lee, D., and Thomas, A. (2014). 'Neolithic settlement at the woodland's edge: palynological data and timber architecture in Orkney, Scotland', *Journal of Archaeological Science*, 51, 225–236.

Fenech, K., Schembri, J., and Vella, N. (2015). *Taken by storm? Scientific investigations into Malta's past environment*. FRAGSUS Project, University of Malta. <http://fragsusuom.weebly.com/scientific-investigations-into-maltarsquos-past-environment.html>.

Flores, J. R., and Paardekooper, R. (eds) (2014). *Experiments Past: Histories of Experimental Archaeology*. Leiden: Sidestone Press.

French, C., Scaife, R., Allen, M. J., Parker Pearson, M., Pollard, J., Richards, C., Thomas, J., and Welham, K. (2012). 'Durrington Walls to West Amesbury by way of Stonehenge: a major transformation of the Holocene landscape', *The Antiquaries Journal*, 92, 1–36.

Fuller, R., and Warren, M. (1993). *Coppiced woodlands: their management for wildlife*. Joint Nature Conservation Committee.

Gibson, A. (1996). 'The later Neolithic structures at Trelystan, Powys, Wales: Ten years on', in Darvill, T., and Thomas, J. (eds). *Neolithic houses in Northwest Europe and beyond*. Neolithic Studies Group Seminar Papers 1. Oxford: Oxbow.

Green, C. (forthcoming). 'Borehole S2BH2 (Site 2)'.

Green, M. (2000). *A Landscape Revealed: 10,000 Years on a Chalkland Farm*. Stroud: Tempus.

Grigsby, P. (2015). 'The Demands of the Neolithic Houses at Durrington Walls: Time, Resources and Landscape', Ancient Technology Centre, Cranborne, Dorset. Poster presentation, Experimental Archaeology Conference, University College Dublin and Irish National Heritage Park, 16–18 January 2015.

Hamm, B., and Muttagi, P. K. (eds). (1998). *Sustainable development and the future of cities*. London: Intermediate Technology Publications.

Hansen, H.-O. (2014). 'Experience and experiment', in Flores, J. R., and Paardekooper, R. (eds). *Experiments past: Histories of Experimental Archaeology*. Leiden: Sidestone Press.

Harmer, R. (1995). *Management of Coppice Stools*, Research Information Note 259, Forestry Authority, Research Division, Farnham. <http://www.forestry.gov.uk/pdf/rin259.pdf/$FILE/rin259.pdf>.

Harmer, R. (2004). *Restoration of Neglected Hazel Coppice*. Information Note, Forestry Commission, Edinburgh. <http://www.forestry.gov.uk/pdf/fcin056.pdf/$FILE/fcin056.pdf>.

Hedges, J. W. (1984). *Tomb of the Eagles: Death and Life in a Stone Age Tribe*. New York: New Amsterdam.

Hillam, J., Groves, C. M., Brown, D. M., Baillie, M. G. L., Coles, J. M., and Coles, B. J. (1990). 'Dendrochronology of the English Neolithic', *Antiquity*, 64 (243), 210–220.

Hodder, I. (1994). 'Architecture and meaning: the example of Neolithic houses and tombs', in Parker Pearson, M., and Richards, C. (eds), *Architecture and Order. Approaches to Social Space*. London: Routledge, 73–86.

Hofmann, D., and Smythe, J. (eds) (2013). *Tracking the Neolithic House in Europe, Sedentism, Architecure and Practice*. One World Archaeology. New York: Springer.

Hoskins, W. G. (1988) (with additional material by Christopher Taylor). *The Making of the English Landscape*. London: Hodder and Stoughton.

Hourigan, N. (2015). 'Confronting Classifications – When and What is Vernacular Architecture?', *Civil Engineering and Architecture*, 3(1): 22–30.

Hugh-Jones, S. (1995). 'Inside out and back to front: the androgynous house in northwest Amazonia', in Carsten, J., and Hugh-Jones, S. (eds), *About the house: Levi Strauss and beyond*. Cambridge: Cambridge University Press.

Huntley, B., and Birks, H. (1983). *An atlas of past and present pollen maps for Europe: 0–13000 years ago*. Cambridge: Cambridge University Press.

Ishimura, T. (2007). *Report of the archaeological excavations at the Wakakusa Garan, the Horyuji temple in 1968 and 1969*. Nara National Research Institute for Cultural Properties Repository. <http://hdl.handle.net/11177/958>, <http://repository.nabunken.go.jp/dspace/bitstream/11177/958/1/BA85661343_251_253.pdf>.

Jacques, D., and Phillips, T., with contributions from Hoare, P., Bishop, B., Legge, T., and Parfitt, S. (2014). 'Mesolithic settlement near Stonehenge: excavations at Blick Mead, Vespasian's Camp, Amesbury', *Wiltshire Archaeological and Natural History Magazine*, 107, 7–27.

Larsson, M., and Debert, J. (eds) (2013). *NW Europe in Transition*. Oxford: Archaeopress.

Last, J. (2013). 'The end of the longhouse', in Hofmann, D., and Smyth, J. (eds), *Tracking the Neolithic House in Europe, Sedentism, Architecture and Practice*. One World Archeology. New York: Springer.

Lawson, A. J. (2007). *Chalkland: An Archaeology of Stonehenge and its Region*. Salisbury: Hobnob Press.

Lobisser, W. (2006). 'Construction of a circular ditch system and houses of the middle Neolithic', *EuroREA Journal of (Re)construction and Experiment in Archaeology*, 3, 11–15.

Lynch, G. (1993). *Brickwork: Historic Development, Decay, Conservation and Repair*. The Building Conservation Directory. Tisbury: Cathedral Communications.

Macdonald, E. (n.d.). 'Sustainable Management of the Scots Pine in the Northern Periphery', Silvicultural Guidance Note 1 – Species Overview. Forest Research. <http://www.pineinfo.eu/userfiles/file/guidancenotes/speciesoverview.pdf>.

Malone, C. (2001). *Neolithic Britain and Ireland*. Stroud: The History Press.

Mellars, P. (1976). 'Fire ecology, animal populations and man: a study of some ecological relationships in prehistory', Proceedings of the Prehistoric Society, 42, 15–45.

Moore-Colyer, R. J. (1996). 'Agriculture in Wales before and during the Second Millennium BC', *Archaeologia Cambrensis*, CXLV, 15–33.

Muir, R. (2000). *The New Reading the Landscape: Fieldwork in Landscape History*. Exeter: University of Exeter Press.

Murray, H. (2004). 'Third Neolithic longhouse found in Scotland', *British Archaeology*, 78, 6.

Orme, B., and Coles, J. (1985). 'Prehistoric woodworking from the Somerset Levels: 2. Species selection and prehistoric woodlands', *Somerset Levels Papers*, 11, 7–24.

Parker Pearson, M., Pollard, J., Richards, C., Thomas, J., Tilley, C., Welham, K., and Ruggles, C. (2006). *The Stonehenge Riverside Project: Summary interim report on the 2006 season*.

Parker Pearson, M. (2012). *Stonehenge: exploring the greatest Stone Age mystery*. London: Simon and Schuster.

Parker Pearson, M. (2013). 'Researching Stonehenge: Theories Past and Present', *Archaeology International*, 16, 72–83.

Parker Pearson, M., et al. (2008). 'The Stonehenge Riverside Project: exploring the Neolithic landscape of Stonehenge', *Documenta Praehistorica* XXXV, 159- 160. <http://arheologija.ff.uni-lj.si/documenta/pdf35/thomas35.pdf>.

Pennington, W. (1986). 'Lags in adjustment of vegetation to climate caused by the pace of soil development. Evidence from Britain'. *Vegetatio*, 67(2), 105–118.

Pyzel, J. (2013a) 'Change and continuity in the Danubian longhouses of lowland Poland', in Jofmann, D., and Smyth, J. (eds) *Tracking the Neolithic House in Europe: Sedentism, Architecture and Practice*. One World Archeology. New York: Springer.

Pyzel, J. (2013b). 'Afterlife of Early Neolithic houses in the Polish lowlands', *Past Horizons, adventures in archaeology*. <http://www.pasthorizonspr.com/index.php/archives/03/2013/>, accessed 25 May 2015.

Rackham, O. (2003). *The Illustrated History of the Countryside*. London: Weidenfeld and Nicolson.

Ralston, I. (1982). 'A Timber Hall at Balbridie Farm', *Aberdeen University Review*, 168, 238–249.

Renfrew, C. (1973). *Monuments, mobilization and social organization in Neolithic Wessex*. London: Duckworth.

Renfrew, C., and Bahn, P. G. (2000). *Archaeology: theories, methods and practice*. London: Thames and Hudson.

Reynolds, P. (1987). 'The scientific basis for the reconstruction of prehistoric and protohistoric houses', *EuroREA, Journal of (Re)construction and Experiment in Archaeology*, 3.

Richards, J. (2007). *Stonehenge: The Story So Far*. Swindon: English Heritage.

Richards, J. C., and Allen, M. (1990). *The Stonehenge Environs Project (HBMCE Archaeological Report 16*. London: English Heritage.

Richmond, A. (1999). *Preferred Economies*. Oxford: BAR British Series 290.

Rowley-Conwy, P., and Owen, A. (2011). 'Grooved ware feasting in Yorkshire: Late Neolithic Animal Consumption at Rudston Wold', *Oxford Journal of Archaeology* 30(4), 325–367.

Royal Commission on Historical Monuments (England) (1979). *Stonehenge and its Environs: Monuments and Land Use*. Edinburgh: Edinburgh University Press.

Scott, W., and Gough, S. (eds) (2004). *Key issues in sustainable development and learning: a critical review*. London: Routledge Falmer.

Serjeantson, D. (2014). 'Survey of animal remains from southern Britain finds no evidence for continuity from the Mesolithic period', *Environmental Archaeology*, 19(3), 256–262.

Shire, D., and Martin, K. (n.d.). 'The Oaks of the Blean', Blean Heritage and Community Group. <http://www.theblean.co.uk/wp-content/uploads/2011/02/Oak.pdf>.

Simpson, D. (1996). 'Ballygalley houses, Co. Antrim, Ireland', in Darvill, T., and Thomas, J. (eds). *Neolithic houses in Northwest Europe and beyond*. Neolithic Studies Group Seminar Papers 1. Oxford: Oxbow.

Smyth, J. (2013). 'Tides of change? The house through the Irish Neolithic', in Hofmann, D., and Smyth, J. (eds). *Tracking the Neolithic House in Europe: Sedentism, Architecture and Practice*. One World Archeology. New York: Springer.

Startin, W. (1978). 'Linear Pottery Culture Houses: Reconstruction and Manpower', *Proceedings of the Prehistoric Society*, 44, 143–159.

Stevens, C. J., and Fuller, D. Q. (2012). 'Did Neolithic farming fail? The case for a Bronze Age agricultural revolution in the British Isles', *Antiquity*, 86 (333) 707–722.

Storm-Clifton, B. (2014). 'It's Getting Hot in Here: living conditions in a Neolithic building reconstruction'. Poster – 9th Experimental Archaeology Conference, University College Dublin.

Svenning, J.-C. (2002). 'A review of natural vegetation openness in north-western Europe', *Biological Conservation*, 104.2, 133–148.

Thomas, J. (1996). 'Neolithic houses in mainland Britain and Ireland – a sceptical view', in Thomas, J., and Darvill, T. (eds), *Neolithic Houses in Northwest Europe and Beyond*. Neolithic Studies Group Seminar Papers 1 (Oxbow Monograph 57). Oxford: Oxbow, 1–12.

Thomas, J. (2004). 'Current debates on the Mesolithic-Neolithic transition in Britain and Ireland', *Documenta Praehistorica*, 31(11), 113–130.

Tipping, R., Bunting, M. J., Davies, A. L., Murray, H., Fraser, S., and McCulloch, R. (2009). 'Modelling land use around an early Neolithic timber "hall" in north east Scotland from high spatial resolution pollen analyses', *Journal of Archaeological Science*, 36(1), 140–149.

Tubby, I., and Armstrong, A. (2002). *Establishment and Management of Short Rotation Coppice*. Edinburgh: Forestry Commission. <http://www.forestry.gov.uk/pdf/fcpn7.pdf/$file/fcpn7.pdf>.

Vera, F. (2000). *Grazing Ecology and Forest History*. Wallingford: CAB International.

Viner, S., Albarella, U., Parker Pearson, M., and Evans, J. (2010). 'Cattle mobility in prehistoric Britain: Strontium isotope analysis of cattle teeth from Durrington Walls (Wiltshire, Britain)', *Journal of Archaeological Science*, 37 (11) 2812–2820.

Wainwright, G., and Longworth, I. (1971). *Durrington Walls: excavations 1966–1968*. London: Society of Antiquaries.

Walsh, F., Lyons, S., and McClatchie, M. (2011). 'A post-built Early Neolithic house at Kilmainhan, Co. Meath', *Archaeology Ireland*, 25 (3), 35–37. <http://www.jstor.org/stable/41550225>, accessed 26 May 2015.

Watterson, A., Baxter, K., and Watson, A. 2014 'Digital Dwelling at Skara Brae', in Russell, I. A., and Cochrane, A. (eds), *Art and Archaeology: Collaborations, Conversations, Criticisms*. New York: Springer, 179–195.

Waterson, R. (2013). 'Transformations in the art of dwelling: some anthropological reflections on Neolithic houses', in Hofmann, D., and Smyth, J. (eds). *Tracking the Neolithic House in Europe: Sedentism, Architecture and Practice*. One World Archeology. New York: Springer.

Webster, C. J. (ed.) (2007). *The Archaeology of South West England*. Archaeological Research Framework, Resource Assessment and Research Agenda. Somerset County Council.

Wessex Archaeology (2004). *Boscombe Down Phase V Excavations, Amesbury Wiltshire 2004*, Post-excavation Assessment Report and Proposals for Analysis and Final Publication.

Wessex Archeology (2005). 'Boscombe down phase V excavations, Amesbury, Wiltshire 2004: Post-excavation assessment report and proposals for analysis and final publication report', Salisbury: Wessex Archaeology.

Whittle, A. (1996). *Europe in the Neolithic: The Creation of New Worlds*. Cambridge: Cambridge University Press.

Wickham-Jones, C. (2015). *Between the Wind and the Water, World Heritage Orkney*. Oxford: Windgather Press Oxbow.

Wilkinson, K., and Straker, V. (2007). 'Neolithic and Early Bronze Age environmental background', in Webster, C. J. (ed.), *The Archeology of South West England*. Archeological Research Framework, Resource Assessment and Research Agenda. Somerset County Council.

Wilson, E. O. (1998). *Consilience: The unity of human knowledge*. London: Little Brown.

Winter, L., and Grigsby, P. (2015). *A Summary of the Construction of Prototype Neolithic House 851*. Ancient Technology Centre, Cranborne, Dorset.

Appendix 1: Glossary

Purlin	rod, woven horizontally between rafters to support thatch.
Rafter pole	thick, load-bearing pole transferring weight of roof onto walls.
Sail	vertical, or wall stake.
Wall binding weaver	thinner rod twisted around door posts to tie them into the wall.
Wall stake (or sail)	vertical stake with pointed end, hammered into the ground.
Wall weaver	long rod, woven horizontally between the vertical stakes.

PAULINE WILSON

3 Towards a methodological framework for identifying the presence of and analysing the child in the archaeological record, using the case of Mesolithic children in post-glacial northern Europe

ABSTRACT

Numerous commentators have demonstrated that, until recently, the place of children has been overlooked by archaeologists and this needs addressing. However, over the past 20 years or so, studies of the child in the archaeological record have been increasingly conducted. A number of these have considered the active and agentic roles engaged in by children rather than viewing them as simply the passive objects of adult behaviour and it is the active orientation that this study takes. There are many difficulties in accessing the child in the archaeological record particularly from pre-history. Nonetheless, an attempt has been made to develop an archaeological methodological framework for identifying the presence of and analysing the child in the archaeological record, applying it to the case of Mesolithic children in post-glacial north-western Europe, featuring the Mesolithic sites of Blick Mead, in Stonehenge landscape and Tubney Woods in Oxfordshire. Thus a process of archaeological triangulation is engaged. The methodologies comprising the framework include ethnographic analogy; analysis of material; landscape and object phenomenology; and archaeological experimentation. A review of interpretations of 'child' is also provided. The conclusion from the study is that triangulating an appropriate framework of archaeological methodologies can provide for a plausible understanding and interpretation of the lives of children in a specific context.

Introduction

The study reported here is an interpretation of what children's lives might have been like in the Mesolithic Stonehenge landscape. It draws on an exploration of the use of a methodological framework designed to understand and interpret the lives of hunter-gatherer children in prehistory (Wilson, 2015; 2016), which was primarily concerned with the identification and assessment of archaeological methodologies. However in undertaking this theoretical and methodological assessment, Blick Mead, the recently discovered Mesolithic site at Vespasian's Camp was utilised to explore the appropriateness of archaeological landscape and object phenomenology, through which an interpretation of prehistoric children could be made.

In addition to research conducted at Blick Mead, experimental archaeology was conducted at Besselsleigh and Tubney Woods in Oxfordshire, where Mesolithic artefacts and features have been found. The findings from this together with ethnographic analogy and archaeological records from elsewhere have been used to flesh out the interpretation. For both Blick Mead and Besselsleigh and Tubney woods palaeo-environmental data is available and provides further context.

Archaeology and children

To some extent, the place of children has been overlooked in the archaeological record (Sofaer Derevenski,1994; Moore and Scott, 1997; Kamp, 2001). Such an omission is odd, since between 40 and 60% of most populations considered by archaeologists is likely to have been children (Baxter 2005:10). Reasons suggested for such a lack of information include that children, quite literally, are

not so evident in the archaeological record because their more delicate bones simply do not survive post depositional transformations (Baxter, 2005; Kamp, 2001; Janik, 2000), they are problematic to archaeologists whose interpretations are dependent on material remains and associated culture; and/or, similar to the situation of the missing women of archaeology, which has been claimed to be partially a function of gendered power relations (Wylie, Conkey and Spector 1984; Claassen, 1992; Gero and Conkey, 1991; Meskell, 2001), it is not unreasonable to suggest that, in the case of children too, omission may have something to do with dynamics of modern day adult assumptions and power. Just as children today, in those countries with resources enough to indulge in archaeological pursuit, are not often perceived as significant, in power terms, in the reality of any current society, notwithstanding their increasing consumer importance, children of the past were and still are seen as inconsequential.

Thus, the main intent of the project the study reported here draws on was to identify a possible approach to finding children in prehistory, that is, to discover what methods of looking for them may be used. This key concern was addressed through the following question: which archaeological methodologies could be incorporated into a plausible framework for appropriate data collection and analysis for the study of children in prehistory?

Scope of research

Rather than address this question in abstract terms, once the framework was constructed, it was assessed against observations from archaeologically recorded Mesolithic sites in northern Europe, ethnographic comparison with Hunter –gather groups of today and experiential and experimental activities with children at Mesolithic sites the UK.

Immediate questions that arise about the nature of the Mesolithic child include, at least:

1. What constitutes 'child'?
2. What might constitute a child in the Mesolithic?
3. What did a child in the Mesolithic experience in relation to place/location; societal structures/behaviours; objects?
4. What activities did a child in the Mesolithic undertake?

With the exception of the first of these, which is, essentially, definitional, each of these questions requires information in addition to that which can be gained from analysis of material culture and demands a consideration of a variety of appropriate archaeological methodologies.

In what follows, I begin by addressing what constitutes 'child'. I then review archaeological research methodology and apply a selection of methodologies to the case study of Mesolithic children, such as could be found in the Stonehenge landscape. I conclude with a discussion of the usefulness of such a methodological framework.

Understandings of 'child'

When discussing how to examine the nature of Mesolithic childhood with others, reactions from others invariably involved assumptions made about children from modern western perspectives, such as, did people recognise the idea of children in the past? Weren't children just used as labour? Didn't they just kill them if there were too many? Weren't they cruel to children? I don't suppose they educated

them? Such comments seem indicative of an almost economic view of children, where children are identifiable as a separate group in any society and require development into useful members of it. This hints at perspectives on the child such as, individuality and her/his developmental nature towards an ultimate state of economic wellbeing. Such notions can certainly be traced back to some of the earliest societies in the historical record, that involve settlement and the production of economic surplus, from, for example ancient Sumer, which has produced a schoolboy's account of his daily routine (Kramer, 1949, 2015) and biblical sources, via Greek philosophers and accounts from ancient Rome, through the Medieval European construct of children, as all human beings, being originally sinful to a variety of enlightenment pronouncements about the native innocence of children. Such commentaries are more often than not essentialist in nature; but there is a different approach.

During the past 100 years or so, in industrialised societies in particular, there has been an emphasis on staged development of the child. At its most prescriptive, this might be how well a child is expected to be able to undertake certain tasks, such as reading, behaving morally and so on by a certain age. In what Kamp (2001) describes as the western medical model of childhood, she indicates that here the 'universal period of childhood (is) grounded in biological and psychological reality' (3). She emphasises the headlines of this model as being the construction of biological and psychological indices, from which markers can be drawn to identify the point at which childhood becomes maturity and various finer gradations on this route, such as 'infant, toddler, child ...' (3). She then discusses the potential outcomes in views on childhood that arise in the West because of this model, for example, emphases on education, nuclear family, child happiness and so on.

In my view it is the application of such a model in this way which could be problematic when applying it to other cultures, such as hunter-gatherer, rather than the model itself, which can be more broadly drawn, using not only individual psychology and biology but also sociological context, to posit certain developmental stages with fluid age boundaries. If a child in any culture is to be sought, it is as well to examine the issues of when people are children – at what age(s) – as well as what is a child. A developmental stage model provides a useful structure to explore this.

Thus, I start the answer to the question 'when are people children?' by describing the life-span stages of children, which developmentalists who take in these broader perspectives have identified over the past 100 years or so (for example, Erikson, 1950; Piaget, 1952; Bandura,1989; Rogers, 1961; Bowlby, 1969; Chowdorow, 1989; Gilligan,1982). Such an approach provides a framework with which to examine and also, specifically, integrate how biological, cognitive and social processes develop (not only, as Kamp indicates, biological and psychological). Biological processes are those that involve changes in the individual's physical nature; cognitive processes, changes in thought, intelligence and language; and social processes, changes in relationships with other people, which involve emotions and personality.

Drawing on various analyses, derived from the developmentalists listed above, approximate age ranges indicated for these stages as well as some of their defining characteristics are indicated in Table 3.1.

Table 3.1: Stages of a child's life

The pre-natal period: birth to 9 months	Maximum rate of biological growth which produces behavioural capabilities
Infancy: birth to 18–24 months	Extreme dependence on adults; psychological activities begin, e.g. language, sensori-motor co-ordination, symbolic thought, social learning
Early childhood: end of infancy to c.5–6 years	Learning to become more self-sufficient and care for self; spend hours in play with peers; develop some skills used throughout life
Middle and late childhood from c. age 6 to adolescence	Further mastery of skills and more self-control
Adolescence; entered c. age 10 lasting until c. age 18–22	Transition from childhood to adulthood

The descriptors in this stage model are not deterministic in the way that Kamp identifies. It is only when determinism is brought to the model from a particular perspective, such as, for example, because a child at between age six to adolescence can develop mastery of skills, adults must educate him/her formally, does the model become questionably transferable between cultures. Further, although ages are mentioned, they are framed in terms of ranges, rather than points and thus there is some flexibility in application. Interestingly this life course approach has been reported by anthropologists Tucker and Young (2009) who indicate that the Mikea, of Madagascar, identify three developmental stages within children, which each have a specific term, although they assign no age ranges. The stages are as follows:

Table 3.2: Child life stages recognised by the Mikea

Infant (aja mena)	Babies that have not yet been weaned and have no mobility beyond that supplied by caretakers; Infants do not forage or engage in any other work
Children (olo kely)	Children who are weaned and prepubescent, are mobile enough to leave camp and travel/work with others in the environs of the camp, but are not yet old enough to travel alone
Adolescents (olo be-be; kidaho lahy)	Young people nearing, experiencing or just past puberty, unmarried, with complete independent personal mobility, who can travel alone; As this activity increases, adulthood is conferred

An immediate question to be addressed is whether the definitional framework of childhood presented in Table 3.1. can usefully be applied to further societies of today, typified as hunter-gatherer and, by analogy, to Mesolithic hunter gatherers. Here I join company with Kamp again when she states 'an optimal first step in the study of prehistoric children would be the determination of significant cultural age categories and their basic characteristics' (4). This is essentially a methodological issue and requires undertaking alongside other methodologies that may be used to gain an understanding of children in pre-history. The issue now is, what other methodologies?

Archaeological methodologies

The archaeological methodologies selected to form the framework included ethnographic comparison as identified above, analysis of material culture, landscape and object phenomenology and archaeological experimentation. The theoretical perspectives which led to this particular selection are briefly presented here. A full discussion can be found in Wilson 2015, pp. 10–28.

Methodology: The very idea

The focus of this study concerns the relative usefulness of archaeological methodologies for studying children in pre-history. There are a number which could be selected; the question is, which? Possibly, not all are suitable for the task; potentially, not all are feasible and some may not be attractive to the researcher within her or his worldview, that is, what the researcher fundamentally believes things are like and what, for the researcher, constitutes knowledge.

However, before embarking on a selection of methodologies against the criteria of suitability, feasibility and preference it is well to identify what maybe on the menu. Thus I briefly describe what

may be considered to be archaeological methodologies, before making my choice. However, even the word methodology has various interpretations from a narrow dimension to something much broader.

Thus, for example, to social scientist Norman Blaikie (1993) it is 'the logic or strategy of enquiry, to the processes by which knowledge is generated and justified' (12), but to archaeologist, Matthew Johnson (2010), it is 'The techniques and methods used to collect and interpret archaeological data'; he adds 'Some feel that methodology is part of theory; others insist that it is kept separate' (241). Archaeologists Renfrew and Bahn avoid using the word, producing a widely used and fundamental text about 'Archaeology: Theories Methods and Practice' (2000). That such luminaries should do this might sound a note of caution that methodology is a troublesome concept in archaeology.

A quick Google exploration of the use of the word methodology by archaeologists does, indeed, reveal that many choose it to describe the sequence of the practice they undertook through which they investigated particular phenomena. By being action orientated these identify methodology as separate from theory. Elsewhere, though, there are archaeologists, such as those who frequent the Theoretical Archaeology Group, who are more amenable to the necessary integration of theory, method, and technique. Even the very construct of methodology produces debate concerning its essence in archaeology and this is before we even get to the merits of sometimes competitively championed alternatives; but I have to start somewhere with methodology and have chosen to begin with a commonly used description of chronological development, found in the 'many texts' alluded to above. Take for example, Trigger's (2006) 'A history of Archaeological thought'.

Although, as his title indicates, Trigger is concerned with a wider history, that is, first tracing the antecedents and early development of what might be today recognised as archaeology, by about a third of the way through his text, he settles on reviewing what may be referred to as approaches or methodological orientations, namely culture historical, processual and postprocessual.

Each of these meta-methodological approaches has its own collection of methodologies within; each methodology, a set of appropriate methods; and each method a set of techniques. Essentially the culture historical approach is the identification of past societies into cultural, ethnic, tribal groups through classification of their material culture. Processual archaeology considers that culture is determined by environmental, in the widest sense, constraints and that these constraints will cause adaptive processes in culture to occur. Once it is known what changes the environment will cause, it is possible to predict the outcome in a culture. In this way it is, like physical science, founded on deterministic cause and effect. The post-processual approach is a broad church; but seems to have come to mean all that is not and succeeds processualism. It is not the intent in this chapter to review and consider each of these meta-approaches, there are plenty of texts the reader may access for such a review. However, I should just mention that some of the methodological 'contents page' of all that is post-processualism has been plundered here, as becomes apparent below (I hope).

To make a persuasive case for any archaeological discovery it would seem sensible, if not mandatory, to select the necessarily coherent set of technique-method-methodology-meta-approach. This ultimately is a response to the type of archaeological question to be addressed; but the choice of how to address a question also rests upon the researcher's views of the world and what constitutes knowledge. In this regard, an archaeological discovery is interpretive, 'Always momentary, fluid and flexible ...', as Hodder states (1997). This is a position that many archaeologists have increasingly come to adopt. Thus a quick examination of what archaeologists may mean by interpretive (sometimes interpretative) archaeology is useful.

Interpretive archaeology

The purpose of any piece of research is conditioned by a number of things; but will definitely be predicated on ontological and epistemological positions of the researcher. Although, up to a point and for specific purposes, aspects of conducting research may be undertaken objectively, thus for

example, statistical analyses of the distribution of types of flint tools may produce interesting and forceful information for interpretation of activities at a particular site, it is subjective and personal perspectives which will generate any investigation and the questions to be asked. Therefore, ultimately, any investigation may be said to be interpretive. It is the case however that, under certain conditions and for particular purposes, some interpretations may be more useful than others. In short, I would rather be treated for a broken arm by someone who had studied a scientific method of how to go about mechanically fixing broken bones, than someone who had studied how to repair them through reciting mending poems over my limb. Nonetheless, in a field somewhat less precise than bone-fixing, such as archaeology and because I have set myself the task of selecting 'appropriate' methodologies from the menu available, I summarise the ontological and epistemological positions that have led to my selection of methodologies.

A brief excursion

The genesis of this study happened during a car journey I took through the English county of Wiltshire, with my then six-year-old granddaughter, who announced, from the backseat, 'I love the countryside'. In an instant she reflected feelings I had held since I was about her age and it made me consider whether an appreciation of the 'countryside' – either positive or negative was something many children developed and if previous generations of children, more used to the bucolic, had these feelings.

This event took place when I was also introduced to the Mesolithic archaeological site of Blick Mead, at Vespasian's Camp, in the Stonehenge landscape. Of course, almost up to very recent times, no ancestral child living in the British Isles, would have experienced what vast numbers of children do today, the contrast between urbanisation and countryside; but my granddaughter's deep feelings for 'the countryside' led me to ponder what living in an environment such as Blick Mead, spectacularly 'the countryside', was like for very much earlier generations of children. As Blick Mead is a Mesolithic site, I became tentatively convinced that a contemplation of the experience of the Mesolithic child could be an informative enterprise. This was concurrently re-enforced by reading Parfitt's (2015) environmental report on Blick Mead, in essence, that it had not changed much over the millennia. So a decision was taken that one approach to the Mesolithic child was through experience of place.

On reflection, after my journey, I foresaw there would be many difficulties in attempting to study the child of so long ago and, indeed, in even constructing the categorisation of child; but further review of the archaeological and anthropological literature indicated that it might be feasible, if I drew on a number of approaches. In addition, I knew from my earlier work as a psychologist, with an interest in life-span development, that there was a body of work on the concepts of child, childhood and children, so I should be able to make sense of this too.

Over the years, I have variously attempted to define, succinctly, what the essence of the discipline is. Initially, I positioned myself in a belief that, for me, it is a meditation on the human condition through a contemplation of material culture (drawing on Brumfiel, 1987); but this definition seemingly lacks an acknowledgement of significant postprocessual orientations, which have now developed beyond original reactions to the positivistic path that archaeology was treading in the mid-twentieth century. One of these further turns in the road, expanding the discipline philosophically, is phenomenology, which has been very specifically, identified with 'landscape archaeology', especially among English archaeologists (Johnson 2010). This resonates with the events of my day out with my granddaughter.

At first sight, landscape archaeologists might seem simply to address two orientations. One is concerned with how humankind has impacted landscapes – modifying natural topography, for example to provide defensive positions, or define boundaries or building specific structures at particular places, such as Stonehenge; the other, how landscapes have impacted on humans – why a certain site would be the ideal place for a hunting camp; why material is deposited by people at natural places. If processual archaeologists, for example Lewis Binford and Kent Flannery are studied, such a conclusion might be drawn.

However, especially as far as what has been categorised as 'the English landscape tradition' (Johnson, 2010:234) is concerned, there is a sense in which landscape archaeology is much more, or less, depending on the extent to which case-study, anecdote, interpretation and understanding of place is preferred to grand theories of location. Tilley (1994) expounded this orientation initially. Briefly his contribution was to address space as it might have been perceived in the past. In this English landscape tradition, the individual is seen to experience landscape and this experience will be reflexive and unique. The words 'experience', 'reflexive' and 'unique' immediately flag up to me my personal philosophical history as a psychologist. Psychology as a discipline has many variants ranging from the clinical to the political but the branches of most relevance to this study are individual and small group psychology, my particular field of interest, where the person (or persona) is the focus of study, with analysis stopping at limited social interactions between individuals in small scale interactions, between relatively small groups of people – families for example, parents and children, couples, work teams, small group leaders and the led. How these matters are studied has been a major feature of debate within the discipline, particularly since 1990, which parallels the debates in archaeology and I have been interested to note that, Greene and Moore (2002), commenting on interpretive archaeology state 'the significance and humanity of sites and artefacts are enhanced by viewing them from a perspective of individual experience' (283).

Science versus the rest

Of all the humanities, psychology has often been regarded as the most frequent user of a scientific approach, in that hypotheses are set and data collected to confirm or refute these. One of the ambitions of the discipline has been to explain the determinants of behaviour, especially why people do dysfunctional things. However, it was as the 1960s moved in that the 'science' of psychology came under greater scrutiny; for one thing it was not necessarily delivering a 'better' world and the pre-eminence of this orientation has waned over the past 50 years.

Recognition of the limitations of the scientific approach in the social sciences and developing alternatives is not, however, simply a case of prioritising understanding over explanation, mutability and transience over immutable laws of relationship between one variable and another and replicability of observable results. The social sciences involve people, who take actions and these can produce unexpected consequences. In Giddens' (1975) view, not only are the social sciences concerned with enacting people, whose actions are fuelled by motive, reason and intention; but they should also take account of the institutional structures, often only 'dimly perceived' (Giddens 1976: 161) from which individuals and the social structures they form, draw their intentions, reason and motives, thereby constantly reproducing such structures. In this, his Structuration Theory, Giddens identifies the duality of structure in that 'social structures are both constituted by human agency, yet at the same time are the very medium of this constitution' (1976:121). Human beings are seen as agents and this is consonant with interpretive archaeology with its focus on the individual. It has been alternatives to the science of psychology, the development of understanding rather than explaining and the notion

of human agency that I have drawn upon and developed in my previous professional work, so it is unsurprising that I am initially drawn to interpretive, post-processual archaeology.

A word on post-processual archaeology

In terms of first English and then North American archaeology, perhaps the most significant contributor about how archaeology could confront the limits of scientificity is Ian Hodder. (Indeed, he coined the term post-processual.) Becoming critical of the scientific perspective in his studies, in which he used spatial analysis, in the 1970s, his questioning developed him as a leader in post-processualist theory in the decades that followed. Initially, using ethnoarchaeology in Eastern Africa, Hodder came to understand that a processual approach to archaeology (such as middle-range theory, developed by Binford in the 1970s) could not be confidently used to understand behaviour (1982).

There was no uncluttered relation between environment and action by which the former uniformly predicted the latter, as in processual approaches. In such a deterministic model there was no necessary room for the inclusion of the way individuals' cognitions of their particular world together with how they might symbolically represent these, that is the agentic aspect of people, would intervene and this was therefore a profound limitation to any attempt to either understand or explain behaviour through examining traces in the environment, or cultural artefacts, or a combinations of both. Although a processualist, such as Flannery might wish, even claim, that archaeologists should strive to reconstruct the whole ecological system, that is, process behind both the 'Indian and the artefact' (1967), without access to the reflexive relationship between mind and representation of any particular mind, the picture could not be complete. Environments and artefacts and combinations thereof are not passive or inert. They are each created by a particular mind, or perhaps a consensual group of minds, whether that is the archaeologist today, or an individual in the past. Hodder was not the only archaeologist to draw attention to this problem; but, perhaps, one of the most influential at that time, not least because he attempted to put into practice archaeological methods and techniques consistent with this methodological approach at the important site of Çatalhöyük over a prolonged period.

Thinkers about the state of archaeology gradually collected a set of propositions which coalesced together in what Hodder had termed postprocessual archaeology, certainly by the 1980s. Some 30 years on, Johnson has produced a list of what he identifies as the 'flavour' of post-processualism, summarising it as a rejection of scientificity and the 'theory/data split'; a belief that 'interpretation is always hermeneutic'; a rejection of a philosophical opposition between materialism and idealism; a need to include consideration of thoughts and values in the past in any archaeological analysis; the recognition of human agency; the recognition that material culture is like a text; the recognition that context is important; and the recognition that interpreting the past is always a political act, read from the political meanings produced in the present. (2010: 105–107). Many archaeologists, including Hodder at Çatalhöyük, have adopted post processual approaches, for example Bender et al. (2007), Johnson (2002), and, particularly relevant to my study, generated by the Stonehenge landscape, Tilley (1994, 2004).

Tilley (1994) focused on space as it might have been perceived. He considered the location and orientation of sites in relation to each other, especially the visual interconnectivity of sites, thereby creating a spatial narrative. In approaching an understanding of British prehistoric landscapes he drew on ethnographic case studies from around the world as analogies for spatial perception, such as the mythological landscape associated with Ayers Rock in Australia. I return to Tilley's approach and the influence it has had in more detail, when considering the methodologies I select for this study.

However, lest it should be seen that a move from cultural historical, through processual to post-processual archaeology is a linear progression, a note of caution is needed. As indicated, post-processual

archaeology includes a range of concepts. Hodder himself said that the main thing about post-processualism was the 'post' (1991:181) and Criado, quoted in Hodder (1995:227) critiqued the debates between processual and post-processualists as being simply fights between European and American academics.

There was a problem with the term and, in any case, the position itself evolves. Thus, more recently, the term 'interpretive archaeology' drawing especially on the reflexiveness of the post-processual approach has expanded in the repertoire. This is characterised by Holtorf and Karlsson as being 'multiperspectived, multivocal, personal and individualised ... allowing different pasts to emerge from the archaeological record' (2000: vii). Bintliff expresses the same perspective as, that in interpreting the past 'explanations [*sic*] have to be created using many different voices, methods, kinds of information' (2000:164). In this way interpretive archaeology can employ critiques and analyses from orientations other than, for example, male, western, political systems and cultures, which are so frequently found in the early years of the discipline. Greene and Moore (2010) consider that the following concepts can be enlisted into interpretive archaeology: in relation to people, meaning; agency; habitus; structuration; identity; and, in relation to artefacts, materiality; biographies; fragmentation (i.e. deliberate breaking and distribution of artefacts) and personhood (i.e. the relations and boundaries between personhood and objects, both inanimate and animate).

Just as in archaeology, psychology has honed its less deductive and more inductive processes. It has returned to hermeneutics, understanding, interpretation, relativism, and non-determinism and in much of my research I have been one of its adherents. That said, as Holtorf and Karlsson and Bintliff, quoted above, recommend for archaeology, many psychologists, including me, engage in a pick and mix of methods and techniques to interpret. To illustrate from practice, although most of the research I have been commissioned to undertake has been of an exploratory and discursive nature and has frequently employed qualitative modes of data collection and analysis, this is not say that I will not use hypothesis testing and, if appropriate, quantitative data collection methods and analysis. It all depends on what I consider is needed to get at what I am trying to understand, or even explain. There is frequently and ebb and flow between induction and deduction; but my point here is, that I am particularly comfortable with an orientation in archaeology that emphasises interpretation rather than explanation.

There is reflexivity here too. If I had not wanted to take up with a phenomenological approach, having visited Vespasian's Camp with my granddaughter, then I would probably not have studied such an esoteric subject as the child in the Mesolithic. If I had not been interested in the individual, I might not have chosen to study children. My identity has set my interest in my study along certain lines; but how do I now go about examining the matter. What will constitute knowledge in this case? Time to turn to an epistemological approach, congruent with my ontological perspective, which may generate the data required to gain an interpretive understanding of being a child in the Mesolithic.

Epistemology

Before deciding on an approach, inescapably bound up with epistemological choices, is a consideration of just what type of data may be available – what is there out there? – to enable the differentiation between that indicative of or related to a child and that indicative of, or related to an adult. The answer is, not much.

There is material found and behaviour indicated in burials of children, or at least of individuals who may be biologically identified as young, for example, the swan's wing in which a neonate had been buried in a Mesolithic cemetery in Denmark and close by the 'boy' with a stone placed in his mouth where his tongue would have been (Albrethsen and Petersen, 1997); but this focus, as much as

anything else, indicates how non-children thought of the child, rather than necessarily how children of the Mesolithic experienced life.

There are theories suggested about how children might have been engaged in their communities; for example how they 'worked' or how they featured in ritual. Such speculations may be prompted by the micro nature of artefacts, through ethnographic comparison, or by art, featuring, for example, small handprints. So the question is, how can we add to this limited data set?

How can analysis via material culture be added to?

I consider that to examine the experience of a child in the Mesolithic, this study should be largely guided via what I described above, as the hermeneutic tradition re-developed in the twentieth century in a number of disciplines, including archaeology, particularly in the post post-processual phase, where experimentation, phenomenology and agency have gathered momentum.

To summarise the methodological nature of this study, what I seek is an understanding of what it might have been like to exist as a Mesolithic child, that is, to allow what Holtorf and Karlsson (2000) might refer to as one of many 'different pasts to emerge'. This can include a critical review of the scant material culture from this era, interpreted as representing the child and how others have interpreted this; but methodological adjuncts to finding out about the child will, of necessity, have to be included. The further away from an analysis of the physical, for example, deducing from the bones of a child what he or she might have eaten; or, from the size, or practical usefulness of artefacts, whether they may have been made by a child, the exercise becomes ever more one of interpretation. Where the physical remains peter out, the starting point of such interpretation is what happens and exists today, nothing else is available.

There is an issue as to how reliable drawing on today's human populations is, as a guide to what this process was like in the Mesolithic, in particular, how they perceive, process perceptions and then act upon these. In short, how similar are twenty-first-century *Homo sapiens sapiens* to Mesolithic *Homo sapiens sapiens*?

This question brings me to the field of evolutionary psychology. A thorough review of this subject is too extensive to incorporate here, so, for the time being, I have to satisfy myself with a few key points. The prevalent view is that the essence of people, their basic psychological structure, thought, emotion and, if it exists, psyche have not changed recently; at least in the last 50,000 years and certainly not in the last 10,000. Although work is in progress, engaging in the possibilities of genetic research, possible changes that have been suggested include, differences in level of aggression; development of certain cognitive functions, such as the capacity to undertake mathematical thought, once populations began farming; and that ADHD might have been more common in non-settled groups, who needed to be more alert in their environments than settled communities (Moyzis, Wang et al., 2009). I do not consider these propositions to enlighten any discussion of the relationship between the psychology of people today and of those of 10,000 years ago, that is, in the European Mesolithic. Thus, I make the assumption of similarity.

Once stepping away from the limited material culture available from the Mesolithic and using what we can from today, the methodologies that lend themselves to interpreting the past are phenomenology and its endpoint, narrative, as proposed by Tilley (1994), together with experimentation, in the present; but since it is sensible, given time constraints, to at least have some idea of what might be sought and to deflect from the 'all things to all people' critiques of phenomenology, this is where starting with ethnographic analogy is useful, to direct towards what to look for. Thus, as means of knowing, the methodologies I consider are ethnographic analogy, archaeological phenomenology and narrative and archaeological experimentation.

Ethnographic analogy

At the outset, I should record that there is critique of the use of contemporary or historic hunter-gatherers when considering the Mesolithic. Of first consideration is the question of whether hunter-gatherers are an identifiable cultural type. This has been addressed by a variety of commentators since the 'Man the Hunter' conference held in 1968. Kelly, 2013 provides a review of some of the key arguments on this issue and concludes that 'the category of hunter-gatherer continues to be one the anthropologists give special significance' and then, drawing on Testart (1988:1), gives the reason for this that 'like our intellectual forebears, we seem overwhelmed by the fact hunter-gatherers appear to be the most ancient of so-called primitive societies – [by] the impression that they preserve the most archaic way of life known to humanity'. He continues that this impression 'leads many anthropologists ... to seek a glimpse of the past in the present' (269), which he is 'sympathetic' to, but he warns that if archaeologists use ethnographic comparison between now and then it 'must be tested against the most direct record we have of ancient societies ... the stone tools and bones that are all that remain of our ancient ancestors' (270).

Others add to the justification by addressing human evolution and make the case that humans today are not much different from biologically modern humans who, evidence suggests, developed, in Africa, 200,000 years ago and behaviourally modern humans of c. 100,000 years ago (Bock, 2009 drawing on Binford, 1968; Lancaster and Lancaster 1987; Lee and Devore, 1968; Washburn and Lancaster, 1968, all cited in Hewlett and Lamb, 2009: 109). Thus it is plausible that, since it is commonly held that an alternative lifeway to hunter-gathering has only existed for, at most 12,000 years (although recently published research has pushed the timespan to 23,000 years, Snir et al., 2015); but more likely, for many of the world's populations, only the last 1,000 years, the nature of the human lifespan, that is, what cognitive, behavioural and to some extent biological developmental changes occur, and when, are likely to have evolved in the context of a hunter gathering lifestyle.

The evolutionary school of thought is, however, criticised. This sceptical view may be summarised by what Barnard (2004) terms 'The Kalahari debate' (7). The proposition is that comparison between the space – geographical, economic and political, that modern hunter-gatherers inhabit is not like the space of the past.

Geographically, today, hunter-gatherers dwell in what might be termed marginal areas – hot, arid, cold, snow covered, dense jungle and so on. These areas are not at all like the lands found by early hunter-gatherers entering Europe or North America, which in many ways must have been desirable and abundant. Thus, say the critics, successful use of ethnography by archaeologists is deemed to be possible only when the ethnography and archaeology take place in the same location, such as, for example Binford's 1970s study among the Nuniamuit or Yellen's, in the same decade among the Ju/'hoansi or !Kung (e.g. Binford, 1980; Yellen, 1976).

Further, today, is it the case that hunter-gatherers primarily engage in this lifeway from unenforced choice or do they have little preferable option? In other words, to what extent do contemporary economic and political factors determine hunter-gathering as a survival necessity for some, because of accidents of location, government systems, limited access to other resources and so on? If a range of such a complex of factors interact with hunting and gathering, to what extent can ethnographers, or archaeologists for that matter, understand a 'pure' hunter-gatherer perspective, as existed before alternatives developed?

However, maybe there is a way to use ethnography if contemporary archaeologists avoid, as much as possible, regarding today's hunter-gatherers as relics from long ago. In this, the key is that the living conditions of hunter-gatherers today, replicate, in general, if not in specifics, those of past hunter-gatherers and therefore it is plausible that the ways in which hunter-gatherers live today resemble pre-historic ones. In this way, what happens today may be a signpost to what to apply to the past, as found in the archaeological record. This is the approach that Clark took in relation to the Mesolithic

site Star Carr in England, when he compared postulated animal skin working there with that contemporarily being undertaken by hunting peoples of North America and Greenland, and inferred that, as hide workers, women would be present at Star Carr (1954:10–11). Since the record is scant and has always been open to multiple interpretations, direct comparison between the ethnography what happens now and what happened then is an exercise in understanding not explanation.

Archaeological phenomenology and narrative

'Narrative is a means of understanding and describing the world in relation to agency. It is a means of linking locales, landscape, actions, events and experiences together providing a synthesis of heterogeneous phenomena. In its simplest form it involves a story and a story-teller' (Tilley 1994:32).

Just as with phenomenological approaches in other disciplines, this orientation in archaeology has had its critics such as Fleming (1999, 2005, 2006) who took issue with a lack of reference to material evidence in its interpretation; but that is not its point. Phenomenological methodologies do have potential for contributing to understanding, rather than explanation and can be integrated with material evidence.

The ancestry of archaeological phenomenology interests me greatly and here I intend to make a case that, the incorporation of a phenomenological orientation within archaeology provides a nodal point between it and human psychology and therefore interpreting people of the past.

Archaeological phenomenology draws on Heidegger; but Heidegger (1889–1976) was one among several influential philosophers of the nineteenth century turning to hermeneutics and he drew on his predecessors Droysen (1808–1884), Dilthey (1833–1911) and Husserl (1859–1938). In eighteenth-century Germany, hermeneutics was first an approach to interpreting the meaning of biblical texts. This contrasted with the attempts taken by Enlightenment scientific thinkers to prove events in the bible had actually occurred. It was Droysen who, from this, outlined the methodological dichotomy of explanation (broadly science) and understanding (broadly humanities). Essentially, science may explain something, notably a causal relationship; understanding involves empathy, which von Wright (1993) describes as 're-creation in the mind of the scholar of the mental atmosphere the thoughts feelings and motivations of the objects of his study', adding that understanding is also 'connected with intentionality' (11). This introduces the notion of agency, the possibility of meaning in signs and symbols, the significance of rites and institutions.

Dilthey continued the development of the theme of a dichotomy between the sciences and the humanities, considering how, or if, it was possible to be objective in the human sciences, attempting a framework of methods, approaches and categories which all human sciences could use and positing that psychology, particularly the psychology of individual intentionality, could provide a foundation for all of them, as mathematics does for sciences. Eventually Dilthey came to see that since people are social as well as individual, socially produced systems of meaning occurred.

At the same time, Husserl developed the notion of phenomenology. Like Dilthey he was seeking a methodological approach that would be objective, since it would be free from the 'relativism of historical and social entanglements' and would deliver 'true meaning' (Blaikie: 1993:33, drawing on Bauman 1978). Husserl introduced the concept of epoche, a method by which understanding something does not depend on a spatio-temporal world, contaminated as it is by assumptions, beliefs, prejudices, personal knowledge and experience; but, by standing back from it. Husserl considered it possible for a few very special individuals to be in a state of pure consciousness and therefore discover the essence of things, if they could identify and deny their prejudices and existing knowledge.

From this, Heidegger abstracted the usefulness of a non-conceptual method for understanding phenomena; but whereas Husserl recommended disengagement, Heidegger certainly did not. He

considered that understanding is a mode of being and not a mode of knowledge, therefore ontological not epistemological, and we can never be without, or outside it. For Heidegger there is no pure consciousness, people cannot step out of their social world or their historical context. 'Prejudgements shaped by our culture are the only tools we have' (Blaikie, 1993:35).

Psychology meets archaeology

This non-conceptual method was adopted by psychologists in their attempts to study the human condition by putting themselves into the mind of a 'social actor' in order to know what was known by the person as they engaged in some act. As Blaikie (1993) summarises, 'it is the art of re-experiencing the mental processes of the social actor. ... endeavours to construct the life context in which the activity has taken place and in which it has made sense. ... grasping the whole in order to understand the parts' (29), and 'that, as social actors in the world, everything that constitutes our conscious self is intricately tied to both our social interactions and our perpetual physical environment.' 'Thus, rather than referring to the self or subject, he uses the term "Dasein" (literally "being-there") to refer to the human entity (Heidegger 1962, 27)'.

Heidegger came to lay the foundations of modern hermeneutics. 'He could see no escape for interpreters from their location in space and time ... Rather than being a search for the truth, it is an opening up of possibilities' (Blaikie 1993: 36). Thus, clearly, interpretivism derives from hermeneutics and phenomenology. The archaeological application of this philosophical position is phenomenological archaeology. In this, attempts to understand the past through experiential studies of sites and landscapes (and, more recently, objects) rather than undertaking a classificatory exercise of creating suitable units for analysis and then, for example, looking for measurable cross-tabulations, significances, patterns, etc. The latter may want to cut the world and experience of it into manageable chunks, the first, at the extreme, to take on everything; but practice has modified the 'all things to all people' approach, across disciplines. It has become necessary to constrain with boundaries, such as hypothetical working models, for particular cases or contexts.

Until Tilley laid a particular claim on landscape archaeology the subject was somewhat different, with a pre-eminence of mapping, generating a number of techniques, such as central place theory. This looked at 'facts' on the ground and then postulated explanations for causes and/ or consequences of them. However, as noted above, pages xx, Tilley's contribution was to address space as it might have been perceived. Where Tilley led, others have followed and modified the approach, so that narrative has taken its place among a number of archaeological studies in the past 20 years, although not all their authors would claim to be phenomenologists (for example, Mithen 2003; Johnson, 2000, 2002; Cummings and Whittle, 2004; Hamilton et al., 2006).

Tilley's initial conception and developments of it were not without critique. Fleming, for example, focuses on the subjectivity of the approach, which can give rise to any number of interpretations and believes it is not investigative and that findings cannot be replicated (1999; 2005). However, in these comments, Fleming appears to speak from the standpoint of scientificity and processualism. Although early phenomenological work may resonate with an 'all things to all people' note, as it became integrated with other methods such an attribution is less convincing. Indeed, in other fields, psychology and sociology, for example, it has been accepted that what is often referred to as triangulation, that is, drawing conclusions by comparing findings achieved through a variety of methods is acceptable (for example, Gill and Johnson, 1997, Bryman, 2004).

There is an alternative critique of landscape phenomenology that is, however, more compelling, that is, to ask if people of today can possibly 'know', in the same, or similar way, to people of the past (for example, Brück, 2005). The short answer must be no, we cannot possibly know precisely how

human beings saw – in the literal and interpretative sense – anything. A way into this epistemological snag is, rather than start with the individual, we can start with the landscape. In other words, I cannot know, for a past individual, living out an alien way life to me, what the perceptual impact on them was. However, both she and I can be aware of the sensory nature of any landscape – what it feels like, even if we do not conceptualise it in the same way and I may get close to a feeling of what it was like to be there, in the past. Analogy can be of use here just as it might be when comparing hunter-gatherers of the past with today's groups as discussed above. I do not consider any apology is necessary for the perceived shortcomings of this epistemological imperfection. Indeed many other theories of knowledge, some of them employed by archaeologists have their limitations too (the misapplication of statistics, for example. I have frequently had to explain the nature of statistical precepts, such as sample, to students). Again, as indicated above, this only makes the case stronger for coming at an archaeological puzzle through the use of a variety of methodologies.

Phenomenology within archaeology is still a work in progress; but it does seem that in the period since 1994 additions and revisions have been made to this approach (for example Bender et al.'s 2007 reassessment of earlier work on Bodmin Moor, where environmental evidence was incorporated into earlier landscape phenomenology studies). In essence this approach insists on reflexivity.

'It is our job to be as rigorous as possible in defining and assembling the evidence, as honest as possible in admitting when it goes against the grain of prior interpretation, and as open as possible to rethinking and reconceptualising interpretation, narrative and evidence' (Bender et al. 2007, 26).

More recent reviews and critiques have added to the development of this approach. In 2009, Barrett and Koh believed that British landscape archaeology was in crisis, with criticisms such as Fleming's remaining unaddressed; but more interestingly they argue that Heidegger has been inappropriately applied theoretically, rather than challenge practice, perhaps because a decade's or more work, post Tilley's first exposition, such as Hamilton et al. (2006), have provided interpretations simultaneously phenomenological and grounded in the material evidence.

The use of archaeological phenomenology today

Johnson, in 2012 (279–280), identified three new approaches for the continued improvement of phenomenology in landscape archaeology, namely, development of case studies with greater contextual information; further use of GIS and other technologies to provide an evidential base; integration of palaeo-environmental data with experiential models. This is certainly possible for the case study to be used here, since palaeo-environmental and archaeological reports are available as secondary sources.

Object phenomenology in archaeology has similar philosophical antecedents to landscape phenomenology. Here an attempt is made to interpret people through the things they create as indicators of their selves, but reflexivity is recognised in that things also make people. Actively agentic individuals and groups interpret objects and this interpretation is incorporated into everything touching upon life as it is lived, from ritual to social relationships to practice (Olsen, 2010; Robb, 2005; Tilley, 1999).

Archaeological experimentation

Archaeological experimentation developed alongside scientific archaeology, the initial ideal being that experiments could conclusively demonstrate facts about the past. However, numerous variables related to an archaeological investigation would likely interact in any experiment, making conditions difficult

to control and measurement of variables problematic, which, in turn, would make any experiment difficult to replicate – a fundamental condition of scientific method. What is possible, however, is to attempt to demonstrate, replicate or simulate the past, be it in the form of, for example, dwellings, activities, or artefacts and this can provide information for interpretation. Although not conclusive evidence about how things might have been in the past, indicators may be provided to likely processes, decisions, techniques, behaviours and so on. Thus for example, experimentation has indicated that Mesolithic people were unlikely to have roofed their dwellings with turves since the weight of these would cause the structure to collapse (Jones, 2015, personal communication).

A note of caution must be sounded in relation to using experimentation to understand how people in the past may have behaved in that today's assumptions will be brought to this. For example, modern notions of doing things efficiently, in terms of energy used or time spent, may be wholly irrelevant to past activities, or that, just because they are today, certain tasks would be gendered or age-specific.

Nonetheless, archaeologists frequently use experimentation to add insights into interpretations. Since there is so little material on children in the archaeological record, particularly in relation to prehistory engaging children in simulations of pre-historic activities could usefully provide information on children's capabilities, thoughts and feelings.

Ethnographic analogy

This is a methodology frequently used by archaeologists when other sources of data are limited, for example, no written material; little in the way of material culture or partial material culture and is useful in studying prehistory. In this case ethnographic cases studies of extant hunter-gatherers were reviewed and analysed to identify aspects of the lives of children, which may have resonances with hunter-gatherer children in the Mesolithic. Of all the case studies available today and eventual selection of 17 of these was made, because of a variety of limitations.

Towards a selection of methodologies for a framework

Taking Bender's imperative that 'It is our job to be as rigorous as possible in defining and assembling the evidence, as honest as possible in admitting when it goes against the grain of prior interpretation, and as open as possible to rethinking and reconceptualising interpretation, narrative and evidence' (Bender et al. 2007, 26), and Johnson's suggestions of integrating contextual information, such as derived from GIS and other technologies, together with palaeo-environmental data with experience, I can now turn to creating a methodological framework and apply it to a study of the Mesolithic child in northern Europe and to some extent, Blick Mead.

Selection of methodologies

To restate, the purpose of the research is, to add to knowledge concerning the child in prehistoric archaeology; the case study I have selected in order to do this is, what might the experience of being a child have been like during the northern European Mesolithic? To answer this, the following require consideration:

1. What constitutes 'child'?
2. What constitutes a child in the Mesolithic?
3. What did a child in the Mesolithic experience of societal structures/behaviours; place/location; objects?
4. What activities did a child in the Mesolithic undertake?

Thus the issue is, how, following Bender's imperative and Johnson's guide, can I collect epistemologically defensible data in relation to questions 1–4? What, from among archaeological methodologies, could elicit this?

Question 1 concerns a general theoretical topic, about the nature of 'child' and this demands a consideration of thought about this. Sources for this are both oral and historically or currently written and require a secondary data literature review. This is provided above.

Question 2, what might constitute 'Mesolithic child' requires inference. One way of addressing this is to focus on a Mesolithic child as part of a hunter-gatherer community. Hunter-gatherer communities exist today and a claim can be made that, by examining the lives of today's hunter-gatherer children there might be an approximation for their lives in the Mesolithic, so ethnographic comparison is a possible methodology. In this case secondary data, found in published reports, is used.

In addition Mesolithic children have been found in the archaeological record. Many of these finds indicate what adults did to children, post mortem and clues can be garnered about a few aspects of their lives, such as social structures. There are also a few other sites where the presence of children may have been detected, flintknapping areas, sites where art is found, and preserved remains of Mesolithic footprints, for example. Thus archaeological reports of such sites are secondary sources which can be used to provide some information. They can also illuminate the processes of phenomenology and experimentation.

Question 3, what a child in the Mesolithic experienced, in relation place/location, societal structures/behaviours, and objects, may be accessed through recording children of today experiencing landscape and objects integrated with data from archaeological and palaeo-environmental case studies, such Mesolithic material culture as there is and contemporary ethnography of hunter-gatherers children.

Question 4, what activities did a Mesolithic child undertake may likewise be accessed through contemporary hunter-gatherer ethnography and Mesolithic material culture but also analytically integrated with archaeological experimentation

In sum, the methodological framework, once the nature of children has been established, encompasses:

- a review of ethnographies of contemporary or near contemporary hunter-gatherers to provide for analogy
- a review of relevant palaeo-environmental data
- a review of a relevant archaeological record
- landscape phenomenology
- object phenomenology
- archaeological experimentation.

These are presented in Figure 3.1.

The power of triangulation

Commentators on the validity of research have written about the benefits of using a multi-methodological approach, often referred to as triangulation (Denzin, 1970; Robson, 1993; Bryman, 2004; Saunders et al., 2000; Gill and Johnson, 2002). These include the notion that 'multiple methods may

Figure 3.1: Methodological framework for accessing the child in pre-history.

be used in a complementary fashion to enhance interpretability ... and to assess the plausibility of threats to validity' (Robson, 2004:291). It has been employed by a few archaeologists, for example, Wylie (2000), Dillehay (2014). What I suggest here is that the use of multiple methodologies in approaching an interpretation of an archaeological question has been and can be validly used.

A critique of triangulation was mounted by Blaikie (1991:115), in that it can inappropriately combine differing ontological and epistemological orientations such as the scientific with the interpretive, explanation with understanding. However, in this case, all the primary data collection methods are post-processual. The secondary are more varied but those of interpretive importance, with respect to views of children and children's behaviour, that is, ethnographic studies and archaeological reports are also interpretive. The palaeo-environmental data used does employ scientific methods of analysing the climate and topography of and the flora and fauna to be found at the research site; but reports concerning this data, which provide a context for interpretation of children there are also interpretive, as well as, in some cases, definitive.

Although such critique had some traction in the past and clearly wildly differing perspectives in one study could be problematic, it is not necessarily the case that explanation and understanding are diametrically opposed positions to maintain. Studies may be both. Thus, I, like other researchers am content to mix and match approaches. In so doing, I am following Bender's imperative, as quoted above, to reconceptualise 'interpretation, narrative and evidence'.

Data constraints

All research studies have constraints, with regard to both the relevance and accessibility of primary and secondary data. Here, with respect to primary data, access is required to relevant material culture and landscape and the opportunity to experiment, and, of course, to willing child participants, recruited

in the context of ethical considerations. Mesolithic sites are available at Blick Mead/Vespasian's Camp and Besselsleigh/Tubney Woods. With respect to Blick Mead, particularly in the context of environmental reports by Parfitt (2014) and John (2014) which demonstrate that the environment there today is very similar to that in the Mesolithic, this is available for landscape phenomenology. Besselsleigh/Tubney Woods, in Oxfordshire, subject of an archaeological investigation by Bradley and Hey (1993), where the experiments for this study were conducted, are, likewise, a similar environment today to that of the Mesolithic. This was and is open woodland, areas of boggy ground and a ridge with views of the valley and river below. Although experimentation as such does not depend on being in an environment as similar as possible to that in the Mesolithic, perhaps a note of authenticity is added to the children's sense of the place and their reactions to it, if conducted in a similar location, than if in, for example, a school playing field or specially made up area.

There is also primary data access to flint material from Blick Mead. Secondary data on environment is available for Blick Mead in the various GIS and environmental reports becoming available. For the Besselsleigh/Tubney Woods area, environmental information is available in Bradley and Hey's 1993 report. The remainder of data is secondary and is found in ethnographies, archaeological case studies and a variety of reports.

In sum, the following data sources can be used: various ethnographies; archaeological reports from northern Europe; material culture; landscape; experiments; palaeo-environmental analysis (Blick Mead and area and Besselsleigh and Tubney Woods).

Approaching the Mesolithic child via ethnographic analogy

Ethnographic comparison relies on the premise that ethnographic studies, both contemporary and, in some cases, retrieved from the historic record, can legitimately provide insights into an understanding of a Mesolithic child. The ethnographic reports reviewed for this study provided a further refinement of the nature of children and are secondary data sources, indicating what might be looked for in a search for the Mesolithic child. Placing myself in this interpretative orientation I claim that what we know about how today's hunter-gatherers construe children and how the children themselves behave can be used as lenses to focus on the past.

Ethnographic studies reporting childhood life stages

Many of the ethnographic studies I have accessed which note life stages in contemporary or near contemporary hunter-gatherer children are not located in areas that are climatically and consequently environmentally proximate to the conditions in northern Europe during the Mesolithic. Instead they cover low latitude areas in Africa, South America, Australasia and Asia. One justification for the use of analogy with today's hunter-gatherers is that, climate and consequent environmental factors are similar. However this position rests on the notion that analogy is more conclusive than indicative. The proposition is that if peoples inhabit a similar environment to those of many thousands of years ago it can be claimed they are living an (almost) identical life. There is no possibility of proving this contention. However, as those that uphold the use of ethnographic analogy point out this is not the issue. Analogy may direct towards what to look for, not must have been (Lane, 2014; David and Kramer, 2001). I take this latter position and therefore consider it justifiable to

present attitudes to childhood stages held in a variety of locales, including both high and low latitude areas.

Studies of the pre-natal child

As reports in the popular press and other media frequently indicate, the pre-natal child has been studied extensively, internationally, in contemporary culture. Such investigation is often driven by a need to examine the effect numerous factors have on foetal development in the womb, from tobacco smoking and drugs – medical and recreational, via environmental pollution to mother's mental health and nutrition. Of interest here would, perhaps, be any comparative studies which could indicate correlation between lifeways, such as hunter-gathering, sedentism or industrialised and biological growth, giving rise to behavioural capacities. However, I have been unable to identify any such.

Studies of infancy to adolescence stages

The boundaries between these age-stages can be fluid and the illustrative studies I consider here demonstrate this. What is of interest are both similarity and variability of behaviour at each of these stages with the similarity outpacing the variability.

Weaning

Taking age of weaning as an example, Hewlett and Lamb (2009) focusing on six hunter-gatherer groups in Sub-Saharan Africa indicate the weaning period lasting from a minimum of 25 months for some societies to a maximum of 48 for others. Kelly (2013), summarising studies from a wider geographic distribution, identifies weaning ages from 12 to 72 months (Table 3.3).

The mean age of weaning from these statistics is 32 months, but the range is very large, so the mode may give a more useful guide to the reliability of such data in describing weaning period in hunter-gatherers. With nine cases falling at a mean of 24 and eight at 30, it appears reasonable that for most of the cultures reported, weaning period is somewhere around 24–30 months. However, it may be that further inference may be taken from environmental factors applying to each of the cultures, particularly at each end of the range. Thus, the shortest weaning periods are among the Aleut, at 12 months, the Pomo at 15 and the Washo at 18. The longest mean weaning periods of four years plus include the Andmanese; Tiwi; Siriono; Dobe Ju/'hoansi; Ainu; Yukaghir; and Murngin.

The three shortest periods are all cultures to be found in the Western USA, the Aleuts and Pomo are coastal peoples, and the Washo based around Lake Tahoe. From a review of lifeways of each of these cultures, identification of common factors that may affect weaning durations is not apparent. Thus shorter weaning periods are seen in both the cold climate of the northern latitude Aleuts and the more temperature variable Lake Tahoe Washo (cold winters, hot summers). Reviewing those with the longer weaning periods, both the Siberian Yukaghirs and the tropical Andamanese spend four years on this.

Table 3.3: Weaning ages for a selection of hunter-gatherer groups. Source Kelly, 1995:198.

Group	Weaning Age in Months
Washo	12–24
Mbuti	12–36
Montagnis	12–60
Pomo	15?
Micmac	24–36
Slave	24–36
Bella Coola	24–36
Kaska	24–36
Klamath	24–36
Semang	24–36
Eyak	24–36
Yurok	24–36
Yokuts	36+
Andamanese	36–48
Tiwi	36–48
Siriono	36–48
Dobe Ju/'hoansi	36–72
Ainu	48–60
Hadza	30
Aleut	12
Yamana	24
Gilyak	24
Haida	24
Gros Ventre	24
Kutenai	24
Vedda	24
Paiute	24
Aranda	36
Yukaghir	48
Murngin	48
Pume	30–36
Ache	24

For subsistence all these various groups engage in gathering, hunting and fishing. Given that plant resources may be limited in some environments, particularly with these being totally unavailable in the arctic and sub-arctic, and that proportionally less of the diet is provided by gathering plants, perhaps this factor would explain a difference in weaning periods? However, both the Aleuts, Yukaghir are in this subsistence situation and have the widest variance of 12 months to four years.

It is also problematic to identify why there might be similarities. Is it for example, some shared cultural ancestry? This seems unlikely since there seems to be no common source for the languages spoken today. Each of the languages spoken by the three geographically closest and shortest weaning period cultures in Western America (Aleut, Pomo and Washo) belong to different language groups. The same can be said of those with the longest weaning times.

In sum, this brief review would seem to indicate that neither environmental factors, nor possible common deep ancestral cultural commonalities can illuminate weaning practices. In this case, it is unreliable to estimate what weaning periods might occur in the Mesolithic UK.

Kamp (2001) sums this up by stating that beliefs about appropriate weaning ages vary from culture to culture, citing from six weeks to five years, conditional upon a variety of factors, including work, pregnancy, and the availability of alternative food (11).

Thus, drawing on these examples, the ages associated with weaning may vary considerably; but is this of particular significance in studies attempting to interpret the Mesolithic child? One aspect of weaning period is not only that it might affect the child's activities but also the extent to which it

affects the mother's activities and, as the child ages, other carers. Since children learn, from the earliest age, by imitation it is possible that a mother's behaviour is a strong influence. However, just because a child is still being breast fed, does not imply that it is never in the company of others and, as it gets older does not engage in other activities.

Later stages

Apart from weaning, a process that affects both adult and child activities, a variety of behaviours ranging from infancy to adolescence have been identified by ethnographers. What follows are illustrations of this, drawn from studies across a range of habitat types, from the ice and snow of winter Canada to the aridity of Central Australia. However, what researchers have recorded in relation to children in the societies they have also reported is extremely variable. Further, in many, cases studies are more frequently concerned with impact on adults, or on biological factors associated with the health and nutritional development of children, not their behaviours, far less their feelings and sensations. Such constraints considerably reduce the number of studies of use here and this is consistent with the notion of the invisible children of anthropology and, by extension, archaeology.

The major sources I use include Kelly 2013, who edits studies, of greater and lesser extent, of 106 hunter-gatherers societies, worldwide, and Hewlett and Lamb (2009) who edit studies of 25. However, particularly in Kelly, the constraints outlined above apply. Further societies, not included in these texts, are reported by a few, but increasing, number of researchers into hunter-gatherer childhoods and I refer to these. There are also historic reports; but I look no further back than the 1970s, largely because of bibliographic access constraints. An issue related to selecting a sample to present here, drawing on published work, is that this may not necessarily be representative of the range of hunter-gatherers societies in the world today. For example, anthropologists possibly have tended to concentrate on certain areas of the world for pragmatic, personal interest and political reasons.

Hunter-gatherer groups today exist in a wide range of environments, from the deserts of Australia, through more temperate and tropical regions, to the ice of the arctic. I have reflected this in my selection, although climate and related physical environment may not be a key determinant of behaviour. Finally I have included some societies that interact with agriculturalists and/or trade and those that are nomadic herders as well as hunter-gatherers. Increasingly, since the beginning of the twentieth century, 'pure' hunter-gathering has diminished. However, in the societies I have selected, hunting and gathering is still a major, if not a crucial aspect of subsistence.

Thus, it is a combination of the availability of reports in the public domain, the variety of locations and the degree of separation from non-hunter-gatherer lifeways that has conditioned my selection of the 17 cases, listed in Table 3.4, together with sources. Although the examples are intrinsically interesting and may be are described in more detail, space here precludes this. However full details may be found in Wilson 2015 appendix 2. The summary of these studies presented here identifies common themes among them in relation to childhood, which might be used to apply to the interpretation of Mesolithic hunter-gatherer children. The studies render the following themes: Mother's activities during weaning; post weaning caregiving; play activities; self-sufficiency; foraging; small game hunting; large game hunting; fishing; household maintenance; leaving camp; conferment of adulthood.

Not all reports comment on all these categories, therefore each of the case summaries below only include those that are mentioned.

Table 3.4: Ethnographic communities

Community	Sources
1. The Martu, Australian Western Desert	Bird and Bliege Bird, 2009
2. The Aranda, desert areas, Central Australia	The Australian Division of Labor, accessed April 2015
3. Ngatatjara, North West Coast, Australia	Testart, 1985
4. The Mikea, deciduous coastal forest, Madagascar	Tucker & Young, 2009
5. The Hadza, savannah-woodland, Tanzania	Marlow, 2009
6. The !Kung, Northwestern Botswana	Konner, 2009
7. The Bofi, Congo Basin rainforest, Central African Republic,	Fouts and Lamb, 2009
8. The Agta, Philippines, tropical rainforest	Konner, 2009
9. The Ache, Sub-tropical forest, Paraguay	Konner, 2009
10. The Yora, Peruvian Amazonia	Sugiyama and Chacon, 2009
11. The Inuit, Nunavut, Canada,	The Canadian National Collaborating Centre for Aboriginal Health, 2007)
12. The Innu, boreal forest, northern Canada	Alexander & Alexander 2009
13. The Evenki, taiga and tundra of Siberia	Alexander & Alexander, 2009
14. The Komi, Forest and Swamp, East European Plain, Russia	Alexander and Alexander, 2009
15. The Cree, forest, woodland or plains, North America,	Siddiqui, 2013
16. The Nayaka, Southern India, forest	Bird David, 2009

From these 17 studies, it does seem that there is some element of stages in children's lives, observed in various hunter-gatherer communities today. A period post-infancy occurred in eight out of 11 cases reporting this, where caregiving was not provided by a parent but in playgroups, supervised by older children or young adults. In these playgroups, as well as non-subsistence related play, children learned to acquire food for themselves. In most cases, where it was mentioned, foraging began during early childhood, before the age of six. However, where the environment was very dangerous for children, among the Ache of the Paraguayan sub-tropical forest, this did not begin until age nine. Indeed all activities for Ache children seem to be delayed in comparison with other cases, a consequence of the danger perceived and probably actual. Hunting also begins during early childhood (again with the exception of the Ache); but this is, to some extent, conditional on whether the prey is large or small. However, some associated tasks require strength to develop to a certain level, which is not necessarily associated with age. The children acquire food either for themselves or to contribute to group resources. Whether this is being forced to take part in economic activity as queried by some of those I discussed my work with, perhaps brings an inappropriate perspective.

In some groups younger children do not leave camps, although they will forage in the camp area; but as they approach adolescence they are allowed to go further from camp. Adulthood is generally conferred at a younger age for girls, typically on marriage, after first menstruation, around age 15. In this case, adolescence as the transition from childhood to adulthood may be less long for girls than boys, who marry at a later age.

In general, in a variety of western ethnographic reports, mention is made that hunter-gatherer parents are 'indulgent' (Tucker and Young 2009, Konner, 2009, Narvaez, 2015). It does seem that, because experiencing an environment that will provide for the individual and the community is, existentially, absolutely necessary for young hunter-gatherers, indulging children so they may learn, within the bounds of some safeguarding, such as placing younger children in the care of older children, having the occasional lookout adult in earshot, restricting how far someone may roam, is an appropriate strategy.

There is, of course, variation in what children in different societies will experience, again largely determined by environment. For many hunter-gatherer groups for whom plant, that is, foraged food is available and frequently the major constituent of nutrition, this is often mainly gathered by women. Therefore children, given that infant childcare is primarily provided by women, will also take part in foraging or, in their earlier days, play at mimicking foraging. Where meat, such as in the Arctic,

predominates, hunting for it is largely men's work, although women process the meat and make clothing and other materials and equipment from animals. With little or no plant food to gather, women fish and gather shellfish, collect firewood and water. Again, infants and younger children will be witness to this and learn how to do so for themselves.

There is some variation as to when gendered activities emerge and, sometimes, they do not, with respect to hunting. As illustrated in some communities, both adult men and women and children of both sexes, in middle to late childhood, hunt larger game

Themes emerging from the illustrative case studies indicate that:

- adult caregiving behaviour towards children is conditioned by the relative balance of the need to acquire food without being encumbered by the presence of children and the need to sufficiently protect children from danger;
- mixed playgroups, overseen by older children are common and are a centre for learning as much as, if not more than, being with adults;
- in some cases, children become self-sufficient by middle-late childhood;
- mimicking, first in play, in early childhood, is a common method of learning to do things, including the manufacture of artefacts;
- marriage often confers adulthood and marriage age is younger for girls than boys;
- hunting is not always gendered, particularly in respect of small game and sometimes with large game, therefore gender specific hunting activities in children should not be assumed.

The question is, is there enough commonality across these illustrations to make some plausible inferences about the life of a Mesolithic child? I suggest that reliance on older children as carers, lifeway learning taking place in playgroups as well as with adults; capacity for children to forage; capacity for children to hunt and fish with increasing proficiency; and marriage as conferment of adult status are all reasonable candidates. Indeed I recently gained some confirmation for this at the 11th Conference on Hunting and Gathering Societies, held in Vienna, 8–11 September, 2015, where a number of other speakers referred to identifying similar themes.

It is at least plausible that an archaeological appreciation of hunter-gatherers of the Mesolithic could propose similar observations. This would be limited if considering only the scant material culture that exists. However, this could be examined through archaeological experimentation and phenomenology. Thus, indications of the presence of any of these observations in the phenomenological and experimental exercises conducted with children, discussed below, are sought.

Analysis of material culture: Finding children in European Mesolithic archaeology

As noted in the introduction to this chapter, there is still very little published about children's lives drawn from archaeology and much that there is rests on material cultural objects seen to be associated with children and skeletal remains, most frequently retrieved from burial sites. Thus, the bones of children and, sometimes the animals interred with them, flints, stones and minerals and, more rarely, organic matter and things which might be made from these resources represent what might be sources of information. Disposition of burials and the goods accompanying them may suggest social and familial structures, attitude to age and gender or ritual activities in relation to children. Children are sometimes thought to have been found elsewhere, for example, flintknapping areas, places where there is art showing small handprints and occasionally in traces left in Mesolithic sands and silts by footprints.

Although such sources are limited, there are various reports in the literature and the following examples illustrate attempts made by archaeologists to understand Mesolithic childhoods.

Information from burials: Southern Sweden and Latvia

Fahlander (2012) examined graves of those identified as being of children at the Mesolithic site of Skateholm in Southern Sweden. From this, using grave content and spatial arrangement, he deduced that differentiated life stages of children could be identified. Hunter-gatherers in the area recognised differentiation between infants of less than one year old, children up to age seven and children who began to take on adult activities around the age of seven. By the age of 14 burials between Adults and 'children' were indistinguishable, although individuals aged nine to 13 were not in the group at all. Fahlander suggests this absence may be because that this period of life 'constituted a socially distinct transitional phase between childhood and adulthood' (20). These age bands are consistent with the developmental model presented in Table 3.1 of infancy; early childhood; middle-late childhood and the absent group may indicate early adolescence.

Janik (2000) in studies of Mesolithic cemeteries at Skateholm and Vedbæk-Bøgebakken, also in Sweden and Zvejnieki, Latvia, concludes that social relations were based on age rather than gender, although the categories are only twofold – younger people and adults. She indicates that, in Zvejnieki, younger people were defined as independent beings in their own right. In Sweden, they were only accompanied with grave goods when buried with an adult, which she interprets as not being seen as independent.

Studies of flint assemblages

Some have attempted to relate flint assemblages, found at various sites, to children. In so doing, they have relied on experimentation, which is a methodology I use below to provide primary data. Here I examine four reports, by Högberg (2014); Sørensen, 2002 Sternke and Sørensen (2007) and Ferguson (2008).

Högberg considers that children's playful imitation of adult flint working could be identifiable in the archaeological record. He suggests this could be seen if differentiated, but distinguishable work occurs together, assuming that the adult work could be copied and proposes that distinguishing factors would include that the adult work demonstrates a level of technical achievement and identifiable patterns of handling which the child cannot reproduce in imitation. Drawing on Finlay (2007) he indicates that, the child's efforts are seen as 'game-like', 'non-utilitarian', 'poorly knapped', not as skilled as novices and simpler and unstructured in comparison to that of adults (Högberg, 2014:117). Using these factors, he establishes three criteria to assess a Neolithic lithic assemblage from Øresund, in Southern Sweden. These are:

- Systematic technology versus ad hoc technology;
- High quality (selective) raw material utilisation versus low quality (non-selective) raw material utilisation;
- Typological forms versus non-typological forms (119).

He found that flint from a knapping area demonstrated two strategies, one of systematic production of a specialised tool, which were produced from high quality flint; the other the unsystematic production of flakes, of low quality flint. Also found together were a Neolithic square sectioned axe and 'something else', the latter made from poor quality material (125). Högberg's interpretation of this is that an adult was knapping an axe and a child imitated (but did not copy) this. He suggests that serious novice tool makers would attempt to thoughtfully copy, albeit with mistakes, using

better material, and not simply imitate to make something that merely looks like a tool. An expert toolmaker might make mistakes; but would certainly use better material and, essentially, know what he or she should be doing. Thus, he suggests, there is a method here of differentiating a child from a novice, since the imitated axe is an example of child's unorganised play, whereas a novice's act is an example of an older person's learning. The implication is that imitated rather than copied flintwork is indicative of the presence of children.

In 2002, Sørensen (also reported by in Högberg, 2014) asked a six-year-old boy to join him while he was flintknapping, for one week, at a museum demonstration. The boy was not instructed. He observed, imitated and asked questions. The boy produced a set of objects which were like prehistoric tools in form and shape; but had none of their technological attributes. It is not possible to deduce from this that six-year-olds in prehistory would not have produced proficient flint tools; but rather that care must be taken in directly interpreting what a child, particularly in an experiment, may produce, there may be many factors interacting.

Sternke and Sørensen (2009), drawing on earlier work by Sørensen, including the example presented above, use the idea that technical competence and selection of material can be indicators of children's activities in relation to flintknapping, testing this against the Mesolithic Ertebølle assemblage from Sparregård, Denmark. They identify, through experiments, the attributes that are typical of beginners' (such as children's) work, which include lack of motor control, lack of skill and an insufficient conceptualisation of knapping and suggest that evidence of a combination of these in a lithic assemblage would indicate the presence of a child at work.

Ferguson (2008) is concerned with the differentiation of novices and children and states that the two categories should not be interchanged. He assumes that adults enable children to take part in craft production, through training and allowing them to practice. Refining the concept of raw material to include ease of access, value, recyclability and arguing that these would determine the extent to which children would be allowed to use a particular type of material, he adds factors, other than the physical and mental capacity of a child, that would enable them to undertake production, such as the danger associated with such activity and social and contextual matters. He considers social and contextual aspects problematic to identify in the archaeological record; but notes that there may be relationship between the type of lithic technology any particular group uses and the extent to which children may be engaged in production, suggesting that sedentary agricultural villages using simple core tools are likely to have a different learning approach than highly mobile hunter-gatherer groups that used complex bifacially flaked tools and that gender, age and social context of the teacher may be important, for example if only old men or mothers were allowed to take on this role (56).

He also uses the concept of scaffolding, whereby a trainer selectively supports the efforts of a learner. Thus a child may be encouraged to complete some parts of tool production themselves; but an adult undertakes the more complex aspects, until the child can gradually become more and more proficient. This minimises waste of raw material as 'novices' only undertake tasks with minimal risk of failure (52). In his research, Ferguson has discovered that no four-year-old child is able to carry out lithic reduction safely and successfully, even if an adult takes over most of the technical tasks required. A significant observation made in the context of this study is that difficulties arise if the terms of novice and child are conflated. A novice is a beginner and may or may not be a child. Thus it is unhelpful to assume that a beginner's work is that of a child. There must therefore be considerable question as to whether any such work in a lithic assemblage represents the presence of children in such production and indicates that other methods to address the role of children in and their identification from the lithic record are required, such as ethnographic comparison or experimentation.

Through conducting experimental, instructed, flintknapping with children, Ferguson discovered that almost all children under the age of 10 were incapable of producing flakes long enough to thin to a flake blank. If raw material was 'costly' then it would be unsurprising if knapping training did not happen until a later age.

The issue is, how to identify such processes in the archaeological record? Ferguson indicates that, although there may be some record of unskilled reduction in debitage, individual experimentation may be the most obvious clue to a child being present, since children mimic adults.

From these case studies, there is some suggestion of how, possibly, to identify children's practice in relation to the creation of flint tools, which can form a basis for some interpretation. As is discussed below, there was no opportunity in this study to engage children in flintknapping. However, some of the principles can be transferred for identifying and understanding children's presence from the artefacts they fashion and activities they undertake, experimentally and I report this in more detail below.

Specifically in relation to considering Mesolithic children at Blick Mead, Bishop (2015) has produced a preliminary analysis of the flints found there. Inevitably, given the immense quantities of human action associated flint recovered (c. 31,500 pieces), this is far from completed. Certainly no information or opinion has been definitively formed, to date, as to the likelihood or extent of children's involvement in the production or use of flint tools. However, a suggestion I make is that since there is considerable amount of unworked burnt flint, which indicates cooking, as Bishop (2015) suggests, on a scale larger than for a simple hunting camp, and since, as the ethnographic studies above indicate, children may be present at the return of hunters and associated feasting (Bird David, 2009), it is possible that Mesolithic children, who might have numbered between 40 and 60% of the groups' members at any given time, would have been present at this hearthside.

In sum taking together the information in this chapter about Mesolithic children's presence identified from archaeological excavation and an appreciation of material culture, there does appear to be an identification of what is appropriate to certain life stages of a child, indeed, life stages may be inferred; that far from being forced to engage in economically productive activity, children want to do this, from a young age, even if they cannot be proficient until older; and that they can effectively manipulate flint tools given to them.

Landscape phenomenology and children

The site at Vespasian's Camp, including the excavated area at Blick Mead was used for undertaking landscape phenomenology with four children aged between four and nine years. The assumption made here, for the purposes of a phenomenological study is, that in many ways, the site has not altered much since the Mesolithic. To do this, as recommended by Johnson (2010) and Bender et al. (2007) account has been taken of various scientific examinations which have been made of the site, including climate conditions, geology, flora and fauna. These have indicated the following.

In the Mesolithic the area was in the then floodplain of the River Avon, close to the valley side, subject to infrequent flooding. It was probably marshy and with standing water present intermittently. Notwithstanding the raised ground levels today, the site area is similar. The distribution of the archaeology, which has undergone very little redistribution since its deposition indicates that the environment was very stable during the period of Mesolithic occupation, which spans 3,000 years (Young, Green, et al., 2015).

The springhead was more active during the Mesolithic when winters were wetter, summers warmer and the ground water table higher than today, providing for many more perennial springs. The unworked flints found in the springhead basin are a variety of shapes and sizes. Some are nodular or cobble-like, others show the effects of thermal flawing, weathering and being rolled (John, 2015 personal communication). Bishop (2014) suggests that the presence of a wide variety of flint types indicates they were probably brought some distance before being deliberately deposited in the springs. These flint types are in addition to the 31,500 mentioned above. Of particular note are the red and pink flints.

Red flints are visible on the floor of the pools of the outflowing stream from springs. Some of the team working at the site suggest it is these flints which might be one reason which drew Mesolithic

groups to such a special place. They may have had mystical meanings or ritual uses. Further, perhaps flints were specifically deposited in the springs to turn red, producing a regenerating supply. In addition there are pink flints. These are flints picked out of the spring, which, a few hours after being removed, turn and remain magenta pink. This is caused by an extremely site sensitive and rare algae, Hildenbrandia Rivularis, which grows on the flints and dies when removed from water. As a personal speculation, perhaps there was even a Mesolithic industry at Blick Mead and this was the place to visit to acquire a red or pink stone? Hunter gather groups today exchange meaningful objects, would groups in the Mesolithic do likewise?

Other aspects of the site include the comparative pre-eminence of Bos-primigenius (aurochs) as indicated by such bone fragments as have been found. These comprise about 61% of the total. Thus, large game hunting was an important activity. It is possible that these beasts were hunted in the woodland around the springs, rather than on the plain, and dating has indicated that at least one animal was caught in Autumn when aurochsen would more likely be living under the woodland canopy (Rowley Conwy, 2015). Jacques and Phillips together with other contributors also report on a number of these matters (2014).

As noted above, today's site is very like that of the Mesolithic. Modern cattle have replaced the aurochsen, grazing by the riverside, but many trees and other flora of the woodland are the same, as are small animals. Those that have disappeared from the area include wolves and wild boar, so it is a safer environment in that respect; but the presence of water and in particular the springs and the steep sides of the valley still present a danger to children. So what did modern children make of the area?

A children's afternoon at Blick Mead and Vespasian's Camp

In line with the processes of phenomenology, what was sought was the children's perceptions of the site, from their utterances and their behaviour. Unstructured notes were taken together with photographs. Occasionally there was a question aimed at teasing out perceptions, or sensations, such as 'what does this make you feel like'; 'what can you see from there'; 'what do you think you could find to eat'; 'what can you hear'. The accompanying adults' behaviour was also observed, to some extent. (For further details see Wilson 2015, Appendix 3.)

The children were quite content to explore the area without adult guidance or in close proximity, even the youngest at age four, who, on more than one occasion, led the way (the adults were constantly monitoring the children though.) The children explored in changing groups or solo, sometimes tarrying behind when something attracted their attention, sometimes going on ahead.

Things particular to senses commented on were the smell of animals; sounds from the valley below, as we approached the heights of Vespasian's Camp, in the undergrowth, or crow calls; and views. The interpretations children applied to things they experienced included that they could make a shelter in the environment from materials to be found there; they could make weapons to hunt birds and animals; that there had been other fairly recent visitors to the site; that the spring bubbles were inexplicable without recourse to supernatural causes; that the heights would be a good vantage point from which to view enemies or animals; that sticks have a variety of uses. I was fascinated by the oldest choosing to throw the largest flint nodule she could find and carry into the spring and the youngest turning two sticks into a musical instrument with which she beat a steady rhythm throughout most of the visit, although she occasionally hit a tree too. There was a mix between objects in the woodland being a source of both playthings and materials to make utilitarian objects.

In relation to the observations from the ethnographic studies, adult behaviour towards children during the visit to this unknown (for most and certainly all the children) landscape was conditioned by the relative balance of danger and safety. The track through the site was in woodland, on rapidly

rising ground, which fell away steeply at one side. This presented some danger. The adults constantly monitored the children, moving closer or further away as conditions determined. They did however let the children do as they liked with little intervention, they simply remained alert, in case they might be needed. The only major intervention was when children attempted to climb trees at the highest point (120 m above the river below). The adults prevented them from doing so. At the spring the children were more closely monitored than elsewhere and were prevented from venturing into the water too near it.

The children mimicked making weapons – catapults and spears to hunt with. This had not been suggested to them, although they had been told that Mesolithic people would have eaten eggs and children would have gathered these. The weapons were thrown at imaginary targets. A girl took the lead in making hunting equipment showing the boy how to do this.

Interpretation of the landscape phenomenology exercise

Today, the wilder a place, the more fearful of it many people may be, particularly those from non-rural environments. This is unsurprising, especially as non-urban dwelling becomes rarer. In history the wild and untamed landscape has been seen as dangerous, this danger reflected in traditional European children's stories – Red Riding Hood; The Babes in the Wood, for example, and continues to today in Pullman's *Northern Lights* or Tolkien's *The Lord of the Rings*. Blick Mead is by no means wild and it is probably more than 1,000 years since a wolf, more familiar in the Mesolithic, made its presence felt. However, it was a place unfamiliar to the urban children roaming it; yet, even the youngest clearly felt comfortable there and they were not at all bothered about being out of contact with the adults in the party. Mesolithic children would have known the dangers around them, so perhaps it is not too fanciful to suggest that they too would feel at ease at Blick Mead and the surrounding area.

The twenty-first-century children's senses were sharp; they spotted many things – resources for shelter, firemaking and tool making. As such, they seemed to have a strong sense of engagement and feeling for the environmental objects around them. They were responsive to the smells and sounds of the environment and the utility of its materials. Again, might not Mesolithic children have this responsiveness?

The children certainly mimicked adult behaviour (probably engendered by visual media they will have been exposed to though) by attempting to make weapons and analyse the remains of a fire. Mimicking is thematic throughout both the ethnographic and archaeological studies reported above and, it seems, must be part of a Mesolithic child's behaviour too, if human beings have not changed much over the millennia.

The adults associated with the Blick Mead springs are certainly interested in their mystical, ritual, or spiritual connotations. The children were unaware of the adults' thoughts but they did find it a place for play and interest and were very reluctant to leave. Anecdotally, children do seem fascinated with water so it is not hard to imagine Mesolithic children being likewise.

Object phenomenology and children

Object phenomenology may provide for a child's view on Mesolithic artefacts. Few artefacts other than flint or similar tools are found in relation to Mesolithic people and none were available to this study. What was available was an abundance of many types of flint objects, from debitage, through blades, scrappers and boring tools to the tiniest of microliths and these were used to examine children's interpretations.

Interpreting flint tools

Two children were given some flint tools from Blick Mead to examine and asked for their opinions on these, which were recorded. It was interesting that despite the contemporary child's frequent exposure to violence in the media, be it cartoons, fantasy films or news items, these children were able to also hypothesise peaceable uses for flint blade tools, such as cutting up food. Flint scrappers were seen as 'something to shave with' and pointed tools were identified as something to make holes with.

Unearthing (literally) flints and other stones

These two children were joined by two others at the Blick Mead excavation site spoil heap and were told they could look for flints, similar to the ones previously examined by the first two. Initially the children selected out large flint nodules. It was explained that these were what flint tools were made from and that it was thought that 'stone age' children might have been expected to look for them along the banks of the Blick Mead spring and the River Avon. They were shown further examples of flint tools from the spoil heap and the children subsequently sought these, bringing them to adults for identification. The older ones were, after instruction, able to differentiate cortex from worked flints. The three eldest, two aged seven and one aged nine, rapidly became proficient at identifying possible tools and then looking more closely at these for signs of retouch. The youngest, age four, understood that she should look for small pieces of flint, but did not recognise possible tools. She did however tell her mother that she 'really liked' the pink flint she had found (i.e. a small red stone) but had buried it to 'keep it warm'. The others also made up playful narratives about the flints they found, identifying two skulls, a mushroom and a skeleton bone. At this stage, the children had not been shown the magenta pink flints. When they were, a little later, they were unimpressed.

Interpretation of the object phenomenology exercise

The children certainly applied meaning to the objects they were shown or found. They inferred utility from the tools they were presented with; but there was more interpretive variety displayed by them towards the objects they discovered for themselves, in which they drew on and expressed personal narratives. Might it not be the case that Mesolithic likewise might have imbued, objects, in this case stones with stories and meaning?

Experimental archaeology

A day of experimental archaeology was conducted with eight children, at Besselsleigh Wood, an extension of Tubney Woods, where evidence of a Mesolithic hunting base was identified by Bradley and Hey (1993).

The site

Although the site for the experimental day was not specifically chosen because of this, an assumption is made that there are environmental similarities between today and the Mesolithic. The ancient woodlands are situated near the Oxfordshire Corallian Ridge, which itself overlooks the River Thames. A pollen sequence from Cothill Fen, 2 km from the site, for the early post-glacial period suggests that open woodland was present on the ridge. The Mesolithic site was occupied during a period when birch, willow, pine, hazel and elm and later oak, lime and alder were present. All are still there today. Such woodland, together with nearby fen margins and rivers provided for subsistence resources. The excavated Mesolithic site itself was on higher ground, overlooked the Upper Thames Valley and would have been a good vantage point. An unusual feature of the Cothill pollen sequence, which mirrors that found at Blick Mead, is the continuing presence of pine pollen to about 7700 BPE.

The majority of the flint assemblage from the site is Early Mesolithic, likely to date from 9800 8500 BPE and tool types led the excavators to conclude that the site was a winter base camp, set up in an area where herd animals, such as red deer, gathered. Fishing was possible and vegetation and shelter available. It was also suggested that activities such as hide and food processing took place at the site and that in addition to the quantity and range of tool types, the repeated frequency of fire lighting indicated there was repeated or extended occupation and task specific episodes.

The children's experimental day

It was in this location that the children were set a number of tasks, including, following deer trails; identifying plantain leaves and making salve from these; identifying and collecting burdock leaves; identifying and collecting clay; firewood collection and identifying oak firewood; food preparation, particularly venison and trout; making digging sticks with flint tools; making baskets.

The children were able to undertake all of the tasks set them, to some extent. They also attempted firemaking, by using a bow, when left by themselves, having seen an adult do this. They were not specifically instructed, but were told about the various methods that might be used and the importance of having kindling available. They were unsuccessful in their attempts. Since developing firemaking skill requires practice and initial help from a competent individual this is unsurprising and this activity is a clear candidate for a scaffolding approach as described above.

All were able to achieve the tasks that they were set, although the two youngest, at ages seven and six years, 10 months, were less competent than other children, who, for the most part were only a year or two older. The oldest two, at nine and 13 were very competent. They were able to carry out tasks with minimal instruction and demonstration. The older children guided and helped the younger ones as well as each other.

Once an individual had completed a task he or she began to play and was joined by others. The children usually absented themselves from adult presence to do this.

It was disappointing that, for safety reasons, plans had to be abandoned for the children to knap flint themselves. However, there are several reports of this in the literature, as discussed above. All the children were allowed to handle flint tools in order to prepare food and make their digging sticks, which they undertook without mishap. (For further details see Wilson, 2015, Appendix 2.)

In relation to the observations gathered from the ethnographic studies, although the children were monitored by adults, this was not the case all the time. The children frequently ran off to play out of sight of adults. From comments made it seems that the 13-year-old boy was seen by them all as their 'leader'. They bestowed on him the name 'legendary warrior'. The children responded if called back by an adult to undertake tasks.

The children were able to identify possible food plants, once shown what they looked like and gather suitable leaves. After instruction they were also able to adequately prepare both venison and trout by skewering them on sticks they sharpened. They also wrapped the trout in burdock leaves and encased this in clay. The eldest placed these in the fire. This is similar to a report of Hadza children, in Tanzania today, who spend the day in mixed-age groups. In this case a four-year-old was able to retrieve weaver bird fledglings from the nest and string them around his waist on a vine. When he was hungry he pointed to one of the birds and an older boy roasted it for him (Crittenden, 2015, personal communication). The children at Besselsleigh could keep the fire going, although they could not start it and collecting firewood was a chance to be away from the adults.

The children were keen to copy tasks from adults, either proficiently as in the case of basket and digging stick making and food preparation or with non-competent mimicking, as in the case of fire making.

There was no gendered division of tasks. Clay digging, with a heavy modern spade, was undertaken by the most delicately built of the girls, together with carrying it back to camp (with others). In this, although it was clearly testing for the four children carrying the very heavy clay, all, including the youngest and smallest, were determined not to give up. All took part in food preparation and basket making, which are frequently seen as gendered tasks.

Interpretation of archaeological experimentation

The children's behaviour during this brief experiment does indicate hunter-gatherer children's behaviour and, to some extent, that of adults present, identified in the ethnographic studies considered above. This includes the balance of risk between close and non-close supervision; the role of older children; possibility for self-sufficiency; mimicking; and non-gendered task activity. In my view, given sufficient learning opportunity children of the ages represented on the day could certainly forage to provide for themselves and, I suspect hunt and this would be a plausible indication for Mesolithic children's behaviour.

Assessment of the usefulness of an archaeological methodological framework to aid understanding of the child in the Mesolithic

A final aspect of this study needs to be addressed. How well does an archaeological methodological framework approach work in the search for an understanding of pre-historic children? The research questions examined are:

1. Which archaeological methodologies could provide appropriate data collection and analytic methods for the study of pre-historic children?
2. To what extent can a useful and plausible methodological framework be created for use by archaeologists examining the experience of pre-historic children?

A methodological framework, comprising a review of material culture, a review of archaeological studies, ethnographic comparison, landscape phenomenology, material phenomenology and archaeological experimentations was applied to a case study of the life of a child in Mesolithic Blick Mead.

It sought to address the following:

1. What constitutes 'child'?
2. What might constitute a child in the Mesolithic?
3. What did a child in the Mesolithic experience in relation to societal structures/behaviours; place/location; objects.
4. What activities did a child in the Mesolithic undertake?

Question 1 was addressed by considering historic commentary, contemporary views from 'western' industrialised societies and ethnographic reports on children in hunter-gather societies today. The historic commentaries tended to demonstrate essentialist views of a child, whereas modern commentaries tended towards developmental models, postulating ages of childhood. It was this latter approach that was used in reviewing selected ethnographies and, as such was consistent with Kamp's (2001) suggestion that 'an optimal first step in the study of prehistoric children would be the determination of significant cultural age categories and their basic characteristics' (4). Indication of an appreciation of childhood life stages from the ethnographies, with differentiated behaviour from and treatment by adults of children related to age, sometimes a proxy for strength, did emerge to some extent, until children were no longer considered as such and became adults. Common themes included:

- the use of older children as carers for younger, usually in 'playgroups' providing safety for the latter and freeing more competent parents and other adults for resource gathering;
- that learning often developed in playgroups, commencing as mimicking and then becoming more competent;
- frequently, where it is relevant, foraging begins in early childhood, and in some cases, children become self-sufficient by middle-late childhood;
- that marriage often confers adulthood and marriage age is younger for girls than boys;
- that hunting is not always gendered, therefore gender specific hunting activities in children should not be assumed.

Given the assumptions made by colleagues presented in the introduction to Chapter 1, concerning the nature of children, such as 'weren't children just used as labour?'; 'didn't they just kill them if there were too many?'; 'weren't they cruel to children?'; 'I don't suppose they educated them?', from the ethnographic studies I have reviewed, it would seem that such views on childhood in the past, if compared with hunter-gatherer childhoods today are limited and possibly conditioned by worst-case reportage.

Doubtless, as it is today, life in Mesolithic hunter-gatherer groups could be challenging and sometimes tragic, with, under some circumstances, communities completely wiped out or, children suffering to a great extent from adverse events; but evidence from today's groups indicate strength amongst children to provide for their own survival and, as some point out, from a society that many would consider, perhaps mistakenly, at the margins of survival, 'carefree' (Konner, 2005:29; Canadian National Collaborating Centre for Aboriginal Health, 2007). In addition, what is too frequently seen in the west as a problem among some hunter-gatherer groups of being 'too' indulgent towards children, which in the worst cases leads to governments imposing inappropriate systems of control and education on hunter-gatherer groups, such as in Australia, Canada, and Russia, such indulgence is more likely to be a strategy to ensure survival. This issue was recently discussed during the 11th Conference on Hunting and Gathering Societies, held from 7–11 September in Vienna, during session 38 on Hunter-Gatherer Childhood, where papers by Narvaez, Crittenden and Minter tended to support this position. I conclude that considering childhood from the methodology ethnographic analogy, has, in this case, provided insights into a pre-historic hunter-gatherer childhood.

Question 2 develops the inquiry into what life might be like for a child in the Mesolithic. This was addressed by both ethnographic analogy and consideration of the archaeological record, the latter particularly in northern Europe.

With respect to ethnographic analogy, the issue is to what extent studies of today provide a plausible appreciation of life in prehistory. The key opinion on this is that such analogy is relevant if a position is taken that regarding today's hunter-gatherers as relics from long ago is inappropriate; but that the living conditions of hunter-gatherers today – hunting and gathering – replicate those of past hunter-gatherers and therefore it is plausible that the ways in which hunter-gatherers live today is indicative of what might have happened in the past and acts as a signpost for what to apply to the past. This may be corroborated to some extent by information from archaeology. Thus, is there any sign of childhood stage in the archaeological finds from the Mesolithic? Can any of the themes summarised above be seen in this? Are there additional inputs to understanding a child's life?

In the archaeological studies of burial sites in northern Europe reported above, there is differentiated treatment which appears related to the life stage of a child (and not other factors, for example, gender). Studies of flint assemblages, which have incorporated experimental archaeology, indicate that, far from being forced to make tools, children want to do this, from a young age, even if they cannot be proficient until older; and that they can effectively manipulate flint tools given to them. This adds to the picture of a Mesolithic child as actively and voluntarily engaging in mimicking and learning life skill through quotidian and play activity, towards a position of self-sufficiency. This notion may, to some extent, critique the image created of a Magdelanian 'school' of flintmaking identified at Etiolles in France by Pigeot (2006), where concentric rings of less skilled apprentices are deemed to circle a master knapper, which seems to rely on the modern construction of the value of a formalised education as commented on by Kamp (2001).

Considering childhood from the methodologies of ethnographic analogy together with examination of archaeological material culture has, in this case, provided insights into a pre-historic hunter-gatherer childhood.

Question 3 was primarily addressed by engaging children in landscape and object phenomenology at Blick Mead, which, as reported above, has remained unchanged, in a number of respects, since the Mesolithic. What they might have experienced in terms of society and behaviour is better addressed by the archaeological record and ethnography as commented on above.

With respect to place and location in experiencing the landscape the children appeared to feel quite safe. They were in the presence of adults, but the latter were not always in view. They were sensitive to the environmental smells, sounds, and views and actively engaged with it, although it was new to them. These children were all town dwellers, not particularly familiar with woodlands and springs, yet they quickly found possibilities for things to do and make. There was no suggestion during the exercise from the adults about what they might do; but they looked for possible shelter places and materials and suitable sticks for mimicking hunting weapons; interpreted a fire site and left their mark on the landscape, from hitting trees with sticks, leaving handprints on trees and in one case, depositing a large flint nodule in the spring, which they were reluctant to leave. There was no gendering in the activities. Thus in answer to what did a child in the Mesolithic experience in relation to place/location, it is plausible that they would feel comfortable in an environment such as Blick Mead, were able to sense and distinguish sounds and animals by their smell and to use the environment, potentially from a very young age.

The Mesolithic objects available for children to consider were flints. This was done in two ways. Children were given some Mesolithic flint tools to examine and asked what they were and what they might be used for. They immediately identified them as useful objects and then proposed specific uses. When the children were given the opportunity to discover their own flints at Blick Mead, they made up their own narratives about them. The children were not particularly impressed by the pink flints created in the spring by the action of the algae Rivularis hilderbandsis although the youngest, at four years, did make up a story about a red flint (but not one coloured by the algae). With regard to the pink flints retrieved from the spring, it is the adults familiar with these who are creating narratives about them, of significance and ritual. We, of course, have a repertoire of belief and ritual to draw on. The children did not, although they certainly had an alternative, which led them to identify flint

shapes as skeletons, mushrooms or bones. There remains the question of why the oldest child dropped the largest flint nodule she could find nearby into the spring. Her answer at the time was 'I dunno'.

In this case, I suggest that the flints did not have any particular spiritual significance for the children, indeed, they have not featured in their lives significantly to date, so why should they? But, the children do like stones, which fire their imagination. The nature of human relationships with stones, from pebble to diamond is beyond the scope of this study; but they are objects a child can pick up and possess. It is intriguing to speculate what a Mesolithic child might have made of stones in general and flints in particular, maybe both were special to them, the former because they could be possessed, and possibly the more unusual they were, the more valued and curated, the latter because they would understand how useful they are. It is interesting that stones are placed in the graves of Mesolithic children (Albrethsen and Petersen, 1976) and that the object phenomenology engaged in, with them here, has provided some intriguing thoughts.

Question 4, concerning the activities of Mesolithic children, was addressed by ethnographic analogy and archaeological experimentation. From the former it became clear that children could and would provide food for themselves and others, develop their skills, particularly among themselves, undertake household tasks and look after each other, especially care of the younger by the older, and play. In the latter, children were set to find and/or prepare food and make some household equipment independent of adults. In all of these tasks, which used the resources of ancient woodland, the children demonstrated a lesser or greater degree of competence, depending on age and the older children were looked upon by the younger as their helpers and/or leaders. The children certainly found plenty of time to play. Essentially this brief experimental activity does seem to reflect what even young children are able to accomplish in an environment similar in nature to the Mesolithic.

It is now time to assess whether using a framework triangulating ethnographic analogy, palaeo-environmental data, archaeological record, landscape phenomenology, object phenomenology and archaeological experimentation can answer the methodological question of how we might look for children in prehistory. To address this, the final part of this study is a narrative, about children, living about 7,000 years ago, at Blick Mead. The story is presented in the left-hand column below. The methodological method of obtaining this understanding, together with sources, is presented in the right hand column.

Table 3.5: Application to the Mesolithic site of Blick Mead 5000 BPE: A children's story

Narrative	Sources
It is an autumn day in 7000 BC. The equinox has passed and the sun is less long in the sky every day, although the temperature is currently warm, especially immediately around the house, although, on the cliffs above it can now be cold and windy. Rising from their sleeping place near the hearth in the house, the children go outside to warm themselves up in the sunshine.	Hoare and Jacques, in Jacques and Phillips, 2014 (hereafter J&P) Konner, 2009
They then set off to retrieve sealed willow baskets containing toads which were placed in the river overnight to wash slime off the creatures, which they will cook and eat back at the hearth. This is something they do quite regularly and especially as the colder days begin to set in.	Parfitt, in J&P Personal communication, Jacques, 2015 Crittenden, 2015
The river is some 400 metres from the house. To get there they jump from tussock to tussock, making it a game. They also pluck and eat any berries or fungi they come across, although the youngest have to be closely watched by older boys and girls, to prevent them from eating anything harmful.	Young and Green, 2015 Crittenden, 2015; Konner Bird & Bliege Bird; Australian Division of Labour; Kamei; Marlow; Konner; Fouts and Lamb; Sugiyama and Chacon; Bird and Bliege Bird; Kamei;

(*Continued*)

Analysing the child in the archaeological record

Table 3.5: (*Continued*)

They are noisy, playful. They pick up sticks and make pretend weapons, hit trees and poke in the pools with them.	Marlow; Australian Division of Labour (all 2009)
At the river they make footprints in the mud, but venture in only as far as the baskets.	*Landscape phenomenology*
The water is very cold, it is not like the spring water, close by the house.	*Experimental Archaeology* Roveland, 2000; Bell, 2007
After the heavy rains of the past few days the eldest child is aware that the banks of the river, where it is deepest, will have been washed away by the torrents flowing through and she searches for flint nodules, sticking out of the bank.	Jacques, reporting Kinge and Roberts, J&P
She retrieves a couple, quite large. The adults will be pleased with this when she shows them. Maybe, as a reward, they will let her try making a blade from an old core.	*Lithic report*, Bishop, J& P; Bishop 2015 *Landscape phenomenology*
The men left very early in the morning, just as it began to get light. They are tracking through the woodland bordering the river, hoping to come across the first of the overwintering aurochs to arrive, the animals seeking a warmer, sheltered environment, plants to browse and watering holes at the numerous pools which spread across the area. In recent days the group have heard the occasional bellows of these beasts together with the sounds of deer and boar.	Högberg, 2014; Ferguson, 2008 Alexander & Alexander, 2009; Bird David, 2009 Rowley-Conwy, 2015; Jacques, J&P
The women, with the exception of a young woman, who has just given birth, also left the house early to forage. They have to go further afield now as the close-by hazel bushes have been stripped and they do not want to be slowed down by young children and infants. Some of the women will go a further distance to find more of this most important foodstuff, perhaps setting up hunting camps. All are also searching for fungi and berries.	*Ethnographic analogy* Tucker and Young; Bird and Bliege Bird; Marlow; all 2009
The play increases the children's hunger and they set of for home. They have a basket of toads; but all now start to gather firewood. Using cords made from vines by the women and some of the older children they bundle it up to carry on their backs. They continually pick over leaves, looking for grubs or fungi to eat and pull berries off twigs as they pass. The woods are very quiet. It is the time of year.	
However an alarmed swan suddenly takes off from a large pool nearby. The two youngest drop their firewood and run off in pursuit of it. They do not yet understand hunting, simply mimicking what they have seen adults do. The eldest tells them off. She is concerned that they could have been in danger and that they were bound to have wasted their time being not yet able to hunt effectively; but then she adds – 'good try'.	*Experimental archaeology* *Ethnographic analogy* Siddique, 2013
The children come across a pool with coloured stones. They pick them out as treasures. Nearby is a heap of ashes. They play with this, smearing their faces with the ash.	*Fauna report* Legge/Rowley-Conwy, 2014 *Ethnographic analogy* Kamei; Marlow; Fouts & Lamb; Konner; Sugiyama & Chacon; Bird David; Alexander & Alexander (all 2009);

(*Continued*)

Table 3.5: (*Continued*)

Back at the house an older man had been tending the fire and sewing. He has an injury and did not go with the others to hunt. The new mother is breastfeeding her days old infant and looking after another. She has also been making baskets She takes the toads from the children and tells them they should have collected some leaves, directing two to go back to a likely spot. The toads will be wrapped in these and placed beneath heated stones to be cooked.	Canadian National Collaborating Centre for Aboriginal Health (2007) John, 2015, personal communication *Landscape phenomenology* *Experimental archaeology*
The flint finder shows the old man her flints. He praises her and shows her how to make a blade from an old core, warning her that she must not look at him while he is working, only at the flint. He knows that she is not yet competent, but might produce something a little better than just a toy.	*Ethnographic analogy* Canadian National Centre for Aboriginal Health (2007); Aboriginal Health (2007); Bird & Bliege Bird; Fouts & Lamb (both 2009)
The other children make digging sticks, or cordage and storage baskets from creepers.	*Experimental archaeology*
When the women return, they help prepare some of the foraged food for preservation, laying berries out in the sun and roasting hazelnuts. If the men catch a beast there will be many jobs, from processing meat for storage to making any number of things from hide, sinews, bone, horns (or antlers), hoofs.	*Ethnographic analogy* McKnight 1981 *Archaeological reports* Högberg, 2014; Ferguson, 2008; Sørensen, 2002;
The work of the camp is disturbed by the arrival of a boy running in from the direction of the river. He has been sent ahead by the men to tell the group set the hunt has been successful and they are bringing an aurochs calf.	*Experimental Archaeology* *Ethnographic analogy* Bird & Bliege Bird, 2009; Siddiqui (2013); Alexander & Alexander (2009); Sugiyama & Chacon (2009)
The children are very excited and run out along the route the boy took, to greet the hunters. Certainly some of the aurochs will be eaten now, the women set about completing the butchery the hunters have started at the kill site and the rest will be preserved by smoking and drying.	Ethnographic analogy Konner, 2009
After all have eaten their fill and are settling down to their sleeping places, the old man says to the girl, tomorrow you may put your blade into the spring, when I marry to your sister.	Fauna report Rowley-Conwy, 2015 *Ethnographic analogy* Kamei, 2009 Siddique, 2013 *Landscape and object phenomenology*

A credible tale? I would like to think so, from what I have considered and reported here in this study. I hope that readers will also. This, however, is only the start of the journey and I look forward to applying a framework approach to further research, eventually perhaps simulating a mixed-age experimental Mesolithic group, living for some time, in a homebase in a Mesolithic landscape.

Bibliography

Alexander, B., and Alexander, C. (2009). Accessed at <http://www.arcticphoto.co.uk/evenki.asp> (also Even.asp and Cree.asp), March 2015.
Bandura, A. (1977). *Social Learning Theory*. Englewood Cliffs, NJ: Prentice-Hall.
Barnard, A. (2004). 'Indigenous Peoples', *Anthropology Today*, 20 (5), 19.
Barrett, J. C., and Koh, I. (2009). 'A phenomenology of landscape: A crisis in British landscape archaeology?' *Journal of Social Archaeology* 9 (1), 275–294.

Bauman, Z. (1978). *Hermeneutics and Social Science*. London: Hutchinson.
Baxter J. E. (2005). *The archaeology of childhood*. Walnut Creek, CA: Altamira Press.
Bell, M. (2013). 'Stone age footprints in the Severn Estuary', accessed at <http://www.getreading.co.uk/news/local-news/reading-researchers-dig-up-stone-4048525?pageNumber=6>.
Bender, B., Hamilton, S., and Tilley, C. (1997). 'Leskernick: stone worlds; alternative narratives; nested landscapes', *Proceedings of the Prehistoric Society* 63, 147–178.
Bender, B., Hamilton, S., and Tilley, C. (2007). *Stone Worlds: Narrative and Reflexivity in Landscape Archaeology*. Walnut Creek, CA: Left Coast Press Inc.
Bintliff, J. L. (2000). 'Archaeology and the philosophy of Wittgenstein', in Holtorf, C., and Karlsson, H., *Philosophy and archaeological practice; perspectives for the 21st century*, Göteborg: Bricoleur Press, 153–172.
Binford, L. R. (1983). *In pursuit of the past, decoding the archaeological record*. London: Thames and Hudson.
Bishop B. (2015). Archaeological Investigations at Blick Mead, Amesbury: Trench 24.
—— (2014). 'Assessment of the lithic material', in Jacques, D., and Phillips, T., et al., 'Mesolithic Settlement near Stonehenge: excavations at Blick mead, Vespasian's Camp, Amesbury', *Wiltshire Archaeological and Natural History Magazine* 107, 15.
Blaikie, N. (1993). *Approaches to Social Enquiry*. Cambridge: Polity Press.
Bock, J. (2009). 'What makes a competent adult forager?' In Hewlett, B. S., and Lamb, M. E., *Hunter-gatherer childhoods, evolutionary, developmental and cultural perspectives*, New Brunswick, NJ: Aldine Transaction, 109–128.
Bowlby, J. (1989). *Secure Attachment*. New York: Basic Books.
Bradley P., and Hey, G. (1993). 'A Mesolithic Site at New Plantation, Fyfield and Tubney, Oxfordshire', *Oxoniensia*, Vol. LVIII, Academic Journal Offprint.
Brück, J. (2005). 'Experiencing the past? The development of a phenomenological archaeology in British prehistory', *Archaeological Dialogues*. 12(1) 45–72.
Brumfiel, E. (1987). 'Response to Earle, T.K and Preucel, R. W. Processual archaeology and the radical critique', *Current Anthropology*, 28, 501–540.
Bryman, A. (2004). *Social research methods*, 2nd edn. Oxford: Oxford University Press.
Canadian National Collaborating Centre for Aboriginal Health (2007), <http://www.nccah-ccnsa.ca/en/>, January 2015.
Chowdorow, N. J. (1989). *Feminism and psychoanalytic theory*. New Haven, CT: Yale University Press.
Claassen, C. (ed.) (1992). *Exploring gender through archaeology: Selected papers from the 1991 Boone Conference*, Madison, WI: Prehistory Press.
Conkey M. W., and Gero, J. M. (1997). 'Programme to practice: Gender and feminism in archaeology', *Annual review of anthropology* 26 (1–38).
Conkey M. W., and Spector, J. (1984). 'Archaeology and the study of gender', *Advances in Archaeological method and theory* 7. 1–38.
Crittenden, A. (2015). 'Energetics and play among Hadza Children', conference paper delivered at the Eleventh Conference on Hunting and Gathering Societies, Vienna, 7–11 September.
Crowe, B. D. (2008). *Heidegger's phenomenology of religion: realism and cultural criticism*. Chesham: Indiana University Press
Cummings, V., and Whittle, A. W. R. (2004). *Places of Special Virtue: Megaliths in the Neolithic landscapes of Wales*. Oxford: Oxbow Books.
Current Archaeology (2015). Issue 69.
Darvill, T. (2005). *Stonehenge: The biography of a Landscape*. Stroud: Tempus.
Dillehay, T. D. (2014). Introduction to *Contributions to Global Historical Archaeology* Part I 'History and Polity, the telescopic polity'. Albany: New York State Museum Research & Collections Division.
Edmond, M. (1999). *Ancestral Geographies of the Neolithic: Landscape, Monuments and Memory*. London: Routledge.
Erikson, E. H. (1950). *Childhood and Society*. New York: W. W. Norton.
Fahlander, F. (2012). 'Mesolithic Childhoods: Changing Life-Courses of Young Hunter-Fishers in the Stone Age of Southern Scandinavia', *Childhood in the Past* 5, 20–34.
Ferguson, J. R. (2008). 'The when, where and how of novices in craft production', *Journal of archaeological method and theory*, 15(1), Skillful Stones: approaches to knowledge and practice in lithic technology, March, 51–67.
Finlay, N. (2007). 'Blank concerns: issues of skill and consistency in the replication of Scottish later Mesolithic Blades'. *Journal of archaeological method and theory*, 15(1), Skillful Stones: approaches to knowledge and practice in lithic technology, March, 68–90.
Flannery, K. V. (1967). 'Culture History vs. Cultural Process: A Debate American Archaeology', *Scientific American*, 217, 119–122.

Fleming, A. (1999). 'Phenomenology and the Megaliths of Wales: A Dreaming Too Far?', *Oxford Journal of Archaeology*. 18(2), 119–125.

Fleming, A. (2005). 'Megaliths and post-modernism: the case of Wales', *Antiquity*, 79, 921–923.

Fleming, A. (2006). 'Postprocessual Landscape Archaeology: a Critique', *Cambridge Archaeological Journal*, 16(3), 267–280.

Gero, J. M., and Conkey, M. W. (eds) (1991). *Engendering archaeology: Women and prehistory*. Cambridge, MA: Basil Blackwood.

Giddens. A. (1976). *New Rules of Sociological Method*. London: Hutchinson.

Giddens, A. (1991). 'Structuration theory, past, present and future', in Bryant, C. G. A., and Jary, D. (eds), *Giddens' theory of structuration, a critical appraisal*. London: Routledge, 201–21.

Gill, J., and Johnson, P. (2002). *Research methods for managers* (3rd edn). London: Sage.

Gilligan, C. (1982). *In a different voice*. Cambridge, MA: Harvard University Press.

Golden, M. (1993). *Children and Childhood in Classical Athens*. Baltimore, MD: The Johns Hopkins University Press.

Greene, K., and Moore, T. (2010). *Archaeology, an introduction* (5th edn). London: Routledge.

Grimm, L. (2000). 'The construction of the individual among North European fisher-hunter-gatherers in the Early and Mid-Holocene' in Sofaer Derevenski, J. (ed.), *Children and material culture*, London: Routledge, 53–71.

Hamilton, S., Whitehouse, R., Brown, K., Coombes, P., Herring, E., and Thomas, M. S. (2006). 'Phenomenology in Practice: Towards a Methodology for a "Subjective" Approach', *European Journal of Archaeology*, 9(1). 31–71.

Havighurst, R. J. (1973). 'History of developmental psychology: Socialization and personality development through the life span', in Baltes, P. B., and Schaie, K. W. (eds), *Life span developmental psychology*, New York: Academic Press.

Heidegger, M. (1962). *Being and Time* (trans. Macquarrie, J., and E. Robinson). London: Harper & Row.

Hewlett, B. S., and Lamb, M. E. (2009). *Hunter-gatherer childhoods: Evolutionary, Developmental and Cultural Perspectives*. New Brunswick, NJ: Aldine transaction.

Hoare, P. (2014). 'The geology and geomorphology of Blick Mead' in Jacques, D., and Phillips, T., et al. (2014), 'Mesolithic Settlement near Stonehenge: excavations at Blick mead, Vespasian's Camp, Amesbury', *Wiltshire Archaeological and Natural History Magazine* 107, 14.

Hodder, I. (1991). *Reading the past, current approaches to interpretation in archaeology* (2nd edn). Cambridge: Cambridge University Press.

—— (1995). *Theory and practice in archaeology*. London: Routledge.

—— (1997). 'Always momentary, fluid and flexible: towards a reflexive excavation methodology', *Antiquity*, 71, 691–700.

Hodder, I., and Hutson, S. (2003). *Reading the past, current approaches to interpretation in archaeology* (3rd edn). Cambridge: Cambridge University Press.

Högberg, A. (2014). 'Playing with flint: Tracing a child's imitation of adult work in a lithic assemblage', *Journal of archaeological method and theory*, 15(1), Skillful Stones: approaches to knowledge and practice in lithic technology, March, 112–131.

Holtorf, C., and Karlsson, H. (2000). *Philosophy and archaeological practice; perspectives for the 21st century*. Göteborg: Bricoleur Press.

Jacques, D., and Phillips, T., et al. (2014). 'Mesolithic Settlement near Stonehenge: excavations at Blick mead, Vespasian's Camp, Amesbury', *Wiltshire Archaeological and Natural History Magazine* 107, 7–27.

Janik, L. (2000). 'Apprentice flintknapping: Relating material culture and social practice in the Upper Palaeolithic in Sofaer Derevenski', op. cit.

John, D. (2015). 'The cause and significance of crimson flints in springs associated with the Mesolithic settlement at Blick Mead, Vespasian's Camp, near Stonehenge, Wiltshire', personal communication.

Johnson, M. (2000). 'Self-made man and the staging of agency' in Dobres, M. A., and Robb, J. (eds), *Agency in Archaeology*. London: Routledge, 213–231.

Johnson, M. (2002). *Behind the Castle Gate*. London: Routledge.

Johnson M. (2010). *Archaeological theory, and introduction* (2nd edn). Chichester: Wiley-Blackwell.

Johnson, M. (2012). 'Phenomenological Approaches in Landscape Archaeology', *Annual Review of Anthropology* 41, 269–284.

Jones N. (2015), MA programme: Stonehenge, a landscape through time, personal communication.

Kamp, K. (2001). 'Where have all the children gone? The archaeology of childhood', *Journal of archaeological method and theory* 8(1), 1–29.

Kelly, R. L. (2013). *The lifeways of hunter-gatherers, the foraging spectrum* (2nd edn). Cambridge, Cambridge University Press.

Kramer S. N. (1949). 'Schooldays: A Sumerian Composition Relating to the Education of a Scribe', *Journal of the American Oriental Society* 69 (1), 199–215.

—— (2015) 'Sumerian School Days [Text and Object],' in Children and Youth in History, accessed <http://chnm.gmu.edu/cyh/primary-sources/408>, January.

Lane, P. J. (2014). 'Hunter-gatherer-fishers, ethnoarchaeology and analogical reasoning', in Cummings, V., Jordan, P., and Zvelebil, M. (eds), *The Oxford Handbook of the archaeology and anthropology of hunter, gatherers*, Oxford: Oxford University Press, 104–150.

Legge, A. J., with Rowley-Conwy, P. (2014). 'Faunal remains, in Mesolithic Settlement near Stonehenge: excavations at Blick mead, Vespasian's Camp, Amesbury', *Wiltshire Archaeological and Natural History Magazine* 107, 17.

McKnight, D. (1981). 'The Wik-Mungkan concept Nganwi: A study of mystical power and sickness in an Australian tribe', *Bijdragentot de Taal Lande en Volkunrunde* 137(1), 90–105.

Man the Hunter Conference (1966), University of Chicago, April.

Meskell, L. (2000). 'Feminism in Archaeology', in Code, L. (ed.), *Encyclopaedia of Feminist Theories*. London: Routledge, 35–6.

Mithen, S. (2003). *After the Ice: A Global Human History 20,000 – 5000 BC*. London: Weidenfeld & Nicolson.

Moore, J., & Scott, E. (eds) (1997). *Invisible people and processes: Writing gender and childhood into European archaeology*. London: Leicester University Press.

Moyzis and Wang (2009), accessed at <http://discovermagazine.com/2009/mar/09-they-dont-make-homo-sapiens-like-they-used-to>, July 2015.

Narvaez, D. (2015). 'Darwin's moral sense and the hunter-gatherer childhood model', conference paper delivered at the Eleventh Conference on Hunting and Gathering Societies, Vienna, 7–11 September.

Pala, M., at al. (2012). 'Mitochondrial DNA Signals of Late Glacial Recolonization of Europe from Near Eastern Refugia', *The American Journal of Human Genetics*.

Parfitt, S. (2014). 'The small vertebrae remains, in Mesolithic settlement near Stonehenge: excavations at Blick Mead, Vespasian's Camp, Amesbury', Jacques, D., and Phillips, T. (eds), *Wiltshire Archaeological & Natural History Magazine*, 107, 7–27.

Piaget J. (1952). *The origins of intelligence in children*. New York: International Universities Press.

Rawson, B. (2003). *Children and Childhood in Roman Italy*. Oxford: Oxford University Press.

Renfrew, C., and Bahn, P. (2000). *Archaeology, theories, methods and practice* (3rd edn). London: Thames and Hudson Ltd.

Rogers, C. R. (1961). *On becoming a person*. Boston, MA: Houghton Miffen.

Roveland, B. (2000). 'Footprints in the Clay: Upper Palaeolithic children in ritual and secular contexts', in Sofaer Derevenski, op. cit. 29–38.

Rowley-Conwy, P. (2015). 'Isotopes and C14 on aurochs', personal communication to David Jacques, July.

Rowley-Conwy, P., with Legge, A. J. (2014), 'Faunal remains, in Mesolithic Settlement near Stonehenge: excavations at Blick mead, Vespasian's Camp, Amesbury', *Wiltshire Archaeological and Natural History Magazine* 107, 17.

Siddique, R. (2013). 'Roles of men, women and children, wood land Cree', accessed at <https://prezi.com/8tsvgjivwiit/roles-of-men-women-and-children-woodland-cree/>, January.

Snir, A., Nadel, D., et al. (2015). 'The Origin of Cultivation and Proto-Weeds, Long Before Neolithic Farming', accessed at PLOS ONE, 10 (7), e0131422 DOI: 10.1371/journal.pone.0131422, September.

Sofaer Derevenski, J. (ed.) (2000). *Children and material culture*. London: Routledge.

Sternke, F., and Sorensen, M. (2007). 'The identification of children's flintknapping products in Mesolithic Scandinavia'. In McCartan, S., Schulting, R., Warren, G., and Woodman, P. C. (eds), *Mesolithic horizons: papers presented at the Seventh International Conference on the Mesolithic in Europe, Belfast*.

Sterling, K. (2014). 'Man the hunter, women the gatherer? The impact of gender studies on hunter-gatherer research (a retrospective)'. In Cummings, V., Jordan, P., and Zvelebil, M. (eds), *The Oxford Handbook of the archaeology and anthropology of hunter, gatherers*, Oxford: Oxford University Press, 151–173.

Testart, A. (1988). 'Some major problems the social anthropology of hunter-gatherers', *Current Anthropology*, 29, 1–31.

Tilley, C. (1994). *A Phenomenology of Landscape*. Oxford: Berg.

Tilley, C. (1996). 'The powers of rocks: topography and monument construction on Bodmin Moor', *World Archaeology*. 28(2). 161–176.

Tilley, C., Hamilton, S., and Bender, B. (2000), 'Art and the representation of the past', *The Journal of the Royal Anthropological Institute*. 6(1). 31–62.

Trigger, B. G. (2006). *A history of archaeological thought* (2nd edn). Cambridge: Cambridge University Press.

Tucker B., and Young, A. G. (2009). 'Growing up Mikea: children's time allocation and tuber foraging in Southwestern Madagascar' in Hewlett, B. S., and Lamb, M. E., op. cit.

Von Wright, G. H. (1993). 'Two Traditions' in Hammersley, M. (ed.), *Social Research, Philosophy, Politics and Practice*, London: Sage.
Wylie, A. (2000). 'Questions of evidence, legitimacy and the (dis)unity of science', *American Antiquity*, 65(2) 227–237.
Yellen, J. (1976). 'Settlement pattern of the !kung: An archaeological perspective', in R. B. Lee and I. Devore, eds, *Kalahari hunter-gatherers*, Cambridge, MA: Harvard University Press, 48–72.
Young, D. S., Green, C. R., et al. (2015). 'A report on the geoarchaeological investigations and environmental archaeological analysis at Blick Mead, Amesbury, Wiltshire (NGR: SU 14891 42020)', Quaternary Scientific (QUEST), School of Archaeology, Geography and Environmental Science, University of Reading, Whiteknights.

CHRISTINE SMITH

4 The effectiveness of an enhanced grid extraction system within the context of the Blick Mead spring excavations

ABSTRACT

This chapter investigates the effectiveness of using a pragmatic new approach towards excavation methodology for removing the Mesolithic lithic assemblage from within the waterlogged topography found in Trench 23 at Blick Mead Spring, Vespasian's Camp, Amesbury, Wiltshire, utilised during August 2014. The method consists of an experimental grid system unique to this situation as a controlled excavation technique and based on archaeological quadrant grid systems supported by personal fieldwork. This dissertation examines the lithic assemblage found within Trench 23 and considers how this may relate to the landscape of the Stonehenge plain before the building of the monuments. Discussion was enhanced by the retrieval technique employed, enabling statistical analysis to point to significance in the deposition pattern of the worked flint and burnt stone. It has been possible to create a spacial patterning of the artefact's distribution and deposition within the limitations of the segment stratigraphy. Worked flint is direct evidence for tasks done by the people creating the tools and burnt flint their socialisation within a site. Through the more detailed collection technique, this dissertation brings together the archaeological evidence, and through statistical analysis, provides possible answers for why there is such an extensive area of worked stone deposition within the spring complex, and why the people of the Mesolithic chose Blick Mead for a settlement.

This chapter evaluates the results of an experimental project, on which I was the lead manager, to devise a controlled finds extraction method that was pragmatic, using a retrieval technique that would yield results in a limited excavation time. The technique would be used in wet conditions, in a confined area, inexpensive to implement, practical and repeatable either at Blick Mead or other spring location sites.

Several test pits had been opened in previous excavations from 2005 and a single weekend's research plan was to follow the same format. Excavations to see the extent of a previously found cobbled surface which was assessed as Medieval were undertaken in Trench 11, during the excavations a second lower cobbled surface seemed to provide a protective cover over the Mesolithic stone working assemblage suggesting the area around the spring had been a site of continual usage, importance and significance for many millennia (Jacques et al. 2014). Trench 11 was not subsequently dug down to the depth of other trenches, due to a decision to pursue excavations elsewhere on site.

As new trenches (Trench 19 and Trench 22) were opened and deepened, my interest increased, especially in the assemblage of flint tools that were beginning to be found in the waterlogged conditions. The high quantity of struck flint emerging from the site was entirely unexpected. In Trenches 19 and 22 a substantial number of unstratified Mesolithic flint works were found, which represented the full reduction sequence, with retouched pieces being 3% of the assemblage and microliths the most common type (Bishop personal communication 2014). The progress in excavating the finds was a great success however it was at this point I began to realise that while the flints themselves were providing evidence this could be enhanced if they could be seen in context, the waterlogged conditions of the trenches mean's this was not possible, under normal excavation techniques.

In 2010, a colleague and I were asked by the field archaeologists on site to open another trench, which was Trench 23, located north of the spring. It was the extensive finds in this trench that gave me the opportunity to research the flint deposits and put them in context with other excavations on the site.

As a whole, the Blick Mead site has radio-carbon dates which include every millennium in the range of Mesolithic activity. 57–59% of animal bones which could be identified belong to the species Aurochs (*Bos Primigenius*) which is the largest assemblage of the animal found in Europe (Rogers; Durham University report, in press 2015). These bones prove the dates for knapping waste and used

discarded tools because they were found in their presence and context. It is certainly conceivable that Blick Mead is an undisturbed site and was continually occupied throughout the period by the Mesolithic people. The entire bone sample has been examined by Durham University and subsequently radio-carbon dated. Large mammals represent 17% of assemblage including Red Deer (*Cervous elaphus*) and 9% were Pig (*Sus scrofa*). Small animal remains were also found and verified by Simon Parfitt, including salmon (*Salmonidae*), trout bone (*Trutta*) and evidence of a cooked toad (*Bufo*). However, the most abundant rodents are the bank vole (*Clethrionomys glareolus*), mouse (*Apodemus*), and a yellow necked mouse (*A.flavicollis*) scarce in the records from Mesolithic sites (Yalden 1983). These remains of fish and wild animals make Blick Mead typical of other Mesolithic sites. The faunal assemblage has also been subject to a radio-carbon dating programme and given the spring a range of 7596–4695 cal BC. This is the longest sequence for a Mesolithic site in Europe. This makes Blick Mead and Trench 23 a particularly good site for testing the new methodology.

Trench 23, which is the subject of my enquiry, has yielded one radio-carbon date of 6698–6567 cal BC from an Auroch.

The Mesolithic lithics assemblage has a date range across the Mesolithic period in Trench 23, which has been examined by Dr Barry Bishop the site lithics consultant. It seems likely the area around Trench 23 was returned to several times during this period. The evidence of faunal remains found alongside the flint assemblages may give evidence for the complicated question of how the Mesolithic peoples used the landscape in their daily lives.

The findings from Trench 23, in relation to the depositional context of the site, are intriguing, and make this a particularly good area for testing out the methodology, with Trench 23 lying on the river terrace. The trench revealed intense Mesolithic activity and the flint work is from a grey clay deposit similar to layer 59 in Trench 19. It is possible that this is representative of a continuous spread across 35 metres or separate pockets of activity. The flint assemblages from Trenches 19, 22 and 23 are exceptionally extensive and the largest found in Wiltshire even though only c. 16 m² of the site at Blick Mead had been excavated up to 2014, as can be seen in (Figure 4.1).

Figure 4.1: Site diagram showing positions of Trench 11 (the northernmost trench shown on the Lynchet), 19, 22, 23 (Jacques and Phillips 2014)

Once it had been established that the material culture was widespread, how to interpret the evidence became more important. The variety of animal bones found and the selection of flints showing workings from all aspects of manufacture indicate that Blick Mead should not be interpreted as a task-specific site which is related to one archaeological focus. As several activities were taking place it could be a 'base camp' where the people either stayed or revisited on numerous occasions throughout the Mesolithic period (Bishop & Jacques et al. forthcoming 2015).

It would seem logical that most of the material used at Blick Mead was of local origin and sourced close by to the site. This is perhaps another reason why Mesolithic people chose this area (Bishop personal communication 2014). Bishop suggests that because of the texture and variable colour of the flint found on the Blick Mead site, a number of local sources could have been used, for example nodules eroded out of the hill where the later hill fort was sited or from the ancient channels that form the focus of the springs and river terraces.

Flint finds are direct evidence for what tasks were done by the people working flint, for example making tools for hunting and food preparation (Ingold 2000). A challenge for this study is to present a new interpretation using my method of retrieval to show how these materials found at the Blick Mead site relate to the culture of the people that lived during the Mesolithic and how their flint assemblage was eventually disposed of in the spring area.

Conneller (2011) makes a point which may be relevant in her research that sites are often looked at from a 'male' hunter gatherer prospective. The animal bones found around many Mesolithic sites suggest there were many extended activities associated with their existence other than just tool making. It is often overlooked that in any area with mass tool production, as seems to be happening at Blick Mead, the people making the tools would need food, warmth and shelter in order to survive. Food is especially important although quite how the Mesolithic people around Blick Mead processed the hunted animals is still open to investigation. Meat may not have been the staple food in everyday survival seeds, nuts and fruit may have played a more important role, gathered from the area around the spring, with the added advantage of being stored for later use. It has been suggested because of the size of an Auroch it may have been used for feasting at the site (Jacques & Phillips 2014).

Parker Pearson (2003) claims that 'The smell and taste of food and drink can stimulate memory and different foodstuffs can be used to create cultural identities.' However, it is a challenge to know how to interpret the materials we have found and relate them to the culture of the people who lived at that time. This is of great significance when testing my theories within Trench 23. Understanding the links between the stone tools and the bones of the animals could help us to understand the material culture, as will thinking of Mesolithic scatters as the places people lived and worked and not just find spots.

At Blick Mead, apart from the flint, there are some animal bones, pollen and grains; however, overall there remains little surviving evidence despite new scientific methods because items made from wood, rush, and animal skin were not durable and the Mesolithic people produced no remaining surface stone structures as in preceding periods (Quest report publication – forthcoming 2014). This is typical of Mesolithic sites and led Spitkins (2010) to say that 'focused studies on detailed in situ assemblages would be invaluable'. She also highlights that 'prehistoric sites have typically been labelled 'lithic scatters' due to much of the material being out of context and based on collections of artefacts usually recovered from surface collection or eroded sites'. This emphasises the importance of a controlled extraction method, which is what I developed and achieved in Trench 23.

With this in mind, I returned to the site in 2012. Excavations in Trench 23 located 45 metres north of the spring, began with the aim of ascertaining the spread of Mesolithic material across the spring, including the spread of the cobbles in both layers also the other excavations had found substantial deposits of worked flint in Trench 19, 35 metres south. Initial excavations in Trench 23 encountered the likely post-Medieval flint cobbled layer once again at a depth of 15 cm. The layer of cobbles was removed, and normal trowel excavation took place removing context 70, the second layer of flint cobbles was encountered again, which were also removed, the layer below contained many worked

flints, and this continued until the water level was reached, when the extraction proved only achievable by removal of large buckets and spades of sediment, because of the waterlogged conditions. This was subsequently taken for sieving and recording.[1]

The problems retrieving finds in context when dealing with water logged sites like a spring were immediately apparent and this prompted me to consider how best to record the finds to preserve the in-situ record. The sheer quantity and quality of flint work from Trench 23 and 22 showed that Blick Mead was a site of intense Mesolithic activity, and in both, the flint work was from a grey clay deposit, although it was unclear whether it was continuous across the site or isolated pockets of activity. Further explanation was needed as to how it was deposited and why. This prompted my sense of enquiry in terms of developing a method, of excavation which could most accurately plot and record all the artefacts and their positions in relation to each other.

Depending on the season and weather conditions, Trench 23 was below the water table on numerous occasions. To dig in a spring area under these conditions, I felt needed a different approach. The other trenches had mainly been dug down layer by layer, with the context containing the flint assemblage being under water, so buckets of wet mud were sifted through on the sides of the trench. Although a large number of struck flints were emerging from the hand sifting and later large water trough sieves were developed, the assemblage was still collated from a complete context area, meaning the deposition profile was lost.

This presented a unique opportunity to try a new approach. Firstly, to modify previous attempts at working in the often muddy and quick changing conditions that occur on the Blick Mead site, because of the nature of the spring's natural environment. Secondly, to retrieve any stone implements in a way that the flint finds would be recorded and stored, so that a new generation of researchers could use the exact same set of data. This would allow an extension of the study using new advances in techniques and excavation allowing a re-examination in conjunction with fresh excavations at the site, to provide different insights as to why Mesolithic man chose this area. After consultation with the onsite archaeologists, the main overall objective was to collect the Mesolithic material as near to its deposition position as possible in the circumstances of the conditions in Trench 23 on the Blick Mead site.

Using a 1 m by 2 m grid section, as the basis of my modified extraction aid, this was then further divided into 10 cm by 20 cm sections with a depth of 5 cm, which were dug out to these dimensions. This method is based on the established Wheeler Grid System and with some modifications to fit my experimental area I was able to remove the lithic material within the stratigraphy of its deposition. This enabled me to access and research the deposition pattern to a degree not done on this scale within the Blick Mead area excavated so far or other waterlogged spring locations.

To aid my analysis I have used Pearson's Chi-square test which analyses how likely it is that an observed distribution is due to chance. This was successfully used at the Flag Fen site, to test if the size and weight difference of utilised flakes was significant at Fengate, Peterborough (Pryor 2007).

Using this methodology, I can suggest answers to some of the questions around why this extensive cache of material was so prolific here at Blick Mead. In particular, how it became deposited in the spring and has now become one of the largest lithics finds in Wiltshire and the Stonehenge landscape,

1 During the Archaeological dig of 2017 in Trench 24 the same feature of a second flint cobble surface as found in Trench 23 in 2014 was excavated, indicating that the cobbles may have been of more significance to the whole site than first appreciated, extending across the broader area of the Spring. This section of the flint cobbles was extracted using larger grid squares to my experiment but the same principal, enabling a more detailed quantification to be undertaken. This more precise extraction of Trench 24 finds, as evidenced in Trench 23, gave parallels of possible hearth sites, and another matching carbon date to the Stonehenge Postholes. This gives strength to my conclusion of the importance of a simple but effective method of extraction, that can enable finds from the site to show the huge importance Blick Mead must have held during the Mesolithic period. The stratigraphy of finds helps to consolidate the results of seasonal continued occupation that was returned to over many centuries and held a special symbolic link to past generations.

so far, when previously it had been thought there was nothing much of any importance before the building of the stone monuments.

That this belief was widely held for so long shows that there are many gaps in knowledge of the continuity of Mesolithic life during this period because only limited remains of fauna and flora survive. Renfrew (1996) highlights 'the problem of trying to explain sites, by culture and social progress from the limited remains' which he believes 'shows the importance of context'. This and my previous discussion of the importance of context in interpreting material culture show that finding an effective extraction system using a quantitative methodology approach could not be more important. Could the application of my new technique, which enables the context of finds to be preserved even in water logged conditions help us to solve this problem in the context of Blick Mead? As a result, could my focus on context combined with the extensive occupation span found at Blick Mead aid a better understanding of this period of history?

Associating flint tools to human action is a recent phenomenon in our history. Modern archaeology began with the acceptance of Darwin's principal of evolution, antiquity of humanity and the Three Age System for ordering material culture. Renfrew (1996) explains that, in the 1960s and 1970s, archaeologists began to question what had happened, when, and why as they began to recognise the importance of identifying and accurately recording where finds were found, in association with what other artefacts or organic remains and how it was deposited.

Hodder (1986) was one of the first to challenge the established methodologies and assumptions and ask for a rethink of reconstructions and create a better methodological framework for better archaeological practises. More recently (2014) he has added to understanding of the Mesolithic existence in terms of material belongings such as their mobility through the landscape, and the idea that throughout the Mesolithic period, they replaced clothes, homes and tools as they wore out. The evidence for the biodegradable items has gone, leaving in the majority of cases only the stone tools as evidence of their existence. As a result of improvements in archaeological practices, these stone tools can aid our understanding of how they lived within the environment.

There are many Mesolithic sites recorded in Britain and across the continent but understanding how they were used and occupied only emphasises the problems of understanding the organisation of the Mesolithic population at the time. Many sites were found before science could assist in the dating and recording and as a result their value is lost due to the destructive nature of an archaeological dig. Once the area has been excavated unless detailed logs are kept, the area becomes useless for further study. Froom (2012) argues that a more specific description of excavation methodology and consideration of artefact taphonomy and micro debitage recovery by presenting the data in tables including detailed quantification of the assemblage by artefact found would have helped place the artefact assemblage in context. Johnson (2015) shows that this is still a current issue and one that still needs to be addressed because 'if the exact location of each artefact transported back to the laboratory is known then the object can be tied to its context within the site' (Johnson 2015).

Perhaps due to less interest in the people themselves rather than the stone tool collections, context has not been a major concern previously; as a result, excavations yielded very little information as to what purpose the tools themselves held within the social community of the period. Conneller (2006) suggests the relationships between the people, the objects they discarded and the places they visited is still poorly accounted for, since many archaeologists sort the assemblage but take no account of its deposition.

However, some significant progress has been made. Ingold (2000) refers to 'task scape' where he links the procurement of the available resources, whether it is stone or the animals within the environment, to the process of tool manufacture and the subsequent deposition of the debris. Thereby he interlocks the processes of the Mesolithic people as they went about their everyday survival with the perceived surrounding landscape. Ingold (1986) also warns that there is a danger we will create an image of the world driven by technological adaptations and neglect to mention the people who lived through them which would create a history of things not persons.

Starr Carr is an exception because it has been re-interpreted more than any other Mesolithic site of its kind, influencing subsequent sites and excavations (Clarke 1954). The re-examination of the

flora and fauna by Legge, and Rowley-Conwy (1988) was possible because of the careful cataloguing of the finds, and new scientific methods of investigation. This in turn has lead to other sites being reinterpreted from the new information and could lead to a wider placement of the known camps already investigated.

Referring to Blick Mead, Allen (1995) an archaeologist working within the Stonehenge landscape had stated that 'Nowhere in the Stonehenge sequence was the late Mesolithic represented'. Even more recently Lawson (2007 p. 11), in a similar manner, claims 'this relatively short period between the disappearance of the ice age and the introduction of agriculture is called the Mesolithic (Middle Stone Age). Although there are few traces of people in the Stonehenge landscape throughout this immensely long Palaeolithic and Mesolithic period, it is an important one because it was the time when the land was finally shaped and the physical setting for the later monuments was created.' Contrary to these statements, within the Blick Mead spring area, all open trenches under excavation were by this time yielding large quantities of worked flint, burnt flint and some animal bone. It was becoming clear we were excavating a cache of Mesolithic material including worked flint that reflects the entire process of tool production known at this time and a long human occupation period.

If Trench 23, when it was dug down to the same depth as Trench 19, proved to yield the same amount of worked flints it was realised that this would be an indication that the whole site was of archaeological significance in assessing where it stood within the Mesolithic era of the Stonehenge landscape. Finding dateable bone alongside the flint assemblage at Blick Mead gives a time and place in the stratigraphy of the trench and its contents. A Carbon-14 dating test from the University of Durham, on an Auroch bone (Bos pimigenus) found in Trench 23, context 79 this became equal to 98 when the onsite supervisors reclassified the context layers of Trench 23 to facilitate my experimental layers), came back as (6698–6567) BC–(7596–7542) BC, making it a match in date with the Mesolithic wooden posts predating the building of Stonehenge (8500–6600 cal BC) which were found during the construction of the old car parking area for the Stonehenge monument (Vatcher and Vatcher 1973). The date of the posts and accompanying bone, plus the enormous amount of bone and flint being found on the Blick Mead site suggest that the Landscape was indeed inhabited during this time.

If the finds and detailed plans of the excavations at Blick Mead are to be re-examined in the light of discoveries in the future, the research has shown that detailed recording is of paramount importance. Blick Mead could prove to be the missing link that defines the Stonehenge landscape as to what we see today.

Methodology for Trench 23

In 2012 a 1 m x 1 m sondage (a deep trial trench used for inspecting stratigraphy) was dug against the northern baulk to a depth of 0.6 m below ground level. The 2012 and 2013 excavations revealed a 20 cm layer of thick grey silts clay at this level (context 79 of Trench 23) and produced 1018 Mesolithic struck flints, which is a higher density than any square metre in Trench 19, 10 animal bones and two pig teeth (Jacques 2014). Early excavations at the site had involved both *in-situ* recovery of worked stones and bones, but the majority came from searching through the spoil on the sides of the trenches and was recorded as unstratified. A methodology for retrieval and a tighter stratigraphic control was implemented to be sure the flint work removed was assigned to a specific depositional context layer assigned by the onsite supervisors. As a result, within the trench total sieving ensued immediately.

The 1 m by 1 m test pit on the north-west side of Trench 23 was extended in May 2014. Whilst excavating, it was possible to peel back one section of the earth almost like a turf of grass exposing the flints laying in situ. This presented a unique insight into how the flints were arranged. This was a 'one off' chance to exploit the perfect conditions. Within the limited time allowed for digging on

the site, the onsite archaeologists suggested they were collected, cleaned and recorded. However, it subsequently proved to be impossible to repeat this process over the whole area because of the heavy viscous texture of the sediment and the wet conditions.

Although worked flints continued to be found within the context layers of Trench 23, the working conditions were disappointing. The wet claggy sediments and the failure to repeat the process of finding the flints lying sandwiched between the layers of clay was making the decision of how to access the placements of the flints within the stratigraphy of the context difficult.

Context 79 in Trench 23 was sealed by a Mesolithic horizon of viscous, dark brown, silty clay 0.2 m thick, which extended uniformly across the trench. In Trench 19 this layer was divided into 9, 1 m by 1 m squares and 5 cm in depth so the distribution of finds could be examined and recorded with more control (Jacques 2014 p. 9).

Returning to Trench 23 in August 2014, it was hoped conditions would be favourable to continue and retrieve the finds in a logical and systematic procedure. Disappointingly the layer of excavation was below the water table, and the trench was full of water.

If Trench 23 was going to yield a detailed account of the placement of the finds within its layers, an adaptation of the 1 m by 1 m grid square used in Trench 19 would have to be designed to fit the limitations of the small scale 1 m by 2 m area of unexcavated baulk remaining within Trench 23. Also, to explain the deposition within Trench 23, smaller sections would give a better indication of the way the flints might have been deposited or discarded. A good indicator is by the different sizes and types of flints recovered, and their condition when found within these sections.

I identified the area to the north-east of the previously excavated part of Trench 23 to be the test section of my adapted version of 1 m by 1 m grid squares used previously in Trench 19. Before any excavation began, I devised a research plan to suit the conditions encountered at Blick Mead, which was approved by the on-site archaeologists. This entailed a method for overcoming the problems of the water-lain terrain, which included the spring area to the north of the site. I identified the unexcavated ledge to the east of the original 2013 excavation area within Trench 23 as the best site for the experimental dig to try and overcome the problems of excavation within a waterlogged or boggy environment. The conditions would make it a good test of the effectiveness of my advanced grid system in resolving what is best way to achieve my objective, within the confines of the Blick Mead site.

The area was also suitable because it was untouched; there had been no previous test pits and contexts were intact. This meant all finds subsequently recorded would be encased in the soil layer in which they were deposited. The area was prepared and dug down to context 98 which from the original excavation in Trench 23 was the context most likely to contain the assemblage of flints. Context numbers for the layers of change of soil and deposit conditions within Blick Mead are assigned by the onsite supervisors for conformity throughout the site.

The size of grid I decided to use in Trench 23 was 10 cm by 20 cm digging out a spit of 5 cm, over the 1 m by 2 m section selected. Coming from a biological science-based background, I utilised a metal quadrant square, which gave me the exact 1 m by 1 m shape I needed. Made of metal and a solid shaped square, this gave me the stability to attach 10 cm by 20 cm string segments, thus marking out the area clearly and defined. To ensure the depth was 5 cm marked lollipop sticks were placed round each segment. The size of segment was chosen as 10 cm by 20 cm rather than a 10 cm by 10 cm square to reduce the extraction time of the material in our limited time frame. It also made removal easier within the waterlogged conditions with either hands or a trowel.

My enhanced extraction system worked well in the conditions at Blick Mead and enabled the finds to be extracted in a logical, sectional and more controlled way so each section could be plotted and laid out on a measured grid square precisely as they were removed. This had the added benefit of providing visual evidence to consider how they became deposited.

The reason the section size was chosen was to enable a more enclosed extraction area, which hopefully would place the flint finds in a deposition position that we could replicate once they had been cleaned. From the previous section dug out on the north-west side of Trench 23 in the April

Figure 4.2: North-facing section. Trench 23

dig of 2014, I knew that numerous numbers of flints had been found within this area of Trench 23, laying under the proposed context layers I had selected. As I was aware that the flint assemblages were widespread, as demonstrated earlier, it was reasonable to assume the flint layer extended into the test pit on the north-east side. Therefore, it should be possible to address the question of how effective this method would prove to be, within the limitations of the trench and its waterlogged soil layers.

Having identified the location in which I would conduct my research, the process, removal, collection and cataloguing of any assemblage found within the water laden trench will now be considered. This will use my experimental grid section method of retrieval to try and place the assemblage within the restricted grid and maintain its context.

The area identified measured 1 m by 2 m because time for the excavation was limited. Hence also the decision to use an arbitrary grid system loosely based on the biological quadrant, and archaeological grids which have been successfully used in the other disciplines. I adapted the grid size to fit the limitations of the excavation area.

Using the 10 cm by 20 cm sections, the area was dug down in two separate layers known as 98A and 98B. Each 10 cm section was labelled A, B, C, D, E, F, G, H, I, J and each 20 cm section was subdivided into 1 > 10 along the west face of the trench.

The 10 cm by 20 cm sections worked well using a trowel and hands, which proved the best tools for the conditions we were facing. By going down in 5 cm spits, removed soil samples could be placed immediately into a clean tray, which kept each excavated segment separate. By dividing the working area into these manageable sections, the extraction was more controlled and gave a better awareness of the artefacts and their deposition. Although the top layers of soil were wet, it was possible to dig the sections out, which were then hand sieved as they were removed from the trench. The finds were not fine sieved as with the previous layers because we did not have access to the sieving machines. Small finds less than 3 mm and small shavings are not accounted for in the total of finds. All finds that were recovered were bagged and labelled with the same context number, as the section they were dug from, so there was no cross contamination. Only if the exact location of the artefacts within the grids is known can the object can be tied to its context within the site and used afterwards when the site is being interpreted.

Weather conditions deteriorated during the course of the excavation. On previous occasions a water pump was made available for the removal of the excess water, but on this occasion the trench had to be bailed out by bucket each morning before any excavation could take place. This caused the soils to become even boggier and claggier. By dividing the area into these manageable sections, I was still able to extract the samples for hand sieving in the marked-out sections even though the sediment was waterlogged. This gave an accurate account of the flints recovered from each section. There was a feeling of satisfaction, given the disappointment of not being able to repeat the process of the layer of flints deposition found during the 2014 dig. Although it was a slow and meticulous way of extraction, by the end of the period I felt I had devised a different way to record, and as near as is possible to reproduce the finds in the situation at the time of deposition. My method could visually recreate the deposition later when they had been washed and catalogued. The finds were stored placed in sealed plastic bags. Storage bags were labelled Vespasian's Camp, 2014, Trench 23, Context 98A, section A1 to A10. Subsequently, Context 98B A1 to A10. This mirrored the sections as they were dug out and maintains the context which my research and literary reviews highlighted as being of paramount importance.

The flints and bone were washed and cleaned and placed in plastic cartons labelled with exactly the same information as the plastic bags, for ease of storage and to prevent misplacements.

Now that I have put in place a method of recording and collecting the assemblage, which would test my idea, I can consider the feasibility of applying it to other sites or subsequent excavations at Blick Mead in the future. Careful recording and collating will give the ability to reassess the assemblage at any time as archaeologists would have the advantage of knowing its position of deposition within the grid sections and the relationship to the context of the trench. As my literature and research reviews discuss and Birch (2010) reminds us, this issue is of great importance because 'it is possible that we are systematically misinterpreting and therefore mismanaging these landscapes as a result of the application of inappropriate methodologies, or an insufficient range of recovery methods'.

Finally, to provide an interpretation of the evidence collected, by processing and analysis, hopefully to achieve a better understanding of how and why it was originally deposited in this area of the spring. Throughout the process of analysis, I will address previous conclusions concerning the deposition of the assemblage, in which (Parker Pearson 2012), suggests it may have been deposited over the site in the transport of the sediments through the action of hill wash or slope wash, from the higher ground surrounding Blick Mead and the gravel outcrops to the north.

From my detailed research, into various grid systems used through archaeological sites in many parts of the world, digging in a water filled constant temperature spring area using the grid system I designed is to my knowledge unique to the Blick Mead site. This was further evidenced by personal communications with the lecturers who are themselves eminent archaeologists including Professor Lord Colin Renfrew, Professor Timothy Darvill, Professor Peter Rowley-Conwy, and Dr Mark Bowden. I am also encouraged that a similar idea, although on a larger scale, to mine has been successfully used in other disciplines.

My research into the methodology of grid systems proves that archaeological methods to gather data continue to be used across other disciplines. My method of data recovery using the scale of grid at Blick Mead does not seem to be a common theme, with a 1 m by 1 m square being the most frequently encountered measurement used. The smaller segment quadrants seem to be used for positioning over artefacts, to enable detailed drawings and positions to be recorded, rather than for the extraction of artefacts prior to cataloguing. My research has shown all the disciplines use at some time a grid system of co-ordinates to plot positions of trenches, using a datum point, or fixed reference point from which all measurements are taken. Each square in the grid is precisely measured and assigned a number, exactly as at Blick Mead. All literature points to the importance of precise recording techniques, stratigraphy and accuracy because the nature of the procedures involved destroy the original site of the artefacts. Precision of detail, regardless of the medium is paramount.

Data set flint analysis

The flint assemblage collected from Trench 23 context 98A and 98B is my data set, which amounts to over 1,000 pieces. Therefore, I decided to limit the type of flints recovered in order to make the cataloguing a manageable recording listing. The main types used in this research are general tools such as microliths, burins and tranchet adzes as well as blades (which are twice the length to width), worked flakes, which are all other worked flint flakes of all sizes, burnt flint and cores. The types of stone tools found in the experimental section of Trench 23 mirror stone tools found in upper layers of Trench 23 and over the whole excavated part of the site. The 1 m by 2 m by 10 cm section yielded three microliths, four micro burins and two tranchet adzes. All the tool finds which are mainly in slightly chipped to good condition found in the modified grid of Trench 23 have been verified by lithics expert Dr Barry Bishop. The amounts of debitage material shows there was a significant amount of flint working taking place on the site.

A micro-burin or burin is a modified blade which is characteristically Mesolithic with a chisel-like edge possibly used for engraving wood, bone or antler. They are not normally considered to be completed tools, but more of a useful by-product, thought to have been made during the manufacturing process of microliths. They are usually an indication of on-site production.

Microliths are one of the major implement types found and are generally the indicator for the Mesolithic period. It is thought to be one of the most frequently used and multi-functional tools and often inserted into wood and antler making composite tools for hunters. It seems clear that tool making was a very important part of Blick Mead.

Blades were catalogued from Trench 23, using the definitive measurement of twice the length to width, parallel edges and ridges on the dorsal side. These consisted of many in slightly chipped to good condition which suggests they had little disturbance since deposition. The assemblage of blades found within the grid sections are of three types being straight, concave, or convex. This suggests a variety of uses, with the majority possibly being used for cutting, sawing or scraping.

Flakes made up the bulk of the finds in the experimental area. These consist of pieces of knapping debris of all sizes, classified as 'debitage' if they measure 15 mm or less in maximum dimension. These

small shatter flakes are produced in considerable numbers during the reduction process or from trimmings of cores and retouches different techniques are used to remove flakes from a core, depending on the tool that is being maunufactured. Many are simple by products genenratated during the processes of blade based manufacture, and generally make up the majority of debitage found, which are pieces of struck flint and fragments that do not fall into any of the named catergaries. The debitage from a typical Mesolithic archaeological site will include a mixture of flintworkings, spread over a large area. The essessive amount found at Blick Mead shows there was significant flint manufacture taking place, also an indication of a place people would have stayed on a more permanent basis (Butler 2005).

Also, for the purposes of this reseach, the term flakes includes any unclassifiable broken blades and larger flakes or 'macro- assemblage', which are anything over 15 mm with the majority measuring anything between 15 mm and 100 mm in maximum dimension.

A core is a selected nodule of flint from which flakes and bladelets are removed. It consists of a striking platform which must have an angle of less than 90° to the face of the core and the angle at which it is struck must also be less than 90° (Butler 2005). This reflects a variety of ways flakes and blades were extracted using a standardised approach to the preparation of striking platforms. Once this was established blade or flake production could commence. Barry Bishop noted from his assessment of the cores in the previous excavations of stratified contexts of Trench 23 that all but three were blade types, with the exception of one that had been used as a hammer stone and a large angular chunk that had been discarded at an early stage due to the developments of thermal faults.

Butler (2005) makes reference to the fact that cores may have been carried around by the flint napper, because the cores were worked to obtain the maximum number of blades. The bladelets were then removed when needed, this process produced far more flakes than actual blades and Early Mesolithic cores tend to be well worked and small.

Tranchet adzes are very distinctive tools generally considered to be associated with Early Mesolithic activity. One of the adzes from Trench 23, found in grid section 98B B3, measures 110 mm by 40 mm.[2]

A tranchet adze was manufactured from flint nodules and, once the overall shape of the adze was prepared, a series of tranchet adze-sharpening flakes were removed giving the adze its name. This process also meant if the adze became blunt it could be repaired by the removal of another sharpening flake, struck from the lateral edge of the adze, near the blade, which removed a traverse flake across the blade of the adze and by doing so produced a sharp cutting edge (Care 1979). Butler (2005) thinks that they are used for woodworking tasks and possibly grafted onto antler or wood. Mellars and Reinhardt (1978) suggest they could equally have been used for digging, not dissimilar to a modern mattock or pick. The adze is frequently considered to be an object of symbolic importance (Bradley & Edmunds 1993; Thomas & Tilley 1993; Tilley 1996; Hampton 1999) so it is significant that Trench 23 produced four tranchet adzes.

The preparation of cores and the subsequent amount of flint work found at the Blick Mead site suggests it was a site of great importance and a possible 'home base' settlement, used on a frequent and repeated occupational basis over many centuries. Both the microlith typology and the radio carbon dates substantiate this, with the manufacture of flint work proving occupation from at least the eighth through to the fifth millennia cal BC (Bishop personal communication 2014). New research is showing that people perhaps went back to the same site over a long period of time as they had associations of earlier occupations and remaining debris. This would also provide a sense of spiritual history surrounding certain areas, ancestral exploits the mythology of good hunts and mystical waters (e.g. Tacon 1991; Edmonds 1999). These ideas are certainly gaining ground from the once sceptical more traditional ideas of Mesolithic nomadic hunter gatherers' wanderings. The idea of migratory routes possibly along ridges especially those of the Jurassic Oolites and Chalk, which were probably

[2] In Oct 2018 the Adze found in Context 98B B3 of Trench 23 (2014), has been taken to Bradford University to check for signs of retouch and usage.

dry and free from forest, in contrast to the lower ground which was wet and wooded, created known paths used over centuries both for animals and humans, is a new and exciting prospect for further research (Edmonds 1983).

Other sites alongside the River Avon, Downton for example, could account and strengthen the notion of movement up and down the river's edge in Mesolithic times. However, the sense of how widely travelled the people were, or if the movement was on foot or using the natural flow of the river by boat, is not known at this time.

Water courses do provide places for migratory animals and humans could exploit this not only for food sources, clothing and tools, but as places to shelter and provide fresh water. The underlying chalk geology contains flints, which was an important commodity for the prehistoric hunter, and can be flaked or napped in a predicable way to make the cutting and scraping tools that define this period of history (Lawson 2007).

Theories are constantly changing as to how to interpret the materials found. The instigation for my research and subsequently my methodology involved trying to establish a method of excavation which would provide a more detailed way of trying to pin point the location of the finds to the area that was being dug, with the intention of replicating the deposition pattern. This in turn could give a better understanding of how the Blick Mead site was inhabited during the Mesolithic period by an initial focus on the flint assemblage and then cataloguing the types of flints found, using my new approach to the methodology. The data has been collected and quantified, but it is proving difficult to interpret as to why the flints were found in the area of the spring, when the only solid information available is in the flint workings themselves. The potential integrity of flint deposits is often not appreciated and without a greater understanding of the process by which material was deposited in the past, our understanding of technology will remain fragmentary (Warren 2006).

Statistical analysis

For the purpose of my project, I have selected the burnt flint and the waste worked flints found in the experimental layers 98A and 98B of Trench 23. The basic element of my research is to access the effectiveness of my extraction technique, the modified grid square. Once its effectiveness has been established I can use my findings to work out if this enhances our ability to determine whether these scatters of lithic assemblages that were found within the experimental area are significant clusters, provide a deposition pattern to determine whether the deposition is a natural occurrence and purely random, or some other activity has produced and influenced the deposit found.

Whilst working in Trench 23, in the conditions experienced during the trial experimental excavation in 2014, the grid system provided a controlled way of extracting the sections one at a time. Each section could be sieved, and articles found collated to that grid position. Even when the weather deteriorated, and the ground became waterlogged, extraction was still possible, and continuity of each section was maintained over the whole experimental area. Therefore, in that sense the modified grid system of the small size sections proved a very effective and easy to use method on a site with changing water levels. Being mobile, the grid could be extended using the same size segments within a larger outer frame, depending on the area under investigation. The only measurement I would change is to make the segments squares as suggested by Professor Tim Darvill (personal communication 2015), because of the 20 cm I used on one axis, make a 20 cm by 20 cm grid square to make the actual analysis of the assemblage statistically easier to formulate the results.

The chi-square test was used to test the initial hypothesis that the context of burnt stone and the worked flint, found in these two layers was transported down into the spring through natural erosion of the sediment from the surrounding higher ground. This would be due to fluid movement of water

downwards as in the action of flash flooding or hill wash, periodically occurring due to the changes of surface water, through rainfall or melting ice and snow, and therefore would have been deposited in a random natural occurring deposition pattern. If the test results indicate the deposits are not random then my method will have proved very effective evidence, from which to draw further conclusions.

Within my results I hoped to find connections or correlations between the flint assemblage and its deposition and to express this through levels of statistical probability using the chi-square test. This is a statistical hypothesis test and is used to test how likely it is that an observed distribution is due to chance.[3] Using the observed data, I hope to determine if the deposition of the clusters of flints, found in Trench 23, are regularly spaced patterns or their distribution is purely random.

The sheer quantity of the burnt flint and the extent to which it had been subjected to extreme temperatures in the heating process suggests it had been purposely produced at the site. Such large quantities of burnt flint, as found at Blick Mead covering the whole excavated area so far, is rarely found on Mesolithic sites. New evidence, following initial research into the purpose of burnt flint found at sites by Clark and Rankine (1939), is emerging that this waste could be generated from using the stone to boil water or heat food (Butler 1998; Harding 2000; Lewis and Walsh 2004; Bishop 2008a; 2010). Bishop (2014) explain that food could be boiled by placing in animal skin bags and held over the hot stones, or roasted on a bed of hot stones, or buried in pits beside the heated stone.

Also, according to Sergant, Crambe and Perdaen (2006), particular attention should be paid to burnt flint finds and their location to any ephemeral of burning and its plotting, as they often indicate the presence of a working environment, whether it be tool making or food preparation, within the context of excavation site.

Trench 23, in the area which was dug out in the previous season's excavations on the NW side of the trench, context layers 70, 79 and 90, an area of 6 m^2, had yielded 636 pieces of burnt stone weighing 6,645 g. This stone is indistinguishable to that found in Trench 19 and Trench 22; in terms of condition, raw material and technological attributes all were extensively burnt and showing the characteristics associated with intense heating including colour change to a grey or white 'fire-crazed' appearance (Bishop 2014).

This section of context upper 98, was dug out by the spade full and placed in buckets to go to the fine grading sieves for cleaning and collating, so it is impossible to place the burnt stone in its specific depositional situation other than directly above the two levels of 98A and 98B within the 1 m by 2 m area that formed part of my experimental grid system. 98A and 98B (the experiment) contained 312 pieces of burnt stone showing the same level of characteristics.

For the purposes of the chi-square test, the size of the sections had to be symmetrical, so I used a 20 cm by 20 cm measurement. This meant combining the grid segments 1&2, 3&4, 5&6, 7&8, 9&10 and using the 1 m by 1 m square sections A – E for calculation 1 and F – J for calculation 2.[4]

To further test my hypothesis and the results from the statistical test I began to look at the geological significance. The chalk landscape of this area is dissected by numerous dry valleys. Springs are found in the lower reaches of these dry valleys, where the water table intersects the ground surface. Blick Mead is a small natural basin being more or less a stable spring position where a restricted and

[3] I have used a significance level of $p = < 0.05$ in my calculations.

[4] Calculation 1 for layer 98A 1 – 10 A – E Burnt Flint:
The P-Value is 0.006146, representing a 0.6% chance, and indicates there could be another factor involved.
Calculation 1 for the layer 98A 1 – 10 F – J Burnt Flint:
The P-Value is 0.00755, representing a 0.7% chance, and indicates that there could be another factor involved.
Calculation 2 for the layer 98B 1 – 10 A – E Burnt Flint:
The p-value is 0.176045, representing a 17% chance that the probability is due to chance alone.
Calculation 2 for the layer 98B 1- 10 F – J Burnt Flint:
The p-value is 0.009442, representing a 0.9% chance, and indicates there could be another factor involved.

shallow body of water is trapped periodically, with the changing volume of ground water (Jacques et al. 2014).

Previous thoughts from the excavations due to the topography of the area and the finds themselves came to the conclusion that the flint work came to be deposited within the spring area by means of hill-wash or flash flood. Both of these involve the deposition being transported due to energetic water action causing sediment flow, in this case the flint workings and the soil surrounding them, being washed down into the spring location. Assuming the flint assemblage was on the higher ground to the north and west of the spring line; movement would occur when the sediments became unstable and began to slide through gravity. In this instance the flint nodules, worked flints and burnt flints would move down the slope along with the sediments, caused by a flood of water or heavy rainfall loosening the soil. The flints and stone tools would tumble, roll and slide within the flow, knocking into each other as they were suspended and moved along by the mud. In some cases, the larger pieces could be deposited on the edge of the flow, at its furthest extent, leaving the smaller pieces trapped and deposited in the slower flow as it ebbed. When the flints entered moving water such as a stream or river they are likely to either sink to the bottom and stay there or be carried along by the water until deposition. Finer grained or flatter material will be moved faster and further than coarser grained material, so it will become separated out or sorted (Open University S260 2002).

It could be conceivable that a sudden rush of water from the higher ground, washing down the incline from the north and west of the site into the spring basin, bringing with it the worked stone assemblage. However, this assemblage would have to have been accumulated on the higher ground during the tool making procedures of the Mesolithic communities whilst occupying the area. Due to the extent of the coverage of the lithic material over the site and that Mesolithic flint work has been recovered associated with radiocarbon dates spanning the period 7593–4695 cal BC and that this occurs throughout the context layers, which represent linear time scales in their deposition, it seems reasonable to assume that, to achieve this, slopes of the higher ground would need to have been eroded during one massive flood action, causing the millennia worth of flints and other finds to be deposited in one geological sequence or event (Parker Pearson 2013). Another interpretation is that water movement, during a frequent or seasonal time frame, with much the same water energy as described previously, would allow the lithics to be deposited layer upon layer, without much disturbance to the preceding flood wash sediments.

Could the influence of a physical barrier of some kind such as higher ground or a bend in the river, have stopped the flow of water and then resulted in the deposition of the assemblage? It is possible that the hypothesis of one flash flood or subsequent years of flooding over the time span accounted for the chronological sequence of flint deposits within the spring site, but the statistical probability points to some other factor (Paillot personal communication 2015).

That some other factor is responsible is also suggested because neither interpretation already discussed can account for the generally good condition of the lithics and bone samples across the entire site or the fact that the layers appear to have built up over millennia. This assumption is also supported 'because of the good condition of the flint workings at Blick Mead it can be assumed that the position of the deposition within Trench 23 was in close proximity to the original in situ site of the Mesolithic stone workers, before finally coming to rest in the water' (Bishop 2014). This is substantiated by the Quaternary Scientific Quest report 2014, which states Trench 23 in the northern part of the site, is close to being on raised land at the edge of the spring. The area from which the archaeological material has so far been recovered lies on the alluvial floodplain but very close to its edge where the valley side rises from a well-marked break of slope (Green 2014). From the condition of the flint work and the associated organic remains it seems likely that the Mesolithic occupation site was in the area of the flint scatter or very close by, and that the archaeological material has experienced little redistribution since its original deposition.

The good condition of the bones found generally over the site also enables better assessment of whether the flints had been redistributed. Trench 23 has limited bone fragments and those that were

found have mainly failed any tests, due to the acid content of the sediment, which is common on many sites with acid conditions (David Johns 2014). Coulerach on Islay is near to one of the richest flint beaches in Western Scotland with many discarded worked flakes and stones, but its purpose remains unclear because the peaty acidic soil has destroyed any bone material that may have been present to provide dates of human habitation (Mithen & Findlay 2000). Trench 23 did have one significant result from context 98 which was a radio-carbon date of 6698 – 6567 cal BC from an Auroch, which placed it with the dates of the wooden posts at Stonehenge, as mentioned previously certainly before the building of any stone monuments.

It was concluded that the bone had been deposited within the spring soon after usage because remains of fresh flesh were attached at the time of deposition. We know this due to the type of insects found in the assemblage. Also, the recent report from Reading University has found evidence of the predaceous diving beetle (*Dysticus agabus)* and the water scavenger beetles *Helophorus brevipalpis* and *Laccobius minutus*. *Agabus* species typically inhabit ponds and lakes. *H. brevipalpis* is typically found in temporary ponds but it is also found in slow running water. *L. minutus* is likewise found in ponds, ditches and streams. According to Koch (1989) it prefers cold, acid, vegetation-rich waters. The results of the assessment clearly indicate a very open environment on both the wetland and dry land, with only isolated occurrences of trees and shrubs. This suggests that the sequence post-dates the widespread woodland clearance most often associated with the late prehistoric period. The wetland environment appears to have been dominated by sedges and grasses with buttercup, dandelions, thistles, daisies, valerian, pinks, sorrel and bulrush perhaps forming a meadow-type community. Grassland probably dominated the dry land, forming a suitable habitat for animal grazing. Taken together, this fauna indicates the presence of a small, vegetation-choked pond or bog with moss or grass tussocks on the margins, situated in a landscape that includes nearby herbaceous meadows.

This immediate deposition may have led to their preservation (Jacques, personal communication 2015). Bones that are weathered or have broken damage from scavenging animals are distinguishable from those buried or deposited immediately (Green 2002). Evidence from both trenches therefore supports the hypothesis that the flints were not deposited by flash flooding or hill wash.

Using a remote Data Harvest 'easy sense Q' advanced self-contained portable data logging devise, I made a test of the constant temperature spring water found in Trench 23 during the duration of our experimental excavation in August 2014. The pH calculation was taken at 11am each morning which averaged to a significant acidity level of 5.6. The sensor has a pre-set calibration range suitable for testing acids and alkalis for scientific analytical specifications. This confirms why little bone material survives within Trench 23 and is supported by David Johns 2015.

A bore-hole survey completed by Reading University over the Blick Mead site during October 2013 and January 2014 resulted in more accurate levels of sediment deposit. Taking into account the proximity of Trench 23 being situated between bore hole 15 and 21, the survey is featured in (Figure 4.3).

The survey by Reading University of the site showed that sand and gravel underlay all the fine grain sediment sequences recorded in the boreholes. Immediately overlying this, in the north of the site, is a unit of sand where Trench 23 and borehole 21 is located. This forms the base of the sediment sequence from which the Mesolithic flint work has been recovered. This analysis of the area of Trench 23 will help explain in my discussion how the flint workings were deposited within this sediment. Upper alluvium which is very wet, weakly consolidated dark to olive brown in colour, poorly sorted, gritty, sandy and silty clay, overlays the sand. There appears to be no made ground in borehole 21. The upper alluvium slopes up to the north-west towards the edge of the alluvial flood plain and this seems likely to have been a mixture of water laid fine grained sediment introduced by the flood waters of the Avon. The surface of the flood plain has been affected by areas of man-made flint nodule paving reported from several of the archaeological trenches (Jacques and Phillips, 2013).

Applying the same formula of the chi-square test, to the worked flints, to see if there was as much significance to their distribution in Trench 23, the findings were interesting and showed many parallel results.

Figure 4.3: Positions of the bore-holes in relation to the approximate positions of the trenches at Blick Mead
(*Quaternary Scientific QUEST*)

Using the information available at this time from the geological evidence contained within the report of the Mesolithic Settlement at Blick Mead (Jacques et al. 2014), I would argue the hypothesis that the distribution pattern of the burnt and worked flints is random and the deposition being caused by energetic surface water runoff and as such a natural occurrence is unlikely. The distribution pattern expressed by the statistical analysis is that the distribution of the burnt and worked flints within this area of 1 m by 2 m is non- random and that some other factor has influenced the deposition of the burnt and worked flint deposit in this area of Trench 23. This proves there is significance to the distribution, of both the worked and burnt flint assemblage. This is further confirmed because it would appear that there was a significant relationship between the deposition of the burnt and worked flakes within the context of the experimental section of Trench 23.[5]

5 Worked flakes Calculation 1 98A section 1/2, 3/4, 5/6, 7/8, 9/10 A – E:
 The P-Value is 0.099695. This represents a 10% chance that the probability is due to chance alone.
 Worked flakes Calculation 1 98A section 1/2, 3/4, 5/6, 7/8, 9/10 F – G:
 The P-Value 0.118224. This represents an 11% chance that the probability is due to chance alone.
 Worked flakes Calculation 2 98B section 1/2, 3/4, 5/6, 7/8, 9/10 A – E:
 The P-Value is 0. 026785.This represents a 2% chance and indicates there could be another factor involved.
 Worked flakes Calculation 2 98B section 1/2, 3/4, 5/6, 7/8, 9/10 F – J:
 The P-Value is < 0.00001. This represents a 0.001% chance and indicates there could be another factor involved.

Discussion

Having collated the results I have concluded that the statistics point to a non-random distribution of the assemblage and is not consistent with the theory that it is through a geological transportation system caused by a flood or hill wash. The question is now to try to make an educated case for how the Mesolithic flint assemblage could have become deposited within the Blick Mead site. This is achieved by looking at the overall picture from my results and making an interpretation. I incorporate how the landscape of the spring was laid down in the deposits accounted for within the bore-hole survey (2014). I shall explore the landscape, as a place people knew and passed on by their ancestors to new generations or by ritual. Also, through the materials they discarded, in this instance the burnt and worked flints from Trench 23, the existence of the Mesolithic people within the camp and their subsistence including the use of fire.

Recent approaches to finds of worked stone tools show more interest in the mobility, behaviour and social significance of the landscape. In the past the deposits of Mesolithic stone tools and bone were discarded by archaeologists and dismissed as rubbish with no correlation to the people or their lives. Gradually this attitude has changed through research like the excavations at Blick Mead. It has also been recently highlighted by Rona Davis (2012) who studied the nature of Mesolithic activity at selected spring sites in south-west England, in which she suggests that shared beliefs underpin the Mesolithic depositions and activity at spring locations. However, it remains an understudied topic and reinforces the potential of springs to enrich current knowledge of Mesolithic people within the landscape. My research experiment will hopefully provide patterns that will emerge to show there is a structure to the deposition, so other factors must have influenced the deposition of the assemblage.

French and Pryor (1993) and Waller (1994) think that chalk land landscapes, especially down land valley systems, had an entity each with its own individual circumstances, timings and paleoenvironmental history, for example the fens of East Anglia with their own unique entity rather than a pan-fenland sequence. Did Blick Mead have its own micro climate, including the nature of the constant temperature of the spring? We know from the animal and plant remains it had a diverse ecology, meaning it would have been an all year-round resource area rich in food, providing shelter, wood for fires, lithics materials and abundant fresh water from the springs, steams and the River Avon. This would be an ideal location in which Mesolithic people could find all they would need for subsistence to live. Ritual practices could also play a part by highlighting the importance of distinctive landscape features, seasonal events, cultural attitudes towards discard of particular resources and depositional practises (see papers in Lee and Daly 2000). Many Mesolithic sites are located within a short distance of streams or spring lines so proximity to water appears to have been a positive consideration (Myers 1992).

Firstly, looking at the landscape, McFadyen (2011) argues that living spaces and areas were actively being made in the Mesolithic, rather than a group of people just inhabiting a meaningful place or clearing. It was the beginnings of the dynamics of a relationship with the landscape involving actions, like tree felling, chopping wood, hunting, butchery, tool making, and utilisation of an area. It is difficult to imagine how the Mesolithic population perceived the notion of their world or landscape because all we have generally is the scant remains we find in our excavations perhaps it is appropriate to concentrate on Blick Mead within the landscape as it was without Stonehenge and the monuments which dominate much of our modern thinking.

Haughey (2009) also suggests it is at this time when the avenues began to connect the first wooden monuments to the rivers, like the wooden posts found within the boundaries of the later Stonehenge circle. Trench 23 has a radio carbon date linked to the posts, which she also makes a point of, since if they were erected as tall as some suggest, they could have been seen from the River Avon. It is worth noting how close the avenue passes to Vespasian's Camp.

Due to our modern perceptions it is difficult when trying to match find spots or caches or lithic scatters to a particular moment in time and interpret what might have happened, or why

that particular site was chosen, not to make a scenario of best fit. Much of Tilley's work centred around old water courses or spring heads and he does not accept 'find spots' but looks beyond the place as just an area of lithic manufacture but as lived in spaces, occupied by people who are leaving these scatters as they move across the landscape. These assemblages are all interconnected with the lives and subsistence of the people for whom they formed part of their everyday routine tasks.

Whether certain places were used at certain times of the year, the deposits of stone tools cannot answer. The carbon dating of the bones, found alongside the stone tools, strongly suggest Blick Mead had been returned to again and again, so there must have been a connection across the generations as to the significance of this particular place. A relationship with the spring, its benefits and the wider knowledge gained of paths and routes across landscape, through continuously returning to the same area, emphasises the mobility of the population and their connection to the surroundings. The landscape is redolent with past action and plays a major role in constituting a sense of the past and its people, by ancestral and spiritual entities, and an affinity people have within an area of land, its topography, waters, paths, and boundaries (Tilley 1994).

Landscape becomes the mediator between the people, the objects they produced and the way they perceived their environment. It may well have been instrumental in how they disposed of their unwanted or no longer needed materials, making them interactive with the surroundings. This might also underlie the importance of the place at that space in time. This leads onto how the archaeology of the stone tools can perhaps help us connect to the landscape. Returning again to Ingold's Taskscape theory, that the actions of the Mesolithic people lead them to be engaged with their landscape through their social and technological actions and not just living within it.

Although this shows that the people had an affinity with their surroundings, unfortunately, the settlement evidence at Blick Mead provides few clues as to the social organisation or how they utilised their surroundings. Binford (1993) reminds us of this in his statement that 'archaeologists need to recalibrate their perspective of hunters and gatherers from the 5-foot square excavation unit at a single site to an area of more than 300,000 square kilometers'. This highlights the problems of trying to reconstruct past environments for which modern analogy does not exist. Actually, documenting the scale of mobility is extremely difficult and constrained by the evidence available (Spitkins 1999).

From sites that have been found it can be assumed that Mesolithic peoples occupied the length and breadth of the country including Ireland, Wales, and Scotland, utilising upland, lowland, and sea shores. The general distinctive style of the lithics and tool technology proves that links were made between these areas and travel through the landscape was possible, emphasised through items found in one location but made elsewhere. Still Mesolithic in production, adaption that place the lithics into particular types, or the nature of the material used, meant it had to have travelled with someone. For example, a rare slate tool found at Blick Mead, where slate is not found in the geology of the local environment. We can only speculate as to why the slate item was found at Blick Mead and why it was deposited with the flint tools. One suggestion is that it was a gift or sacred offering. The consistency of finds at these sites are uniformly recognisable as Mesolithic, even with regional adjustment or slight detail change, wherever they are, including the continent. However, on the question of mobility of the Mesolithic population across the landscape more work needs to be done.

Jacques (2014) suggests that Blick Mead is a base camp defined by Binford (1980) as typically referring to the place where any resources are returned having been acquired by small groups travelling to 'task specific sites' devoted to particular activities such as fishing, hunting or collecting raw materials. The products of these excursions, consisting of a varied range of activities, are brought to the residential base camp normally occupied for a summer or winter season. Therefore, could its location within the Stonehenge landscape and, as has been demonstrated, the ease of mobility be the reason for the settlement in this area? Perhaps looking at what limited resources they did leave behind can enlighten the way we perceive their existence.

Settlement sites

Returning to Conneller (2011) with observations that Mesolithic sites and the variety of lithic assemblages found suggest a more complex side to the activities going on, often overlooked, as the tool making, and knapping debris is most evident. Mesolithic people would have used fire, much as indigenous tribes do today, for warmth, to scare prowling animals and cooking. Much of our understanding comes from the study of analogies with modern hunter gathers. Hearths and locations of fires are likely to exist on Mesolithic sites but had not been identified.

Once hearths were highlighted as an area that needed more thought, the methodology, mainly during research in Mesolithic Europe, changed and resulted in large numbers of Mesolithic sites being discovered in France. The understanding of how they were organised is poor as many of the excavations were carried out before the use of modern recording techniques and little interest was shown in any social aspects of the sites other than the flint assemblage. With more emphasis now being placed on how sites were used as places people inhabited, at excavations in Al Poux Garonne, Lot, hearths have been excavated and a possible hut which has typical scatters of ash, charcoal, burnt stones, discarded tools, knapping debris and faunal remains. At the site of Ruffey-sur-Seille they have discovered concentrations round a principal hearth with knapping and food debris spread over a 50 m^2 area in the Early Mesolithic to 15 m^2 in the later Mesolithic. Sites are showing common features of hearths in one form or another (Bailey & Spitkins 2008).

At Choisey, artefacts and evidence of domestic activities are distributed around an external hearth with knapping debris, and what appears to be interpreted as a hut structure, spread over an area of 4 m^2, with an internal hearth around which sleeping and domestic actions could have taken place (Sera et al. 2002). At the Camp of Mokracz in Poland one hearth measured 1 m x 1.6 m and was up to 100 cm deep, seems to have been located within a hut structure and was radio-carbon dated 7430 +/- 150 BP (Vermeersch & Van Peer 1990).

Other sites in Britain, Ireland and Scotland have also shown evidence of hearths during excavations. March Hill is a well-preserved site with knapping debris in evidence around four hearths each showing distinct differences suggesting they were used for different functions. Also 70% of the artefacts had moved less than 3.5 cm from their original deposition (Spitkins 2002). From this evidence Spitkins imagines a 'snap shot' of time with people sitting round hearths repairing and making tools. More recently Garvald Burn (Ballin 2015) in Scotland was located near a river source and small streams. The layout suggests it may have been a small task transit camp settlement with a domestic hearth, around which was a dense knapping floor associated with primary production. At Howick in Scotland the main feature was a circular structure, situated near a stream, averaging 6 m in diameter with postholes, stake hole pits and a sequence of hearths containing flints. Analysis of the burnt stone from its hearths shows presence of wild pig among its remains and it seems it was occupied over a considerable period of time. This has been interpreted as a settlement site and radio-carbon dated to the eighth millennium BP (cal) by Waddington (2002). Oakhanger, in Hampshire has quantities of waste flint debris from tool making and implies repeated occupation intervals. At site V, six hearths are evident (Mithen 1999).

Looking at the area of the Blick Mead site and the assemblage of burnt flint and worked flint that has been deposited it may be possible to incorporate this to Spitkins' image where she describes an idyllic setting of the Mesolithic sitting around a hearth. One way to do this is to investigate if the flint deposition could relate to Binford's 'throwing zone' which he centres on an external hearth. At least this could represent a different way of thinking on the deposition distribution.

Binford's model has two distinctive zones of discarded material and tends to be created around open hearths. A 'drop zone' is generally composed of small waste items that may be used again and accumulate where people are sitting. There is also a 'toss zone' either behind or in front of the sitting area consisting of waste items that are no longer needed. As a result, even after limited use two

concentric semi-circles of size-sorted debris are created. Open hearths do appear on base camps, but the idea is complicated by cleaning up areas such as 'site maintenance activities' causing re-deposition of the items. This can result in debris being moved from the 'toss zone' therefore losing some of the special distinctness of the assemblages in each zone and effectively restructuring the pattern initially created. It is possible, however, as at the Mask site (Binford, 1978), found two external hearths measuring 50–75 cm in diameter, with a drop zone forming a ring 50–100 cm from the edge of the fire, and the forward toss zone 2.25–2.75 cm from the fire edge (Gamble 1999).

On consideration of hearths and the fact that they are often overlooked, could it be possible that the collection of burnt and worked flint from Trench 23 had formed part of a fire setting on the site? This prompted more research and opened up new possibilities for my data set.

Analysis of scatter results

To try and analyse my results further and interpret them with the exciting information found in my research suggesting the burnt and worked flint could indicate a hearth within and around the excavated area of Trench 23. The next step was to take the statistical information from the chi square test, collate the information and form a scatter diagram showing the numbers of burnt flint pieces and worked flakes within the grid sections. Would this show a deposition distribution pattern, from which to draw a conclusion that there was a hearth in this trench?

Circling areas where the concentrations of the worked and burnt flint were at their greatest, showed up significant clusters on all the diagrams. Looking at the burnt flint chart in the first instance, 98B (Figure 4.5) does seem to show two areas section (A-D: 1–6) (G-J: 1–6) on the diagram that have a significant deposition of burnt flint, while 98A (Figure 4.4) has a more central deposition pattern (D-G: 1–6). The pattern in 98A (Figure 4.4) is not so clear. As it was the higher section it may have had more disruption and the burnt and worked flint become more scattered and spread out as a result. The chi squared analysis shows there is something statistically significant within the 1 m by 2 m area excavated, within Trench 23. The difficulty of the analysis is trying to interpret this information with the probability of what was in the other section of the trench previously dug out. Burnt flint was certainly found within the same context, along with worked flint of a higher quality, but having no precise data, its position and stratification is lost.

It is plausible that centres of high concentrations of the burnt flint are hearth sites. 98B (Figure 4.5) has two areas that could be concluded to represent parts of hearths and the fact they appear to only be 40 cm apart could be that each time the community returned they started a new hearth in close proximity to the old one from a previous visit, or it represents one large hearth that has been disturbed. Either way could they form a pattern of hearths across the site? The extent to which the lithic scatters and bone remains are found across the Blick Mead site, hearths should be expected considering the domestic and tool production activities associated with Mesolithic sites researched in other locations. Sergant (2006) also suggests very little is known about hearths in the Mesolithic and that they are often overlooked, as most are non-structured features and barely visible above ground. Minimal effort is being made to locate theses 'invisible hearths' before the area is simply dug out as quantities or patches of burnt flint. Archaeologists are now beginning to attach importance to locations of burning. Hearths and locations of fires can be significant as they represent a sign of 'home' (Manz & Spitkins 2008). Careful excavation, which I have undertaken, can identify hearths even when not immediately obvious (Sergant, Combe & Perdean 2006).

The proposed hearth sites in both sections could have been brushed to one side and replaced, or the water table rose lightly washing some of the burnt flints around which would create a scatter pattern containing a mix of burnt flint and worked flint.

Trench 23 Context 98A Burnt Flint

Figure 4.4: Showing the deposition pattern of the Burnt Flint within the grid sections of Trench 23 98A

Both 98A (Figure 4.6) and 98B (Figure 4.7) show a marked increase in worked flint deposits within the proposed hearth sites, although only two to three pieces showed signs of burning. With the concentrations of the worked flints being highest over the positions of what appear to be the hearth sites, is this just a coincidence? One possible solution is to take Binford's model and make a theoretical plan

Trench 23 Context 98B Burnt Flint

Figure 4.5: Showing the deposition pattern of the Burnt Flint within the grid sections of Trench 23 98B

of best fit, using the 'site maintenance activity' idea where perhaps sharp debitage from the knappers sitting around the fire could have been placed in the fire or the dying embers. This is a possibility as it would be a safe place where people would not tend to walk even after the fire was extinguished, which could create the accumulations in these areas.

Through my research into external hearths, I have found evidence for possible large hut features and hearths both internal and external on several sites. This makes the findings and possible feature

An enhanced grid extraction system within the context of the Blick Mead spring excavations 133

Trench 23 Context 98A Worked Flint

Figure 4.6: Showing the deposition pattern of the Worked Flint within the grid sections of Trench 23 98A

that was found in Trench 24 at Blick Mead during the dig session in 2014 even more intriguing for continuing further excavations, which could be followed by reassessment of the flint distribution. There should be a focus on the distribution of the burnt stone and layers of flint found. This in turn could relate to a new evaluation of other finds over the site and the large amount of lithics already recovered. Indirectly, it could help interpret the assemblage found in Trench 23 during my experimental test section.

Trench 23 Context 98B Worked Flint

Figure 4.7: Showing the deposition pattern of the Worked flint within the grid sections of Trench 23 98B

Looking at other possibilities for the arrangement of the deposition from the scatter diagrams, the Reading report (in press 2015) suggests the trenches are on a higher gravel terrace and that could mean some areas of the site during the Mesolithic period could be above the water table. The land is higher in the north of the site where Trench 23 is situated. As well as the acid soils, this might also

explain why there is less bone preservation found. The area of the site is close to the alluvial floodplain of the River Avon, where the river now makes a broad meander loop, on the west side of the town of Amesbury. River systems are important in the shaping of the environment and, by erosion, sediment transportation and deposition have helped shape what is seen at Blick Mead today, which is a flat area that was flooded over millennia during high water levels. These leave the landscape with deposits of greyish, green and claylike silt, pale brown and claylike silt, olive, grey, flinty, sandy and silty clay and gritty clay which are all characteristic of water lain deposits. It is highly probable the River Avon changed its course many times, with tributaries crossing the nearby floodplain extending over the Vespasian's camp area.

Above the water table, sand banks could have made an ideal place for the Mesolithic flintknappers to choose for their task. Flint nodules were among the deposits and in plentiful supply. Frequent centuries of flooding and sediment deposition covered the ancient site and protected it from other elements and subsequent human occupations. This has kept it undisturbed and virtually in situ. Taking this into consideration, the gradual flooding of the river may have eventually eroded the areas of activity of the Mesolithic occupants, causing them to be dislodged or disturbed and fall into the ebbing water. They would be deposited with little water travel, but slowly slumping down to be covered by the collapsing sediments. This could explain why the shape of the deposits may still resemble hearths and knapping areas, showing as significant deposits on the scatter patterns, but not necessarily completely in the original situation and also explain their good condition being deposited immediately in the anaerobic sediment conditions (Chris Green 2014). However, as Dr Barry Bishop remarked because of the good condition of many of the tools, they had not travelled far from the original deposition site. Froom (1976) describes some Mesolithic sites around Wawcott, where the area would have consisted of channels with mudflat islands and shallow rivers and springs, with reeds and rushes, set within a well wooded valley. Indications of flooding in the form of silt layers covering lithic finds imply the settlement at the water's edge was partly seasonal.

The way debris is discarded can shed light on the behaviour of the small group of people who occupied the site at the time (Renfrew 1996). A characteristic feature of this period is the deposition of material in caches or hordes of flints, flakes and blades. Could the act of creating the cache be part of a ritual act bringing together the community and linking to the environment they inhabited (Woodman 1978; Finlay 2003)

Springs as special places

It seems that archaeology in recent years has placed increased interest in the significance of 'natural and special places'. Bradley (2000). Blick Mead spring could be thought of as one such place. During research into springs in the south-west, Rona Davis noted that Mesolithic artefacts, especially lithics, were often associated with spring sites and the better preserved the lithic material the more likely it was deposited with some form of ritual behaviour. Especially in spring locations which included those with exaggerated properties like a constant warm temperature or bubbling springs. The spring complex at Blick Mead has both of these properties, with the exceptional algae (Hildenbrandia rivularis) which grows in the dappled light and unusually warm spring water of 10–15°C and causes the flints once removed from the water to turn a permanent bright pink colour. This spring also releases bubbles to the surface and, although we cannot say for definite that this was also happening in the Mesolithic, there is no evidence so far to the contrary. Maybe they were places where the sacred and everyday life occupied the same special environment.

Could springs allow contact with the spirits as the water emerges from the ground (Carmichael in Carmichael et al. 1994)? Or could the notion, of transplanting a piece of the landscape, from one

location to another, therefore giving the new location the power of the other be a correct interpretation (Lewis 2008, 2011)?

Lewis and Lane (2004) approached the idea of ritual as being an action rather than a particular kind of action. We have the assemblage of flints, but not the beliefs as to why they were discarded or abandoned in a particular way and so the physical action taken is lost. When Mesolithic finds are examined there does seem to have been an order to the act of the disposal in several scenarios, which involve conscious and intentional disposition rather than unconsidered abandonment. The intentional disposal of items in water appears to have been commonplace throughout the Mesolithic of Europe (Karsten 1994; Bradley 1998 and Strassburg 2000). Many sites are located within a short distance from streams or spring lines so proximity to water appears to have been a positive consideration (Myers 1992). Tilley suggests that 'find spots' should be taken as a collective as a band of Mesolithic scatters alongside old water courses, or significant points like spring heads at Blick Mead.

We take the changing seasons, our environment, natural phenomena like thunder, winds, rain and the stars for granted, due to knowledge gained through years of study, but perhaps they held a special symbolism to individuals or groups, as indeed they still do to all indigenous tribes. The deposition of scared objects within watery environments is characteristic of several ancient European ideologies and many Mesolithic adzes have been found whilst dredging the River Thames. The adze and its deliberate deposition is considered to be a symbolic act. One example is at Culverwell in Portland where a pit contained three deliberately placed objects: a smooth pebble, scallop shell and a tranchet adze as well as a catch of 12 picks (Palmer 1999). This suggests the adze might be symbolic of valuable items being placed in the ground and beyond reach. In Ireland many adzes have been found deposited by lake edges or thrown straight into the river (Woodman et al. 1999). Many adzes have been found in 'watery' contexts as at Killaloe on Shannon (Woodman et al. 1999) acknowledges the importance of these deposits of adzes and suggests there by be more complexity to the deposition that is often misinterpreted. Taking into account other scatters found on Lough Allen were they tied to the world of ritual practises and more complex technical acts of deposition rather than casual discards? Could this explain why so many tranchet adzes have been found on the Blick Mead site, including two found in my experimental sections?

Water was important, the location of a settlement may have more to do with the need for a good base with a supply of fresh water than access to food. River valleys and springs may have been locations of choice as indicated by the residue from flint working and fires burning which would have produced many waste products, many of which would have been sharp chippings. Having established that water may have been considered to have special properties, can my method help us to understand whether the flints at Blick Mead were deliberately gathered up and thrown or tossed into the spring? This could also account for the quality and preservation of the tools, which show no sign of wear or years of surface abrasion, and account for the accumulation in caches, but I doubt this would apply to the burnt flint in the same manner. Another possibility the waste was collected and thrown into the water at the end of the period of occupation, a deliberate action to clear the site ready for the next seasons visit. Perhaps a votive offering to the spring for renewed growth. We know from our experience of the excavations from one year to the next how quickly the vegetation grows covering our excavations with lush new undergrowth. Would this entice animals, and plants to flourish in the rich landscape, renewed during the vacant season? This could explain why the scatter diagrams show significant amounts in one place, and several separate areas of like sizes of deposition. In Trench 23, as stated before, I encountered in situ archaeology, so it is doubtful this is the case.

Cummings (2009) envisages people depositing not only lithics but all forms of material in very specific ways and in specific places. Are these finds of discarded materials along river banks, springs and sea shores representing the ritualised deposits of items deliberately deposited in the water? Was ritualised activity intertwined with the domestic flint tool making and cooking fires. Why were the worked flints, tools and burnt flint deposited together? Everyday items can take on a special meaning when used in rituals and they need not be rare or unusual. Where rivers and springs feature within

myths, they can play an important part. The depositing of the seasons camp within the water and the sight of the items sinking down, or as Haughey (2007) describes, water being sensory, the ripples that appear on the water in concentric circles when items are thrown or dropped into the water have a hypnotic effect, which she links to circles found on later sculptures, and carvings. The sound of water is also compelling and evocative.

Driscoll (2009) summarises that 'The lithic remains were part of the community's relationship with their world, and how they used and deposited the stone was there understandings of the world and themselves. The difficulty for us is in relating the patterns to a historical society'.

Conclusion

The effectiveness of my methodology may be considered within the site at Blick Mead, in relation to the experimental excavations in Trench 23, and if it has enabled me to draw a conclusion from the assemblage of flint remains, belonging to the Mesolithic people who in habituated the Spring area.

In an analysis of the effectiveness of my grid extraction system which used a new procedure in the approach to the methodology of excavation within a spring environment, I conclude that it enabled us to ask better more focused questions concerning the materials found and their initial deposition. The experimental grid system did indeed enable the extraction of the overall 10 cm spit depth, to be dug out easily, and within the stratified grid sections. Which was stored checked and recorded proving a very effective recording technique preserving the integrity of the context from which it came, even though the sediments were often under water and wet and claggy. My research showed that grids have been used on many other sites and is an historical and archaeological accepted technique.

What my experimental sections have achieved is an assemblage of stone tools from a 1 m by 2 m by 10 cm section within the boundaries and limitations of Trench 23 to be examined. With the aid of statistical analyses, those results have produced a scatter diagram of the distribution over the extracted area. The sheer quantity of lithic material extracted from this small section of Trench 23 is too numerous for microware analysis within the time frame of the dissertation and probably impractical during any excavation. However, the method of retrieval and the storage system enabled each of the quadrants to be placed within its own labelled box, replicating the deposition area. This places the assemblage of stone workings in the context they were recovered from and will enable further research to take place at a later date, or when new information is available. As such it is much more effective than many other excavations I have researched and mentioned in this dissertation.

Although the statistical chi square tests showed conclusively that the distribution was significant and non-random, the interpretation of the result is problematic. The information contained within the scatter diagrams highlighted areas where the assemblage was most prevalent, and this has only enabled me to make an interpretation of what might have happened. The new approach of extraction I devised in segments was certainly achievable and gives exciting insights as to what could be discovered if further lithic analysis, which takes in a wider area of the site, is undertaken. One area of interest could be under the remaining spring location yet to be excavated or perhaps it could be extended to other significant scatters. It is my belief that the results I found using this technique would not have been possible using the existing excavation methods previously employed at Blick Mead.

The Mesolithic span of continuity of settlement alone and the extensive array of lithic material we have extracted, substantiated by laboratory analysis of flora and fauna found on the site, proves that the spring at Blick Mead is a special place and suggests why people chose to occupy the area through the millennia of time, making this an area of importance within the Stonehenge landscape.

Whilst our understanding of the complexity of the relationship between the Mesolithic people and their environment needs more research their affinity to water, springs and wetland areas is constant with

many of the sites excavated. This shows the Mesolithic population interacted with their surroundings and used the landscape, travelling through it more widely than we appreciate. By looking more closely and devising a technique to excavate within the spring area, the underestimation of spring environments can be brought to the fore. I believe they hold a key to Mesolithic life.

What my excavation has proved is that because of the condition of many of the flint tools, flakes and burnt stone is that since deposition they have remained virtually in situ. There are many ideas as to why articles were deposited including prestige, usefulness, history, exchange or longevity of ownership. In particular, many adzes have been recovered from water related sites but claiming the deposit was intentional is difficult, to prove, and could be misleading without further evidence.

The significant statistical test results, the distribution of the assemblage, and the position of worked flints around hearths, alongside new research from Mesolithic sites make these findings compatible with Binford's model. Identifying uniform scatters and the processes of tool making taking place around the fire make compelling evidence toward the fact that I have encountered hearths at the site.

Fires would have been used for many purposes within the community. They may have been dismissed on numerous excavations, potentially just dug out as an assemblage of burnt flint and not within a context. My experimental section in Trench 23 may have confirmed the use of hearths within the site as the patterns certainly fit the criteria of hearths found on other sites during my research within the British Isles and the Continent.

Reading Universities' (2014) unpublished survey showed areas around Trench 23 that could have been sand banks or areas of dry land above the water level, where activities such as tool making, and cooking may have taken place during the regular visits to the site. While the flint assemblage has been retrieved from within the spring area of Blick Mead it cannot be assumed it originally went into the water as a primary place of deposition. Many factors may have played their part; options include that it was a deliberate act of votive offering, clearing the area of the remains of the last season, a gift to the spring environment or an investment for the future by appeasing nature to renew for the next visit.

It must not be forgotten that the deposition may even have been unintentional and caused through nature, for example, the changing levels of water slowly washing away the sand banks or dry land, which may have caused the debris to fall into the receding waters and be covered by the accompanying sediment, becoming entombed and protected. Eventually it may have become part of the river bed, flood plain or spring, which caused the assemblage to be deposited in the watery environment and kept in the deposition situation buried beneath alluvium and sediments. What we are more certain of is that the deposits moved only slightly due to water action as the material was well preserved.

Whilst it is possible the scatters and the statistics do represent Mesolithic hearths, all that is certain is that they represent a non-random pattern of scatters of burnt and worked flakes from Trench 23. From the information I have found during my research, I believe they do represent areas of working flint debris and hearth sites, consistent with Binford's model of flint napping debitage, which have after use, been slowly washed into their present positions within the spring sediments. The fact that the flint assemblage appears to cover the entire trench is due to the slow washing of water movement dislodging and fanning out the lithics from the initial dense hearth sequence during normal erosion processes. Once in the spring the sediment covers them immediately preserving the assemblage and preventing damage, which is why they appear in such good condition and so extensive a cache. This could also explain the separate deposition zones, stratified layer by layer found during the excavations, following the time line of settlements at the site. Therefore, that I have been able to demonstrate through my enhanced grid system, a non- random distribution within a small area of 1 m by 2 m excavated from Trench 23, identifying a pattern emerging in the statistical analysis to make a plausible argument supporting a hearth, suggesting the overall success of the effectiveness of the methodology within the Spring excavation at Blick Mead.

Bibliography

Adkins, Roy, Adkins, Lesley, & Leitch, Victoria (2008). *The Handbook of British Archaeology*. London: Constable & Robinson Ltd.

Bailey, Geoff, & Spikins, Penny (2008). *Mesolithic Europe*. Cambridge: Cambridge University Press.

Birley, Robin (1994). *Vindolanda Research Reports, new series*. Volume 1: *The Early Wooden Forts*. Newcastle upon Tyne: Colden Offset.

Bishop, Barry (2014). 'Struck Flint, Worked Stone and Burnt Flint Report', *Archaeological Excavations at Blick Mead, Vespasian's Camp, Amesbury, Wiltshire*.

Bishop, Barry (n.d.). 'Working stone in Prehistoric Britain (a Social Perspective), Mesolithic stone working' (unpublished).

Bowden, Mark (1999). *Unravelling the Landscape: an inquisitive approach to archaeology*, Stroud: RCHME/Tempus.

Bowden, Mark (2010). *Stonehenge World Heritage Site Landscape Project: Wilsford Barrows, Archaeological Survey Report Research Department Report Series 108*. Portsmouth: English Heritage.

Bradley, Richard (2000). *An Archaeology Of Natural Places*. London: Routledge.

Brennand, Mark (2004). 'This is why we dug Seahenge', *British Archaeology*. Issue 78.

Brown, Tony (2008). *The Bronze Age Climate and Environment of Britain*, 'Bronze Age Review volume 1'. University of Southampton. <http://www.britishmuseum.org/bronzeageview/1>, accessed 18 February 2015.

Butler, Chris (2012). *Prehistoric Flintwork*. Stroud: The History Press.

Clark, Graham (1971). *Excavations at Starr Carr – An Early Mesolithic site at Steamer near Scarborough Yorkshire*. Cambridge: Cambridge University Press.

Chisham, Catherine (2006). 'The Upper Palaeolithic and Mesolithic of Berkshire', *Thames and/Solent Research Framework*, available from <http://thehumanjourney.net/pdf_store/sthames>, Wessex Archaeology. Accessed 28 January 2015.

Coady, I. (2004). *What Is the Nature and Extent of Early Holocene Activity within the Stonehenge Environment?* Unpublished undergraduate thesis, School of Conservation Sciences, Bournemouth University. Accessed 11 February 2015.

Coles, John (1972). *Field Archaeology in Britain*. London: Methuen & Co. Ltd.

Connellor, Chantal, & Warren, Graeme (2011). *Mesolithic Britain and Ireland – New Approaches*. Stroud: The History Press.

Cunliffe, Barry (2013). *Britain Begins*. Oxford: Oxford University Press.

Darvill, Timothy (2006). *Stonehenge the Biography of a Landscape*. Stroud: Tempus.

Darvill, Timothy, Marchall, Peter, Parker Pearson, Mike, & Wainwright, Geoff (2012). 'Stonehenge remodelled', *Antiquity, 86*, pp. 1021–40.

Darvill, Timothy, & Wainwright, Geoff (2009). 'Stonehenge excavations 2008', *The Antiquaries Journal*, 89(1), pp. 1–19.

Davis, Rona (2012). *The Nature of Mesolithic Activity at Selected Spring Sites in the South West England*. PhD thesis. Worchester University.

Edmonds, Eric (1983). *The Geological Map an anatomy of the landscape*. London: Her Majesty's Stationery Office, Frowde and Co.

Great Britain Department of Transport (2012). *Following the Fosse Way through Nottinghamshire Archaeology and the A46*, Cotswolds Wessex Archaeology Department of Transport.

Greene, Kevin (2002). *Archaeology: An Introduction* (4th edn). London: Routledge.

Dilehay, Tom, Rossen, Jack, & Netherley, Patricia (1999). 'Middle Pre-ceramic household, ritual & technology in Northern Peru', *Chungara* volume 30. No 2. 1998, and (Impreso 1999) edition, pp. 11–124. Universidad de Traapaca Arica – Chile.

Ellis, C. J., et al. (2003). 'An Early Mesolithic seasonal hunting site in the Kennet Valley, southern England', *Proceedings of the Prehistoric Society* 69: pp. 107–135.

French, Charles. et al. (2012). 'Durrington walls to west Amesbury by way of Stonehenge – A major Transformation of the Holocene Landscape', *The Antiquaries Journal*, 92. pp. 1–36.

Froom, Roy (2012). 'The Mesolithic of the Kennett Valley', available from *The Pre-History Society*, <http://prehistoricsociety.org>, Accessed 18 December 2014.

Gamble, Clive (1999). *The Palaeolithic Societies of Europe*. Cambridge: Cambridge University Press.

Gearey, Ben, Bermingham, Nora, Chapman, Henry, et al. (2010). 'Peatlands and the Historic Environment', *Scientific Review*, December.

Higginbottom, Edward (1985). 'Excavation Techniques in Historical Archaeology', available from <http://ashadocs.org>, *Australian Historical Archaeology* 3. pp. 1–14. Accessed 6 January 2015.

Hodder, Ian (1986). *Reading the Past*. Cambridge: Cambridge University Press.

Hodder, Ian (2014). 'The Entanglements of Humans and Things: A Long-Term View', *New Literary History*, Volume 45, Number 1, Winter 2014, pp. 19–36. Baltimore, MD: The Johns Hopkins University Press.

Hunter, John, & Cox, Margaret (2005). *Forensic Archaeology Advances in theory and practice*. London: Routledge.

Hunter, John, Roberts, Charlotte, & Martin, Anthony (1997). *Studies in Crime: An Introduction to Forensic Archaeology*. London: Routledge.

Jacques, David, & Phillips, Tom (2014). 'Mesolithic settlement near Stonehenge: excavations at Blick Mead, Vespasian's camp Amesbury', *Wiltshire Archaeological and History Magazine*, volume 107, pp. 7–27.

Jacques, David, Phillips, Tom, & Lyons, Tom (2012). 'Cradle of Stonehenge – Vespasian's Camp', *Current Archaeology* issue 271. pp. 28–33.

Jacques, David, Phillips, Tom, & Lyons, Tom (2014). 'Return to Blick Mead – Exploring the Mesolithic origins of Stonehenge's ritual Landscape', *Current Archaeology* issue 293. pp. 24–29.

Johnson, Grahame (2015). *Archaeology Expert*, <http://www.archaeologyexpert.co.uk/sirmortimerwheeler.html>, accessed 11 May 2015.

Jones, Andrew, & MacGregor, Gavin (2002). *Colouring the Past – the significance of Colour in Archaeological Research*. King's Lynn: Biddles Ltd.

Krawiec, Kristina (2012). 'The Mesolithic to Bronze age landscape development of the Trent Derwent Confluence Zone Shadlow Quarry – A Multi-disciplinary contribution to the Environmental reconstruction of an aggregate-rich landscape', M.Phil thesis, Institute of Archaeology and Antiquity College of Arts and Law University of Birmingham.

Lawson, Andrew J. (2007). *Chalk land-an archaeology of Stonehenge and its region*. Gloucester: The Hobnob Press.

Legge, Anthony J., & Rowley-Conwy, Peter A. (1998). *Starr Carr Revisited: A Re-analysis of the Large Mammals*. Oxford: Alden Press.

Linder, Elisha, & Raban, Avner (1975). *Marine Archaeology*. London: Chassell.

Malm, Torben (2012). 'Excavating submerged Stone Age sites in Denmark – the Tybrind Vig example', *Nordic Underwater Archaeology*, January 2003, revised 2012, <https://www.abc.se/~pa/publ/tybrind.htm>.

Marx, Robert F. (1975). *The Underwater Dig: An introduction to Marine Archaeology*. New York: Henry Z. Walck.

Medlycott, Maria (2011). 'Research and Archaeology revisited: a revised framework for the East of England East Anglian Archaeology', *Occasional paper No 24:*, Association of Local Government Archaeological Officers East of England. Henry Ling Ltd. The Dorset Press.

Menotti, Francesco, & O'Sullivan, Aidan (2013). *The Oxford Handbook of Wetland Archaeology*. CPI Group (UK) Ltd.

Mithen, Steven (2003). *After the Ice Age: A Global human history 20,000–5000 BC*. London: Weidenfield & Nicolson

Open University (2001). *The geological History of the British Isles and Surface Processes SXR260*. The Alden Group.

Parker Pearson, Mike, & the Stonehenge River Side Project (2013). *Stonehenge A New Understanding-Solving the Mysteries of the Greatest Stone Age Monument*, The Experiment, LLC.

Pickard, Catriona, & Bonsall, Clive (2007). 'Late Mesolithic coastal fishing practises – The evidence from Tybrind Vig, Denmark', <http://www.academia.edu/297660>.

Pitts, Mike (2014). 'Secrets of the Stones', *BBC Focus magazine* issue 269, pp. 48–52.

Pryor, Francis (1978). *Excavation at Fengate, Peterborough, England: The second Report, 1978*. Royal Ontario Museum.

Pryor, Francis, & Bamforth, Michael (2010). *Flag Fen, Peterborough Excavation and Research 1995–2007*. Exeter: Short Run Press.

Radley, Derek (1969). 'An archaeological survey and policy for Wiltshire Part 11', *Mesolithic Wilshire Archaeological and Natural History Magazine 64*, pp18–20.

Rainbird, Paul (2008). *Monuments in the Landscape*. Stroud: Tempus.

Regan, Rodie, Evans, Christopher, & Webley, Leo (2004). 'The Camp Grounds excavations: Colne Fen Earith Assessment report no 654', *Cambridge Archaeological Unit*. Cambridge: University of Cambridge.

Renfrew, Colin, & Bahn, Paul (1998). *Archaeology – Theories Methods and Practice* (2nd edn). London: Thames and Hudson.

Renfrew, Colin., et al. (2013). 'The Settlement at Dhaskalio – The Sanctuary at Keros and the origins of Aegean ritual practice: the excavations of 2006–2008', *McDonald Institute for Archaeological Research Cambridge*. Exeter: Short Run Press.

Roberts, Alice (2014). *Roman Britain: a Time Watch Guide Vindolanda Excavations*, BBC 4, 17 February 2014.

Roberts, Alice, & Williams, Matt (2014). *Digging for Britain, BBC 4*, 3–24 February, Series 3, 1–4.

Roberts, Neil (2014). *The Holocene: An Environmental History* (3rd edn), New York: John Wiley & Sons Ltd.

Rowley-Conwy, Peter (2004), 'How the West was Won', *Current Anthropology*, Volume 45. London: British Museum Press.

ScARF, 'Scottish Archaeological Research Framework Executive Summary', <http://www.scottishheritagehub.com/content/61-mesolithic-lifestyles>, accessed 29 July 2015

Sergant Joris, Crombé, Ph., & Perdaen, Y. (2006). 'The "invisible" hearths. A contribution to the discernment of Mesolithic non-structured surface hearths', *Journal of Archaeological Science* 33, pp. 999–1007.

Spitkins, Penny (2010). *Palaeolithic and Mesolithic West Yorkshire*. West Yorkshire Archaeology Advisory Service research agenda.

Stringer, Chris (2006). *Homo Britannicus*. London: Penguin Books.

Waddington, Clive, Bailey, Geoff, Bayliss, Alex, Boomer, Ian, & Milner, Nicky, et al. (2003). *A Mesolithic Settlement site at Howick Northumberland, A Prelininary report*. York University.

Webster, Graham (1963). *Practical Archaeology – An Introduction to Archaeological Field-work and Excavation* (reprinted with minor corrections 1965). London: A&C Black Ltd.

Wheeler, Mortimor (1956). *Still Digging*. London: Michael Joseph Ltd.

Wilkinson, Keith, & Stevens, Chris (2008). *Environmental Archaeology, Approaches, Techniques and Applications*. Stroud: Tempus.

KEITH BRADBURY

5 An evaluation of the relationship between the distribution of tranchet axes and certain Mesolithic site types along the Salisbury Avon

ABSTRACT

Finds of tranchet axes and other Mesolithic material in the Stonehenge landscape have tended to be regarded as anomalous or stray. When the find spots for the axes are examined in the context of the discovery of a complex, muliti-phase Mesolithic settlement at Blick Mead, they can be seen as having been deposited deliberately in order to mark the activity area of a home-base settlement. By cross referencing tranchet axe find spots with topographic, geological and environmental evidence it should be possible to locate as yet undiscovered Mesolithic sites.

Introduction

The aim of this project is to examine Mesolithic finds in the Stonehenge landscape, particularly tranchet axes, as set out in the literature and at Blick Mead in order to gain a better understanding for their distribution. I also consider factors relating to the location of Mesolithic settlement sites and suggest where another could be found.

Until recently significant evidence of Mesolithic occupation of, and activity in, the Stonehenge landscape has been scant. The discovery and identification of three postholes, located at what came to be the old Stonehenge visitors' car park (Vatcher and Vatcher 1973, p. 57–63 and Allen, 1994, p. 471–473), and dated to be in the range of the ninth to seventh millennium BC is often interpreted as anomalous (Parker Pearson, 2012, pp. 135–137) and (Richards, 1990, p. 263).

Despite the Stonehenge area being one of the most extensively surveyed archaeological landscapes in Europe, it wasn't until excavations were carried out at Blick Mead, Vespasian's Camp (Jacques et al. 2014, pp. 11–13) that a significant number of Mesolithic finds, and a persistent settlement site was located. At Blick Mead between 2005 and 2015, 32,207 pieces of Mesolithic period struck flint were recovered, including 11 tranchet axes (Bishop, 2014, pp. 49–50 and Bishop, 2015, p. 1) comparing in numbers and range of struck flint to the discoveries made at Downton, south of Salisbury (Higgs, 1959), and like that site, identified as a long-term home-base, in this case dated from the eighth to the fifth millennium BC.

The small number of tranchet axes previously found in the Stonehenge landscape had been viewed as stray finds, despite usually being directly associated with home-base areas (for example, see Butler, 2008, pp. 114–118). Such a hypothesis has never been tested in the Salisbury Avon area, probably precisely because of the previously small and not particularly well recorded data set (Bishop, personal communication, 2015). Now, with the results from the Blick Mead excavations, it is possible to reassess this association in an area which has evidence for the longest term 'persistent place' (Barton, 1995, pp. 81–82) in the Mesolithic period in Europe 7596–4246 cal BC (Jacques, personal communication, 2015).

To be clear at this early stage, for the purposes of this piece of work the word axes is used to cover both tranchet axes and adzes. I have adopted Roy Froom's logic that 'in the absence of microscopic analysis, it is difficult if not impossible to distinguish between axes and adzes – it may simply be a matter of the way the artefact was hafted' (Froom 2012, p. 29). Butler prefers the use of the collective

term 'adzes', but essentially both tools would have been fashioned from a nodule of flint in a similar manner with 'the sharpening flake struck from the lateral edge of the adze (axe), near the blade, which removed a transverse flake across the blade of the adze (axe) and by doing so produced a sharp cutting edge' (Butler, 2012, p. 100).

Previous studies

The riverine pattern of the distribution of Mesolithic sites in southern England was first noted in 1956 (Rankine, 1956, p. 9) when he detailed the location and context of the site finds. He noted the importance of rivers and tributaries as major routes and stated that 'throughout the greater part of Southern England ... the disposition of Mesolithic sites around the estuary of the river and along its banks right to the headwater of its feeding streams'. He also put forward the idea of central base camps each associated with a network of satellite camps, which would be close enough for their resources to be exploited and transported by water for the benefit of the base camp.

More recently, Froom has also argued that in the Kennet Valley, an area geographically close to the Avon valley, 'virtually all of the excavated Mesolithic sites are located either on the flood plain or immediately adjacent to it' (2012, p. 8). And, in a recent personal communication, further developing Rankine's point, he said that a series of base camps and settlement camps along the Avon valley would make perfect sense, but that a number of sites will not be found due to the effects of modern ploughing. It has also been suggested that the sparse evidence of Mesolithic activity on higher ground is a result of primarily hunting and gathering taking place on the uplands, with other activities being carried out in the valleys (Bowden, 2015, p. 16). In his work on the excavations at the Mesolithic site at Downton, Higgs highlighted the importance of following the flint concentrations, as traces of any other material has often been leached by water action from the soil (Higgs, 1959, p. 214).

Butler (2008, pp. 114–118) believes 'it is possible for archaeologists to take the data provided by a flintwork assemblage from a site and use this to suggest how that site might have operated, what activities were carried out, and how the site fits into the overall Mesolithic landscape'. He suggests that 'a system of base camps and task-specific sites may have been operated during the later Mesolithic period'. He hypothesises that 'base camps are likely to be located at a place where food and other resources are readily available, for example beside a river or lake', and associates tranchet adzes with these more permanent base camps.

Froom (2012, p. 295) puts the case for continuous, but not permanent, occupation in the Kennet Valley, and 'taking into account all lines of enquiry it is hard to escape the conclusion that the Late Mesolithic of the Kennet Valley is a singular entity'. His excavations at the various sites along the Kennett Valley have yielded a range of tranchet axes but they were not found at every site. Lawson (2007, p. 27) refers to the valley of the Kennett as being home to 'one of the richest concentrations of Mesolithic sites in Britain' and that it 'initially flows across chalk geology in much the same way as the rivers close to Stonehenge and can therefore be used as a useful guide to the potential of rivers like the Avon, only 3km from Stonehenge'.

In the *Stonehenge Environs Project* in 1990, Richards notes that 'with the exception of the three postholes in the Stonehenge car park ... previously recorded finds provide little evidence for Mesolithic activity on the chalk areas adjacent to the River Avon ... their ... sporadic distribution can provide little firm evidence for mobile exploitation of this particular chalk zone.' However, while expressing the view that 'evidence for Mesolithic activity is extremely slight', he later refers to a 'sample excavation of a colluvial bench on the western side of the river below Durrington Walls', giving 'an indication that hunter-gatherer activity was concentrated on the Avon Valley.' Also at Durrington Walls, he refers to 'pollen spectra ... suggestive of the type of woodland resulting from regeneration of Mesolithic clearance', serving to 'strengthen the evidence for Mesolithic activity on the margins of the Avon Valley.'

The study area of the Stonehenge Environs Project extended from Robin Hood's Ball causewayed enclosure in the north to the Wilsford barrow group in the south, and covered the area from Amesbury and Durrington Walls in the east to the Ordnance Survey Map number 298 SU10 gridline in the west. Overall it is clear that, as a systematic analysis of the River Avon valley was not part of this study's methodology, key evidence for a Mesolithic footprint in the area was not assessed sufficiently. A tiny quantity of Mesolithic finds, and no tranchet axes, were found during the course of this project. Allen in Cleal et al. (1995, p. 62) notes that 'a major hiatus is indicated in the (Mesolithic) environmental sequence ... from the snail and pollen evidence: nowhere in the sequence is the Atlantic (late Mesolithic) represented'. Similarly, there is a complete absence of datable Late Mesolithic activity in the area, and in a critique of Richards' study Allen also states that 'it must be borne firmly in mind that this may be a product of the nature of the fieldwork in the area than a true reflection of past human activity'.

In the twenty-first century, investigations were carried out by French, Scaife, et al. (2012, p. 30) on sediment sequences, palaeosols, pollen and molluscan data for the *Stonehenge Riverside Project*. The conclusion was that 'the Avon palaeo-channel 1 pollen record suggests intermittent woodland development and modification and opening-up of this landscape in the later Mesolithic and earlier Neolithic (with) significant inroads into its woodland cover'. They note that, unusually, pine retained a strong presence in this landscape until the third millennium BC. The large posts erected in the Stonehenge car park five millennia earlier were pine tree trunks, most certainly locally sourced. It is thought that this indicates long-term management of this resource in the area, which, in the face of more invasive species such as oak would, unencumbered by man, have displaced the pine trees (Branch, personal communication, 2015). As with the *Stonehenge Environs Project* 1990, the *Hidden Landscapes Project* 2014 did not include a survey of the banks of the Salisbury Avon and tributaries.

Darvill (2010, pp. 63–65) also summarises and reflects on the paucity of Mesolithic find spots. He offers possible explanations as 'inappropriate sampling strategies' adopted for field walking and speculates that 'later prehistoric alluvium and colluvium is sealing land surfaces occupied in this time period'. The handful of then known tranchet axe find spots are featured in his corresponding map of the Stonehenge landscape. Parker Pearson (2012, p. 23) also refers to the scarcity of traces of Mesolithic hunter-gatherers in the Stonehenge area, whilst putting the case for their using the Avon valley for campsites, and putting forward West Amesbury (Bluestonehenge) as one found example.

Three Stonehenge Mesolithic postholes discovered in 1966 are mentioned by him and others (Lawson, Dawson, Richards, etc.). The original discoveries (Vatcher and Vatcher 1973, pp. 57–63) were made in the Stonehenge car park and pine charcoal from them was radiocarbon dated (Pit A 8820–7730 cal BC, and Pit B 7480–6590 cal BC), as was material from a further, nearby, pit (Pit 9580) found in 1988 by Martin Trott. His unpublished excavation (covered in Cleal et al., 1995, pp. 43–47) gives dates from three depths ranging from the earliest at 8090–7690 cal BC to the latest 7580–7090 cal BC. The C14 dates for the pine post remains found in the postholes indicates the approximate time at which the pine trees themselves were felled, and so it is possible that they were raised in the postholes a little later than the indicated dates. Mike Parker Pearson's question 'where did the Mesolithic builders of these posts live?' (2012, p. 137) reflects the prevailing view that Mesolithic occupation of the area generally was ephemeral and enigmatic.

Overall the number of Mesolithic artefact find spots referenced in Richards' and Darvill's work is very small, especially when contrasted with earlier work at geographically proximate topographically similar locations, which revealed many such sites (by both Rankine 1956 and Jacobi 1981) in the south of England, and Froom (2012) specifically along the Kennett valley. While noting that 'Wiltshire appears to have little Mesolithic association', Rankine (1956, p. 37) refers to significant discoveries having been made in the Wylye and Nadder valleys (both flowing into a joint river system with the Salisbury Avon), and on the Marlborough Downs. Their existence led him to say that they 'definitely indicate that exploration of the chalk outcrops may reveal further settlements'. Jacobi (1981, p. 13), when concentrating on neighbouring Hampshire and the relative richness in Mesolithic sites found

there, noted how rarely find spots occur singly, leading him to believe that where one is found, there should be a suspicion that further investigation will reveal further sites.

Two of the excavated sites which he later refers to are Mother Siller's Channel and Hengistbury Head, both of which would have been a short distance from the southern extension of the Salisbury Avon. Along the Kennett Valley Froom (2012, pp. 3, 327) has himself identified some 50 to 60 'well defined' sites and found Mesolithic artefacts at 20 or more locations. He puts these against the background of up to 20 previously recorded sites in the Newbury to Thatcham area. Along this corridor a large number and a diversity of sites has been found in an area underlain by chalk occasionally overlain by clay-with-flints, and gravel and other alluvial deposits. This geological background contains an important feature the Kennett Valley has in common with the Salisbury Avon Valley – its chalk streams.

In Froom's analysis of home-base camps he suggests they are more likely to be found at a place where food, water, fuel and building materials intersect – a river, spring, or lake and that other sites are likely to be located near to activity related resources, for example a source of flint, or woodland for hunting. The positioning of the raw materials, and the litihcs in particular, can help us to understand how networks are connected in carrying out technological acts. Careful analysis of material found from all stages of the selection and manufacturing process and 'refitting in conjunction with spatial analysis will provide information about how lithic material was used across a site' (Conneller, 2008, p. 160–176). Analysis of the material found and find spots can then be viewed as a whole in an effort to reveal a task-scape of inter-locking and related activities (Ingold, 1993, pp. 153, 158).

It is clear that understanding the Mesolithic uses of the Salisbury Avon landscape is at an early stage, but the recent discovery of there being a substantial Mesolithic presence in the Blick Mead area of the Stonehenge environ, provides an opportunity to reassess the Mesolithic uses of the river valley margins, through testing Butler's argument that the location of tranchet axes in the area could be used as key evidence when interpreting site types.

Methodology and research

In re-assessing historic documents, LIDAR, Ordnance Survey (OS) maps, British Geological Survey (BGS) maps, google maps and Historic Environment Records (HER) for the area, and undertaking field walking, I have tried to ascertain whether there are as yet undiscovered Mesolithic places along the Salisbury Avon through relating the find spot areas for tranchet axes to topographical features. This has also involved researching the case for them having any economic resources which might have aided certain types of settlement, and reassessing the written evidence in light of what has been revealed at Blick Mead. I received permission from five landowners to carry out field walking in order to survey the landscape. I also assessed the lithics reports from excavations at Trenches 19, 22, 23 and 24 at Blick Mead to see what indications are given as to the activities of its occupants. My methodology also involved me having discussions with a range of experts in the field, such as Froom, Bishop, Branch, Bowden, Gaffney and Darvill.

Using the published literature, and leaving the excavations at Blick Mead and Downton aside for the moment, *Wiltshire and Swindon Historic Environment Records* list 12 tranchet axes found in the Wiltshire Avon valley within a 6 kilometre radius of the River Avon. At only one find spot (Milford Hill, Salisbury, where two axes were discovered) could I find a record for more than a single tranchet axe having been found. Narrowing the search to the stretch between Durrington Walls and Lake brings the number of axes down to five, one of which has no clear find spot and is listed as having been found in 'Amesbury parish' in 1874. Four axes with more precise find locations were all found on the Upper Chalk. They are held by the Wiltshire Museum in Devizes as part of the Clay Collection (I have added the museum's description in parentheses).

- One of the three axes was found at Ordnance Survey (OS) co-ordinates SU 1620 4150 (flint Tranchet Axe, broken at its butt end, fully patinated, length not recorded) at Holders Road, Amesbury, close to the junction with Antrobus Road, a location which is approximately 1 km south-east of the nearest point of the River Avon, and approximately 2 km east-south-east of Blick Mead. I measured the length of this broken axe to be 130 mm.
- A second was found in a 'Field near Stonehenge' at OS SU 1300 4180 (small flint Tranchet Axe, some damage, fully patinated, from King's Barrow Ridge, length 98 mm; width 55 mm; height 24 mm), on a line running north-west from the River Avon to Stonehenge, and approximately 1 km from both.
- A third axe was found 'south-west of Stonehenge' at OS SU 1200 4210 (small flint Tranchet Axe, fully patinated, Clay number 30a, from Tumulus 22 on Hoare's map, length 100 mm; width 43 mm; height 16 mm near to tumulus 22). This find point is just over 2 km from the nearest point of the River Avon, and Blick Mead.
- A fourth tranchet axe was found at Wilsford (South) near Starveall Plantation OS SU 121 404. This tool is 120 mm long.

None of these axes are included in Harding's flint report in Cleal et al. (1995, pp. 368–371), which is concerned with the finds from twentieth-century excavations that are held by Salisbury Museum. He does express surprise that there is 'no clear evidence for Mesolithic activity in the flint assemblage, given the presence of Mesolithic pits in the car park'. He considers the tranchet axe from Young's excavations in the car park to be Neolithic rather than Mesolithic, as despite the fact that both ends of the 'implement end in a clear "tranchet" edge ... the blade end has been flaked subsequently, suggesting that the tranchet blow was not a deliberate attempt to sharpen the implement'.

As it has been suggested that this type of axe possibly originated as a tranchet axe and was later sharpened in a different manner, and as this particular axe is included in Darvill's summary of Mesolithic finds, I have included it in my analysis (Butler, 2008, p. 103 and Darvill, 2010, p. 63). The finds of tranchet axes at Blick Mead should be seen in the context of the handful of Mesolithic finds in the Stonehenge landscape made before 2005. As of June 2015, 11 tranchet axes have been found at Blick Mead in an area of 16 m² (Bishop 2014, pp. 49–50) and (Jacques personal communication, June 2015).

Taking the river corridor north towards its source includes two more tranchet axe find spots. One of these was found between Pewsey and Sharcot on the Third River Terrace (OS SU 1550 5950). The other north of Pewsey Hill Farm, Pewsey on the Lower Chalk (OS SU 1650 5780). Following this 6 km corridor of the River Avon south towards Downton takes in a further five tranchet axe finds after a notable absence of reported finds of approximately 10 km between Wilsford and Salisbury. The five finds were made at; Milford Hill, Salisbury where two axes were found on the Third River Terrace (OS SU 1510 3000); and one each at Southampton Road, Salisbury (at OS SU 1550 2930 on Alluvium); north of Petersfinger Bridge, Salisbury (at OS SU 1600 2922 on the Third River Terrace); and on plateau gravels at allotment gardens in Alderbury (at OS SU 1850 2750).

In order to get the most from the various data sets I applied a consistent set of questions:

- Does the distribution of tranchet axes suggest a 'deliberate' marking of activity areas at the boundaries of 'central' site' territories?
- Is there evidence for deliberate deposition of these artefacts; and if so does it point to ritual associations with the axe?
- Does the distribution point to good flint sources being close by?
- Does the distribution point to certain areas being exchange and trading points?
- Is it possible to locate 'lost Mesolithic sites' by cross referencing the find spots of tranchet axes with various other types of evidence – topographic, environmental, geological?

I established a number of places where it is possible that further investigation could lead to the discovery of a home-base, which I narrowed down to the two most promising.

The location where the finds of Mesolithic worked flint finds were found in buried soil by Wessex Archaeology at Countess Farm (Leivers and Moore, 2008) shares a common river terrace with the excavation site at Blick Mead. Both are on the former floodplain of the Salisbury Avon and, although now separated by the A303, are only 100 metres or so apart. It is likely that they both once formed part of a single Mesolithic home-base, and both are on the same side of a connecting valley.

As a consequence of the field walking I had conducted, and in order to test the validity of the theory, and try to gauge the extent of the home-base, I carried out a small, surface only survey on a grid I had laid out with tent pegs and builders line at a site at Countess Farm. The site is on a strip of 'set-aside' land close to the A303, and immediately across the road from the Blick Mead site. The grid was set out, pegged and strung, from a point at Ordnance Survey point SU 15027 42096, and stretched 5 metres west and 4 metres south from this point. Each of the 20 metre square units was allocated a number from 1A to 5D. A detailed fingertip survey was carried out of each of the lined-out squares.

The few dozen finds were collected, and bagged separately, for each individual square. A preliminary observation of the washed and selected finds by Barry Bishop indicated that it represented a mixed assemblage of worked flints ranging from the Mesolithic to the Bronze Age. Perhaps unsurprisingly, the squares closest to the worked field yielded the greatest number of finds per square, reflecting the deposition of material thrown up by the use of the plough. Some of the material found was sufficiently interesting and of an age to indicate that a few well placed test pits dug here could prove to be extremely worthwhile in trying to ascertain its relationship with the Blick Mead home-base.

Lake, some 5 kilometres south of Stonehenge, is a similarly intriguing location. Evans (1897, pp. 627–628) describes Palaeolithic implements found in the 'river drift' at Lake, 10 km north of Salisbury, which he notes at that time was the highest point in the Valley of the Avon that discoveries had been made. He describes the finds as being made in the gravel where 'the beds have been cut through by the deepening of the valley'. Making a more general point he believed that it should be possible to predict where 'river drift' would occur 'of such an age and character to be likely to contain Palaeolithic implements' by examining the widening action of a stream on its valley (pp. 679, 680). Evans didn't believe there was sufficient evidence at that time to distinguish the Mesolithic from the Palaeolithic, and used the term Palaeolithic for the period ending with the Neolithic period. I have, therefore, taken his pointer on where tools can be found as likely to be equally valid for the currently defined Mesolithic period.

The geological conditions described by Evans were in evidence more than a century later during the excavations of a Medieval inhumation, possibly a 'bog body', at Lake, at Ordnance Survey point SU 4137 1388 at approximately 60 metres above OD (Ordnance Datum is a measure of altitude and roughly equates to sea level) on land adjacent to the River Avon and situated on alluvium over Valley Gravels and Upper Chalk (McKinley, 2003, p. 7–9). During the course of excavations 40 fragments of flint, undiagnostic flakes and possible core fragments were found, indicating a date range from the Neolithic to the Bronze Age. In addition, an extensive layer of unworked burnt flint was seen at the interface of the natural valley gravels and the waterlain blue-grey clay. As well as the lithic material discovered at Lake, there is further evidence of prehistoric activity to be found just 300 metres away in the form of four Bronze Age bowl barrows.

There is much to suggest that Lake would be a promising location for extensive fieldwork and possible excavation to reveal Mesolithic activity. It meets many of the criteria that must have been considered when deciding where a Mesolithic home-base should be sited. My field walking showed it to be situated at a point in the Salisbury Avon that is easily accessible from the river banks. In contrast, further north towards Wilsford there is not sufficient land available between the tall, steep banks of the valley and the river to have established a settlement that wasn't susceptible to regular flooding. A number of fresh springs nearby would also have been an attraction to hunter-gatherers and animals. The geological and topographic conditions found at Lake are similar to those seen at Blick Mead where an enormously rich resource of Mesolithic finds was uncovered. The waterlogged conditions in evidence at the excavation of the fifth or sixth century AD 'bog body' at Lake, speculated as an

inhumation buried in a watery context with ritual associations (McKinley 2003, pp. 7–18), are similar to those experienced at Blick Mead and thereby present good conditions for the *in situ* preservation of prehistoric faunal material.

A prime consideration for Mesolithic people deciding upon the location of their settlements would have been access to reliable supplies of fresh water (Froom, personal communication, 2015). In the Salisbury Avon landscape the porous nature of the chalk means that rain soon disappears from the surface of the ground, and available sources of water are therefore few. As a result the only reliable sources of water would have been rivers and streams, together with springs, and perhaps a small number of ponds where the chalk is overlain with less permeable clay-with-flints. Mellars and Rheinhardt (1978, pp. 266–274), Lawson (2007) and Froom (2012) have all stressed the scarcity of dependable fresh water supplies on the chalk outcrop and how this would have had an important bearing on the location of sites chosen for occupation.

Lawson notes that in a Wessex context where prehistoric sites are not located in river valleys they are more likely to be situated near springs and in 'places where superficial geological deposits (clay-with-flints or Reading beds) cover the chalk bedrock' (Lawson, 2007, p. 35) as the deeper soils which formed over these geologies would have created a more 'luxuriant vegetational cover than existed on the thinner soils of the chalk'. The resulting limited number of viable sites for occupation could have meant that Mesolithic groups would have needed to have travelled further to exploit the full range of resources that the landscape provided (Mellars, 1978, p. 266). Mellars also notes that major sites known to have been established on the chalk in the Mesolithic were situated in locations close to the edges of the outcrop with easy access to fresh water and the neighbouring geological formations and associated resources (as at Blick Mead), and cites Downton as an example.

Positioning a home-base at the edge of a geological outcrop would have afforded its occupants a wider range of plant and animal resources to exploit within a short distance from the camp. Different plant varieties thrive on each of the geologies. This in turn broadens the spectrum of animal species attracted to a radius easily reachable from the camp and they, in turn, can be exploited. Establishing a home-base close to a spring and river would have broadened the palette still further. There is likely to have been a different range of trace elements in each water source, one warmer than the other, and for the most part spring water would be slower moving than the river (John, personal communication).

Odum (1971, pp. 157–8) describes this phenomenon as the 'edge effect', where the transitional margin between two or more environmental communities commonly contains the organisms of both the overlapping communities and others. 'Edge species', are characterised by, and limited to, the overlap. As well as an increase in plant and animal varieties at the margins, Odum argues for a tendency for an increased density in some of the species at the transition, so at such junctions of geological formations, with access to both river and spring, there would be an increase in the number and quantity of exploitable resources available. Higgs & Vita-Finzi (1972, p. 28) make the point that Mesolithic sites are commonly located at the junction of very different habitats, the integration of whose resources resulted in a viable economy. Mellars (1976) argues that such access to a wide variety, and a stability of exploitable re-sources, added to a Mesolithic community's long-term viability as it minimised the effort required to obtain sufficient resources for the group to remain sustainable.

Rivers have long been considered of primary importance as route-ways in the postglacial landscape in the south, particularly so in wooded landscapes. Jacobi (1981, p. 13) for example highlights 'a pattern ... of re-use of favoured locations, normally adjacent to a spring as at Longmoor ..., a stream, as at Oakhanger, or a river, as at Kingsley Common, in all probability by the same or by techno-logically closely related social groups.' At Longmoor more than 15,000 pieces of worked flint were found, not including tranchet axes, and it is assumed to be a site where flint blades were manufactured. At both Oakhanger and Kingsley tranchet axes have been found. These locations are on tributaries of, or are close to, the River Wey. Rivers would have offered a particularly effective form of transportation in a densely wooded landscape.

When one factors in Rankine's concept of satellite locations (1956, p. 24), the number and range of environments whose resources could be effectively exploited would have been greatly expanded. The Salisbury Avon is essentially a chalk stream. As such the water would have been alkaline and biologically exceptionally productive. Chalk streams tend to run clear and as they tend to be spring fed are less prone to seasonal temperature variation. This means they are less to prone to approach freezing in the winter (Froom, 2012, p. 3).

Rivers would have potentially provided a means to communicate with other occupants of the same river system and beyond. Despite the resources that would have been required for, and the significance of, substantial constructions in the Stonehenge car park, the fact that large numbers of Mesolithic artefacts have not been found on the plain in the Stonehenge landscape, leads to the suggestion that the river valley is where evidence of occupation would be found. The river valley and its margins would have provided the chief sources of the essentials of life and would therefore have been a focus for activity.

The surroundings of a spring would be a beneficial place to establish a settlement for sound, practical reasons. There is also evidence to suggest that there are symbolic reasons in play for the choice of these as preferred locations.

An Upper Chalk landscape is less likely to suffer floods than other geological formations. Excess rainfall is absorbed up to the point of saturation when excess water is drained off by springs along the valleys into a body of water that Evans referred to as 'the subterranean reservoir' (1897, pp. 663–664). This has the benefit that rivers and streams on the chalk are less liable to flood and suffer from the effects of variable rainfall. Furthermore, springs deliver the absorbed water throughout the year. They are to be found where the water table intersects the ground surface in the lower reaches of otherwise dry valleys, such as at Blick Mead. The Salisbury Avon was wider (approximately 60 metres across), and faster flowing in early prehistoric times, and its banks less defined and stable (Parker Pearson, 2012, pp. 156–157). Springs, such as those found at Blick Mead and West Amesbury, would arguably have provided easier access to water than the river for both people and animals.

When analysing Mesolithic flint tools from excavations at Butter Hill, Wallington, in Surrey, the use of inferior quality, thermally flawed flint rather than the better quality material available nearby was questioned by Leary. A reason proposed for the choice of the less practical material was that it might have been given some added significance as a result of being associated with the spring-heads of the tributaries of the River Wandle (Leary et al., 2005, p. 25). The capacity for the rare, red, algae Hildenbrandia rivularis found in the spring at Blick Mead to change the colour of flint to a permanent, bright pink within two days of it being removed from the water may have given this location added significance, and made it special, in a similar way.

Access to flint sources was of prime importance to Mesolithic people in southern Britain. Flint's hardness and durability, and the fact that it can be worked predictably, lends it to being fashioned into a variety of tool types. In the pre-metal age it would have been the best available raw material integral to carrying out a wide range of tasks (Butler, 2008, p. 16). Evidence suggests its use in a wide variety of hunting implements, and tools associated with wood-working, and the processing of animal carcasses and vegetable matter in the Mesolithic. Butler (2008, p. 83) highlights the microlith and the tranchet axe as the two very different tools that best characterise flint working technology in the Mesolithic period. The microlith formed part of the hunter's tool kit and was used in arrows, and other composite tools. He suggests that the tranchet axe, a much larger tool made and found in much smaller numbers, was probably used for woodworking or in the felling of small trees.

Mellars (1978, pp. 267–269) observed that 'the area of concentrated axe distribution coincides precisely with the areas of southern England in which suitable flint supplies for axe manufacture would have been readily available.' The flint formed in chalk deposits of southern Britain often takes the form of irregularly shaped nodular flint. It can be taken directly from the chalk, the freshest and best suited to knapping, or from secondary sources such as where the chalk has been eroded, leaving pebbles on a beach, or from gravels and pebbles from a river foreshore scoured out by the action of water.

Although flint from the Upper Chalk is seen as the preferred source of raw material in a landscape covered by vegetation, its visibility would normally have been limited to hill or cliff sections, and river valleys (Care, 1979, pp. 94–95 and Froom, 2012, p. 327). Another available source of flint on the chalk Downs used for making tranchet axes is found in the clay-with-flints (Butler, 2008, pp. 15–20). The colour of the flint, and its inclusions, can help identify the source of the flint, as can the staining of the flint from its exposure to a range of elements over time, the patination. However, it should be noted that as access to high quality flint in southern Britain was limited, sites where this raw material could be found would have been prized and the locations likely to show signs of nearby industry and repeated occupation (Care, 1979, p. 95). The availability of flint suitable for axe making would have been a key factor in site location.

The Stonehenge and Avebury World Heritage Site landscape is mostly underlain by chalk. Bands of grey flint nodules with a thick white cortex are found in its upper levels (Bowden, 2015, p. 2). A variation on this description can be applied to the appearance of the bulk of the flint found at Blick Mead. More than 80% of the worked flint here is recorded as being a 'mottled semi-translucent light grey to light/mid brown glassy flint containing differing proportions of opaque yellow, grey or brown cherty patches' (Bishop, 2014, p. 13). The Mesolithic assemblage additionally included a 5% element of a relatively flawless translucent black flint commonly found on the Salisbury Plain and surrounds. Much of the flint was probably acquired from deposits eroded from the chalk hill site on which Vespasian's Camp was established, and from Salisbury Avon terrace gravel deposits. Some of the nodules were likely to have been up to 250 mm in diameter (Bishop, personal communication). Also among the finds was a substantial quantity of flint and a small number of pieces of other lithic material from further afield. The significance of this is covered later as part of the Blick Mead site description.

In terms of the association between the locations where tranchets have been found and certain Mesolithic site types, Rankine (1956, pp. 9, 17) regarded them as the 'type tool of forest culture' and their wide variety in size, weight and form 'implies a variety of functions in connection with a wood industry'. More than any other tool type found from the period, tranchet axes would have been suited for the building of shelters' roofs and walls, and the fashioning of wooden boats for fishing and short distance travel. A number of possible uses for tranchet axes have been proposed including their use in woodworking, tree felling, digging and as chisels or wedges (Butler, 2008, p. 101, Mellars and Rheinhardt 1978, pp. 266–274, and Bishop, personal communication). Mellars and Reinhardt (1978, p. 270) note that tranchet axe find spots are concentrated in river valleys and around spring-lines, offering the Thames valley and certain stretches of the Darrent, the Kennet, the Wey and the Hampshire Stour as prime examples. They speculate that they could have been used for making dugout canoes.

Citing Binford (1983) and Jochim (1998), Butler (2005, p. 114) 'suggests that a system of base camps and task specific sites may have operated during the later Mesolithic period.' They would 'provide a base from which sub-groups of people would journey to locations within their territorial range where other 'task-specific' activities were carried out, for example short stay hunting camps.' Recent research has shown that the Salisbury Avon was likely to have facilitated movement between a number of bases, hunting camps and other sites (Jacques, 2014) with, presumably, socially connected groups of people working together (hunting and fishing, gathering food, fuel and raw materials, and manufacturing tools).

Evidence of early Holocene activity in the Stonehenge area has been provided by French, Scaife et al. (2012) from Durrington-Avon data, which suggests that the Avon palaeo-channel 1 pollen record shows signs of an intermittent woodland development, as well as a modification and opening-up of this landscape in the later Mesolithic. The discovery of Bluestonehenge, adjacent to the River Avon at West Amesbury, and inter-visible with Vespasian's Camp, has also revealed a 'riverside spot … (which) was a campsite for hunter-gatherers living off the resources of the river and its margins' (Parker Pearson, 2012, p. 230), but apart from the work at Blick Mead (Jacques, 2014), there continues to be little attention paid to the Mesolithic uses of this landscape, and none at all on the way the distribution of certain key artefacts from that period, such as tranchet axes, might indicate certain types of use and residential activity.

The above is surprising as Higgs' work at Downton in 1959 detailed a substantial and *long durée* Mesolithic activity area with a large range of worked flint tools, including a number of 'core axes', or tranchet axes. The evidence suggested a wide range of activities carried out at a temporary, seasonally occupied camp (Higgs, 1959, pp. 216, 231). The excavations at Blick Mead, Vespasian's Camp, 2 km from Stonehenge have been ongoing since 2005, with Mesolithic material found since 2009 (Jacques, 2010, pp. 11–13), and arguably some specialists working in the field in the Salisbury Plain landscape have been slow to recognise the significance of the finds and contexts from this site.

As with Froom's findings from the Kennet Valley, the site is served by a 'sheltered position and constant water temperature around the springs' (Jacques, 2014, pp. 22–23). These would have created extended growing seasons and provided an attractive location for human habitation. Blick Mead was evidently rich in economic resources 'Blick Mead and its surrounds were likely to have been abundantly wooded in the Mesolithic and therefore rich in fuel and building material for shelters and log boats.' Bishop in his 2014 flint report on the site (publication forthcoming) concludes that with the wide variety of tool classes present, it is 'at least reasonable to conclude that they were used for an equally wide range of activities' referencing Mellars (1976) term 'balanced assemblages' to best describe the situation. He further states 'together with the sheer size of this assemblage, it is difficult to avoid the conclusion that it represents a 'home-base', a location that saw extended and/or repeated occupation by a wide section of the community undertaking a wide range of subsistence and other tasks'.

Both Blick Mead and Downton, were connected to the River Avon, and therefore to potentially extended networks of people. Such sites are often seen as meeting points (Bowden, 2015, personal communication) and hint at the possibility that detailed research of the Salisbury Avon landscape could reveal more Mesolithic sites. The Historic Environment Record (HER) listings of tranchet axes is useful as a starting point in this regard (see below).

The relationship between tranchet axes and Mesolithic sites in or near to the Salisbury Avon valley: Known and putative

As previously noted, a tranchet axe was found in a 'field near Stonehenge' from King's Barrow Ridge. One was also found 'south west of Stonehenge', and a further one near Starveall plantation (all tranchet axe references are as detailed in the Wiltshire Museum Clay Collection). The axe from a 'field near Stonehenge' was found at a spot roughly 1 kilometre west/north/west of the hunting camp discovered by Parker Pearson at Bluestonehenge, West Amesbury, and is also close to the southern extreme of Kings Barrow Ridge. The tranchet axe described as being from 'south-west of Stonehenge' was found less than 500 metres south of the Mesolithic postholes in the Stonehenge car park. At Wilsford South near 'Starveall Plantation' a tranchet axe was found along with two 'micro-blade cores'. This find spot is not obviously associated with any other Mesolithic find in the Stonehenge WHS landscape, it is from further to the south and more in the direction of Lake Bottom.

Table 5.1: The location of tranchet axe find spots in the Stonehenge landscape

Location	Nat. Grid Ref.
Holder's Road, Amesbury	SU 1620 1450
Near Starveall Plantation	SU 1210 4040
South-west of Stonehenge	SU 1200 4210
Field near Stonehenge	SU 1300 4180
King Barrow Ridge	SU 1350 4270
Blick Mead	SU 1501 4199

Known sites are either sites at which Mesolithic finds or features have been identified, or evidence from excavations at Neolithic sites is suggestive of associated Mesolithic activity.

Downton is located close to the Salisbury Avon, 9.5 km to the south of Salisbury. The site is situated on a terrace 42.5 metres (140 feet) above AOD and 7.5 metres (25 feet) AOD, and overlooking, the present river (Higgs, 1959, pp. 209–214). At the bottom of the river terrace lie Late Glacial orange clay gravels. The gravels are overlain in the hollows by a uniform red silt, which does not 'cap the prominences'. 'The chipping floor and living site are subsequent to this stoneless silt and lie partly on the uncapped gravels', and partly in a layer consisting of red clay and stones. Higgs' excavations in 1957 revealed 38,086 pieces of Mesolithic struck flint, of which 933 were identifiable implements (including scrapers, microliths, saws, and axes).

Among the finds were six or seven 'Core' or tranchet axes and nine axe sharpening flakes. While Higgs was able to link densities of scrapers and saws with particular parts of the site, he found no concentration of axes or axe sharpening flakes in any specific area. A Mesolithic settlement was confirmed by the discovery of a posthole, more than 20 other stake-holes, an apparent hearth, a small hollow and 'clear traces ... of a shelter or shelters in the form of stakes sharpened and obviously intended to be driven into the ground'. No faunal remains were found at the site, probably due to the alkaline conditions in the soil which is typical of chalk landscapes. The work carried out at this site gave some hints as to what might be found at other topographically similar locations along the Salisbury Avon, although it was not until another half century later that a comparable settlement was found.

The monumental postholes in the Stonehenge Car Park were discovered by Vatcher and Vatcher (1973, pp. 57–63) in the first instance and were later dated by Allen (1994, pp. 471–473), to be in the range of the ninth to seventh millennium BC. The postholes ranged from 1.5 to 2 metres in diameter, were around 1.3 metres deep and likely to have held posts of some 0.75 metres in diameter (Allen, 1995, p. 43). The probable size of the pine posts raised in them was described by Allen (1994, p. 472) as possibly totemic, or that there may be a parallel with native North American sites where, usually pine, posts represent a herding structure which animals were moved towards and then channelled into corrals to be slaughtered.

The composition of the molluscan assemblage analysed from the Allen identified third pit (number 9580) by Allen (1994, pp. 51, 470) indicates the open nature of an existing or recently cleared woodland, and he suggests this as a possible reason as to why the posts would have been erected here. The posts were erected in a cleared landscape and would have been visible at a considerable distance from higher ground. However, the radiocarbon dates reveal that all three posts would probably not have been standing at any one time, and no more than two would have been contemporary with one another. Although the postholes are aligned along the lower slopes of a dry valley that meets Stonehenge Bottom at the Avenue 'elbow', they would have been clearly visible from the north and east. The posts may have been set up to mark the east/west and west/east movements of aurochsen and other large beasts through this more open landscape. Hunters could have taken advantage of these sight lines, with the posts giving them an indication as to when the animals would be at certain locations (Jacques et al., 2014, p. 24).

It is widely considered that the water table in this landscape has fallen considerably since prehistoric times. Bowden (2015, p. 15) believes water would have flowed in this valley at certain times of the year and 'the posts might have marked the position in the valley where water was likely to issue'. This point in the landscape could therefore have been marked, or memorialised, as somewhere animals could be found, to be channelled further down the valley to killed more effectively (Jacques et al., 2014, p. 24). Parker Pearson (2012. p. 137) wondered if there might be a wider distribution of such pits and postholes around Stonehenge. In later sections I highlight the discoveries at Winterbourne Stoke Long Barrow which could be seen as further evidence to support his view. Young's excavations in the Stonehenge car park close to the postholes revealed an unusual tranchet axe, the ends of which had been sharpened with a tranchet blow, which entails it having been struck from its lateral edge, near the blade, in order to remove a transverse flake across the blade of the axe (Butler, 2008,

p. 100). The axe was subsequently flaked, thereby showing sharpening techniques associated with both Mesolithic and Neolithic traditions. There had been a lack of evidence of proximate Mesolithic activity until 2008 when the Stonehenge Riverside Project (Parker Pearson, 2012, pp. 234–6) cut four trenches close to the Stonehenge Palisade ditch approximately 400 metres to the south of the postholes in the Stonehenge car park and found a cache of worked flints of which 'many were long blades from the Mesolithic period'. Parker Pearson interpreted this as evidence of a nearby Mesolithic campsite in a 'small valley' (2012, p. 236), and therefore likely to signify activity related to the posts.

At Bluestonehenge, West Amesbury, in earth underneath the henge bank, the Stonehenge Riverside Project found a single layer that included Late Mesolithic microliths, and more substantial blades from the Early Mesolithic. They also noted a spring on a chalk promontory to the north of Bluestonehenge. They speculated that in the Mesolithic, when the water table was higher, the springhead would have been further up the valley 'perhaps not far from the Neolithic settlement on the slope of King Barrow ridge' and that it fed a stream which flowed to Bluestonehenge. They found further Mesolithic flints on its north bank. Some 500 pieces of Mesolithic worked flint were found in total (Parker Pearson, 2012, p. 230 and Bishop, 2014, p. 17). This leads to the belief that this was once a riverside hunting camp, one with good access to the important transportation route afforded by the Salisbury Avon.

Bax, Bowden et al. (2010, pp. 31–37) looked in detail at the excavations carried out at the Winterbourne Stoke Crossroads long barrow, and the three empty pits discovered by Cunnington and Thurman in 1865 which were uncovered beneath it, one 'at the head of the primary internment'. This pit was measured by Thurnam to be both 0.46 metres deep and in diameter, and the other two pits referred to as being of a similar size. They noted the discovery of an unstratified surface find of a finely made, backed flint bladelet, defined by Butler (2008, p. 35) as a small blade less than 12 mm wide, from the centre of the long edge of the [long] barrow. Finds within the survey area included another Mesolithic flint bladelet' from the centre of the long barrow and a flint scraper possibly of Neolithic date together with a single-backed flake and a flint flake, both of unknown date.

The Winterbourne Stoke Crossroads long barrow is estimated to have been built between about 3750 to 3400 BC, and is therefore the earliest monument in this part of the Stonehenge landscape (Bax et al. 2010, p. 37). The primary Neolithic interment from the first pit had at its head the crouched skeleton of a young man together with a 'bludgeon-shaped flint nodule'. An ischium, since lost from the original excavation, of an old horse or possibly a cow or red deer was found less than a metre from his feet (Bax et al., 2010, and English Heritage advice therein). These type of pits were found beneath a number of long barrows and round barrows dug by Cunnington and 'sometimes occur in odd numbers or singly'. Reference is made in Bax (2010) to a personal communication with Field suggesting that the pits could have housed 'free-standing, monumental posts' marking an already significant place'. This is similar to one hypothesis proposed as to the purpose for the Stonehenge car park postholes.

Lawson (2007, p. 36) mentions the coincidence of Mesolithic features found beneath or close to Neolithic monuments, and that monuments that we now view as Neolithic may 'well have already acquired a special significance in the Mesolithic'. The burial of bodies, tools and perhaps curated animal bones in the Neolithic on or close to places or symbols that were significant in the Mesolithic could have been a way of memorising them and expressing a continuity with past customs and practices.

When Christie carried out work at the extreme west end of the Greater Cursus in 1959, her excavations of a ditch (on the east side of Winterbourne Stoke round barrow G30) revealed a deep, oval pit containing pine charcoal and burnt flint (Christie et al., 1963, pp. 370–82). Although not a point raised by Christie herself, this is strongly suggestive as being evidence of Mesolithic activity, as pine was almost entirely absent from the south of England by the start of the Neolithic period (however, it should be noted that Branch in a 2015 personal communication indicated the persistence of pine in the Stonehenge landscape up until circa 3000 BC). The prospect remains of a Neolithic monument again being purposely positioned above, and including within it, signs of Mesolithic activity. Lawson (2007, p. 35) suggests that evidence for substantial Mesolithic pits, which are often

found near later monuments, point to a people engaged in a wider range of activities than merely hunting and gathering in a natural landscape.

In 1980, as part of the Stonehenge Environs Project, a pit was found on a ridge top close to the Coneybury Hill henge monument which, due to the circumstances of its discovery, came to be known as the Coneybury Anomaly (Richards, 1990, pp. 40–60). The pit was originally 1.9 metres in diameter and 1.25 metres deep. Radiocarbon dating put the time that the pit had been filled in to approximately 3850 BC, and so in the Early Neolithic. The contents of the pit included 1,375 sherds of pottery, 2,110 animal bone fragments, and also 1,500 flint artefacts in pristine condition. Although the bulk of the animal bones consisted of domesticated cattle, wild species of animals were represented by at least seven roe deer, two red deer, a pig, two beavers and a brown trout. Richards thought that the material deposited in the pit indicated the remains of a Neolithic feast, or period of feasting. Lawson (2007, p. 36) notes that the contents may represent a continuation of Mesolithic traditions with 'consumption of wild animals, the exploitation of the river valley for wildlife and flint and tool production based on blades' combined with evidence for the newly arrived Neolithic feasting practices.

Another interpretation could be that bones from Mesolithic contexts had been curated and later buried in the pit with the remains of Neolithic feasting to monumentalise the place, or a set of practices, at a site which was already special before the Coneybury Henge was constructed. It should be noted that the aurochsen remains were found in the upper fill of the pit, giving weight to the thought that these bones had been curated. All results so far obtained from a new dating programme initiated by Wessex Archaeology have given C14 dates from the Early Neolithic of circa 3800 BC.

Darvill (2005, pp. 70–75), when comparing the Coneybury Anomaly to other pits in a Neolithic context, speculated as to whether places that were once occupied might have been remembered and celebrated by later periodic visits. Perhaps the Coneybury Anomaly itself was dug out to make concrete earlier memories of the place, to be a link with the Mesolithic, 'to signify different material cultures' and 'freeze-frame a transition between the late Mesolithic and early Neolithic in a way suggestive of a moment of cultural appropriation or assimilation' (Jacques, 2014, p. 25). Bowden (2015, p. 16) takes this point up, and refers to possible 'cultural threads that extended across archaeologically defined periods'.

Thoughts of consciously made connections with the past can be applied to the piece of animal bone discovered in the packing of Sarsen 27 at Stonehenge and radiocarbon dated to 4340–3980 BC (Darvill 2005, p. 66). The dates put it at the cusp of the Mesolithic/Neolithic transition, and it is also therefore evidence of pre-henge activity. The bone is bovine and unlikely to be from a domesticate, and it is therefore most probably from an aurochs. The dating evidence from the bone is close to, and indeed overlaps, the latest C14 dates from the bone of aurochsen unearthed at Blick Mead which gave a range of 4336–4246 BC. This could have been another conscious decision made to link a Neolithic monument with memories relating to a hunter-gatherer past.

Wessex Archaeology carried out archaeological work for the Highways Agency (Highways England) for the A303 Stonehenge Improvement scheme between 1992 and 2003. The earliest deposits encountered in the surveys comprised a buried soil of Mesolithic date containing a Late Mesolithic flint assemblage west of Countess Farm (Leivers and Moore, 2008, pp. 12–19). Five evaluation trenches were dug 'on the lower slopes of the valley side at the back of the higher floodplain of the River Avon, in an area of mapped calcareous gley alluvial soils ... on chalky and gravelly river alluvium'.

One of these trenches, Trench 3 'straddled ... a distinct ... break of slope on gently sloping ground on a south-facing dry valley at c. 70–71 meters above OD'. They recovered a total of 226 pieces of worked flint and 180 fragments of burnt unworked flint (3,425 grammes). The flint scatter 'was found to be confined predominantly within the relict soil just off the terrace edge'. It was in very fresh condition and 'unlikely to have travelled very far from its original place of deposition' and therefore revealed as a further site on the margins of the Salisbury Avon where Mesolithic activity took place.

Finds of charcoal from 1.47 to 1.6 metres below the northern floodplain of the River Avon east of Durrington Walls, and dated to 8300–7100 BC, indicate that at that time there was a woodland dominated by pine, birch, hazel, oak, and elm (French in Cleal et al., 2004). In later worked carried

out by French et al. (2012, p. 13–25) they speculated that a slight change in the Salisbury Avon river course outside the eastern entranceway to Durrington Walls could relate to 'increased run-off in the catchment as a consequence of the earliest inroads into this wooded environment in the later Mesolithic periods'. They also noted the unusual and substantial presence of pine persisting until 2900 BC, making up roughly 20–50% of dry land pollen.

From additional radiocarbon dates taken, and relating it to the limited level of woodland intensity and its regular depletion, they link this to the possibility of a number of 'substantial but episodic inroads' into the wooded landscape towards the end of the Mesolithic and into the early Neolithic periods possibly as a result of human activities, 'including clearance and monument building on the adjacent downland'. Their work on molluscan data when put in context of other recent work on chalk locales suggests that the more open, less wooded, landscape at Durrington (and at Stonehenge) 'may have had its antecedents in the earlier Mesolithic'.

This evidence points to the prospect of Mesolithic people already viewing this area as desirable or important, and significant effort being put in to manage the environment. Richards (1990, p. 263) refers in his Stonehenge Riverside Project to a personal communication with Roy Evans, noting an excavation of a colluvial bank on the western side of the River Avon below Durrington Walls where an 'in situ flint industry of blade form ... associated with microliths' was revealed giving us a further indicator of Mesolithic activity in the area. Care (1979, p. 100) refers to the phenomenon of Mesolithic activity in restricted areas of the chalk creating areas of more open country that would have been attractive to settlers in the Neolithic; and that these places were likely to be the locations for Neolithic ceremonial sites, and not where people settled.

Intriguingly, Darvill (2010, p. 67) gives details of a perforated-dolerite pebble hammer found inside Durrington Walls. Unfortunately, it is undated, but as a likely import from the Welsh Marches it is an 'exotic' find indicating possible cultural links with distant places. The closest tranchet axe find spots to Durrington Walls are both a couple of kilometres away, one to the south-west, at the south of Kings Barrow Ridge, and one to the south-east at Holders Road. The second of these was found a short distance from Boscombe Down sports field where a Mesolithic pit was excavated and molluscan evidence has shown the post to have been set up on cleared land (Wessex Archaeology, 1996, p. 11).

At Woodhenge, a short walk to the south of Durrington Walls, a single trench was cut through the bank and ditch on the south-east side of the henge where charcoal and a core-trimming flake perhaps dated to the sixth or seventh millennium BC was found, with indications of a woodland fauna setting (Evans and Wainwright, 1979, pp. 73, 162, and 192–194, and Darvill, 2010, p. 64).

Blick Mead can be viewed in the context of this distribution of find spots in Stonehenge and Avebury World Heritage Site. Discoveries were made on the alluvial floodplain of the Salisbury Avon at a place where the river takes a loop to the west of Amesbury. The site is on the north side of the river approximately 150 metres from the present main channel of the Avon and close to the boundary between the alluvial floodplain and the valley-side. Topographical surveys have indicated that the current ground level at the spring is approximately 77 metres above OD, falling away to 74 metres above OD at the river.

Excavations have been carried out on an ancient springhead depression, 'the largest of a complex of springs in the vicinity' on the southern edge of a deposit mapped as Quaternary Head by the British Geological Survey (BGS) (Hoare in Jacques, 2014, p. 8). It is further described by the BGS as being of Late Cretaceous Seaford Chalk Formation, and the Head composed of clay, silt, sands and gravel. Peat overlays the chalk gravel, sands, and flint chalk deposits. In the northern part of the site large quantities of Mesolithic flintwork have been uncovered, together with organic material from a unit of sand of no more than 0.2 m thick. Surveys have revealed that the 'areas displaying the highest densities of Mesolithic flintwork so far identified in the archaeological investigation are situated where the underlying gravel surface, and hence the mantle of sand, rise slightly towards the edge of the alluvial floodplain' and are 'just to the north of the shallow east-west depression recognised on the gravel surface and tentatively identified as a former channel' (Nick Branch, personal communication, 2015).

In this topographic and geological context, between 2005 and 2013, more than 30,600 pieces of Mesolithic struck flint were found, largely from excavating an area of 16 m² (Bishop, 2014). In October a further 1,599 pieces of worked flint, together with 1,391 pieces of burnt flint weighing a total of 33,655 grammes were recovered (Bishop, 2015). Bishop believes that this means that it is very likely that they were used in carrying out a wide range of tasks and functions. Together with the sheer size of this assemblage, 'it is difficult to avoid the conclusion that it represents a home-base', a location that saw extended and/or repeated occupation by a wide section of the community undertaking a wide range of subsistence and other tasks'. As of June 2015, amongst the wide range of worked flint found at Blick Mead, 11 tranchet axes have been found.

Radio carbon dates taken from the spring at Blick Mead range from 7596 BC to 4246 BC, from 13 dates with at least one from each of those millennia, represent the longest chain of Mesolithic dates from any site in Europe, and give a unique view into the transitional point between the Mesolithic and the Neolithic in this locality.

The finds at Blick Mead are not just limited to lithics. There has been a wide range of faunal material discovered, 2,430 fragments as of October 2014 (Jacques, 2014). Of the 270 identifiable fragments found in trenches 19, 22, 23 and 24, 155, or 57%, were identified by Durham University in 2015 as being of aurochs (Bos primigenius), and a further four pieces as likely to be of aurochs. 'Almost the entire skeleton was represented in the assemblage with the foot and ankle bones comprising the majority of the assemblage' (Rogers, 2015).

Table 5.2: C14 results from Blick Mead samples carried out by SUERC laboratory

Context no.	Material	Radiocarbon Age BP	Cal BC (68%)	Cal BC (95%)
67	Wild pig tusk	8542 ± 27	7593–7569	7596–7542
65	Aurochs tooth	7355 ± 30	6330–6100	6360–6080
64	Wild pig tooth	6396 ± 26	5464–5325	5469–5320
77.1	Animal bone	6114 ± 28	5199–4992	5208–4948
76	Aurochs ankle	6018 ± 31	4947–4848	4998–4810
67	Aurochs leg bone	5900 ± 35	4798–4722	4846–4695
105	Charcoal			4336–4246

Durham University calculated the Minimum Number of Individuals (MNI) of aurochsen to be four, but highlighted the limitations of the calculation and the possible under-representation of this figure in the case of Blick Mead (Rogers, 2015, pp. 22–25 and pp. 32–34). They further identified that four of the aurochsen bone fragments showed cut marks resulting from the effects of butchery. In addition, from a Mesolithic context, 46 fragments of red deer were found, as were fragments of roe deer, elk, wild pig, hare and wolf.

Foot and ankle bones made up a significant proportion of the fragments of Aurochsen and other major species found in the four trenches at Blick Mead. Legge & Rowley-Conwy (1988, p. 75), referencing Binford (1978) posit that this assemblage would normally be likely to indicate a hunting camp, as 'hunters not surprisingly take away the bones with the most meat, fat and marrow, and leave behind those with least'. The assemblage is more complex at Blick Mead, as the high number of proximal hind limbs and phalanges also found could indicate that it was a base camp, or home-base, using Binford's assumptions.

Rogers (2015, p. 53) argues that the delta 18 Oxygen results indicate that the aurochsen were likely to have been local to the Blick Mead site, and that this would go some way to explaining why the faunal assemblage shows characteristics of both a hunting site and a home-base. The existence of local aurochsen (and other large animals) may indeed be one of the major reasons why a home-base was

set up at Blick Mead. The tranchet axes at the site could well have been required for the construction of canoes or log boats to be used for the transportation of the dismembered parts of animals from the kill site to base camp. In a wooded landscape moving their spoils by water it is likely to have been easier, and safer, than dragging heavy carcass parts across the land.

It is interesting to speculate as to why faunal remains were discovered at Blick Mead, but not at Downton, despite the lithic material found at each indicating that both were home-bases. This is likely to be down to the fact that the waterlogged conditions experienced at Blick Mead have been more conducive to the preservation of bone over the intervening millennia than the conditions that prevailed and in which the excavations were carried out by Higgs at Downton.

In his primary assessment of the lithic material recovered from features, buried soils and overlying colluvium from Trench 24, Bishop (2015, p. 1) found that of the 1,599 struck flints, just under half comprised of macro-debitage, or struck pieces measuring over 15 mm in maximum dimension. This, together with a significant quantity of burnt flint weighing over 33 kg, was recovered from a single trench. In this trench three separate features were identified, a pit/tree-throw [105], feature [111] and posthole [115] all yielding a range of struck flint and unworked burnt flint. The scale of the assemblage from this single trench is such that it exceeds most other assemblages of the period from any site in Wiltshire.

Bishop believes that the unworked burnt flint 'indicates deliberate burning on a scale that exceeds what might be expected from casual hearth use ... and ... is most likely to have been generated through cooking activities, but if so would be on scale very rarely encountered at Mesolithic sites'. The Posthole [115] yielded a small quantity of unworked burnt flint and 12 struck pieces of flint that were in good condition, one of which could be dated to the later Mesolithic. The Pit/tree-throw hollow [105] contained a much larger quantity, over 14 kg of intensively and uniformly burnt flint. It had become fire-crazed, and the consistent grey-white colour was seen as representing deliberate burning. A small number of unburnt struck pieces were also found.

It was the Feature [111], evidence of a possible structure, that gave the most wide-ranging flint assemblage. The quantity of burnt flint recovered, 3 kg, was not as significant as in the pit/tree-throw hollow [105]. The struck flint assemblage comprised of 366 pieces in mostly 'good or even sharp condition ... is technologically homogeneous ... the product of blade-based reduction system ... and comprises all stages in the reduction sequence' (Bishop, 2015, p. 2). The pieces included a significant number of microliths, together with three micro-burins which in themselves indicate the manufacture of microliths at the site. The assemblage also included extensively reduced cores, potentially useable flakes and blades and a variety of retouched implements including a piercer. Of the microliths, three micro-scalene triangles and two rods could be dated to the later Mesolithic, a bi-truncated rod more likely to come from the Middle Mesolithic. The sum of the evidence on offer, and in particular the state of preservation of the struck flint found, leads Bishop to state that 'Its condition indicates that it has experienced only minor post-depositional movement, raising the possibility that the features and buried soils at the base of trench 24 do represent a contemporary Mesolithic surface and series of structures'.

The large number of tranchet axes found at Blick Mead makes even more sense when seen in the light of a structure, or structures, discovered at the location, the association between the tool and its likely functions becomes more manifest. More than any tool known to be available in the Mesolithic, the tranchet axe is suited to the modification of a lightly wooded landscape, and the construction and fashioning of wooden structures. At Blick Mead there is evidence of a multiphase occupation of a substantial house, or houses, which would have required substantial resources to be organised in its construction. Significant quantities of raw materials would have had to be collected, a wide range and number of tools made, and all of the occupants fed and watered.

The tranchet axes, together with the bulk of the lithic assemblage found at Blick Mead, were uncovered from a deposit of water-lain clayey sands. From its condition and stratigraphic position it appears that the assemblage was discarded into slow moving or stagnant water (Bishop, 2014, p. 47).

Parallels can be drawn with the deposition of knapping scatters at Thatcham (Churchill, 1962, pp. 363–370) and around the springs of the River Wandle at Carshalton (Leary et al., 2005, pp. 1–28) and could represent a ritual disposal of artefacts into the symbolically significant, life enhancing, spring.

There is as yet no evidence of a significant Mesolithic site of occupation along the banks of the Salisbury Avon to the north of Blick Mead and, apart from the possibilities associated with the recently re-analysed evidence at Boscombe Down, no traces of a substantial contemporaneous habitation to the south until Downton. In this context Blick Mead can be seen as a key focus in the Stonehenge landscape, helping to make sense of the stray finds and signs of activity in the car park at Stonehenge, Bluestonehenge, Winterbourne Stoke Long Barrow, at the western side of the Greater Cursus, and other find spots in the World Heritage Site landscape. The locations above that have been described as hunting camps can be seen in this context as easily reachable kill sites to which groups of hunters made forays and returned to the home-base with their spoils.

Jacques (2014) and Bowden (2015) put forward the possibility that the purpose of the posts in the Stonehenge car park postholes was to mark a point in the landscape where large animals passed by, or came to drink, and could then be corralled further south along the valley to a point where they might more easily be slaughtered. The car park posts would have been inter-visible with Kings Barrow Ridge and Coneybury Hill which are in turn inter-visible with Vespasian's Camp, of which Blick Mead forms a part, as would the posts raised in the posthole(s) in the playing field at Boscombe Down. Their purpose may have been to not only signify but to memorialise the hunting of these beasts.

The excavation from Trench 24 of a large quantity of unworked burnt flint, together with the substantial amounts found at previously excavated trenches, and likely to represent 'cooking activities on a scale very rarely encountered at Mesolithic sites' (Bishop, 2015) raises the prospect that large scale feasting took place at Blick Mead. The excavation of a large number, and wide variety of animal bones at the site reinforces this possibility. A large number of aurochsen, wild boar and red deer bones have been found at the home-base and if this was a location from which wide scale slaughter of large animals would be orchestrated, it represents a meaningful site for feasting to have taken place. The hunting, butchery, cooking and consumption of the beasts would have been centred at this frequently visited and long occupied site. 'It is difficult to escape the conclusion that the quantities of meat produced by them, as well as the efforts needed to kill and render them, created an opportunity for structured social rituals, such as large scale feasting' (Jacques, 2014, p. 23). A sizeable gathering would have meant that the orchestration of a large scale feast became possible, the arrivals would have been part of the chain involved in the tasks necessary to stage it. The tranchet axes were the best adapted tool for building the boats to transport the animals from the place where they were killed, for clearing small trees and bushes from the feasting site and providing firewood for it. They were also a tool with sufficient heft to have been used to break large bones in order to extract the calorie-rich marrow.

There is evidence from the combined lithic assemblage to suggest that people had travelled considerable distances from Blick Mead and returned, or others had journeyed from afar to get there. As previously described, the bulk of the flint used at Blick Mead is likely to have been gathered from nearby, in what is a flint-rich landscape. However, also present is a relatively flawless translucent black flint 'not commonly encountered in the Salisbury Plain area' making up less than 5% of the assemblage, and a similar amount of 'bullhead bed' flint (with its green cortex and underlying orange band) from at least 16 km upstream (Bishop, 2014, p. 14). A small amount of opaque white through to mid grey 'stony' chert was found. There is exploitable chert from along the Nadder Valley some 16 km to the south-west but this does not have the same characteristics as the chert found at Blick Mead, and the origin of the chert in the assemblage is uncertain.

Two exotic tools from the assemblage are particularly striking and have their origins from further afield. The first seems to be a 42 mm long 'Horsham' point. It is made from a light-greenish slate which appears to have been purposefully formed into a close approximation of the distinctive microlith type. Slate is not found locally to Blick Mead, and the closest source for this particular type of slate is either Cornwall or the Welsh Marches. The fact that it is made of slate means that it would have been

unlikely to be suitable for any practical purpose. With a geologically similar find from Hampshire, Jacobi (1981, p. 20), in detailing Mesolithic slate blades found at Broom Hill, hypothesised that these had been acquired from people inhabiting the 'south-western peninsula'.

The second tool is a sub-angular elongated block of sandstone. It is 198 mm long, 56 mm wide and 34 mm deep, weighs 767 grammes and could loosely be described as phallic shaped. Its two faces are smoothed, and the two sides are both 'bevelled and have a rougher finish, consistent with fine pecking' (Bishop, 2014, pp. 44–45). It appears to originate from the West Midlands (Tony Brown personal communication). Along with the tranchets, which in some design ways it parallels, it is a possible example of people leaving prestige goods in the spring area.

Excavations carried out by Wessex Archaeology at Boscombe Sports Field, Boscombe Down ahead of the construction of a new housing estate, revealed a large pit, number 148, at the southeastern edge of the site (Wessex Archaeology, 1996, p. 11). It had the appearance of an extremely large (1.4 metre diameter) posthole with 'very compact chalky fills against the sides and a well-defined pipe of dark humic soils in the centre of the feature'. In the report, a possible functional parallel was drawn to the postholes in the Stonehenge car park. Although excavations down to 1.45 metres did not reveal the base of the pit, a 'relatively high quantity of very small charcoal fragments' was noted'. Later radiocarbon dating of the recovered pine charcoal put the date of the pit to 8460 BC to 8250 BC (Alistair Barclay, Wessex Archeology, 2015).

Boscombe Down is situated in a valley and the associated benefit of retention of moisture on the clay-with-flints found there would have made the area attractive to animals. It should also be noted that the posthole is at a point which is inter-visible with Vespasian's Camp, and one of the tranchet axes found in the Stonehenge landscape was at Holders Road, Boscombe Down, a short distance from where the Wessex excavations took place. The environmental evidence for pit number 148 included evidence of land snails from open country-loving species, but with shade-loving species predominating. Wessex Archaeology interpreted the results as suggesting a once cleared feature had fallen into disuse (Wessex Archaeology, 1996, p. 24). The nearby find of a tranchet axe from Holders Road could be seen to be associated with the clearing of the land prior to the pine post being raised in the Mesolithic period.

From later excavations by Wessex Archaeology (2004) at Boscombe Down, at the eastern edge of the site, to the east of the dry valley, they discovered, in Pit 8326, the articulated skeleton of a juvenile aurochs comprised of 682 bone fragments. 'The absence of the upper limb bones and placement of the lower limbs next to the head indicates a deliberate and unusual selection and deposition practice'. The report of the excavation by Wessex Archaeology (2004, p. 44) also indicated that open conditions had been establish by the Late Neolithic period, again providing a possible link to earlier tranchet axe associated land clearance in the Mesolithic.

The finds of Mesolithic flints by Wessex Archaeology (Leivers and Moore, 2008) together with lithic material from my finger tip search of a 20 m² grid at Countess Farm at a location just on the other side of the road suggests a continuation of the Mesolithic home-base extending north from Blick Mead. They share a common river terrace on the flood plain and are only separated by approximately 100 metres.

As covered in more detail in the Methodology section finds of pre-Neolithic struck flint around Lake recorded by Evans (1897, pp. 627–628) and his description of the topographical geographical conditions in which they were found, gives a good pointer as to where Mesolithic activity took place. When this overview is added to the recorded positioning and geological conditions experienced at Lake at the time of the excavations of a possibly Medieval 'bog body' (McKinley, 2003, pp. 7–9) with its associated Neolithic to Bronze Age worked flint and an extensive layer of burnt flint, and then combined with the nearby evidence of Bronze Age activity from bowl barrows, a picture of a possibly significant prehistoric landscape starts to emerge.

The lie of the land adjacent to the Salisbury Avon at this place is important. It would have been easily accessible from the river banks to hunter-gatherers and animals, in a way land towards the

north of it would not. The presence of a number of fresh springs in the close vicinity means that a wider range of vegetation would have grown, and been available as a resource for longer periods of the year. The range of vegetation together with the rivers and springs would themselves have made this area very attractive to a range of animals. Animals drinking at, and fish from, the water could be exploited from low lying terrain close to the river. Furthermore, the attraction of Mesolithic people to the symbolism associated with springs cannot be ignored.

Lake lies at the point at which a deeply cut channel stretching from the Salisbury Plain at Stonehenge meets the Salisbury Avon. Bowden (2015) thinks it probable that water would have flowed in this valley in some seasons in the Mesolithic. The channel passes Stonehenge Bottom on its way south past the point where the Mesolithic posts from the Stonehenge car park once stood. As mentioned previously, their presence could have been to indicate the movement of animals or where they gathered to drink. The topography is such that it invites the possibility that aurochsen and other large beasts attracted to the water may have been driven along the valley by hunters to Lake where they could be ambushed and slaughtered.

Rather than view the exotic finds at Blick Mead as purely anomalous, it is instructive to look at them in light of the evidence for large scale feasting at the location, and the possible symbolism of these artefacts to be seen in this context. The lithic finds, a substantial quantity of intensely and purposefully fired burnt flint, together with the disarticulated remains of large quantities of aurochsen, red deer, wild boar and evidence of hunting, butchery and cooking give rise to the belief that complex, structured, social rituals took place at this location.

The understanding of the origins, meanings and significance of lithic material has been shown to be extremely important (Conneller, 2008, pp. 160–176). She argues that it is not only the mechanical and the functional, properties that give meaning to an object, but also the symbolic dimensions of materials. She further suggests that it may be a consideration of the social position of the animal that is to be killed that orchestrates the whole of the 'chaîne opératoire', the process by which the raw material is selected, worked, reworked and the tools and discarded material dealt with. The 'chaîne opératoire' of itself incorporates a 'socially transmitted body of knowledge, as a socialised suite of gestures on matter'. In this way raw materials can be used to illustrate how networks can connect diverse groups in carrying out technological acts.

When considering the manufacture and use of a tool, a number of contributory actions need to be considered. At one location a flint nodule or pebble would be selected and transported to the place where cores, flakes and blades are created and worked. A composite hunting tool could require a shaft to be chosen, cut and worked, and a source of mastic found, before all of the elements are brought together to form the finished artefact. The hunter involved in dispatching an animal would additionally have a social connection with those who butchered, cooked and ate the beast, and those who processed the hide, sinews, bone, horn or antler, for clothing, shelter, decoration and additional tools. All participating in this involved process would be connected while conceivably having aspects of their identities evoked, projecting their biographies on the objects worked (Conneller, 2008, and Jacques, 2014, p. 23).

She also believes that raw materials should be considered not only as an indication of how far and wide the hunter-gatherers travelled or who they traded or exchanged with, but also as an embodiment of the place where they were procured. The places at which they were found could be seen as imbuing the raw material with special significance (Conneller, 2008, p. 169). Jacques suggests that the comprehensive artefact collection at Blick Mead could represent a record of events, memorising social connections and rituals. The evidence for a slate Horsham Point and an as yet uncharacterised sandstone tool, both discoveries without parallel in the Wiltshire landscape, made from raw materials likely to have been procured hundreds of kilometres from Blick Mead, and fashioned using techniques also unknown in this area, leads to the conclusion that the social connections of those that came to the site were both complex and wide ranging.

The discovery of 11 tranchet axes at Blick Mead, and five other finds in the Stonehenge Environs, together with six or seven axes found at Downton can help us to consider their significance and the

possible reasons for their disposal at the locations at which they were found. In southern Britain tranchet axe manufacture was best suited to locations where large nodules of preferably good quality flint could be found, normally from clay-with-flints outcrops or occasionally from large suitable pebbles (Butler, 2005, p. 100). Badly flawed flint would render the manufacturer of these tools, which are normally found in southern England to be between 70 mm and 300 mm long, impractical.

There are numerous woodworking uses for which the tranchet axe was the best suited tool in the Mesolithic toolbox. The geographical scarcity of the raw material used for the manufacture of a tool which was likely to have been important in the felling of small trees, the construction of shelters and building of canoes would have afforded it a significant trading value, especially outside of the chalk lands. The enhanced value given to these artefacts can be illustrated by the often smaller size of the tranchet axes found away from flint rich areas; and evidence (from sharpening of the tool itself, and from discarded sharpening flakes) for the curation of the tools. This can be contrasted with Blick Mead where there is a lack of small tranchet axe finds, and no sharpening flakes have been found. Bishop (personal communication) suggests that this points to the tranchet axes not being made locally, but being brought to the site from their place of manufacture. If we take a lead from Conneller's theory of object biography we can see how tranchet axes could be seen to be imbued with the diverse sentiments of home, and travel associated with the connection between social groups, together with the hunting of animals and the transportation of their carcasses back to the home-base.

More than two thirds of all tranchet axes found in the Stonehenge landscape came from excavations of the home-base at Blick Mead. The others were found singly, and have been seen up until now as random finds in the landscape. What the find spots have in common is that they are all within a 5 kilometre radius of Blick Mead. A number of them have been found close to places at which there is evidence (albeit occasionally slight) of activity taking place in the Mesolithic period. These 'stray' finds of tranchet axes on King Barrow Ridge, at the Stonehenge car park, and near Boscombe Down, are likely to have had their sense of place based at Blick Mead, if not their origin, and been deposited at places which would have been within the day to day activity area radiating out from the home-base, Blick Mead. Its outreach or hinterland perhaps marking and memorialising concepts of home in the nearby landscape.

Butler associates the tranchet axe with activities likely to be carried out at more permanently occupied sites, or raw material procurement sites (2008, p. 114). The evidence from Blick Mead, where a significant number of tranchet axes were found, is that the site was occupied over a considerable time span and not just for short stay occupation. The lithic material found there suggests a wide range of activities were carried out at the site. Most of it was probably made at, or close to, the site. The assemblage appears to reflect the movements of the hunter-gatherers who followed their prey according to the seasons and chose to occupy sites as a function of the varying availability of exploitable animal and plant matter (Bishop, personal communication). The faunal remains together with a substantial amount of intensively burnt cracked flint suggests that large scale feasting took place. Emerging evidence of a substantial 'house' at Blick Mead also speaks of persistence, and permanence, at the site.

While there is an availability of flint resources in close proximity to the home-base, there is as yet no compelling evidence to suggest that it was used in the manufacture of tranchet axes. No definite tranchet axe preforms or rough-outs (both early stages in the manufacturing process) have as yet been excavated at the site. The Mesolithic landscape model described by Butler is one containing a network of task-specific sites centred on a river side or lake side in a woodland clearing (2008, p. 116). The vast quantity of worked flint and wide range of tool types found at Blick Mead, its awls and piercers, borers, blades, bladelets, micro-burins, as well as the tranchet axes and the range of activities undertaken that the assemblage suggests, place the site in his interpretation as a base camp or multifunctional site. However, the manufacture of microliths evident from the finds of bladelet cores, whole and broken bladelets and micro-burins and the microliths themselves is more typically associated with an assemblage likely to be found at a hunting camp. In essence, we are looking at a site showing characteristics of both a home-base and a hunting camp. Light is shed on this in the form

of the analysis of the aurochsen bone assemblage suggesting that they were likely to have been local to Blick Mead (Rogers, 2015, p.53). What we appear to have at Blick Mead is a home-base that was established as a result of locally found aurochsen, and from which hunting took place, not so much a task-specific site as a multi-functional one.

A number of sites in the Stonehenge landscape can be characterised as having a connection to Blick Mead. The site at Bluestonehenge has been interpreted as a hunting camp. Other Mesolithic find spots don't fit so easily into Butler's task related categorisation of the landscape, having no obvious functional basis themselves, or any practical link to another site. The reason for artefacts being deposited at these locations appears to be symbolic, sites that mark or memorialise places in the home-base's task-scape. Butler's hunter-gatherer model of Mesolithic activity in the landscape might therefore be improved if were slightly nuanced to incorporate symbolic find spot locations radiating out from the home-base hub, as well as the functional ones.

The finds of Mesolithic material from across the Stonehenge part of the World Heritage Site were seen as random and unconnected, but when they are viewed as a whole, Blick Mead can now be seen as a nexus in the landscape, the connection to which other Mesolithic activities in the area are defined. Blick Mead stands out as the only long-term Mesolithic 'persistent place' to have been found in this area. Carbon-dating from a range of material from the excavations shows that people occupied the site throughout the entirety, and in all millennia of the Mesolithic period. There is a range of evidence to indicate it was a home-base with structures built within it. The large quantity of burnt flint and faunal evidence unearthed tells us that feasting on a grand scale took place there. Tools associated with hunting, animal and plant processing, settlement construction and riverine boat building were found and often made at the location.

There is compelling evidence of wide-ranging activities carried out by hunter-gatherers often associated with a largely nomadic lifestyle. Rather than look at Blick Mead in isolation, it is instructive to view how it can be seen as being linked to other places, as part of a network of connected people, places and things, making it possible to explore the fluidity of identity, meaning and things (Conneller, 2008, p. 165). This approach potentially brings new meaning to both the home-base and the disparate finds made in the surrounding area, the other pieces of evidence of Mesolithic activity can be seen as radiating out from the Blick Mead fulcrum, and the hinterland no longer seen as a passive landscape but a 'taskscape' of inter-locking and related activities (Ingold, 1993, pp. 153, 158).

If the Stonehenge car park pine posts indicated the movement of large animals, and from where they were channelled further down the valley to be more easily killed (Jacques, 2014, p. 24 and Bowden, 2015, p. 15), Blick Mead, and Lake, are suitable destinations. Blick Mead is situated to the east of these channels/side valleys, at a point where the valley opens up as it reaches the Salisbury Avon. Hunters based and equipped at Blick Mead would have been ideally placed to dispatch the beasts in the valley as they were driven south and haul their carcasses a short distance back to camp.

A similar purpose can be imagined for the locations of the other substantial postholes in the Stonehenge landscape from the same time. The radiocarbon dates of the pine charcoal from all of the postholes found fall into the range of the multi-phase activities at Blick Mead. The Mesolithic riverside hunting camp at Bluestonehenge, West Amesbury (Parker Pearson, 2012, p. 230), like the site at Countess Farm, is situated just a short distance from Blick Mead and is likely to have been one of a number of satellite hunting camps used by occupants of the home-base, the purpose of which was to provide food and other resources to the central hub.

A number of the Salisbury Plain surface finds of tranchet axes were not from securely datable contexts. As they were likely to have been valuable items, and most were found in still good condition, the tranchet axes can be seen as items purposely deposited in the landscape to mark out the territory controlled by the inhabitants of Blick Mead, or as part of a ritual association memorising the activities that took place there, the symbolic dimension of the axe representing the home-base.

Of the five tranchet axe find spots, four can be associated with a nearby Mesolithic footprint. The axe from Holders Road, Amesbury can be associated with both the large Mesolithic posthole

and ritual burial of an aurochs at Boscombe Sports Field. The find from 'a field near Stonehenge' at the southern extreme of Kings Barrow ridge is roughly a kilometre from Parker Pearson's riverside hunting camp at Bluestonehenge. The tranchet axe from 'south-west of Stonehenge' was found less than 500 metres south of the Mesolithic postholes in the Stonehenge car park. At the car park itself and close to the postholes Young excavated a tranchet axe. Unfortunately, the axe found appears to have been extensively modified and it has been interpreted as being unlikely to have been deposited at the location in the Mesolithic.

In light of the discoveries at Blick Mead there is a case to be made for re-viewing such anomalous discoveries. When it was supposed that there was only a very slight Mesolithic presence in the Stonehenge landscape aside from the car park postholes, the tendency could have been for certain prehistoric finds and find spots to have been looked at with an Early Neolithic bent. Could it be that this axe design represents something more interesting, some sort of design overlap between two cultures, in effect a Mesolithic/Neolithic hybrid?

As an extension of this logic, Downton can be seen as being similar to Blick Mead, as a nexus point, a central hub from which a task-scape radiates. Due to the lack of faunal remains, the evidence is not as clear and distinct as that provided for Blick Mead, but there are signs that indicate similar patterns of activity. There was a considerable quantity and range of lithic material found at the site (Higgs, 1959). This, when viewed along with the posthole, stake-holes, clear traces of a shelter, or possibly shelters, and a hearth provides strong evidence for a home-base. Also, topographically the settlement was situated on a terrace 7.5 metres above the Salisbury Avon, and so ideally placed for the river to be used as a connecting artery to smaller camps where hunting would take place and other foodstuff and raw materials could be sourced.

As yet no sites other than Blick Mead have been proposed as having links to Downton. The distance between the two settlements is roughly 16 kilometres by river, which would tend to suggest occasional rather than frequent social interaction between the respective site occupants. A small number of tranchet axes have been found to the south of Salisbury at locations close to the river valley. The closest was found on plateau gravels to the north-west of Alderbury at Ordnance Survey point SU 1850 2750, some 7 kilometres upriver from Downton. Another four tranchets were located to the south of Salisbury in an arc of less than 1.5 kilometres a short distance above the river valley. The nearest of these was found on the Third River Terrace to the north of Petersfinger Bridge, Salisbury (at OS SU 1600 2922) approximately 9 kilometres north of Downton. Two more were found on the Third River Terrace at Milford Hill, Salisbury (OS SU 1510 3000) and a further one on Alluvium at Southampton Road, Salisbury (OS SU 1550 2930).

All of the five tranchet axes were found on the east bank of the Salisbury Avon (the same side that Downton is positioned) and within an approximate radius of 11 kilometres of Downton. The distance between the find spots of tranchet axes and the home-base is greater than that between Blick Mead and the sites memorialised from it by the deposition of tranchet axes. However, an 11 kilometre radius still represents a credible task-scape for Downton with the tranchet axes deposited at memorable places within the landscape regularly covered by habitants of the home-base.

Discussion

When reviewing the range of available evidence for Mesolithic activity in the Stonehenge landscape the picture that now emerges is not one of occasional discrete and isolated find spots, but something much more rich and complex and suggestive of extensive inter-related activities.

The first evidence for there being a significant Mesolithic presence in the Stonehenge landscape was the discovery of the three Mesolithic postholes in the Stonehenge car park (Vatcher and Vatcher).

The collection, dressing and erection of three pine posts 75 cm in diameter and thought to be up to 3 metres in length would have taken considerable resources away from normal day to day subsistence. Dating evidence suggests that the three posts were unlikely to have been put up at the same time, so the process probably took place over more than one period. This suggests that people in the Mesolithic not only visited the Stonehenge landscape, but saw it as being of sufficient importance to mark their presence in it, and make manifest their association with it on an ongoing basis.

The raising of the posts in the Stonehenge car park would not have taken place if the location had not already been seen as important in the eyes of hunter-gatherers. The work involved in digging the substantial pits, the felling, dressing and transportation of the pine for the posts, and the raising and supporting of them would have involved many participants. Evidence for Mesolithic people in Britain constructing long lasting structures is far from commonplace and reflects the importance that the place or memory held for them. The time consuming business of the hunter-gatherer's day to day survival is rarely associated with time being dedicated to leaving a substantial footprint on the land, let alone the raising of monuments. In this context the theory of the posts being raised to mark the movement of large beasts that would later be corralled further down the valley to be killed and feasted upon is the more attractive of the theories so far offered (Lawson, 2008 and Jacques, 2015).

There are signs in the Stonehenge landscape of pine posts of large dimensions being raised in pits at a number of locations, and some of these locations being further memorialised by the raising of Neolithic monuments above them. Taken together the posthole pits found at the Stonehenge car park, Winterbourne Stoke Crossroads long barrow, at the west end of the Greater Cursus, and on Boscombe Down represent a complex picture, one of co-ordinated groups of people working together on a shared plan or vision.

Further evidence of a landscape being managed in the Mesolithic is provided from work carried out at Durrington Walls. Analysis of pollen and molluscan data points to a reduced level of woodland intensity and its episodic depletion from the end of the Mesolithic. French et al. (2012) believe that this was the result of human intervention and clearance of the adjacent downland. The substantial persistence of pine in this woodland until 2900 BC, when set against the background of the encroachment of more invasive tree species across southern Britain, in itself attests to the widespread management of an area that charcoal remains show had been exploited from the ninth millennium BC (Cleal et al., 2004). The discovery of a buried Mesolithic soil at Countess Farm is additional evidence of local activity at this time.

Before the discoveries at Blick Mead, finds of diagnostically typical Mesolithic worked flint had occasionally been made in the Stonehenge landscape. Individual tranchet axes had been located at five separate locations within a 5 kilometre radius of the Stonehenge car park postholes but they were widely dismissed as stray finds, and the one from a context close to the Stonehenge car park postholes believed not to be Mesolithic in origin. Mesolithic lithic material was located within close proximity of an inhumation at the Winterbourne Stoke Crossroads Early Neolithic long barrow, and a significant quantity from excavations by Wessex Archaeology at Countess Farm.

The evidence provided by the Stonehenge car park postholes and from various pits underlying Neolithic monuments together with the detailed analysis of pollen, soil and molluscan data found in the World Heritage Site landscape had already suggested an extensive Mesolithic territory that was being systematically managed, exploited and marked. All of this indicates a complex interaction between people and their ownership of place, and not merely roaming bands of hunter-gatherers living a basic hand-to-mouth existence.

However, up until the discovery of a home-base at Blick Mead, Mesolithic activity in the Stonehenge landscape was seen as lacking in significance and not inter-connected. Unfortunately, the Stonehenge Environs Project field walking methodology adopted by Richards (1990) was flawed in the way that it did not examine the river valleys and the margins of the World Heritage site landscape. There is a wealth of literature relating to southern Britain signposting where in a landscape evidence of Mesolithic settlement is most likely to be found. The importance of river valleys and springs as rare

resources of reliable clean water on chalk land geology have been well signposted. The metaphysical importance of springs to hunter-gatherers has also been suggested. A large number of Mesolithic sites have been discovered along the river valleys of southern Britain and recorded as likely to been linked with each other from at least the time of Rankine in 1956, and pointers were given as to where, and under what conditions, such sites are likely to be found.

When examinations are made of the prevailing topographical and geological conditions in the Kennet Valley, where a very large number of sites have been documented, a strong indication is given of the likelihood of finding similar sites along the similarly endowed Salisbury Avon. Occupation sites have been discovered on the floodplain of the same river system as the Salisbury Avon that flows through the Stonehenge and Avebury World Heritage Site. The river floodplain, though forming part of the defined survey area, was not investigated adequately. The fact that such a large, well funded, and significant project found minimal evidence for Mesolithic activity in the landscape may well have served to understate the importance of the Mesolithic and how it was viewed subsequently, and led to various signs of it being overlooked.

Finds of Mesolithic material had from previous research been seen to be stray, anomalous, and tiny in number. A possible reason for this phenomenon is pointed out by Green (in Care, 1979, p. 95) where he notes that 'Mesolithic flint work and knapping debris tends to occur in limited concentrations within extensive knapping areas where diagnostic Neolithic and Bronze Age flints predominate' and so this leads to under or inadequate recording. As some sites are completely lacking in microliths there is a danger that in the absence of other diagnostic Mesolithic items they could be wrongly diagnosed as being from a later period (Butler, 2008, p. 118).

The Stonehenge Environs Project which, while seen as a comprehensive study of the surrounding landscape, didn't adequately take account of the rich possibilities presented by the Salisbury Avon and its margins. This together with the surprisingly small number of finds identified as Mesolithic from extensive field-walking has served to colour the research agenda of those that followed. It would seem that blindspots had developed in people's research agendas with details not being made enough of. One such instance of this is the interpretation of the tranchet axe found in the Stonehenge car park.

Before the discovery of the enormous number of finds at the Mesolithic site at Blick Mead, it would appear that the lithic and faunal dataset from the Stonehenge and Avebury World Heritage Site landscape hadn't been examined in sufficient detail, and a substantial consideration of the importance of Mesolithic occupation activity in the Stonehenge landscape had been conspicuous by its absence. However, the work at the recently revealed settlement has resulted in a number of local find spots and their artefacts previously dated to the Neolithic being re-examined and reassessed.

An important and complex Mesolithic settlement, a home-base, had been identified further south along the Salisbury Avon valley floodplain at Downton more than 50 years earlier (Higgs, 1959). Its distance from the Stonehenge World Heritage Site landscape meant that no meaningful link with the day to day and persistent activities on Salisbury Plain can be made.

The discoveries at Blick Mead, north-east of Vespasian's Camp, Amesbury, Wiltshire have helped provide evidence for where the people who built and used the Stonehenge car park posts lived (Pollard, personal communication, 2015). Blick Mead was occupied at a time that each of the posts was raised and continued to be thereafter. The radio carbon date range from the site, 7596–4695 cal BC, from 12 dates covering each millennium in between represents the longest chain of Mesolithic dates from any site in Europe (David Jacques, personal communication). The dates show the persistence of a Mesolithic settlement for a period of 3,000 years up to and including the time the Neolithic period is commonly believed to have started in southern Britain.

There is abundant evidence for wide ranging tool manufacture and use. The lithic assemblage suggests that hunting, and the butchering and processing of the resulted carcasses together with the preparation of vegetable matter took place there. The tranchet axes found at the site would have been used to clear the land, construct the shelters, and fashion the canoes to allow easy movement in the landscape and to facilitate hunting and social contacts with neighbouring groups. In light of

the unusual tranchet axe found close to the Stonehenge car park postholes, it is interesting to note Bishop's assessment of two of the tranchet axes found at Blick Mead (2015, p. 57). While most of those discovered in the same context had been sharpened using the conventional transverse blow, one's tip was formed by 'fine radial flaking' and another has radial flaking on the 'other side to the transverse blow'.

There are indications from substantial quantities of burnt flint and a wide range of animal bones, including a number from aurochsen, for feasting having taken place at the home-base. The exotic objects brought there from hundreds of miles away testify to the broad reach of its inhabitants and the external connections that they had.

Rather than looking at the individual Mesolithic finds in the Stonehenge and Avebury World Heritage Site as being random or anomalous, they should be looked at as a whole to reveal the links between them and the indications they give as to the hunter-gatherers' movement in the landscape and the meaning that the places held for them. Analysis of the available evidence can help tease out the relationships between inter-locking and related activities and reveal a dynamic entity, a task-scape rather than a passive landscape (Ingold, 1993).

In light of Conneller's work on the symbolic dimensions of materials (2008) there is a case to be made for the stray finds of tranchet axes in the Stonehenge part of the World Heritage Site as being purposely placed there and marking the edges of the territory of the Blick Mead home-base. The same hypothesis can be applied to the tranchet axes found within an 11 kilometres radius of the settlement at Downton as signify the range of its territory. Conneller (2005, p. 51) proposed that certain objects as a function of their continued presence at a place could establish relationships between people and places, and that a location could be remembered by the objects deposited there and from the memories and knowledge imbued in them. Tranchet axes, by extending the attributes associated with them, could have invoked thoughts of home, of great feasts celebrating the hunting of wild beasts.

Butler (2008) sets out clearly the reasons for there being an association between tranchet axe finds and the home-base, and also with flint procurement sites. He and others link the axes with the building of shallow draft, river-going boats, and the building of shelters. To this, there is a further more nuanced function that can be added in light of Conneller's work on the inter-relationship between people and places. Blick Mead and Downton can be seen as hubs in the landscape, or task-scape, from which a range of activities was centred and within which important and frequently visited places were memorialised, and the extent of which was marked by the deposition of tranchet axes. The manner of their placement served no economic or functional purpose but can be seen as a way of bringing meaning to the landscape. The ritualised placement of tranchet axes had previously been inferred from a number of recorded Mesolithic sites including the find of a tranchet axe placed vertically into the clay base of a pit on the lip of a small posthole at Broom Hill in neighbouring county of Hampshire (O'Malley and Jacobi, 1978, and Chatterton, 2009, p. 111).

There is some evidence for elements of the Mesolithic activity not only extending across a territory, but also for elements of it persisting through time into the practices of the Neolithic period in the Stonehenge landscape. Mesolithic worked flint was found during excavations of the Early Neolithic Winterbourne Stoke Long Barrow. Wild animal bones were included amongst the evidence for fourth millennium feasting in the infill of the Coneybury Anomaly. Detail from evidence at excavations at the western end of the Great Cursus suggests that it overlays a large Mesolithic pit. A probable aurochs bone from 4340 BC to 3980 BC was discovered in the packing of Sarsen 27 at Stonehenge. The tranchet axe from Young's excavations at the Stonehenge car park has been interpreted as being Neolithic, but when Harding made his analysis of it he would have been unaware of the dating of the finds at Blick Mead. Instead, perhaps the possibility should be raised of the axe being a Mesolithic/Neolithic crossover, a tool incorporating the sharpening practices from both periods. The possibility of this type of practice is mentioned by Butler (2008, p. 103).

By taking into account the literature, my research, and field walking along the Salisbury Avon I have come up with a possible way of locating new Mesolithic sites in this landscape. Analysis of

Ordnance Survey and British Geological Survey maps can give a good indication as to where the economic resources required for a Mesolithic settlement are likely to have been found. In a chalk landscape reliably available sources of easily accessible clean water would have been of prime importance for the survival of the hunter-gatherers, together with the wide range of flora and fauna it would sustain, and importantly its attraction to larger animals that could be preyed upon.

Spring or springs in close proximity would increase the diversity of plants available, providing warmer water of a more constant temperature and an extended growing season. Animals were more likely to be attracted to partially cleared areas where they could drink and be aware of potential predators. While having easy access to the river the hunter-gatherers settlements preferred situation would have been sufficiently high up the valley side not to have been affected by seasonally high flow of the river and flooding, and to be on readily draining land. A source of good flint for tools would also have been important, if not a direct source then a trading link with other groups who themselves would have had access to the essential resource. In a largely wooded landscape, people moving around in the countryside, the transportation of the spoils of hunting, vegetable matter, and raw materials could have been carried out more safely and more easily using small boats or canoes on the river. Along with these indicators I would add another, finds of tranchet axes. With its association with a Mesolithic task-scape, an *in situ* tranchet axe find spot indicates the possible hinterland of a home-base, and I believe likely to be discovered within a 10 to 12 kilometre radius from the hub itself.

At one particular location I found a confluence of most of the factors considered above. My research points to Lake as being one such undiscovered possible setting for a Mesolithic home-base. It is situated at a point where the river banks fall away gently into a meandering curve of the Salisbury Avon. If the course of the river followed a largely similar course in the Mesolithic, when the Avon was deeper and flowed more powerfully, this place would have provided easier and less hazardous access to the water for people and animals than many of the neighbouring parts of the river. Excavations from the site recorded by Evans (1897) onwards reveal it to be situated on alluvium over Valley Gravels and Upper Chalk which would have given the opportunity to position a settlement with good drainage. There are a number of springs in the close vicinity with the ability to enhance the range and duration of available foodstuffs.

Lake shares many of these features of topography and geology with Blick Mead. One similar feature which may have proved particularly attractive as a settlement location is that it is situated at a point where a deeply cut channel stretching from Salisbury Plain at Stonehenge connects into the Salisbury Avon. For reasons outlined by Jacques (2014) and Bowden (2015), and detailed earlier, this could have been a site where large animals corralled south down the valley from a location indicated by the Stonehenge car park pine posts could have been ambushed from the valley sides or slaughtered as they approached the water. A range of worked flint found at Lake, dating from the Palaeolithic hand axes through to Neolithic and Bronze Age finds and extensive quantity of burnt flint, points to a continuity of occupation of this landscape throughout the prehistoric period. Evans noted the pre-Neolithic worked flint finds at Lake. These artefacts when combined with more recent finds of Neolithic, Bronze Age and undiagnosed flint, and the nearby presence of four Bronze Age bowl barrows indicate strongly that this was a significant and often visited place over many millennia, and the logic for there having been a Mesolithic presence here is compelling.

Conclusion

The lithic and faunal assemblage discovered at Blick Mead, together with evidence of a multiphase occupation of a substantial house, or houses, have not only given us an insight into the activities carried out at this settlement, but also allowed us to view the entire Mesolithic Stonehenge landscape from a new vantage point.

The 11 tranchet axes found, together with a wide range of other flint tools, are indicators of Blick Mead having been a home-base. Other worked lithic material, significant amounts of burnt flint, and the finds of animal bones are testament to large scale hunting and feasting taking place at the site. The exotic finds made, of a slate 'Horsham Point' and a mysterious worked sandstone tool each with its origin hundreds of kilometres away, point to a place with diverse and distant connections. It was the place where the people that dug the pits and raised the posts at Stonehenge car park and elsewhere in the landscape might have lived. They opened up the woodland in their territory for settlement and to manage the movement of large animals so that they could be hunted more effectively.

My preliminary field work and research with regard to Lake suggests that there was also a home-base at this location, although no tranchet axes have as yet been found there. The geological and topographical conditions are similar to those found at Blick Mead and a number of home-bases along the Kennet Valley, there is access to a number of springs, and there is a range of nearby evidence of prehistoric activity ranging from the discovery of Palaeolithic hand axes onwards. It is plausible to conjecture that Lake and Blick Mead were related and formed part of the same Mesolithic network. They are approximately 5 kilometres apart and so regular contact between them by river craft would have been possible. Both are at the end of channels leading from Stonehenge Bottom through which aurochsen could be corralled down towards the Salisbury Avon to be slaughtered. It is possible to envisage occupants of both settlements co-operating to manage the hunt, controlling which of the channels the beasts would be funnelled through.

Moving from the speculative back to the known settlements at Blick Mead and Downton and the tranchet axe find spots in their surrounds, it is evident that finds of finished tranchet finds are not made exclusively at home-bases. The tranchet axes can also be seen as radiating out from the home-base as markers of territory, and as an extension of the meaning of the important nexus memorialised in the landscape, a place that its inhabitants saw as belonging to them being imbued through the axes with thoughts of home, and memories of heroic hunts and the feasting that followed.

Bibliography

Allen, M. J. (1994). 'Before Stonehenge', in Cleal, R. M. J., Walker, K. E., and Montague, R. (eds), *Stonehenge in its Landscape: Twentieth-century Excavations*, 55, 471–473. London. English Heritage Archaeological Report 10.

Apple Maps, 2015. Online. Available at <http://maps.apple.com/?q=51.165304,-1.816030&sspn=0.048788,0.110201&sll=51.165304,-1.816030> (accessed 21 September 2015).

Barton, R. N. E., Berridge, P. J., Walker, M. J., and Bevins, R. E. (1995). 'Persistent Places in the Mesolithic Landscape: An Example from the Black Mountain Uplands of South Wales'. *Proceedings of the Pre-Historic Society 61*, 81–116.

Bax, S., Bowden, M., Komar, A., and Newsome, S., 'Stonehenge World Heritage Site landscape project on Winterbourne Stoke crossroads. Archaeological survey report'. *Research department report series no. 107–2010*.

Bishop, B. J. (2014). *Archaeological Excavations at Blick Mead, Vespasian's Camp, Amesbury, Wiltshire. Struck flint, worked stone and burnt flint report*. Unpublished.

Bishop, B. J. (2015). *Archaeological Investigations at Blick Mead, Amesbury: Trench 24 Preliminary Assessment of the Lithic Material*. Unpublished.

Bowden, M., Soutar, S., Field, D., and Barber, M. (2015). *The Stonehenge Landscape: Analysing the Stonehenge World Heritage Site*. Swindon: Historic England.

Branch, N. (2015). Personal communication. 13 January.

British Geological Survey (2005). 'Salisbury. England and Wales Sheet 298 1:50,000'. *Bedrock & Superficial Deposits Geology*. BGS: Keyworth.

Butler, C. (2008). *Prehistoric Flintwork*. Stroud: The History Press.

Care, V., 'The production and distribution of Mesolithic axes in Southern England'. *Proceedings of the Prehistoric Society* 45, 93–102.

Chatterton, R. (2006). 'Ritual' in Conneller, C., and Warren, G. (eds), *Mesolithic Britain and Ireland* 101–120. Stroud, The History Press.

Christie, P. M., Cornwall, I. W., and Brothwell, D. R. (1963). 'The Stonehenge Cursus'. *Wiltshire Archaeological and Natural History Magazine* 58, 370–82.

Churchill, D. M. (1962). 'The Stratigraphy of the Mesolithic Sites III and V at Thatcham, Berkshire, England'. *Proceedings of the Prehistoric Society* 13, 363–370.

Cleal, R. M. J., Allen, M. J., Newman, C. (2004). 'An Archaeological and Environmental Study of the Neolithic and Later Prehistoric Landscape of the Avon Valley and Durrington Walls Environs'. *Wiltshire Archaeological and Natural History Magazine* 97, 218–248.

Cleal, R. M. J., Walker, K. E., Montague, R. (1995). *Stonehenge in its Landscape. Twentieth century excavations*. London: English Heritage.

Conneller, C. (2005). 'Moving beyond sites: Mesolithic technology in the landscape', in Milner, N., and Woodman, P. C. (eds), *Mesolithic studies at the beginning of the 21st century*, 42–55. Oxford: Oxbow.

Conneller, C. (2008). 'Lithic Technology and the Chaine Operatoire', in Pollard, J. (ed.), *Prehistoric Britain*, 160–176. Oxford: Blackwell.

Conneller, C. (2014). *An Archaeology of Materials: Substantial Transformations in Early Prehistoric Europe*. Oxford: Routledge.

Darvill, T. (2005). *Stonehenge: The Biography of a Landscape*. Stroud: Tempus.

Ellis, C. J., Allen, M. J., Gardner. J., Harding, P., Ingram, C., Powell, A., and Scaife, R. G. (2003). 'An early Mesolithic seasonal hunting site in the Kennett Valley southern England'. *Proceedings of the Prehistoric Society* 69, 107–135.

Evans, J. G., and Smith, I. F. (1983). 'Excavations at Cherhill, North Wiltshire 1967'. *Proceedings of the Prehistoric Society* 49, 43–117.

Evans, J. G., and Wainwright, G. J. (1979). 'The Woodhenge excavations'. In G. J. Wainwright, *Mount Pleasant, Dorset: excavations 1970–1971 (Reports of the Research Committee of the Society of Antiquaries of London 37)*. London: Society of Antiquaries

Exon, S., Gaffney, V., Woodward, A., and Yorston, R. (2000). *Stonehenge Landscapes: journeys through real-and-imagined worlds*. Oxford: Archaeopress.

Field, D. (1989). 'Tranchet Axes and Thames Picks: Mesolithic Core Tools from the West London Thames'. *Transactions of the London and Middlesex Archaeological Society* 40, 1–26.

Fitzpatrick, A. P., et al. (1996). *Boscombe Sports Field, Boscombe Down, Witshire. Excavations in 1995: Assessment Report*. Salisbury: Wessex Archaeology.

Fitzpatrick, A. P., et al. (2004). *Boscombe Down Phase V Excavations, Amesbury, Wiltshire. Post-excavation Assessment Report and Proposals for Analysis and Final Publication*. Salisbury: Wessex Archaeology.

French, C., Scaife, R. G., Allen, M. J., Parker Pearson, M., Pollard, J., Richards, C., Thomas, J., and Welham, K. (2012). 'Durrington Walls to West Amesbury: A Major Transformation of the Holocene Landscape'. *The Antiquaries Journal* 92, 1–36.

Froom, R. (2012). *The Mesolithic of the Kennett Valley*. Oxford: Oxbow.

Gaffney, V. (2014). 'Stonehenge Hidden Landscapes'. *Current Archaeology* no. 296.

Healy, F., Heaton, M., and Lobb, S. (1992). 'Excavations of a Mesolithic site at Thatcham, Berkshire'. *Proceedings of the Prehistoric Society* 58, 41–76.

Higgs, E. (1959). 'The excavation of a late Mesolithic site at Downton near Salisbury, Wiltshire'. *Proceedings of the Prehistoric Society* 25, 209–232.

Higgs, E. S., and Vita-Finzi, C. (1972). 'Prehistoric economies: a territorial approach', in Higgs, E. S. (ed.), *Papers in Economic Prehistory*, 27–36. London: Cambridge University Press.

Ingold, T., 'The temporality of the landscape'. *World Archaeology* 25, 152–174.

Jacques, D., Phillips, T., and Clarke, M. (2010). 'A reassessment of the importance of Vespasian's Camp in the Stonehenge landscape'. *PAST* 66, 11–13.

Jacques, D., Phillips, T., Hoare, P., Bishop, B., Legge, A., and Parfitt, S. (2014). 'Mesolithic settlement near Stonehenge: excavations at Blick Mead, Vespasian's Camp, Amesbury'. *Wiltshire Archaeological and Natural History Magazine* 107, 7–27.

Jacques, D., Phillips, T., and Lyons, T. (2012). 'Vespasian's Camp: Cradle of Stonehenge?', *Current Archaeology Magazine* 271, 28–33.

Jacobi, R. (1981). 'The Last Hunters in Hampshire', in Shennan, S. J., and Schadla-Hall, R. T. (eds), *The Archaeology of Hampshire, Hampshire Field Club and Archaeological Society Monograph.* 10–25, Winchester.

Lawson, A. J. (2007). *Chalkland: an Archaeology of Stonehenge and its Region.* East Knoyle: Hobknob Press.

Leary, J., Branch, N., and Bishop, B. J. (2005). '10,000 Years in the Life of the River Wandle: excavations at the former Vinamul site, Butter Hill, Wallington'. *Surrey Archaeological Collections* 92, 1–28.

Legge, A. J., and Rowley-Conwy, P A. (1988). *Star Carr Revisited: a Re-analysis of the Large Mammals.* London: Birkbeck College, University of London.

Leivers, M., and Moore, C. (2008). *Archaeology on the A303 Stonehenge Improvement.* Salisbury: Wessex Archaeology.

McFadyen, L. (2008). 'Temporary Spaces in Mesolithic and Neolithic: Understanding Landscapes' in Pollard, J. (ed.), *Prehistoric Britain*, 121–134. Oxford: Blackwell.

McFadyen, L. (2009). 'Landscape', in Conneller, C., and Warren, G. (eds), *Mesolithic Britain and Ireland: new approaches*, 121–138. Stroud: The History Press.

McKinley, J. (2003). 'A Wiltshire "Bog Body"?: Discussion of a Fifth/Sixth Century AD Burial in the Woodford Valley'. *Wiltshire Archaeological and Natural History Magazine*, vol. 96, pp. 7–18.

Mellars, P. A. (1976). 'Settlement Patterns and Industrial Variability in the British Mesolithic'. In Sieveking, G., Longworth, I. H., and Wilson, K. E. (eds), *Problems in Economic and Social Archaeology*, 375–399. London: Duckworth.

Mellars, P. A., and Reinhardt, S. C. (1978). 'Patterns of Mesolithic land-use in southern England: a geological perspective', in Mellars, P. A. (ed.), *The Early Postglacial Settlement of northern Europe*, 243–294. London: Duckworth.

Milner, N. (2009). 'Subsistence' in Conneller, C., and Warren, G. (eds), *Mesolithic Britain and Ireland: new approaches*, 60–82. Stroud: The History Press.

Parker Pearson, M. (2012). *Stonehenge: Exploring the Greatest Stone Age Mystery.* London: Simon and Schuster.

Rankine, W. F. (1952). 'A Mesolithic Chipping Floor at the Warren, Oakhanger, Selborne, Hants'. *Proceedings of the Prehistoric Society* 18, 21–35.

Rankine, W. F. (1956). 'The Mesolithic of Southern England', *Research Papers of the Surrey Archaeological Society* 4, Guildford.

Richards, J. (1990). *The Stonehenge Environs Project.* London: English Heritage.

Richards, J. (1991). *English Heritage Book of Stonehenge.* London: English Heritage.

Tilley, C. (1997). *A Phenomenology of Landscape: Places, Paths and Monuments.* Oxford: Berg.

Vatcher, G., and Vatcher, F. (1973). 'Excavation of three post-holes in the Stonehenge car park'. *Wiltshire Archaeological and Natural History Magazine* 68, 57–63.

Warren, G. (2009). 'Technology' in Conneller, C., and Warren, G. (eds), *Mesolithic Britain and Ireland* 13–34. Stroud: The History Press.

Wymer, J. J. (1962). 'Excavations at the Maglemosian sites at Thatcham, Berkshire, England'. *Proceedings of the Prehistoric Society* 28, 329–361.

Wymer, J. J. (1977). *A Gazetteer of Mesolithic Sites in England and Wales.* London: CBA Research Report 20.

DAVID SAUNDERS

6 An assessment of the evidence for large herbivore movement and hunting strategies within the Stonehenge landscape during the Mesolithic

ABSTRACT

With regard to the Stonehenge landscape, the activities for both the Mesolithic population and the animals that lived within the area have not been well understood. To place the animals that lived within the Stonehenge landscape back into the record assists with establishing what economic resources were available within the area. The common idea that there was little Mesolithic activity within the Stonehenge landscape is having to be rewritten after the discovery of a Mesolithic base camp at Blick Mead. Hunter-gathers from the site potentially set up hunting camps on the Stonehenge plain and at the point of the River Avon that was to become Blue Stonehenge. They could also have been part of a network of hunter-gatherer communities who were connected by the River Avon.

The evidence for the view that there is large herbivore movement across the Stonehenge landscape lies in the quantity of faunal remains discovered at Blick Mead. My investigation, carried out by undertaking a recognised field-walking methodology of the wider Salisbury Plain area, shows that approximately a 26-kilometre long section of the plain running north-south from Salisbury to Upavon is potentially impassable to large herbivore herd movement in a west to east direction due to the landscapes steep gradients, with the exception of a small half-mile gap that lies between Woodhenge and the current A303, this section being in-line with the Mesolithic posts and the later Greater Stonehenge Cursus. This potential large herbivore access continues to the east of the River Avon through a small gap of open countryside that links the current Countess Roundabout to a recently discovered Mesolithic posthole at Boscombe Down.

Introduction

This chapter presents an assessment of the evidence for large herbivore movement and hunting strategies within the Stonehenge landscape during the Mesolithic.

The primary objective is to assess large herbivore movement and Mesolithic hunting strategies in and around the Stonehenge landscape. By applying the University of Durham primary data on the faunal remains found at Blick Mead and by using my own archaeological fieldwork in accordance with a standard archaeological methodology (Renfrew and Bahn 2012 pp. 71–94) to supplement missing data through the use of terrain elevation and Ordnance Datum software packages I intend to:

- identify potential large herbivore movement across the Stonehenge landscape west of the River Avon;
- identify whether the recent discovery of a Mesolithic posthole on Boscombe Down also lies within the continued route of potential large herbivore movement;
- undertake viewsheds of the Stonehenge landscape to support the theory that this was potentially a prime Mesolithic hunting site;
- apply the primary data produced by the University of Buckingham in association with the University of Durham on samples of the two aurochs' teeth from Blick Mead (Jacques et al. – forthcoming) in an attempt to establish the extent of roaming that potentially occurred within an aurochs herd.

Methodology

In order to identify potential difficulties that large herbivores would have encountered moving round the wider area of the Stonehenge landscape during the Mesolithic. I have identified accessible water resources, areas of lush vegetation and potential fording points. I have also identified a narrow gap of rolling terrain, moving across the Stonehenge plain that would possibly have concentrated herd movement, potentially leading to the realisation of a successful hunting ground.

In order to identify where these Mesolithic hunters and their groups may have been living, lithic data has been compared from the following Avon Valley sites: the recent discovery of a Mesolithic home-base 2 km from Stonehenge at Blick Mead (Bishop 2014); the Late Mesolithic site found at Downton, near Salisbury (Higgs 1959); the Mesolithic hunting camp to the west of the Stonehenge monument and Mesolithic finds in the spring adjacent to Blue Stonehenge, both found as part of the Stonehenge Riverside Project (Parker Pearson 2012).

To ascertain the degree of openness of the Stonehenge landscape and therefore the ease of large herbivore movement across the plain, I have investigated the suggestion that the Stonehenge landscape was almost always partly open (French 2012) in comparison with other theories about the openness of the landscape (Allen 2012, Scaife 1995 and Green forthcoming) and to investigate the potential degree of forestry management that occurred at other Mesolithic sites, such as Woolaston (Bell 2005), Star Carr (Conneller 2012) and Tybrind Vig (Andersen 2013) in an attempt to identify if this activity could have been responsible for the suggested openness of the Stonehenge landscape.

I have researched areas of known Mesolithic activity within the Stonehenge landscape together with other potential Mesolithic areas identified during the Stonehenge Hidden Landscapes Project in combination with the information ascertained with regard to the openness of the Stonehenge landscape in order to establish potential Mesolithic viewsheds of the Stonehenge landscape.

To ascertain the potential extent of movement that occurred within aurochs herds during the Mesolithic, I have evaluated the primary data produced by The University of Buckingham in association with The University of Durham on samples of the two aurochs' teeth found at Blick Mead (Jacques et al. 2016 – forthcoming).

I have investigated Mesolithic hunting equipment found within the Stonehenge landscape and compared this with research from the peat bogs and underwater sites of Scandinavia, particularly the Mesolithic sites at Holmegaard and Tybrind Vig in order to identify potential hunting equipment used within the area and, through the use of both archaeological and environmental data, put together possible strategies for the hunting of aurochs that could have been used within the Stonehenge environment.

Previous studies

The Stonehenge Environs Project, carried out by Julian Richards in 1990 for English Heritage, was potentially the largest Stonehenge project undertaken within the region until the recent Stonehenge Hidden Landscapes Project (Gaffney 2012). Its aims were to identify the pre-historic settlements in the Stonehenge region, to establish their state of preservation and to determine and to examine colluvial deposits within the study area.

Richards notes that, with the exception of the three postholes within the Stonehenge car park, previous recorded finds within the region provide little evidence for Mesolithic activity on the chalk areas adjacent to the River Avon, confirming this pattern from the relative paucity of finds from the Stonehenge Environs Project's extensive surface collection, which produces only occasional individually diagnosed flint pieces. He decrees that this 'provides little evidence for hunter-gatherer exploitation

of this particular chalkland zone'. In contrast, the indication is that late hunter-gatherer activity is concentrated upon the Avon Valley, where on the western side of the river, south of Durrington Walls, an apparent in-situ flint industry of long blade form is associated with microliths. He concludes that 'there is simply no trace of these hunter-gatherer communities on the chalk plateau of Stonehenge'. However, it should be noted that the Mesolithic long-blades industry is similar to Early Neolithic flint working (Bishop 2015, personal communication)

It is significant that due to the nature of the project's objectives, Richards is primarily concentrating on the areas around the Stonehenge landscape monuments, rather than in the river valleys, and that the majority of the worked flints found by Richards' field-walking team could not be closely dated. However, he carries out extensive surface collection within numerous sections of the Stonehenge Bottom dry river valley.

However, it should also be noted that these are not directly part of the extensive surface collection and that the excavations carried out within the Stonehenge Bottom dry river valley are predominantly carried out to establish, despite pre-conceptions, that there is no colluvium within the Stonehenge Bottom dry river valley complex.

Richards does however indicate that the possibility of Mesolithic activity should not be ignored as he feels that his methodology of using extensive surface collection might be unsuitable for the recovery of diagnostic Mesolithic artefacts. However it should be noted that a field walking exercise, using the same methodology, carried out by students from the University of Buckingham in 2015 at Coneybury Henge and Countess Farm, under the supervision of lithic material expert Dr Barry Bishop, identifies that it is possible to place Mesolithic activity within both of these areas.

The statement by Richards that 'there is simply no trace of these hunter-gatherer communities on the chalk plateau of Stonehenge' and the fact that the Stonehenge Environs Project is undertaken as part of an English Heritage project appears to have become the feature that sticks in the minds of others. Tim Darvill, in his book Stonehenge the Biography of a Landscape, builds upon this feature, stating that 'although usually the period 9000 – 7500 BC is characterised by the style of flint-working found within an area, no extensive Maglemosian flint scatters are known within the Stonehenge landscape'. He does however state that 'the small but dispersed group of features such as the postholes and pits found in the old Stonehenge car park suggest that the Stonehenge landscape is somehow regarded as special by this time, worth marking and deserving of repeat visits'. This characteristic appears to be a common theme running through the investigation of Mesolithic activity within the Stonehenge landscape, where rare evidence finds tend to be 'by-products of other projects', which have the tendency to be neglected.

With reference to the postholes found in the old Stonehenge car park (Vatcher 1966), Darvill doubts that all tree posts stood at the same time, as the radio carbon dates can be spread out over anything between 300 and 1,600 years. He supports this lack of Mesolithic activity by his map of total Mesolithic find spots throughout the Stonehenge landscape, which covers a period in excess of 5,000 years from c. 9000–4000 BC (Darvill 2006 p. 63).

Both Richards' methodology and Darvill's perception of the Stonehenge landscape could potentionally have been different due to Mesolithic excavations already carried out in the wider Stonehenge area in the late 1950s on another Mesolithic site within the Avon Valley.

Approximately 6.5 kilometres south of Salisbury, at Downton (Higgs 1959), which connects to the Stonehenge landscape through the River Avon, more than 38,000 Mesolithic flints were discovered.

These are evenly distributed from the top soil down right through to the undisturbed river gravels (Higgs 1959 p. 212), which Higgs explains by the presence of a Medieval ditch that crosses the Mesolithic hollow at the precise point at which the original survey trench TTUU 2 has been dug, cutting the Mesolithic chipping floor. Higgs also finds evidence for a hollow in these gravels, which suggests the possibility of a Mesolithic pit dwelling and a series of postholes, possibly associated with the flints.

The cut of the Medieval ditch has a major effect upon the context of sections within the site with some mixing of Mesolithic and Neolithic material, however further excavations by Higgs took this

into account where his excavation of the hearth site was unhampered by this disruption, allowing for clear interpretation of the data. Could the Mesolithic group that used the site at Downton have travelled from the main base camp of the site discovered later by Jacques at Blick Mead? The present spring line at Blick Mead directly joins the River Avon. It would potentially join locales via the river to both the north and south.

The discovery that hunter gatherer groups use the Avon Valley for their campsites up to the fifth millennium BC (Jacques 2010) comes to late to change Darvill's perception or to aid Richards' methodology. Jacques re-assessment of the importance of Vespasian's Camp, Amesbury, Wiltshire (NGR SU146417), in the Stonehenge landscape provides evidence for earlier prehistoric use of the site where excavations of the spring result in the retrieval of over 900 flint tools and worked flints ranging from the Early Mesolithic to the early Bronze Age.

Further excavations at Blick Mead, which nestles beneath the Vespasian's Camp hillfort at approximately the midpoint between the Mesolithic postholes in the old Stonehenge car park and the recently discovered posthole at Boscombe Down, identifies that it is situated amongst the largest of a network of ancient springs. Mesolithic deposits containing enormous amounts of worked flint together with burnt flint and bone have been found within the waterlogged trenches, with 'ratios significantly higher than those found at Star Carr' (Jacques 2014 p. 17).

The University of Reading's terrain modelling of the spring area at Blick Mead (Branch 2014), has found that the majority of animal bone and flint tools appear to be deposited to the side of slightly higher areas of land within the spring which would probably have been islands during the Mesolithic period. This gives rise to the notion that these are only the items that were intentionally deposited within the spring area across many thousands of years. As such they are probably only accounting for a small percentage of the overall total number of items (Branch and Green forthcoming, personal communication).

Due to the low number of Mesolithic faunal assemblages found in Britain any new discovery greatly advances understanding of the period. Without the faunal assemblage discovered at Blick Mead and the radio carbon dates associated with them, it would be difficult to analyse in any detail the economic value and potential manipulation of the landscape throughout the Mesolithic period.

Several other Mesolithic sites have produced notable faunal assemblages, such as Star Carr which is predominantly red deer (50%) and Three Ways Wharf in Uxbridge (Lewis & Rackham 2011) which is also predominantly red deer (85%). However, prior to the discoveries at Blick Mead (Jacques 2014) no UK Mesolithic site has a predominance of aurochs, the closest being Star Carr where the abundance of aurochs comprised 16% of the identifiable assemblage (Legge & Rowley-Conwy 1988).

Table 6.1: Overview of species found at Blick Mead © Bryony Rogers University of Durham

| Species Totals ||||||
Species	All Trenches	Trench 19	Trench 22	Trench 23	Trench 24
Auroch	155	139	13	1	2
Possible auroch	4	4	0	0	0
Red deer	46	42	2	2	0
Possible red deer	4	4	0	0	0
Red deer (elk?)	2	2	0	0	0
Roe deer	8	7	0	1	0
Wild pig	23	23	0	0	0
Elk	5	5	0	0	0
Possible elk	1	1	0	0	0
Hare	1	0	1	0	0

Sheep/goat	9	3	5	0	1
Domestic cow	5	1	0	0	4
Pig	5	4	0	0	1
Bird	1	0	0	1	0
Wolf	1	1	0	0	0
Rabbit	1	0	0	0	1
Unidentified	2159	2065	44	11	39
Total Identified	271	236	21	5	9
Total	2430	2301	65	16	48

The large quantity of faunal remains discovered at Blick Mead (Rowley-Conwy 2014) give justification to the belief of large numbers of herbivore movement across the Stonehenge landscape. To date, a total of 2430 bone fragments have been found. From the identifiable fragments (11%) and a further 12 fragments which have been identified through the use of ZooMS (Charlton 2014), which uses the amino acid sequential variation between species, by the end of the 2014 excavation the following breakdown of herbivore species has been found: aurochs (57–59%), red deer (17–19%), wild pig (9%) and elk (2%). As is considered typical for chalk environments the preservation of the Blick Mead assemblage is poor, consisting mostly of highly eroded small pieces where the total mass for all the fragments so far recovered amounts to 9.353 kg. The majority of the fragments, 2,301 (87%) come from Trench 19, where the majority of the remains were found in a single layer of dark brown, viscous, silty clay, concentrated within the southern corner.

However, caution must be used when stating that, the percentage of aurochs' bone is 'the largest proportion of bone from this species known from any Mesolithic site in the UK' (Jacques 2014 p. 24), as prior to 2012 not all material from Mesolithic contexts were sieved. Whilst it was only six days of Mesolithic context excavation that was not sieved, the resultant increase in the percentage of aurochs' bone found could be due to the methodology used, where the larger-sized aurochs' fauna were easier to find whilst smaller fauna from other species were missed.

The placing of aurochs' bone into the springs suggests that both the animal and the location hold high significance throughout the Mesolithic. The unusually constant water temperature of the spring at Blick Mead, which remains between 10° and 14° throughout the year, results in the continuous growth of vegetation around the edge even during the harshest of winters. Could the reason for the initial Mesolithic visitors to the spring be to exploit this factor by hunting the constant stream of animals gathering at the site as a means to survive the winter months? Radio carbon dating from the site produces a sequence of dates ranging from the eighth to the fifth millennium BC (see Table 6.2) which shows that 'people continue to occupy the Blick Mead site for the rest of the Mesolithic period (in excess of 3,000 years) and potentially into the early Neolithic' (Jacques et al. 2014). Whilst the range of radio carbon dates obtained from the Blick Mead site show a sequence of herbivore presence within the Stonehenge area that also ranges from the eighth to the fifth millienium BC.

Table 6.2: Radio carbon dates (95% probability) from Blick Mead (after Jacques, Lyons and Phillips 2017 p. 20)

Date	Position	Item	Notes
7596 – 7542 BC	Trench 19	Wild Boar	Date match with car park postholes
6698 – 6590 BC	Trench 23	Aurochs	Date match with car park postholes
6360 – 6080 BC	Trench 19	Aurochs	
6226 – 6074 BC	Trench 19	Aurochs	
5845 – 5706 BC	Trench 19	Aurochs	Auroch's Tooth – Isotope Data

(Continued)

Table 6.2: (*Continued*)

5469 – 5320 BC	Trench 19	Wild Boar	
5231 – 5048 BC	Trench 22	Aurochs	
5199 – 4984 BC	Trench 19	Aurochs	
4998 – 4835 BC	Trench 19	Aurochs	
4982 – 4832 BC	Trench 19	Red Deer	
4803 – 4702 BC	Trench 19	Aurochs	
4896 – 4695 BC	Trench 19	Aurochs	
4336 – 4246 BC	Trench 24	Charcoal	Context 114 – Mesolithic structure posthole

Investigation of the lithic material from excavations undertaken by Jacques et al. (2014) show that material found at Blick Mead is more varied, 'reflecting a wide range of activities such as clothes making and reed cutting, than typically observed at other Mesolithic sites which tend to produce a limited range of task-specific tools, mostly related to hunting and butchering' (Bishop 2014 p. 15). This suggests that the site is predominantly a base camp perhaps being used throughout most months of the year.

A sandstone slab, with smooth faces and pecked sides has been discovered within the Mesolithic context of Trench 19. The tool, which is not local to the Stonehenge area, could possibly have been used within the production of animal hides (Jacques 2015 personal communication). A similar tool, consisting of a tabular piece of sandstone (4351), which is badly heat damaged, has been found during excavations within the Mesolithic settlement at Howick, in north-east England. Clive Waddington (2007) who carried out the excavations believes that it could have been used for the treatment of seal skins.

There are also types of flint tool not expected to be found in Wessex at all, such as a number of hollow based Horsham points which are more commonly found in the Wealden districts of Sussex, Kent, Surrey, and Hampshire suggesting 'prehistoric visitors to the spring from further afield' (Bishop 2014 pp. 15–17). Could the find of the light greenish slate formed into a Horsham point, which originates from either north Devon or North Wales, indicate that people were also frequently visiting from the west of Britain, or is its arrival due to the transfer of goods along trade routes?

A further possible draw could be the almost magical effect the spring's water has on flint. The combination of the dappled light around the spring together with the presence of an algae (Hildenbrandia rivularis) and the water's unusually constant temperature of between 10° and 14° causes previously submerged stones to take on a striking bright pink hue a few hours after they have been removed from the spring (John – forthcoming). Could the local population, or even visitors to the area, have placed significant bones into this magical spring from successful hunts in order for this success to continue, in a similar manner as the placement, millennia later, of aurochs remains into the Stonehenge ditch?

Further evidence of Mesolithic activity upon the Stonehenge landscape (Parker Pearson 2012) is indicated by the discovery of distinctive long flint blades and microliths found at an ancient spring next to where millennia later the stones were to be placed for Blue Stonehenge. However, as the nature of the Stonehenge Riverside Project is primarily to establish a theory of the difference between the land of the living and of the dead.

> If Ramilisonina's instinct was right then the relationship between the stone circle and the timber circles wasn't a question of prototypes, of one style replacing another. The wooden and stone monuments would have played different roles in the lives of their builders ... [T]he timber circles were monuments for the living as opposed to stone monuments for the dead. (Parker Pearson 2012 p. 10)

Little further research appears to hav been carried out in this area with regard to the Mesolithic period, a fact highlighted by noting that this discovery consists of less than a page within his later book on the project.

Excavations by the Stonehenge Riverside Project, in an area just to the west of the Stonehenge monument discover a potential Mesolithic hunting camp, 365 yards south of the Mesolithic postholes. However this discovery appears to have been entirely due to the insistence of The National Trust that the project remove the total topsoil by hand rather than use their normal practice of digging an appropriate number of metre square test pits and then estimate the find count prior to removing the top soil mechanically. Results from the laboratory, months later, indicates they have discovered long blades from this Mesolithic hunting camp (Parker Pearson 2012 pp. 235–236).

Until these discoveries, Mesolithic find spots throughout the Stonehenge landscape have tended to be described in isolation. However, they can now be tentatively brought together with the Blick Mead data to reveal potential 'patterns of use within both the Stonehenge and the wider Avon Valley landscape' (Jacques 2014 p. 17). It is through the recent discoveries at Blick Mead, especially through the radio carbon dating of the fauna, which establishes the presence of a long-term home-base, that the manipulation of the Stonehenge landscape can be analysed in any detail.

Potentially, one of the most important aspects of research to come from the Stonehenge Riverside Project (Parker Pearson 2012) is the work produced by Michael Allen, Charles French and Rob Scaife, Durrington Walls to West Amesbury by way of Stonehenge: A major transformation of the Holocene landscape (2012) where a potential new sequence of Holocene landscape change has been discovered through investigation of sediment sequences, pollen and molluscan data analysis during the Stonehenge Riverside Project.

Allen suggests that previous interpretations of the prehistoric Stonehenge chalkland landscape, that it consisted off a broadly uniform postglacial, closed deciduous woodland that blanketed the landscape before being tampered with by Mesolithic people, and then progressively cleared by Neolithic and then Bronze Age communities is being brought into question 'as evidence is increasingly emerging that the woodland is in fact more open than previous suggestions' (Allen 2012 pp. 42–43).

Whilst French (2012 pp. 2–4) argues that the overview for southern England, 'which suggests the notion of extensive forest clearance by the Late Neolithic for agriculture is too generalised for the Stonehenge landscape, as the situation is far more complex, consisting of a mosaic of both woodland and grassland'. He states that given the paucity of palaeoenvironmental data, 'the archaeological community needs a better understanding of the nature of the former vegetation cover, and by inference the soil type'. French also questions whether Mesolithic people may initially have been attracted to the Stonehenge area due to the diverse style of vegetation communities and soil types, which includes open areas of grassland, indicating that

> the Stonehenge landscape sequence appears to exhibit a different and more variable course of events than the wider models of climax vegetational sequences and human impact suggest for many other parts of southern England in the earlier Holocene, that the landscape is almost always partly open and that significant inroads into its woodland cover occurr during Mesolithic times. (French 2012 p. 30)

Evidence suggests (Vera 2000 pp. 52–55) that 'the grazing of wild herbivores is able to prevent the grasses and plants from flowering' indicating that, the fact that large herbivores were present in the Stonehenge landscape, which can halt plant development at a particular succession in the vegetation, could potentially be the reason behind the openness of this part of the Stonehenge plain.

However it should be noted that access to much of the floodplain, during French's research, was severely restricted by factors such as urban development, the road system and private access and that the project did not carry out boreholing on the Stonehenge plain east of the entrance to the Stonehenge Avenue with the exception of a single borehole to the eastern end of the Cursus. Vera's proposal that the landscape would have been further opened up by the migration of animal herds suggests that, if the project had continued into the area east of the Stonehenge circle the results would have indicated an increase in the percentage of grassland towards the River Avon.

The Stonehenge Riverside Project's use of palaeoenvironmental and palaeovegetational data assists with outlining the landscape characteristics of the Stonehenge environment from the Mesolithic through to the Bronze Age (Hazell & Allen 2013). Taking information from Pit 9580, which dates to

8250–7750 BC from pine charcoal found within the pit, they are able to conclude that 'the presence of herb components (Asteraceae and Poaceae) together with bracken spores indicate a pine-hazel open woodland'.

Allen's theory that the woodland is in fact more open than previous suggestions, supports previous work undertaken in the area. Scaife (1995 pp. 51–52), also supports the theory that the Stonehenge landscape is more open than previously thought. Using the data from 14 samples taken from Pit 9580 (found in 1988 in the area of the old Stonehenge ticket offices and access ramp by Martin Trott of Wessex Archaeology) Scaife notes that 'although pollen preservation is marginal there is sufficient molluscan data to obtain a detailed understanding of the chalk landscape throughout the Boreal period'. He warns however that, due to the fact that pollen preservation in calcareous chalk and limestone soils is generally poor, caution must be used in the interpretation of pollen data from these areas.

He summarises that Pit 9580 is 'dug in an open pine and hazel woodland. The open nature of the woodland being indicated by the requirement of hazel to have sunlight in order to flower'. He suggests that 'the clearance within the area for the erection of the four post-pits, is large enough to enable a new mollusc fauna to establish indicates that there is open country in the vicinity from which this fauna originates'.

Boreholing is also being carried out within the area around Avon House as part of the Blick Mead project (Branch 2014), who also contends that

> the stable calcareous grassland may have greater antiquity than previously thought, in that restricted areas may form a plagioclimax community during the Mesolithic and that the composition of Mesolithic woodlands in chalk, through their continued dominance of pine, is more diverse than previously thought. (Branch 2014, personal communication)

It could well be that Mesolithic herbivours and people were initially attracted to the Stonehenge area due to this very diverse style of vegetational communities and soil types, which includes open areas of grassland. Perhaps further points for debate should include the origins of stable, calcareous grassland and the extent of human interference with the woodland cover together with the role of pastoralism that herds of aurochs would have upon the development of the landscape and environment (Vera 2000 pp. 52–55).

Therefore from each of the surveys, carried out either in different sections of the Stonehenge landscape or by using different methodologies, the suggestion is that stable calcareous grassland may have greater antiquity than previously thought. This suggests that the suggestion put forward by French, for the possible Mesolithic Stonehenge landscape is potentially underestimating the extent of grassland which possibly extended from the later area of the Cursus, across the whole plain to the River Avon.

Although, with the exception of charcoal found within Mesolithic tree throw pits, there is little current evidence for landscape manipulation within the Stonehenge landscape during the Mesolithic, research carried out on Mesolithic sites at Woolaston (Bell 2005) on the Severn Estuary and at Star Carr in Yorkshire (Milner & Conneller 2012) potentially show how Mesolithic people repeatedly use woodland burning as a means of forestry management to improve their production of food such as hazel. Whilst the underwater excavations in Denmark of the Mesolithic site at Tybrind Vig 5620–4040 BC (Andersen 2013 p. 213), which have 'yielded the most important wood assemblage to date from the late Mesolithic', show that the local vegetation was characterised by human exploitation of the trees, especially of the hazel bushes which were used to furnish material for fish weirs and various types of hunting implements and tools.

Although, as earlier discussed (Scaife 1995), pollen preservation tends to be poor within the calcareous chalk soil of the Stonehenge landscape, it is through the use of palynological research, which is the partitioning of pollen into arboreal and non-arboreal pollen where the openness of a landscape can be established. Van Vuure uses this to potentially establish the environment within which the Mesolithic aurochs lived (Van Vuure 2005 p. 7). This, together with the fact that he relies heavily upon data from the forests of Jaktorow in Poland which is the aurochs last living area, where it should be noted that these final specimens of aurochs were heavily protected, corralled and even

fed by gamekeepers during the winter months, makes it problematic to rely solely upon his research. He however submits that 'aurochs live in a landscape covered with dense forests intermingled with fens and bogs, lakes and rivers' and from this factor of forest density identifies that 'aurochs were not able to oppose or control forest growth'.

Whilst he recognises that others claim that aurochs are able to control forest growth, his recommendation to carry out a full scale field trial in a fenced off nature reserve inhabited by large herbivores identifies some of the problems with Van Vuure's research, that is, the high level of supposition and experimentation within his theory.

One of those who opposes Van Vuure's theory (Vera 2000 pp. 52–55) investigated the pre- and post-inoculation periods of wildlife around the Serengeti National Park in East Africa. The resultant increase in herbivore numbers post vaccination results in the plants remaining in a physiologically young stage for a longer time, so that there is green grass for longer. Vera argues that this applies not only for the herbivorous fauna of Africa, but also for the domesticated species of Europe such as cows, horses and pigs. The fact that large herbivores can halt plant development at a particular succession in the vegetation appeals to Vera, who states that

> if livestock can determine the succession, the wild forms of livestock such as the aurochs, the wild horse and the wild boar, which are present in Europe before livestock, should in principle, be able to do so. (Vera 2000 p. 53)

If the stable calcareous grassland upon the Stonehenge landscape has greater antiquity than previously thought, which produces excellent grazing land, the resultant increase in herbivore numbers could, according to Vera have, at least, prevented the encroachment of the surrounding woodland if not aided the enlargement of the grassland.

Although little research has been carried out within the Stonehenge area to determine the potential annual resources available, a re-analyses of the data from Star Carr has been carried out in an attempt to increase the understanding of seasonal animal movement (Legge & Rowley-Conwy 1988). In this landmark study the remains of large mammals were analysed via investigation of the teeth of young animals, which allows them to establish when the animals had been killed. They conclude that 'most had been hunted during the late spring and early summer which suggests that there is strong evidence for seasonal occupation of Star Carr'.

They also suggest that the size of the herd would be dependent upon the environment within which the aurochs live, with herds being around three times larger for aurochs living in an open plain environment, such as the potential Mesolithic Stonehenge landscape, than herds living in closed woodland.

Continuing with this theme the University of Durham team uses a combination of strontium, carbon and oxygen isotope analysis upon two aurochs' teeth found at Blick Mead to analyse the patterns of residency and mobility amongst the local prehistoric aurochs population. The analysis, carried out by the University of Durham (Rogers, forthcoming) on two aurochs' mandibular M3 teeth (identified as BM421 & BM422) show, through the strontium isotope, a high probability that the aurochs were from the Blick Mead area and, through the carbon isotope, that on a seasonal basis the herd broke up into smaller groups and headed away from the plain and into the forest to winter on acorns and other fruits.

However the oxygen isotope data is in-conclusive, the low number indicating that the aurochs could have travelled from as far away as an Alpine region. Radio carbon dating of one of the teeth (BM422), 5845–5706 cal BC fails to establish whether Britain had become an island by this time period. Although Doggerland would have been flooded there is the slight possibility that a land bridge still remained in the region of the Isle of Wight. Perhaps a combination of strontium and lead as used to determine the patterns of Iron Age horse supply (Bendrey 2008) could be used to clarify the situation.

Having analysed the research from Blick Mead to establish both the longevity of Mesolithic people living within the Stonehenge landscape, the longevity for the presence of large herbivores

crossing the landscape and the openness of the landscape, it is noticeable that the only Mesolithic hunting equipment finds to date within the Stonehenge landscape consist of arrowheads and microliths, from which it is difficult to fully evaluate the efficiency of hunting equipment. However, using Andersen's (2013) excavation of the underwater site of Tybrind Vig in Denmark, primarily due to the unusually good condition of the preservation of organic finds at this site, which also include a complete auroch's skeleton, has enabled this problem to be overcome.

Although, there are subtle differences with regard to both the flora and the fauna between the sites at Stonehenge and Tybrind Vig where, with regard to flora, although the Stonehenge landscape continues to be dominated by pine throughout the complete Mesolithic period (Branch 2014), both sites have a high percentage of hazel, whilst with regard to fauna, although both sites have evidence of aurochs, the percentage at Blick Mead was much higher (Jacques 2014).

With regard to the hunting of aurochs, there are suggestions that during the Upper Palaeolithic, the throwing spear is probably the most common hunting weapon, and that it appears to have been gradually replaced by the bow during the Late Glacial period (Bergman 1993 pp. 95–105). However, finds from Tybrind Vig (Andersen 2013) show that 'the throwing spear continues to be used throughout the Mesolithic Period', where in excess of 30 examples of what Andersen describes as slender shafts have been found.

These shafts have a syringe-feature at the pointed end which Andersen suggests was the functional part, 'being either a mount for a point of some other material such as bone or stone or possibly designed as a blood channel or a reservoir for poison, the blood channel allowing for easier withdrawal of the item'.

Assumptions that the physical properties of hardwood would be an essential resource required for the invention and the development of the bow do not appear to be the case. Bows from the Late Glacial have been found made of softwood like pine, such as the bow from an Early Mesolithic site at Stellmoor. However, possibly because the sapwood is so soft, it was probably combined with antler, and made as a composite bow. There are ethnographic Inuit parallels of antler-limbed bows from the Canadian Arctic which could support this theory. This would mean that the simpler self-bow was preceded by the more complex composite bow (Bálint 2013).

However, climate change in the Mesolithic, resulting in the increased spread of elm, provide an economical solution for the advancement of bow technology. One of the earliest known self-bows, found at the Holmegaard Moor site in Denmark date to around 7000 BC (Bálint 2013). The bow which is 154 cm long has been made from the trunk of an elm tree that had been split down the middle. It has been carved out from the tree so that its back was the flexible sapwood whilst the belly was the harder heartwood. A further 20 bows, one complete, have been found at the Mesolithic site at Tybrind Vig in Denmark (Andersen 2013).

A reconstruction of the Holmegaard bow (Bergman 1993 pp. 95–105), shows that 'the bow has a maximum range of between 150–200 meters'. These Mesolithic self-bows were very effective weapons in the hands of trained archers. The impact of arrows shot from these bows could prove fatal if hit at critical points of the body of an animal, like the chest or the neck. Analyst of the archaeological evidence from animal bones such as red deer, aurochs and wild boar which have been identified as having signs of hunting injuries, from the Tybring Vig and Holmegaard sites, show that most of the injuries are indeed associated with the chest area, leading to the belief that Mesolithic hunters were possibly very skilled in the use of the bow.

Although often referred to within the many papers and books discussing the Stonehenge area, hunting is seldom discussed in any great detail. Hunting sections of these various articles mainly consisting of diagrams of flint arrowheads. To carry out an in-depth account into potential Stonehenge hunting strategies three methods of hunting strategy have been identified – hunting, trapping and the use of pits – which are principally variants of the one activity (Holm 1991 pp. 89–100), this being to obtain large game for food and other purposes. Although Holm is investigating the Scandinavian hunting of reindeer, the actual strategies of the various styles of hunting could potentially transfer to

both the topographical landscape around Stonehenge, although obviously on a much smaller scale, as well as to the hunting of another species of large herbivores, in this case the aurochs. The fact that the Scandinavian Mesolithic site at Lingby II has a faunal assemblage of 11% aurochs (Jacques 2015 personal communication) would support the theory that Scandinavian hunting methodologies could be transferred to the Stonehenge landscape.

Fieldwork

Current accepted landscape archaeological methodologies have been used (Renfrew & Bahn 2012 pp. 71–94) to undertake research of the complete geography of the Stonehenge landscape throughout the World Heritage Site and the Salisbury Plain Training Area to ascertain what makes this specific landscape, where Mesolithic people raised the initial posts and where later monuments were to be placed, so special.

It is important to establish what the landscape was like during the Mesolithic. Lidar photographs of the region show that two postglacial river valleys join just north of what was to become the Cursus and then continue as one larger dry river valley southwards to join the River Avon just south of Wilsford. A further ancient river valley runs east-west dissecting the Stonehenge Bottom river valley at the northern tip of the periglacial feature identified by Mike Parker Pearson (2012), continuing westwards past where the Mesolithic postholes were to be situated.

At the end of previous Ice Ages, although the actual glaciers do not reach the Stonehenge area, meltwater from retreating ice sheets causes torrential fast-flowing postglacial rivers which carve out the river valleys that can be seen today. However, although Palaeolithic hunter-gathers experience this senerio, this would occur millennia prior to the time of Mesolithic people settling in the region. By the time of the Mesolithic, these torrents would probably be replaced by wide, shallow braided rivers, covering the broad floodplain with loose sediment (Branch, personal communication).

Studying both recent Lidar and Ordnance Survey maps of the wider Stonehenge landscape it is noticeable that the east-west path across the southern section of the landscape is cut by a series of steep valleys that would have been formed during previous glacial periods. My initial thought is that during the Mesolithic, when (as can be seen through the research carried out by French, Allen, Scaife, and Green et al.) the slopes away from the main section of the Stonehenge landscape would have still been covered by woodland, it may have proved difficult for herds of aurochs to move across this terrain.

A terrain elevation software package 'Elevation Chart' by Nianliang Mo has been used to plot the terrain elevation of several routes to the south of the current A303, in order to assess the degree of slope steepness running throughout the region. To ensure that a constant section of this landscape is investigated, I use the A360 for my westerly datum points and the River Avon for my easterly datum points.

Investigation identifies that within each of the routes plotted there is at least one section of the landscape that has a slope with a gradient in excess of 40 degrees. These sections could potentially prove to be impassable to large herbivore movement during the Mesolithic period when the steep slopes would be covered in woodland.

It should be noted that the terrain elevation point which dissects the postglacial river valley as it splits into two just to the north of what was to become the Stonehenge Greater Cursus shows only a gentle slope, when expectations would have anticipated the gradient to continue in excess of 40 degrees. However, this point of the valley is used for the disposal of rubbish from the clearance of local military installations at the end of the First World War, which results in the present profile and shape not mirroring the natural form. However, looking at a 1850s Ordnance Survey map shows that the original profile of this section of the valley also has steep sides.

Investigation of the section of the landscape which follow the profile of the Cursus shows that the western section gently descends the plain to the fording point at Stonehenge Bottom before rising in a slightly steeper slope back up to the Kings Barrow Ridge. It is over this section of the landscape that this chapter suggests the herds of aurochs moved on their route to the River Avon.

In an effort, to confirm the acceptability of the methodology, investigation also includes many days walking the Stonehenge landscape studying these terrain elevations in an attempt to evaluate the ease of large herbivore movement that could have occurred throughout the Mesolithic when the landscape is still covered in woodland.

The methodology therefore includes walking the landscape in an easterly direction along the Cursus, before turning south to follow the River Avon between Durrington Walls and the current A303 before moving in amongst the hills to the west of the River Avon south of the A303.

The results of these investigations are more complicated than first appears when presented as a paper exercise. However it appears that the suggestion being put forward, that the Stonehenge landscape to the south of the A303 is blocked to large herbivore movement in an east-west direction during the Mesolithic, would be proved if probable marshy ground were to be incorporated into the equation alongside that of steep slopes.

The one section that fails to comply with this suggestion is the small section that follows the path of what was later to become the Avenue, where sections of the herd would be able to split off from the main herd to reach the River Avon via this route. This is the precise area, by what was later to become Blue Stonehenge, where Mike Parker Pearson (2012) identifies a Mesolithic hunting camp.

However using this methodology identifies a problem as it fails to produce reasons why the herds would not have moved across the landscape to the north of what was to become the Cursus.

A similar experiment carried out by Bowden (2015) using a GIS software programme to highlight slope gradients in excess of 40 degrees which, as stated earlier, would have proved difficult to animal movement in the Mesolithic due to the woodland environment supports the theory that the only west-east route for animal movement to the River Avon lies in the small gap between what was to become Woodhenge and the A303. However Bowden's research also fails to explain why the herds would not have moved across the landscape to the north of what was to become the Cursus. Investigation of the section of the dry river valley at Stonehenge Bottom, where it splits within the area to the north of what 3,000 years later was to become the Cursus shows a deeply incised eastern arm which heads north-east to merge into the southern flank of Durrington Down. The other arm broadens out to the north-west and then sweeps around to the north creating a wide hollow. However, one of the problems experienced by both my own investigation and by the research undertaken by Bowden (2015) is that this point of the valley is used for the disposal of rubbish from the clearance of local military installations. This results in the present profile and shape not mirroring the natural form. In addition to this, the military are also responsible for constructing a sewage farm across the line of the Cursus at Stonehenge Bottom. However use of the 1850s Ordnance Survey map shows that this section of the valley profile originally continues with an identical slope profile as that within the adjacent section of Stonehenge Bottom.

Field walking of the Stonehenge landscape to the south of the A303, together with the results Bowden achieves through use of the GIS software programme, confirms the success of using the terrain elevation software methology as a means to identify areas of the plain that would have presented significant difficulties for large herbivore movement, especially during the Mesolithic when these areas would have been covered in woodland.

Therefore I decided to continue using the terrain elevation software package to determine the slope gradient of the landscape to the north of Durrington Walls, in the section of the plain that has become the Salisbury Plain Training Area, even though physical access to this area would be unobtainable due to it having become a military training ground.

Salisbury Plain is one of a series of bands of chalk outcrops found across much of southern and eastern England. However, here the outcrop is much higher than its surrounding hinterland, which

is divided into discrete sections by the rivers Wylye, Nadder, Till and Avon which have carved out sinuous southerly or south-easterly flowing valleys. These separate from each other by several kilometres of arid chalk downland that during the Mesolithic would have been heavily wooded. The major landscape features running through this section of the plain are the dramatic escarpment that delimits the edge of the chalk to the west and the north and the short, steep-sided coombes that dissect the area which makes it a landscape of rolling hills and hidden vales.

Investigation, using the same methodology as used throughout the southern section of the Stonehenge landscape, highlights that the terrain elevation profiles within the Salisbury Plain Training Area are significantly greater than those which were produced from the area to the south of the A303, where photographic evidence and the research carried out by Bowden (2015) support the theory that large herbivore movement would have been severely restricted due to the slope gradient of a wooded landscape during the Mesolithic.

Three separate sections of steep gradient were highlighted running within The Salisbury Plain Training Area, which this chapter suggests, through comparison with the field walking exercise carried out in the southern section of the Stonehenge World Heritage Site, support the theory that this section of the landscape would result in greater restriction to large herbivore movement than was previously seen in the landscape to the south of the A303.

Therefore a 26-kilometre long section of Salisbury Plain which, when still mainly covered in woodland, as it was during the Mesolithic, is arguably impassable to large animal herds moving from west to east. The only section that appears to give any kind of access to this large herbivore movement is the half-mile gap between Woodhenge and the A303 where the natural slope of the landscape would concentrate herd movement towards the current Countess Roundabout.

Investigation of the research carried out by Allen, French, Scaife and Green, identifies that this was the most open section of the Stonehenge landscape, whilst research carried out by Vera identifies that this potentially initially occurs as a result of large animal movement.

Investigation also identifies that, due to palaeochannels, there is a natural funnelling effect of the Stonehenge landscape with a fording point just to the north of the periglacial feature which was to eventually become the first part of the Stonehenge Avenue (Jacques 2014). This chapter therefore suggests that use of the terrain evaluation methodology across the wider Stonehenge landscape identifies an approximate 26-kilometre long sector of the plain, which runs north-south from Salisbury to Upavon is potentially impassable to large animal herd movement in an east-west direction due to the landscapes' steep gradients. The exception is a small half-mile gap, identified by both my own investigation and by Bowden (2014), that lies between Woodhenge and the current A303 where the majority of large herbivore movement occurs.

Following confirmation of a Mesolithic posthole (A-148) on Boscombe Down in May 2015 (GPS Location: Latitude 51.161926 – Longitude -1.758351) I decided to continue the terrain elevation evaluation into the surrounding area east of the River Avon. The posthole, had been found during a housing development on Boscombe Down by Wessex Archaeology in 1999. However it is not until May 2015, after the extensive discoveries at Blick Mead (Jacques 2014), that radio carbon dates are obtained for the posthole which places it into the Early Mesolithic period around the same period as the Mesolithic postholes found in the old Stonehenge car park (Vatcher 1966). Two radio carbon dates are achieved: 8430–8250 cal BC from section NZA-32469 and 8460–8280 cal BC from section SUERC-36683. The reasoning behind the original decision not to obtain carbon dating being the lack of Mesolithic activity found by the (SEP) and the assumption that the pit was either Late Neolithic or Early Bronze Age (Barclay 2015 personal communication)

Approximately 100 metres south of the Mesolithic posthole, 'a rectangular pit (8326) contains the carefully arranged articulated skeleton of a juvenile aurochs, with the limbs detached, the lower limbs being placed close to the head, which supports the theory of extensive use of the area during the Mesolithic and potentially suggests a deliberate burial practice has taken place' (Wessex Archaeology 2004). Land snail assessment had been carried out by Wessex Archaeology from within the bovine

burial pit (Pit 8326) which potentially suggested that, similar to the area surrounding the Mesolithic postholes in the old Stonehenge car park, this area was open grassland.

However, as there appears to be some doubt with regard to whether the buried animal is in fact a juvenile aurochs or a domestic cow, I decided not to rely upon this snail assessment data. I therefore decided to analyse the snail data taken directly from within the Mesolithic posthole (A-148) undertaken during the Phase II excavation. This identifies that similar to data from the postholes within the old Stonehenge car park, this post is potentially situated on the edge of a mixture of open countryside and woodland.

The decision was therefore taken to carry out further terrain evaluation assessments of the slope gradients of the landscape to the east of the River Avon via use of Ordnance Survey maps and the terrain evaluation software used previously to identify if large herbivore movement is possible from the Countess Roundabout on the current A303 to the Mesolithic posthole found at Boscombe Down.

This highlights, that due to the steep slope gradients the majority of this eastern landscape would prove difficult for large herbivore movement, especially during the Mesolithic when it would potentially be still mostly covered in woodland. There is, however, a small gap providing access that joins the point where the passage from the Cursus to Countess Roundabout, described earlier, ends. This passage continues south-eastwards past the recently discovered Mesolithic posthole at Boscombe Down and out onto the eastern side of the plain.

Investigation of the positioning of both sets of Mesolithic postholes and the various pits throughout the wider Stonehenge landscape (Christie 1963, Vatcher 1966, Wessex Archaeology 2004 & Gaffney 2012) shows that the proposed direction of herbivore movement is closely associated with the placement of these features. My own investigation therefore suggests this could be the most accessible route for large herbivore movement. However, to produce prime hunting territory it is not only important to have the animals but to also have good lines of sight and hiding places where the animals will not detect the hunters.

Investigation of the research carried out by Pearson and Field together with evidence of the landscape viewsheds undertaken as part of my own investigation show that the overall topography of the Stonehenge landscape, with its steep gradients mostly covered in woodland during the Mesolithic and the natural funnel dissecting Stonehenge Bottom, would have concentrated herd movement as they moved towards the River Avon. My own investigation also identifies this area as the only section of the Stonehenge landscape allowing potential large animal access. The amazing views from within this landscape, to the wider landscape, allow hunters to see the approaching herd movement, yet also has a blind spot for the hunters to hide in, thus producing a killing ground.

This narrow section of landscape would allow groups of hunters to operate the classic intercept strategy where one group potentially positions itself within the Stonehenge Bottom recess whilst another group potentially stationed on the Kings Barrow Ridge could signal the arrival of the herd. It is this narrow section of the Stonehenge landscape that Jacques (2014) suggests 'memorialises the special hunting grounds used by local communities for thousands of years'.

Discussion

Jacques' analysis focuses on the wider landscape, where he highlights a number of natural features that would have aided prehistoric hunters. Roughly halfway between Stonehenge and Vespasian's Camp, the King Barrow Ridge slopes down to a part of the plain known as Stonehenge Bottom. In the Mesolithic period and later prehistory this is probably home to a now vanished watercourse draining into the River Avon. Jacques research identifies a fording point where a natural funnel, possibly created by an old river channel, forms a side valley to the Stonehenge Bottom dry river valley at a point

just north of the bend in what was to become the Avenue. 'From there, the terrain draws your gaze to the west – directly towards the area where the Mesolithic posts once stood' (Jacques 2014 p. 24).

My own fieldwork supports that this dry valley funnel potentially offers a route for herds of aurochs traversing Salisbury Plain, and also hiding places from which Mesolithic hunters could spring an ambush. Once the kill was complete, the ancient watercourse along Stonehenge Bottom potentially provides a helpful means to convey heavy carcasses back to the home-base for butchering.

The positioning of Blick Mead, with regard to the potential Stonehenge hunting grounds could be highly significant, in that it lies in the lee of Vespasian's Camp which is the closest section of the plain to offer shelter from the predominant winds that blow across the plain. Whilst the two hunting camps found by Mike Parker Pearson are placed at sites where aurochs would potentially pass on their route to the River Avon, one being at the western end of what is potentially the primary access route across the Stonehenge landscape and the other at the end of what was later to become the Stonehenge Avenue, offering later Neolithic people an accessible route from the River Avon up to the monument.

Could it be a significant factor that Blick Mead lies at approximately the midpoint between the two sets of Mesolithic postholes (those in the old Stonehenge car park and that found recently at Boscombe Down)? Also could the large number of Mesolithic sickle finds within the worked flint at Blick Mead (Jacques et al. 2014) tentatively indicate that people had begun to clear the landscape? As Jacques states, could this have resulted in 'domestication of the forest by accident' leading to the 'open woodland gradually changing to open country'? If the land did offer particularly fruitful hunting grounds, it might explain why Blick Mead was returned to again and again (Rowley-Conwy, personal communication).

Was the Stonehenge landscape almost always partly open or was the landscape manipulated during the Mesolithic to increase the ease of aurochs' movement across the plain, thereby assisting with the local populations hunting strategies? During the Mesolithic period the Stonehenge landscape potentially comprises closed woodland with a clearing running east-west within the area of the Greater Cursus across the whole plain to the River Avon. Although initially this probably occurs naturally due to the migration of animal herds, with some degree of forestry management this could have been improved, increasing the access for large herbivores moving west to east across the Stonehenge landscape towards the River Avon (as posited by Jacques et al.), potentially continuing from the River Avon to the recently discovered Mesolithic post at Boscombe Down.

The argument that, the activities of Mesolithic man had no marked effect on vegetation in pre-Neolithic times in this landscape derives in some extent from the notion that, due to the small human population, people did not need to clear forests to increase food gathering. However, there is a tendency to overlook the possibility that the deliberate use of fire, or even accidental burning, may have had widespread effects.

At Iping Common in Sussex, local replacement of hazel scrub by heath may be associated with the activities of Mesolithic man (Dimbleby 1962) whilst at Oakhanger in Hampshire, Dimbleby speaks of the increasing destruction of the forest cover during successive Mesolithic occupations in the Atlantic period, 'if Mesolithic man did use fire, for example to drive game, the effect upon vegetation might be out of all proportion to his numbers'. The possibility exists that during the Mesolithic period sophisticated systems of land use may have developed that involve deliberate interference with the forest cover.

Peter Rowley-Conwy (2004) argues for the Neolithic revolution instigated by the immigration of new peoples, bringing with them new technologies. However he also identifies evidence in many areas throughout the Mesolithic period to suggest the range and predictability of hazel is improved by manipulation of the environment, as peat dating to the period 6000 to 4500 BC often shows evidence of woodland fires in the form of charcoal layers accompanied by reduced levels of tree pollen. Others argue (Mellars 1976 & Simmons 1996) that regenerated woodland is particularly attractive to ungulates.

As there has been little research undertaken with regard to forestry management within the Stonehenge landscape, I analysed the research that has been undertaken at other Mesolithic sites, such

as Woolaston on the Severn Estuary (Bell 2005), Star Carr in Yorkshire (Milner & Conneller 2012) and Tybrind Vig in Denmark (Andersen 2013) to examine the idea that Mesolithic people undertook significant forestry management to improve the concentration of animals within their region.

Evidence is available to support the theory that Mesolithic people knew how to adapt their environment to suit their needs. Intertidal Holocene sediment exposure surveys at Woolaston in Gloucestershire (Bell 2005) identify areas of peat, which are associated with a submerged forest dating between 5775 BC and 4220 BC, highlighting it is of the Mesolithic to Neolithic period, where there is evidence for Late Mesolithic burning episodes which appear to relate to human activity.

As sea levels rose due to climate warming after the end of the ice age, the Severn valley is progressively flooded where the rising sea drowns a great forest of oak trees with tall straight trunks which show that they had grown in dense climax forest. As this woodland is drowned, so higher ground on the Welsh shore at Goldcliff becomes an island; and on the edges of this is a complex of Mesolithic sites. Charcoal remains on the site suggest people use fire to encourage the growth of particular plants, such as hazelnuts, crab apples and raspberries. 'This evidence may indicate that Mesolithic people were deliberately manipulating the environment to increase their resources, thousands of years before farming began' (Bell 2005 pp. 77–80).

This discovery complements evidence for Mesolithic burning in the uplands, where fire is said to aid the creation of open areas to attract grazers, particularly red deer.

> Several of the fragments of macro-charcoal are clearly identifiable as charred reed stems, strongly implying in situ burning of reed swamp. In one case, significant quantities of macro-charcoal, including several fragments of charred reed stems, are associated with fragments of charred wood, representing a phase of reed burning during which trees still extant within the reed swamp are also charred. (Bell 2005 p. 77)

The recurring nature of the burning, which is consistently associated with increases in fern pollen, covers several hundred years between 5420 and 4200 BC and could be taken as strong supporting proof of an anthropogenic origin (Rowley-Conwy 2014). However, even in situations where charcoal is associated with artefactual evidence for human activity, due consideration must be given to the role of natural agencies such as lightning strikes and wild fires.

Another interesting feature found by Bell at Woolaston are Mesolithic footprints, which are visible on exposed lamination beds. Most of the footprints are in mediocre and poor condition, but by 2001 a total number of 35 footprints are identified as human. Other footprints belong to gulls, cranes and deer. The combined evidence suggests that the Severn Estuary was a focus for human settlement and subsistence during the Mesolithic period. People appear to be gathering plant foods and deliberately setting fire to reeds and woodland, perhaps to encourage new shoots for grazing game animals.

Star Carr, Britain's best-known Preboreal site which dates to about 9000 BC, is located in the Vale of Pickering, in Yorkshire. Recent excavations (Nicky Milner & Chantal Conneller 2012 pp. 1004–1017), suggest that the site is approximately 80 times larger than the small, ephemeral sites considered typical of the period. They identify that this new programme of investigations has re-mapped the extent of Mesolithic occupation, and establishes the nature of both dryland and wetland structures, which suggests a longer-term occupation and larger group size, 'indicating that previous interpretations of Early Mesolithic lifestyles, at least in parts of Europe, require to be revisited'.

A programme of research undertaken at the site in the late 1990s (Mellars and Dark 1998 pp. 231–232), where Dark's research broadly supported the environmental sequence that had been outlined in previous work at the site. However Dark also argues that 'some of the changes to the wetland vegetation previously recorded are unlikely to be the result of natural plant succession but instead result from the deliberate clearance of the lake-edge flora'. This, Dark argues, 'has been caused by the deliberate clearance of the reed beds by fire, the occurrence of which spanned several months of the year'.

There is also evidence that Mesolithic people are deliberately manipulating and managing the wetland vegetation in the wider landscape. High-resolution pollen and charcoal analysis shows that reed and sedge beds were cleared by burning for prolonged periods and on multiple occasions.

Although the reason for the burning is debated, the most common argument is that it forms part of an economic strategy that is designed to maintain predictable and reliable resources around the landscape. It has been argued that 'the burning of the reeds promote the growth of young shoots and create openings at the edge of the lake, to attract animals to the area and make them easier to hunt' (Mellars & Dark 1998 pp. 231–232).

The underwater excavations at Tybrind Vig (Andersen 2013 p. 213) have 'yielded the most important wood assemblage to date from the late Mesolithic (5620–4040 BC)'. These excavations recovered large amounts of wood in the form of charcoal, unworked wood, wooden implements and woodworking waste. The vegetation is characterised by the human exploitation of the trees, especially of the hazel bushes which are used to furnish material for fish weirs and various types of hunting implements and tools. Outside of the local area, according to the pollen data, there is evidence for extensive areas of untouched primeval forest where undergrowth and glades were sparse. 'The considerable proportion of hazel is a sign that the Mesolithic hunter-gatherers have, in the course of 1,400 years, altered the original dense, dark lime forest in the area nearest to Tybrind Vig' (Andersen 2013 p. 391). This supports Zvelbil's theory (1994 pp. 35–74) that in a sense Mesolithic people have started 'farming the forests' and were indeed manipulating the local woodland area to produce the abundance of raw materials required. This would have also resulted in manipulation of the local wildlife habitat resulting in an increase in the amount of large herbivores living within the area.

We see from the earlier assessment of the evidence put forward by Allen, French, Scaife and Branch that the Stonehenge landscape is potentially much more open during the Mesolithic than previously suggested. Although there is no direct evidence of Mesolithic people's use of fire to manipulate the Stonehenge landscape, indirect evidence of Mesolithic burning from the sites at Woolaston and Star Carr show that people from this period have the knowledge to manipulate their locale. We also see that the Mesolithic hunter-gatherers have, in the course of 1,400 years, altered the original dense, dark lime forest in the area nearest to Tybrind Vig.

This chapter suggests that this substantially supports the theory that Mesolithic people within the Stonehenge landscape had the ability to, and probably did carry out significant forestry management within the local area and especially within the area where the majority of large herbivore movement occurred, that being the area between what millennia later was to become the Cursus and the natural funnel identified by Jacques et al.

Van Vuure (2005 p. 7) believes that 'aurochs have a special relationship with marshes and the edges of marshy forests' such as would have been in abundance along the banks of both the braided River Avon valley and the potential river occupying Stonehenge Bottom during the Mesolithic.

Van Vuure uses contemporary descriptions together with characteristics from aurochs' skulls and teeth to categorise that aurochs predominantly act as grazers who mainly feed on grasses but are also willing to supplement their diet by eating autumn acorns and winter branches from bushes and small trees. He believes that 'the behaviour of aurochs can be reconstructed from that of their descendants, modern domestic cattle, and from historical information'. This identifies that aurochs prefer to move across the open landscape, with cows, calves and young bulls grouping together whilst, apart from during the autumn mating season, the older bulls tend to live apart. This would make the smaller, more vulnerable animals within the group an easier target for Mesolithic hunters.

Higgs (1961 pp. 144–154) believes it is probable that 'aurochs would have some degree of seasonal movement in most open habitats', which he demonstrates by research undertaken on the fauna of the Haua Fteah cave in Cyrenaica, Libya, where he notes 'a peak of aurochs' bones at the end of the Pleistocene period which equates to a woodland recession due to cooler conditions and reduced rainfall'. Could the high percentage of aurochs' bones found at Blick Mead potentially be due to the woodland recession across the central band of the Stonehenge landscape as discussed in the earlier section of this chapter?

Aurochs can be characterised as habitual grazers, with the ability to use woodland when advantageous for winter browse and shelter. However, only when woodland was open enough so that light could penetrate to the woodland floor would there have been worthwhile accessible food.

The constant search for open areas, in order to overcome competition from other specialised grazers, could mean that the opening Stonehenge landscape in the area of what was to become the Cursus, leading across the ancient river at Stonehenge Bottom towards the braided River Avon with its localised marsh ground, could potentially result in this area becoming ideal feeding grounds for the aurochs. The movement of these large herbivores across the Stonehenge landscape could 'be able to control forest growth further increasing the emergence of the open park-like landscape' (Vera 2000 pp. 52–55).

Seasonal animal movement studies at Star Carr (Legge & Rowley-Conwy 1988) establish through investigation of the teeth of young animals that 'most had been hunted during the late spring and early summer'. Initial analysis of the faunal assemblage from Star Carr, which consists of fragments from red deer (535), elk (243), aurochs (170) roe deer (101) and wild pig (923), had previously formed the basis for Clark's (1954) initial interpretation of the site as a winter base camp, which was inhabited by seasonally mobile hunters following herds of migrating red deer. However, a later re-assessment of the data shows that the number of antlers has been overrepresented in comparison to the post-cranial elements of the skeleton, suggesting that they have been brought onto the site, possibly for use as raw material (Legge & Rowley-Conwy 1988).

However, comprehensive re-analysis of the faunal assemblage carried out by Tony Legge and Peter Rowley-Conwy (1988), notes that the use of adult red deer crania with unshed antlers was an unreliable indicator when predicting seasonality and therefore focuses on the age-at-death profile of the younger animals based on tooth eruption data. This shows young red deer were being killed in the summer, while the presence of adult red deer crania that had shed their antler indicated a kill around April or May. From this evaluation Legge and Rowley-Conwy conclude that 'a summer occupation was most likely'.

Clark's model of a seasonal pattern of upland-lowland migration has also been critiqued by Legge and Rowley-Conwy (1988) where they argue that the studies of red deer behaviour drawn upon by Clark were not applicable to Star Carr as they were based on open rather than wooded landscapes (Legge & Rowley-Conwy 1988:13). Furthermore, they note that deer in wooded environments do not migrate over long distances and would not necessarily have been absent from the vicinity of Star Carr during the summer season (Legge & Rowley-Conwy 1988).

This also suggests that herds of aurochs were moving across the open plain during this time period with the bulls in particular, becoming more solitary and perhaps using the forest cover more during the rest of the year. If a similar scenario could be applied to the Stonehenge region, could this have resulted in the Mesolithic Stonehenge population either moving on to new locations to follow the herd or changing to a new resource strategy once the aurochs had passed?

Using the wild Chillingham herd, which have been isolated within the Chillingham park for 750 years with little human interference, as the closest possible reference point for the lifespan of ancient aurochs within the Mesolithic period, it is highly probable that life expectancy is approximately 17 years for cows and 13 years for bulls, with the cows maturing around the age of four years whilst the bulls mature earlier around the age of 18–20 months but would take longer to reach a dominant position within the herd.

However, did the aurochs, whose remains have been found within the spring at Blick Mead, live their complete lives within the Stonehenge area or have they travelled from afar, to be intercepted and killed within the area during the process of a much longer journey? Using isotope data from teeth and bone finds within excavations at the Blick Mead site, it would be possible to produce a theory as to the extent of aurochs' movement throughout their lifespan (Rowley-Conwy 2015 personal communication).

A combination of strontium, carbon and oxygen isotope analysis of archaeological dental tissues could be used to plot the lifetime movements of individual animals, potentially reconstructing patterns of residency and mobility among prehistoric aurochs populations from the scientific analysis of their skeletal remains (Montgomery 2014).

This arises from the systematic variation between localities of stable and radiogenic isotopes. Isotopes of strontium have been used in this way for some time. Strontium has four naturally occurring

stable isotopes, one of which, [87]Sr, is produced by the radioactive decay of [87]Rb, which, like strontium, occurs naturally in many rocks and minerals. The abundance of [87]Sr is therefore dependent on both the Rb content and age of the rock or mineral in which it is found. Measured in comparison with its non-radiogenic sister [86]Sr, [87]Sr/[86]Sr ratios can vary from as little as ~0.703 for basic volcanic rocks of recent age to ~0.740 in continental granites.

Since strontium isotope ratios vary in a systematic way between rock units of different ages and lithologies, these differences are reflected in local soils and therefore in plants growing on them and the animals eating the vegetation. It is this which links the skeleton to the locality and provides the basis for the reconstruction of residency patterns.

The use of carbon $\delta^{13}C$ and oxygen $\delta^{18}O$ isotopes to enhance and extend the strontium-based study of residency and mobility is an important new development. The $\delta^{13}C$ values of the aurochs' teeth are linked to the $\delta^{13}C$ values of the plants it has consumed, where variations can be observed as to the environmental conditions within which the plants grew, being affected by factors such as temperature, altitude and the level of recycled CO^2 that is found in dense woodland.

The $\delta^{18}O$ values of the aurochs' teeth are linked to the water supply the animal has digested, where changes in the ratio of oxygen isotopes are due to the physical process of evaporation and condensation within the atmosphere where $\delta^{18}O$ is depleted as the water vapour moves towards the poles however $\delta^{18}O$ can also be further depleted due to altitude or coastal distances.

Analysis of the strontium, carbon and oxygen isotopes has been carried out for the University of Buckingham by Bryony Rogers (forthcoming) on two aurochs' mandibular M3 teeth finds from Blick Mead where the samples, which were identified as BM421 and BM422, could potentially identify the locale from which the aurochs was born and trace movement throughout their lifespan.

The teeth are relatively well preserved and determined to be from different individuals based upon the Grant (1982) wear stages. The wear stage of the tooth from the sample identified as BM422 indicates that this aurochs was between nine and 12 years old when it died. Initial results of the strontium isotope (with [87]Sr/[86]Sr levels lying between 0.708598 and 0.708671) indicate that both of the animals had been born somewhere within a chalkland region and continued to live within the chalkland region throughout their lifespan. However, this does not necessarily mean that they came from the Stonehenge locale.

The decrease in the $\delta^{13}C$ levels which occurs around the same time as the $\delta^{18}O$ values decrease from their summer peak to their winter trough potentially supports the theory (Van Vuure 2005 and Legge & Rowley-Conwy 1988) that aurochs herds split into smaller groups and headed away from the plain and into the forests to winter on acorns and other fruits.

However, although $\delta^{18}O$ values for both BM421 and BM422 are extremely low, indications are that both individuals came from either the same region or different regions with similar $\delta^{18}O$ values. Whilst the highest values could potentially be applied to parts of Scotland and eastern England, there is the possibility that the aurochs could have travelled from as far as an Alpine region. Radio carbon dating from the tooth of BM422 gave a range of 5845–5706 cal BC. Although Doggerland has completely flooded by this time period it is possible that a land bridge could have still survived in the area of the Isle of Wight. However, to produce the combined isotopic signature would require the aurochs to have travelled from the Alpine region through France staying to the chalkland region.

Whilst the long migration through the chalkland regions of France from an Alpine region could explain the flat $\delta^{18}O$ values, the consistent strontium results strongly indicate that the aurochs are either local to the Blick Mead area or from the chalklands along the Lincolnshire/Yorkshire east coast.

Investigation of both the archaeological and environmental data is required, to comprise the basis for a discussion of possible aurochs hunting strategies. Descriptions put forward (Holm 1991 pp. 89–100) for various hunting or trapping techniques have been 'partly based upon the notion that hunting techniques in general may remain similar throughout the millennia', which enables the study of these techniques to be incorporated into the hunting of aurochs within the Stonehenge landscape.

Whilst Holm's research is predominantly about the hunting of reindeer, similarities with the hunting of aurochs can be established. Whilst there are few archaeological sites or radio carbon dates from the millennium after the start of the Holocene and there are indeed few Mesolithic sites in Scandinavia throughout the entire Preboreal period, this absence has also been noted within the British Isles. Factors responsible for this could be that sea levels are still fairly depressed during this time period resulting in distant seashores where, after the disappearance of herbivore herds, settlement may have been mainly in coastal areas that today are buried beneath the waves. However, the transition to smaller and more geometric artefacts together with the use of cores of lower-quality flint shows that the Mesolithic in Scandinavia also developed from the Late Palaeolithic. With regard to using Holm's research to establish Mesolithic aurochs hunting techniques. Aurochs' fauna is found throughout Scandinavia especially at sites such as Tybrind Vig (Andersen 2013), Holmegaard (Bálint 2013) and Prejlerup Bog in Denmark (Sorensen 1986), which together with the discovery of aurochs tooth beads in the graves of Mesolithic cemeteries at Skateholm I & II (Jonsson 1988) which date to ca 5300–4700 BC supports the prominence of aurochs within the Scandinavian region.

However, there are suggestions that Mesolithic hunting strategies might potentially have changed between the early and later periods. During the early period when there is likely to have been a greater degree of animal migration taking place, 'archaeological and ethnographic research potentially identifies that intercept strategies often involve killing significant quantities of animals at one time and in some cases selectively processing the carcasses' (Clark and Straus 1983).

Examples of late summer and early autumn intercept hunting appear to coincide with the period when animals were herding and in their physical prime, as this represents the ideal time to obtain nutritionally rich meat and other resources in advance of the oncoming winter. However, this is in direct opposition to the evidence put forward with regard to the understanding of seasonal animal movement at Star Carr (Legge & Rowley-Conwy 1988) which indicates that hunting was occurring in late spring and early summer. Therefore did the hunting season alter due to the location of the site and the timing of the passing animals?

In terms of later Mesolithic hunting strategies, as warmer climate results in mixed deciduous forests, longer autumn and spring months and milder winters, which potentially make, anticipating the movements or timing of animals congregating more difficult to predict there are arguments that a shift in strategy takes place in Britain (Myers 1989 pp. 78–91), where 'intercept is largely replaced by encounter hunting', which suggests that this involves hunters following or stalking the prey, instead of waiting for the animals at predictable intercept points.

Securing the appropriate nutritional levels during encounter hunting may have become more difficult, particularly if animal populations were lower compared to the earlier Mesolithic period. Hunting may have become more of a year-round activity, where the reduction in the use of seasonal camps could increase the risk of the population failing to meet dietary requirements during the winter and early spring months. 'Less selective hunting strategies may have become more common during this period which may have been offset by increased opportunities to exploit other food sources' (Jochim 1989).

Encounter hunting is also likely to result in changes in settlement patterns, as well as to the organisational structure of the technology used by the Mesolithic hunters. 'Procuring smaller groups of animals in less predictable environments may lead to smaller hunting groups being dispersed across the landscape. Hunting may also change from a group to a more individual activity' (Mithen 1990).

However, although often referred to within the many papers and books referring to the Stonehenge area, hunting is seldom discussed in any great detail. Could the topography of the Stonehenge landscape, with the steep gradients to the north and south of what was to become the Cursus (see above) have a tendency to concentrate herd movement and 'could this central area of the Stonehenge landscape together with the natural funnel dissecting Stonehenge Bottom, offer a potential route for the herds of aurochs traversing the plain' (Jacques 2014 p. 24)?

I therefore investigated three different methods of hunting strategy used throughout Europe during the Mesolithic period, these being hunting, trapping and the use of pits, to see how they would

potentially fit within the Stonehenge environment. Each of these strategies can be sub-divided into their various styles, these being the collective hunt, which requires at least one group of adults, but could also include mixed groups and the individual hunt, which could also include some kind of co-operation between a couple of individuals.

As climate changes occur throughout the Mesolithic hunter-gatherers would have been basically confronted with two choices:

> expansion through increased mobility in order to exploit a greater area, or intensification on particular resources within a smaller area. Oscillation potentially occurs between these strategies with the mixing of strategies probably prevailing during different times and conditions. (Fisher 2002 pp. 157–180)

However the viewsheds from and the openness of the Stonehenge landscape during the Mesolithic period potentially allow for a continuance of the classic intercept strategy, where two groups of hunters potentially may have been involved, one group positioned at the key strategic killing site, such as within the Stonehenge Bottom river valley fording point, whilst the other group wait for the herd to move into the valley, signalling its arrival from areas such as the Kings Barrow Ridge. Evidence from aurochs' bones found both at Tybrind Vig (Andersen 2013) and Prejlerup Bog (Sorensen 1986) in Scandinavia support this theory, which highlights that the animals had been shot with numerous arrows, suggesting that Mesolithic people frequently hunted on a collective basis where the animals were killed at topographically suitable passages within the plain.

The abundance of aurochs' bone found at Blick Mead, identify that aurochs herds potentially continue in large numbers in the region throughout the Mesolithic period (Jacques 2014), which, together with the suggestion that 'Mesolithic woodlands within the Stonehenge landscape continue their dominance of pine' (Branch 2014, personal communication), suggests that, contrary to ideas put forward for other locales during this period where animal species tend to be found in smaller herds or as isolated individuals which require hunter-gatherers to adopt new hunting strategies, the large herds of aurochs continue to migrate across the Stonehenge landscape allowing the local population to continue using intercept hunting strategies.

Scandinavian hunting practices show that large animals were 'often killed on an interceptive basis when passing natural obstructions in the landscape' (Holm 1991) throughout the Mesolithic and into the Neolithic transition period. The natural concentration of the herd at the Stonehenge Bottom fording point could potentially offer this opportunity where the aggregation of the herds whilst crossing water could result in them becoming easy prey.

Further evidence from Scandinavia also identifies trap arrangements where fences or similar structures such as piles of stones, perhaps containing flagsticks, force the moving herd to change direction towards a locality where the hunters kill the animals. 'The animals are driven into the traps via the co-operation of groups of hunters' (Spiess 1979 p. 105). Could the northern part of the Stonehenge landscape, in what was to become the Cursus, consist of such a series of fences or piles of stones acting as scarecrows to restrict the herd in its northerly movement? Although no direct evidence has been found to support this theory the large numbers of aurochs' bone discovered at Blick Mead (Jacques 2014) suggest that a successful hunting ground was situated within the area throughout the Mesolithic.

Could this support the purpose of the Cursus, as Jacques (2014) suggests that it 'memorialises the special hunting grounds used by local communities for thousands of years'? Driving fences often appear to take advantage of the local topography to force the animals to sites chosen by the hunters, the animals being frightened into the trap through the use of noise or movement, where at the end of the drive fence, hunters wait at pitfalls or other traps constructed for instance of wooden posts, where the killing takes place.

Also, could the find of an auroch's foot bone with a Mesolithic blade embedded within it at the Mesolithic site at Blick Mead (Rogers & Bishop, personal communication), potentially indicate the use of hunting pits within the Stonehenge landscape? If hunting pits were placed at the end of strategically positioned driving fences, the number of pits required would have been fairly low, which could

explain why no discovery has yet been made within the Stonehenge landscape. These pits consisting of rows of short spears, along the lines of the stakes used to bring down war-horses in Medieval battles such as Agincourt, with the intention being to disable the animal allowing the hunters to move in for the kill.

However, potentially the easiest form of hunting, that of 'Intercept and Ambush' is probably also practised. If herds of aurochs are moving along traditional routes, which the topography of the Stonehenge landscape appears to suggest, at least a few animals could be killed by the herd simply being attacked by a group of hunters. This style of hunting strategy would negate the requirement to use driving fences, killing sites or adjacent sites which, when used in connection with the collective hunt would require complex and extensive structures. 'This hunting technique is a fairly simple operation where all the hunter has to do is get downwind and close to the line of travel. It is in this context that hunting blinds should be seen' (Barth 1982). The hunters lie down behind the blinds or natural hiding places, waiting to ambush the herds as they pass. Could the numerous pits alongside the potential Stonehenge hunting area have been created to act as hunting blinds along a path known to be used by aurochs?

Further afield, the find of a skeleton at Tybrind Vig (Andersen 2013 pp. 464–467) identifies an aurochs which is killed in the course of an unsuccessful hunting expedition in which the hunters may have used dogs. When it was found, the remains of three microlith arrowheads are recovered from the chest area. A radio-carbon[14] date for the bones shows that it died around 8600 BC, in the early part of the Maglemosian period.

In 1983 the find of another auroch's skeleton, this time at Prejlerup bog in north-western Zealand (Sorensen 1986 pp. 111–117), shows that this aurochs has been shot by at least nine microliths. Does the fact that both aurochs have been shot using microlith arrowheads suggest that this is the preferred method for the hunting of aurochs, where the microlith arrowhead acts as a bodkin against the tougher hide and increased muscular nature of an aurochs, or is this the only form of arrowhead available during this period? Whichever is the case with regard to the hunting equipment used, both examples potentially indicate that the preferred method of hunting throughout the Mesolithic is the group hunt.

Detailed studies submitted on the remains of red deer at Tybrind Vig (Andersen 2013 p. 293) suggest that 'the entire animal is taken back to the settlement where skinning and butchering take place', however this is contrary to evidence put forward (Legge & Rowley-Conwy 1988) from Star Carr which identifies a complete lack of the haunch section across the range of animals investigated.

Although the techniques practised in prehistory have left little remains within the landscape, a site, at Balkweg, in the valley of the River Tjonger, Holland, which potentially represents a single hunting and primary butchering event of a small female aurochs (Prummel 2011), does give support to Legge & Rowley-Conwy where More than 49 aurochs' bones and a flint blade were found on the surface next to a recently dug ditch. Most of the bones had been spread over an area of approximately 2 m², however within a short distance two further smaller concentrations of bone, consisting mainly of vertebrae, were found together with two fitting blade-fragments which dated to the Mesolithic period. Approximately 40 metres upstream the team found part of the vertebra of an aurochs, with traces of burning. Due to the size of these bones the team induced that they probably belong to the same animal. The fact that the bones were found together suggests minimal displacement and since no skeletal element was represented more than once it is probable that all the bones belong to one individual. Whilst evidence for human involvement was obtained by the presence of butchering marks on several bones.

> The most likely interpretation of the Balkweg find is that they are the remnants of a single episode of hunting and butchering in the valley of the River Tjonger during the Late Mesolithic. After the kill the animal is skinned and butchered. The ribcage of the animal is opened and the meat removed from the vertebrae and ribs to be consumed locally. The burnt bones and the burnt flint blade show that the hunters light a fire to cook parts of the carcass whilst bone marrow from the tibia and the metacarpi and metatarsi appear to have also been consumed on the spot. However the rest of the carcass is probably removed from this site to be consumed elsewhere. (Prummel 2011 p. 1462)

This method of butchery could potentially have occurred within the Stonehenge landscape. Using one of the various hunting strategies discussed, the Mesolithic people from Blick Mead could have killed the aurochs within the area of Stonehenge Bottom, feasted on the carcass in the vicinity of the kill and then used the ancient river course to transport the butchered carcass back to the home-base at Blick Mead.

Conclusion

Personal investigation, carried out by undertaking fieldwork and by using terrain elevation software on the wider Salisbury Plain Area, shows that approximately a 26-kilometre long section of the plain running north-south from Salisbury to Upavon is potentially impassable to large herbivore movement in an east-west direction due to the landscapes' steep gradients with the exception of a small half-mile gap that lies between Woodhenge and the current A303. This route potentially continues to the east of the River Avon through a small gap of open countryside towards Boscombe Down, where it passes another recently discovered Mesolithic post and a pit potentially containing the burial remains of a young aurochs.

The natural topography potentially concentrates large herbivore movement though this section of the Stonehenge landscape leading to the formation of a successful hunting territory which is in-line with the Mesolithic posts and the later Greater Stonehenge Cursus. The viewshed from the point just to the west of the King Barrow Ridge identified within the SHLP as 'G2' offers excellent views of the surrounding landscape. It also enables a group of hunter-gathers located at this point to signal to an ambushing group located within the Stonehenge Bottom fording point when any aurochs herd is approaching, whilst the fording point within Stonehenge Bottom allows them to spring an ambush on approaching aurochs herds well within the distance of their bow shooting range.

The notion that there is little Mesolithic activity within the Stonehenge landscape is seriously challenged by the recent discoveries of a potential Mesolithic home-base at Vespasian's Camp (Jacques 2010) and the suspected Mesolithic hunting camps (Parker Pearson 2012). These people could, conceivably be the same hunter-gatherer group that use the site at Downton, as the spring line at Blick Mead directly joins the River Avon. The large number of Mesolithic sickle finds within the worked flint at Blick Mead tentatively indicate that Mesolithic people are starting to clear the landscape.

Assessment of the evidence put forward (Allen 2012, French 2012, Scaife 1995 and Branch 2014) suggests that stable calcareous grassland may have greater antiquity than previously thought and that the Stonehenge landscape is potentially much more open during the Mesolithic than previously suggested. Although there is no direct evidence of Mesolithic people's use of fire to manipulate the Stonehenge landscape, indirect evidence of Mesolithic burning from sites at Woolaston and Star Carr show that people from this period have the knowledge to manipulate their locale. Mesolithic hunter-gatherers have also, in the course of 1,400 years, altered the original dense, dark lime forest in the area nearest to Tybrind Vig. I believe this supports the theory that Mesolithic people within the Stonehenge landscape have the ability to, and probably carry out significant forestry management within the local area and especially within the area where the majority of large animal movement occurs.

Analysis of two Blick Mead aurochs' teeth by the University of Buckingham in association with the University of Durham using strontium, carbon and oxygen isotopic data to determine the possible aurochs' movement results in a high probability that the animals were local to the Blick Mead area.

Through the use of both the throwing spear and the bow, whose technology advances during the Mesolithic period due to climate change and the resultant increase in the spread of elm, Mesolithic hunter-gatherers probably hunt aurochs on a seasonal basis across the open Stonehenge landscape

during the late spring and early summer, although more work needs to be done in this area to establish the reasons behind the apparent differences in hunting seasons between Britain and other areas of northern Europe.

The combination of hunting as a group, the natural topography of the landscape and the continued dominance of pine within the Stonehenge landscape throughout the Mesolithic, potentially enables the local population to continue to hunt upon the central Stonehenge grasslands using an intercept strategy for much longer than other areas by exploiting the large herds of aurochs as they passed through the area. This lack of requirement to change to other resources potentially allowed them to remain within the Stonehenge locale throughout the majority of the year.

Notes on viewsheds

The views from various points of the Stonehenge Cursus into the surrounding landscape are demonstrated graphically by the use of a viewshed analysis routine within a project GIS software programme (Pearson & Field 2011). However, as the viewsheds indicated by Pearson and Field (2011) were looking at the Stonehenge landscape during the Neolithic period, I decided to carry out my own evaluation of the landscape taking into account the proposal put forward within this chapter with regard to the openness of the Stonehenge landscape during the Mesolithic.

Using the positioning of known Mesolithic pits found within the Stonehenge landscape, such as the pit below Winterbourne Stoke 30 Round Barrow (Christie 1963 pp. 370–382), the postholes in the old Stonehenge car park (Vatcher L & Vatcher F 1966 pp. 57–63), the fording point within Stonehenge Bottom (Jacques 2014) and potential Mesolithic pits found within the landscape by the 'Stonehenge Hidden Landscapes Project' (Gaffney 2012) as viewshed datum points, viewsheds were carried out from the following areas.

Viewshed from Winterbourne Stoke 30

The viewshed from the Mesolithic pit at Winterbourne Stoke 30 (Christie 1963) gives excellent unbroken views in a westerly direction for more than a mile with minimum disruption due to hidden dips within the landscape. Although the view to the north-west is lost after approximately half a mile, this section of the landscape is potentially still covered in woodland during the Mesolithic.

This view would potentially allow Mesolithic hunter-gatherers to adopt an intercept hunting strategy, however the moving aurochs herd would also have the opportunity to spot the hunters. The view to the east continues as far as the eastern edge of the Cursus, however, there is no view into the Stonehenge Bottom river valley and therefore little opportunity to forewarn any group hiding within this area waiting to spring an ambush.

Viewshed from the Cursus F1

The viewsheds from the point on the Cursus identified within the SHLP as 'F1' stretch to either end of the Cursus but not beyond this. There is no view into Stonehenge Bottom and the views to the south stop at a natural ridgeline around the Cursus Barrow Group. Any group hiding here would also be unable to communicate with hunter-gatherers operating within the fording point around Stonehenge Bottom. The viewsheds from this location do not appear to have any link with hunting strategies.

Viewshed from the Cursus F2

The viewsheds from the point on the Cursus identified within the SHLP as 'F2' also stretch to either end of the Cursus and slightly beyond at the western end, however not before the horizon is lost in the vicinity around Fargo Plantation. Again there is no view into the fording point at Stonehenge Bottom. Although this location offers views that would allow hunter-gatherers to operate an intercept strategy, there would be disadvantages to using this location. The fact that this point lies upon a direct alignment with the Avenue and the summer solstice suggests that this location has not been chosen as part of a hunting strategy.

Viewshed from the Stonehenge Hidden Landscapes Project G2

The viewshed from the point just to the west of the King Barrow Ridge identified within the SHLP as 'G2' offers unparalleled views of the surrounding landscape. To the north-west the view stretches as far as the western end of the Cursus whilst to the south-west the view extends as far as the Winterbourne Stoke crossroads barrow group. Although this view is broken at points along the eastern side of Stonehenge Bottom, the essential section where the fording point lies can now be clearly seen. This would arguably allow a group of hunter-gathers located at this point to signal to an ambushing group located by the Stonehenge Bottom fording point that an aurochs herd was approaching.

This view also looks directly upon the Mesolithic posts within the old Stonehenge car park. Could these posts have been used to indicate the distance of the approaching herd from the group of hunters waiting to spring their ambush?

Viewshed from Stonehenge Bottom fording point

The fording point within Stonehenge Bottom is the location where the natural topography of the Stonehenge landscape would concentrate herd movement. Although viewsheds are minimal at this location, that could be the reasoning behind picking it as an ambush site.

A group of hunter-gatherers located within this section of the landscape would be able to see eastwards towards signallers at the location 'G2' identified earlier. Although their westerly view is only 100 metres, this would allow them to spring an ambush on approaching aurochs herds as this is well within the distance of their bow shooting range.

Exploration has been carried into this section of the landscape, taking into account the viewpoint of herds of aurochs moving across the landscape, in an easterly direction. The natural topography at this point would result in the herd being within a distance of 45 metres prior to having any chance of catching sight of the hunters. The direction of the wind across the Stonehenge landscape would also have resulted in the hunters being downwind of the herd, a fact that is supported by the placement of the Mesolithic base camp at Blick Mead in the easterly lee of Vespasian's Camp.

Viewshed from postholes old Stonehenge car park

The viewshed from the location of the postholes within the old Stonehenge car park are minimal. Although to the east hunter-gatherers are able to see the eastern end of the Cursus, large sections of this view are disrupted. To the north the view only extends to the Cursus Barrow Group whilst to the south the view is lost almost immediately. The Mesolithic posts could potentially have marked the edge of this hunting territory as they would be visible from most sections of the plain. They could also have acted as a marker indicating that the animals had reached a certain point of the landscape.

Viewshed from Stonehenge Hidden Landscapes Project G1

The viewshed from the point just to the south of the Fargo Plantation identified within the SHLP as 'G1' offers northerly views to the Cursus Barrow Group, however these views only stretch in a westerly direction to the ridgeline of the Fargo Plantation around 100 metres away. My investigation is therefore unable to identify any strength to the hunting strategy from using this location.

Bibliography

Allen, M., Cleal, R., Walker, K. E., & Montague, R. (1995). 'Before Stonehenge', in Cleal, R. M. J., Walker, K. E., and Montague, R. (eds), *Stonehenge in its landscape: twentieth-century excavations*, pp. 41–62. London: English Heritage.

Andersen S. (2013). 'Tybrind Vig Submerged Mesolithic Settlements in Denmark'. *Jutland Archaeological Society Publications*, Vol. 77.

Bálint C. (2013). *The bow from Holmegaard settlement and some remarks on the Mesolithic Bows*. Copenhagen: University of Copenhagen.

Barth E. K. (1982). 'Ancient methods for trapping wild Reindeer in South Norway'. In Hultkrantz, Å., & Vorren, Ø. (eds), *The hunters: Their culture and way of life*. Tromso Museum Skrifter, Vol. 18: pp. 21–46.

Bendrey R. (2008). 'Patterns of Iron Age horse supply: An analysis of strontium isotope ratios in teeth'. *Archaeometry* Vol. 51: pp. 140–150.

Bergman A. C. (1993). 'The development of the Bow in Western Europe. A Technological and Functional Perspective'. *Archaeological Papers of the American Anthropological Association* Vol. 4: pp. 95–105.

Bishop B. (2014). *Development of Prehistoric Flintwork*. University of Buckingham Lecture, Society of Antiquaries.

Boscombe Down Phase II Excavations, Amesbury (1995): Boscombe Sports Field, Assessment by Wessex Archaeology. Report Reference 36875.1

Boscombe Down Phase V Excavations, Amesbury (2004): Post-excavation Assessment Report and Proposals for Analysis and Final Publication by Wessex Archaeology. Report Reference 56240.

Bowden, M. (2015). *The Stonehenge Landscape: Analysing the Stonehenge World Heritage Site*. Swindon: Historic England.

Branch, N. (2015). *Changing Environments in the Stonehenge Area from the late Glacial to the Iron Age*. University of Buckingham Lecture, Society of Antiquaries.

Brown, A., Bell, M., Timpany, S., Nayling, N. (2005). *Mesolithic to Neolithic and Medieval Coastal Environmental Change: Intertidal Survey at Woolaston, Gloucestershire.*

Budd, P., Montgomery, J., Cox, A., Krause, P., Barreiro, B., and Thomas, R. G. (1998). 'The distribution of Lead within Ancient and Modern Human Teeth: Implications for Long-term and Historical Exposure Monitoring', *The Science of the Total Environment*, Vol. 220: pp. 121–136.

Charlton, S. (2014, in press). *Fragmentary skeletal material from Vespasian's Camp*. ZooMS Analysis.

Christie, P. (1963). 'The Stonehenge Cursus', *Wiltshire Archaeological and Natural History Magazine*, Vol. 58: pp. 370–82.

Clark, G., & Straus, L. (1983). *Late Pleistocene hunter-gatherers in Cantabrian Spain, Hunter-Gatherer Economy in Prehistory*. Cambridge: Cambridge University Press.

Conneller, C., Milner, N., Taylor, B., & Taylor, M. (2012). *Substantial settlement in the European Early Mesolithic: new research at Star Carr.*

Dark P. (2006). *Plant Communities and Plant use in the lower submerged Forest and Mesolithic Sites.*

Darvill T. (2006). *Stonehenge, The Biography of a Landscape*. Stroud: The History Press.

Dimbleby G. W. (1962). *The development of British Heath-lands and their soils* (Oxford Forestry Memoirs No. 23). Oxford.

Fisher L. (2002). 'Mobility, search modes and Food-getting technology, from Magdalenian to Mesolithic in the upper Danube Basin'. In Habu, J. (ed.), *Beyond Foraging and Collecting: Evolutionary Change in Hunter-Gatherer Settlement Systems*, pp. 157–180. Fundamental Issues in Archaeology, T. D. Price, general editor. New York: Kluwer Academic/Plenum Publishers.

French, C., Scaife, R., Allen, M., Parker Pearson, M., Pollard, J., Richards, C., et al. (2012). 'Durrington Walls to West Amesbury by way of Stonehenge: A major transformation of the Holocene landscape', *Antiquaries Journal*, 92: pp. 1–36.

Gaffney, C., Gaffney, V., Neubauer, W., Baldwin, E., Chapman, H., Garwood, P., et al. (2012). *The Stonehenge Hidden Landscape Project*.

Green, C. (forthcoming, in press). *Environmental analysis work at Blick Mead*. QUEST.

Hazell, Z., & Allen, M. (2013). 'Vegetation History' in Canti, M., Campbell, G., & Greaney, S. (eds), *Stonehenge World Heritage Site Synthesis: Prehistoric Landscape, Environment and Economy*.

Higgs, E. (1959). 'The excavation of a late Mesolithic site at Downton near Salisbury Wiltshire', *Proceedings of the Prehistoric Society* Vol. 25: pp. 209–232.

Higgs, E. S. (1961). 'Some Pleistocene Faunas of the Mediterranean Coastal Areas', *Proceedings of the Prehistoric Society*, 1961, Vol. 27: pp. 144–154.

Holm, L. (1991). *THE USE OF STONE AND HUNTING OF REINDEER: A Study of Stone Tool Manufacture and Hunting of Large Mammals in the Central Scandes c. 6 000 – 1 BC*. Department of Archaeology. University of Umea.

Jacques, D. (2010). 'A re-assessment of the importance of Vespasian's Camp in the Stonehenge landscape'. *PAST – The newsletter of the Prehistoric Society* No. 66: pp. 12–14.

Jacques, D., Phillips, T., with contributions by Hoare, P., Bishop, B., Legge, A., & Parfitt, S. (2014). 'Mesolithic settlement near Stonehenge: excavations at Blick Mead, Vespasians Camp, Amesbury'. In *The Wiltshire Archaeological and Natural History Magazine*, Vol. 107, pp. 7–27.

Jochim, M. (1976). *Hunter-Gatherer Subsistence and Settlement: A Predictive Model*. Studies in Archaeology. New York: Academic Press.

John, D. (forthcoming). In Jacques, D., Davis, G. (eds), volume 1, *Studies in the British Mesolithic and Neolithic*. Oxford: Peter Lang.

Jonsson L. (1988). 'The vertebrate faunal remains from the Late Atlantic settlement skateholm in Scania, South Sweden'. *Acta Regiae Societatia Humaniorum Litterarum Lundensia*. Vol. 79, pp. 56–88.

Legge, A., and Rowley-Conwy, P. (1988). *Star Carr re-visited: A re-analysis of the large animals*. London: Birkbeck College, University of London.

Lewis, J., & Rackham, J. (2011) *Three Ways Wharf, Uxbridge: A late glacial and early Holocene hunter-gatherer site in the Colne Valley*. Museum of London Archaeology. Monograph Series 1.

Mellars, P., & Dark, P. (1998). *Star Carr in context: New archaeological and palaeoecological investigations at the early Mesolithic site of Star Carr, North Yorkshire*. Cambridge: McDonald Institute for Archaeological Research. pp. 231–232.

Mithen S. (1990). *Thoughtful Foragers: A study of Pre-historic Decision Making*. Cambridge: Cambridge University Press.

Montgomery, J., Budd, P., & Evans, J. (2014). 'Reconstructing the lifetime movement of ancient people: A Neolithic case study from Southern England'. *European Journal of Archaeology*, Vol. 3, pp. 370–385.

Myers A. (1989). 'Reliable and maintainable technology in the Mesolithic of mainland Britain'. In Torrence, R. (ed.), *Time, Energy and Stone Tools*, pp. 78–91. Cambridge: Cambridge University Press.

Ordnance Survey (2012). Sheet 184, Salisbury & The Plain, Amesbury. Ed. C3. 1:50 000. OS Landranger map. Southampton: Ordnance Survey.

Parker Pearson, M., Pollard, J., Richards, C., Thomas, J., Tilley, C., Welham, K. (2012). *The Stonehenge Riverside Project: Exploring the Neolithic landscape of Stonehenge*.

Pearson, T., & Field, D. (2011). *Stonehenge World Heritage Site Landscape Project, Stonehenge Cursus, Amesbury Wiltshire,* Archaeological Survey Report. English Heritage.

Prummel, W., & Niekus, M. (2011). 'Late Mesolithic hunting of a small female aurochs in the valley of the River Tjonger (the Netherlands) in the light of Mesolithic Aurochs hunting in NW Europe'. *Journal of Archaeological Science* Vol. 38, pp. 1456–1467.

Radley, J., & Mellars, P. (1964). 'A Mesolithic structure at Deepcar, Yorkshire and the affinities of its associated flint industries'. *Proceedings of the Prehistoric Society* Vol. 30, pp. 1–24.

Renfrew, C., & Bahn, P. (2012). *Archaeology Theories, Methods and Practice* (6th edn), pp. 71–94. London: Thames and Hudson Ltd.

Richards, J. (1990). *The Stonehenge Environs Project*. Archaeology Report, Vol. 16. Swindon: English Heritage.

Rogers, B. (forthcoming). *Where the wild thing are: Analysis of the faunal assemblage from the Mesolithic site at Blick Mead, Wiltshire. Including a study on the diet and migration of the aurochs*. Durham: Durham University.

Rowley-Conwy P. (2004). 'How the west was lost – A reconsideration of agricultural origins in Britain, Ireland and Southern Scandinavia'. *Current Anthropology* Vol. 45: August-October.

Rowley-Conwy P. (2014). 'Animals in the archaeology of southern Britain Mesolithic and Neolithic periods'. University of Buckingham Lecture, Society of Antiquaries.

Scaife, R. G. (1995). 'A Boreal and sub-boreal chalk landscape: pollen evidence'. In Cleal, R. M. J., Walker, K. E., and Montague, R. (eds), *Stonehenge in its landscape: twentieth-century excavations*. London: English Heritage, pp. 51–55.

Simmons, I. (1996). *The Environmental Impact of Later Mesolithic Cultures*. Edinburgh: Edinburgh University Press for the University of Durham.

Sorensen, K. (1986) 'The Prejlerup aurochs: An archaeological discovery from boreal Denmark'. In Konigsson (ed.), *Nordic late Quaternary Biology and Ecology*. Vol. 24: pp. 111–117.

Spiess A. (1979). 'Reindeer and Caribou hunters: An archaeological study', *Proceedings of National Academy Science USA*. p. 105.

Taylor, M., Milner, N., Conneller, C., Elliott, B., Koon, H., Panter, I., Penkman, K., & Taylor, B. (2011). 'From Riches to Rags: Organic Deterioration at Star Carr'. *Journal of Archaeological Science*. Vol. 38: pp. 2818–2832.

Thomas, J., Marshall, P., Parker Pearson, M., Pollard, J., Richards, C., Tilley, C., & Welham, K. (2009). 'The date of the Greater Stonehenge Cursus', *Antiquity*, Vol. 83: pp. 40–53.

Van Vuure, C. T. (2005). *Retracing the Aurochs: History, Morphology and Ecology of an Extinct Wild Ox*. Sofia-Moscow: Pensoft Publishers.

Vatcher, L., & Vatcher, F. (1966). 'Excavation of Three Postholes in Stonehenge Car Park'. *Wiltshire Archaeological and Natural History Magazine*, Vol. 68, pp. 57–63.

Vera, F. W. M. (2000). *Grazing Ecology and Forest History*. Wallingford: CAB International, pp. 52–55.

Waddington, C. (2007). *Mesolithic settlement in the North Sea Basin: A case study from Howick, North-east England*. Oxford: Oxbrow Books, pp. 110–113.

Zvelebil, M. (1994). 'Plant use in the Mesolithic and its role in the transition to farming'. *Proceedings of the Prehistoric Society*, Vol. 60: pp. 35–74.

JOSHUA C. WHITE

Appendix
Vespasian's Camp, Wiltshire: New insights into an Iron Age community in the Stonehenge landscape

Introduction

The hillfort of Vespasian's Camp in Wiltshire is situated 2 km east of Stonehenge at the north-west edge of the town of Amesbury (NGR SU145417). Despite only having undergone a limited level of archaeological excavation, a relatively good understanding of the hillforts construction and phasing has been ascertained by the work of Hunter-Mann (1999) in 1987. Through the excavation of three trenches Hunter-Mann (1999) establish that the site was occupied from the sixth to fifth centuries BC, with two considerable phases of rampart construction, both belonging to the glacis tradition.

During the 2014 excavation season at the site of Blick Mead (situated in the immediate vicinity of Vespasian's Camp) (see Jacques and Phillips 2014; Jacques et al. 2018), site staff recognised that the downslope collapse of a substantial beech tree growing on the eastern ramparts of the Iron Age hillfort had uprooted archaeological deposits measuring approximately 3.2 m in width, 0.9 m in depth and 2.4 m in height above the modern level (see Figure A.1). Significant weathering to these vertically positioned deposits had resulted in the exposure of a moderate quantity of finds which had begun to fall from their stratified locations onto the surrounding ground surface. As it was only a matter of time before the fragile prehistoric pottery disintegrated and the bone became degraded and fragmented due to further weathering, it was decided with the support of site custodian and University of Buckingham Research Fellow Mike Clarke, that the recovery of this material would be the most appropriate action to take.

This short report details the recovery of the material along with the analysis undertaken by the author on the faunal remains collected. A very brief summary of the ceramics assemblage analysed by Lorraine Mepham is also included; the primary report on this material however has been published elsewhere (see the previous volume in this series).

Recovery method and description of the strata

Once on-site archaeologists had made the decision to recover the finds, the disturbed deposits were systematically cleared away from the collapsed trees' root structure, with finds being collected and then subsequently processed. At no point during this exercise did any ground intrusion or disturbances to secure buried archaeological deposits occur. A total of 52 fragments of pot, 143 fragments of animal bone and seven pieces of struck flint (identified by Dr Barry Bishop as characteristically later prehistoric) were recovered. From the exposed remains two deposits were distinguished; that of 01, a humic loamy silt-rich deposit with a maximum depth of 0.3 m and 02, a compact chalk deposit stratigraphically overlaying 01 and measuring approximately 0.6 m at its deepest point.

The vast majority of finds came from deposit 01 and analysis of the animal bones and the organic rich sediment matrix suggests that it likely represents a midden deposit which accumulated up against the inside of the ramparts. This layer is comparable to Hunter-Mann's (1999, 42) deposit '032/036' located in his trench on the eastern rampart, characterised as silt-rich loams overlain by a deposit of

Figure A.1: Photograph of the deposits upturned by the collapse of a beech tree on the eastern ramparts of Vespasian's Camp. This photograph was taken after the removal of deposit 01 and before excavation began on 02 (looking south-east, scale 2 m)

chalk. Similarly, the chalk deposit uprooted by the tree is of the same composition to deposits '024' and '025' identified by Hunter-Mann (1999, 42), which appear to represent a period of secondary rampart construction. No deposits overlying 02 such as the colluvium seen in Hunter-Mann's (1999, 43) section of the eastern rampart were present; it is likely that these had been eroded by root action and weathering both before and after the collapse of the tree.

Pottery

An assemblage of 52 sherds of pottery was recovered from deposit 01. The detailed report on this material can be found in 'Appendix C2: Iron Age Pottery' by Lorraine Mepham in Jacques et al., *Blick Mead: Exploring the 'First Place' in the Stonehenge Landscape* (Mepham 2018). In summary of this analysis, the assemblage possesses an Early/Middle Iron Age date and consists of both coarse and highly burnished fine wares. Most of the sherds derive from jars, bowls and there is also a single example of a saucepan pot (Mepham 2018).

Faunal remains

Amongst the Iron Age material recovered from the eastern ramparts was an assemblage of 143 fragments of hand-collected animal bone from two separate deposits possessing a total weight of 1.2 kg. Previous excavations at the site have retrieved animal bone from Iron Age deposits; however these have not been subject to a detailed study (Hunter-Mann 1999, 43). With the exception of minor root etching to their surfaces, the bones were in a very good state of preservation; a feature likely attributed to their burial in a humic loamy soil sealed by a deposit of chalk. A relatively high degree of fragmentation was seen across the assemblage; however this is not accredited to their burial environment but is

Appendix

instead believed to be a result of the processing of the bone in antiquity. The small quantity of bones from deposit 02 are discussed and analysed together with those of deposit 01 due to the practicality of analysis and the presence of the same ceramic assemblages amongst both.

Methodology

All fragments of bone were studied in order to determine the element and species. Where this was not possible fragments were categorised as large, medium or small mammal. Species were quantified using the number of identified specimens (NISP) method and the minimum number of individuals (MNI) method. Age-at-death assessments were conducted where possible using published data on fusion ages and tooth wear/eruption from Silver (1969) and Payne (1973) respectively. The sex of ovicaprid pelvic elements was estimated using Boessneck (1969) and biometric calculations were conducted using measurement data from Von den Driesch (1976). Bones were also scanned for evidence of pathology, butchery and other features worthy of note. Information was recorded digitally in multiple Microsoft Excel spreadsheets all held in the electronic archive.

Results

Both the NISP and MNI species quantification methods indicate that ovicaprids, most likely sheep (*Ovis aries*) in this period (Hambleton 1999, 14) were the most abundant species at the site followed by cattle (*Bos taurus*) (see Tables A.1 and A.2). Despite this, due to their proportional abundance and greater size, cattle would have provided the greatest yields of meat at the site. Redistribution of 'medium' and 'large' ungulates to sheep and cattle respectively would be in keeping with these conclusions. Those classed as 'unidentified' represent very small angular fragments with a greatest length less than 2 cm. A single pig (*Sus scrofa*) bone was represented by an unfused distal epiphysis of a tibia. Interestingly, the bones of dog, horse and red deer which are frequently found (in low quantities) at Iron Age sites (Maltby 1996) were not present in the assemblage; a feature that could be taken to suggests that this deposit strictly represents the kitchen waste of consumed animals. Gnawing marks of dogs and a single case of gnawing by a small rodent were recognised on some bones, indirectly indicating their presence at the site.

Table A.1: Iron Age NISP data from Vespasian's Camp

Species	NISP
Cattle (*Bos taurus*)	35
Ovicaprird	37
Pig (*Sus scrofa*)	1
Large Ungulate	11
Medium Ungulate	20
Small Ungulate	10
Unidentified	29
Total	143

Table A.2: Iron Age MNI data from Vespasian's Camp

Species	MNI
Cattle (*Bos taurus*)	3
Ovicaprird	6
Pig (*Sus scrofa*)	1

Fusion data was available for 20% (NISP) of cattle remains, 45% (NISP) of the ovicaprid remains and was also available for the single pig bone in the assemblage. Tooth eruption and wear data was available from eight and four of the sheep and cattle remains respectively. The unfused distal tibia epiphysis from the pig indicates an age less than 3.5 years. Taking this into consideration with the size of the specimen, it seems likely that this individual was slaughtered at the prime age for meat production.

Ovicaprid fusion data illustrates that 41% of the animals survived over the age of three years old and that 23% of animals did not reach this age. With significant proportions of animals surviving both over and under 30 months (considered to be the top end of the optimal age for meat production in sheep, Payne 1973), it appears that a mixed pastoral regime was in practice; a number of animals were slaughtered for their primary products at a younger age, with a significant proportion of animals maintained through adulthood and exploited for their secondary products of milk and wool. Analysis of the tooth wear and eruption data supports this trend with an evenly distributed range of ages present from individuals dying at two to six months to eight to 10 years (see Table A.3).

Table A.3: Tooth eruption and wear data of the ovicaprid remains from Vespasian's Camp

Age	Quantity
2–6 months	1
1.5–3 years	2
3–4 years	1
6–8 years	1
8–10 years	1

Fusion data from the cattle remains indicated that 85% were aged over 1.5 years and 57% were older than 3.5 years. A single fragment of cervical vertebrae from a very young animal was also present in the assemblage which may represent a single instance of a natural infant mortality. All tooth eruption and wear data indicated the presence of adult animals aged between four to eight years old. It is hard to draw inferences concerning the husbandry regimes practiced with cattle from such a small sample size; however, it appears that a significant proportion of the herd reached over the age of 3.5 years, which would suggest that they survived beyond the age considered to be the optimum slaughter point for meat production. This may point to their primary use in traction and milk production; however it is entirely possible for a multitude of reasons that such a feature would equally be recognised in a regime focussed on primary products.

Sex could only be ascertained from two separate sheep pelvic specimens which were both identified as female. Due to heavy fragmentation, measurements after Von den Driesch (1976) were taken for only 10 bones in the assemblage which can be consulted in the archive.

As previously stated, fragmentation is high amongst the assemblage. Intensive processing for bone grease and marrow extraction appears to have taken place and this is further indicated through longitudinal shaft splitting and abundant chop marks (also relating to generalised disarticulation and bulk processing). Finer cut marks are noticed more sporadically on sheep and cattle remains, some indicative of skinning. Evidence of heat application was recognised on nine fragments to varying degrees. The majority were represented by small highly heated calcinated fragments that were likely discarded intentionally or accidentally into a fire. A complete sheep radius had light charring upon the proximal epiphysis, possibly indicating that on-the-bone cooking took place.

Incidences of pathology are low among this sample. The occurrence of minor exostosis is seen upon a single cattle proximal phalange and eburnation and porosity is seen on a single cattle femoral head from an individual over the age of 3.5 years. Moderate quantities of dental calculus can be seen upon multiple ovicaprid teeth.

Discussion of the faunal assemblage

The abundance of ovicaprids in this assemblage is a feature seen at the vast majority of Iron Age sites situated upon or near the chalk grasslands of Wessex (Maltby 1994; Hambleton 1999). Hambledon's (1999) study on animal husbandry during this period established that sheep constitute between 40–70% (NISP) of samples, cattle between 20–50% and pigs represent between 0–20% of the assemblages from sites in Wessex. At Vespasian's Camp we do see a relatively high incidence of cattle remains (constituting 48% of the assemblage, NISP); towards the top end of what would typically be expected from sites in this region. This abundance could potentially relate to the high water requirements of cattle and the close proximity of the Blick Mead spring (Jacques et al. 2018) to the site and the general abundance of water in the immediate landscape; a relationship illustrated by Hamilton (2000, 70) among sites in the Danebury environs. Pigs appear to have only had a relatively minor economic role at Vespasian's Camp, a picture equally seen across other Iron Age sites in the region (Hambleton 1999).

Evidence concerning the nature of the husbandry regimes practiced largely suggests the existence of a mixed pastoral economy with a focus on the production of both the primary and secondary products of sheep. Mortality patterns of sheep broadly fit the general picture for the Iron Age (Hambleton 1999), however the presence of mature adults aged over six years at Vespasian's Camp is not particularly common for this period, nor is the occurrence of a mandible aged between two to six months. The ageing data for cattle is not as conclusive, but broadly suggests that a significant proportion of animals were surviving into adulthood and were likely exploited for their milk and use in traction prior to being slaughtered for meat. Cattle mortality patterns vary quite significantly between sites in the Iron Age and a number both in and outside of Wessex show a similar pattern to that seen at Vespasian's Camp. The single pig as previously stated appears to have been slaughtered at the prime age for meat production; a feature that would be expected in pig husbandry of this period (Hambleton 1999).

Analysis of the assemblage would suggest that little recent intrusive material is present despite its extensive movement, disturbance and weathering; however, this of course cannot be conclusively assessed from the bones alone. The extensive fragmentation (which does not relate to the aforementioned disturbance) and prevalence of cut and chop marks suggests that the remains of animals were heavily processed, with marrow and bone grease also being extensively exploited as primary products. Although this assemblage is limited in the extent to which it can inform us about the cultural practices at the site, Coy (1987, 46) suggests that sheep meat was primarily cooked on the bone during the Wessex Iron Age and this can potentially be seen in the remains from Vespasian's Camp.

Concluding discussion

The recovery of this assemblage has provided an opportunity to further explore the site of Vespasian's Camp and the Iron Age communities of Wessex.

The ceramics assemblage recovered is in keeping with that retrieved by Hunter-Mann (1999), and is indicative of a period of occupation at the hillfort during Early-Middle Iron Age. Previous publications of the site have refrained from reporting upon the faunal remains (see Hunter-Mann 1999), thus hindering our knowledge of the animal husbandry practices employed by the communities in question. From the current assemblage, it has been ascertained that a mixed pastoral economy was in practice focussing heavily on sheep and cattle.

Although we must be careful not to read too much into such a spatially restricted assemblage that has undergone uprooting and weathering, this non-intrusive recovery of archaeological material that

would have otherwise been lost entirely has been important in further expanding our ability to give greater definition to the nature of the later prehistoric communities that occupied the Stonehenge landscape.

This material may play an important role in helping to shape the research questions formulated for future work at Vespasian's Camp or on the later prehistoric communities of the Stonehenge landscape. Of particular significance is the finding that the bone preservation is very good, thus indicating the site's zooarchaeological significance and potential. Additionally, this report as a whole can be viewed as an assessment of the effects that root action is having on the archaeological deposits at the densely forested hillfort. It is hoped that the material recovered, which is to be housed at the Amesbury Heritage Centre, can play a role in bringing local people in closer contact with their Iron Age forebears.

Bibliography

Boessneck, J. (1969). 'Osteological differences between sheep (Ovis aries Linné) and goat (Capra hircus Linné)', Brothwell, D. R. and Higgs, E. S. (eds), *Science in archaeology: A comprehensive survey of progress and research*. London: Thames & Hudson, pp. 331–358.

Coy, J. (1987). 'The animal bone', Fasham, P. J. (ed.), *A Banjo Enclosure in Micheldever Wood, Hampshire*. Winchester: Hampshire Field Club and Archaeological Society, 5, pp. 45–53.

Hambleton, E. (1999). *Animal Husbandry Regimes in Iron Age Britain: A comparative study of faunal assemblages from British Iron Age sites*. Oxford: Archaeopress.

Hamilton, J. (2000). 'Animal Husbandry: the evidence from the animal bones', Cunliffe, B. (ed.), *The Danebury Environs Programme the Prehistory of a Wessex Landscape: Volume 1 Introduction*. Oxford: Institute of Archaeology. 59–76.

Hunter-Mann, K. U. R. T. (1999). 'Excavations at Vespasian's Camp Iron Age hillfort, 1987'. *Wiltshire Archaeological and Natural History Magazine*, 92, pp. 39–52.

Jacques, D., and Phillips, T. (2014). 'Mesolithic settlement near Stonehenge: excavations at Blick Mead, Vespasian's Camp, Amesbury'. *Wiltshire Archaeology and History Magazine*, 107, pp. 7–27.

Jacques, D., Phillips, T., and Lyons, T. (2018). *Blick Mead: Exploring the 'First Place' in the Stonehenge landscape*. Oxford: Peter Lang.

Maltby, M. (1994). 'Animal Exploitation in Iron Age Wessex', Fitzpatrick, A. P., and Morris, E. L. (eds), *The Iron Age in Wessex: Recent Work*. Salisbury: Trust for Wessex Archaeology Ltd, pp. 9–10.

Maltby, M. (1996). 'The Exploitation of Animals in the Iron Age: the archaeo-zoological evidence', Champion, T. C., and Collis, J. (eds), *The Iron Age in Britain and Ireland: Recent Trends*. Sheffield: J. R. Collis Publications, pp. 17–27.

Mepham, L. (2018). 'Appendix C2: Iron Age pottery', Jacques, D., Phillips, T., and Lyons, T. (eds). *Blick Mead: Exploring the 'First Place' in the Stonehenge landscape*. Oxford: Peter Lang, pp. 200–201.

Payne, S. (1973). 'Kill-off Patterns in Sheep and Goats: The Mandibles from Aşvan Kale'. *Anatolian Studies*, 23, pp. 281–303.

Silver, I. A. (1969). 'The Ageing of Domestic Mammals', Brothwell, D. R., and Higgs, E. S. (eds), *Science in archaeology: A comprehensive survey of progress and research*. London: Thames & Hudson, pp. 283–302.

Von den Driesch, A. (1976). *A Guide to the Measurements of Animal Bones from Archaeological Sites*. Cambridge, MA: Harvard University.

Index

Ache 92
ADHD 80
adze, tranchet 121
Ainu 89
Al Poux 129
alder 42, 44, 49, 100
Alderbury 147
Aleut 89
amber 21
Amber Boy 21, 23
ambush site 187
Amesbury 6, 26, 135, 163
Amesbury Archer 8, 27–28
Amesbury Heritage Centre 206
ancestors 15, 23
ancestral memory 6
Ancient Technology Centre 35, 43, 55
Andamanese 89
animal movement, seasonal 190
apple 49
archaeology, experimental 51, 64, 71, 99
 interpretive 75–79
 landscape 76–77, 83–84
 post-processual 78
Arctic 92
ash 43, 49
aurochs 97, 105, 111, 116, 125, 155, 157, 163, 173–199
Australia 91, 102
Avon, river 10, 16, 20, 41, 96, 135, 143, 150, 161, 184
Avon, valley 10, 65, 174
Avon House 42, 48, 180
axe, tranchet18, 143–171
Ayers Rock 78

Balbridie 40
Balkweg 194
Ballygalley 40, 41
Ballynagilly 40
barley 42
barrows 42
base camp 113
Beaulieu Road 18
beetle, diving 125
beetle, water scavenger 125
Besselsleigh Wood 71, 88
bible 73
birch 44, 49, 100
Biskupin 40
blade 120
Blick Mead 15, 35, 42, 71, 76, 88, 96, 111–141, 150–153,
 162–163, 173, 177, 187, 201
 hearths 129
 home-base128, 179, 195

 sandstone slab 178
 Trench 23 116–118
Bluestonehenge 145, 151, 154, 159, 163, 174, 178, 184
bluestones 10
Bohemia 39
bone 202
bore-hole survey 125
Boscombe Bowmen 8, 15, 21, 22, 27
Boscombe Down 5–31, 41, 156, 159, 160, 173, 185
Boscombe Down Ridge 5, 13, 15
Boscombe Down West 5–31
Bourne, river 16, 20, 24
Bronze Age 6, 17
Bronze Age barrows 10
Broom Hill 160, 167
Brzesc Kujawski 39
Bulford 14, 15
bulrush 125
burdock 100
burin 120
butchery 194
Butser Ancient Farm 40, 45
Butter Hill 150
buttercup 125
Butterfield Down 5–31
 eagle head sceptre 10

Canada 91, 102
caregiving 93
Carshalton 159
Çatalhöyük 78
cattle 37, 203
Celtic revitalisation 29
Celts 8, 27
cereal cultivation 40
chalk 16, 35, 127
 pigs 23
child 71–109
 adolescence 89
 burials 12, 18, 21
 definition 72–73
 infancy 89
 life stages 73–74, 88
 Mesolithic 71–109
 play 100
 pre-natal 89
 weaning 89
Chillingham herd 190
Chippenham 5 45
Choisey 129
Chorlton Down 7
Christianity 30, 31
Churchill, Winston 49

Claish Farm 40
Clarke, Mike 201
Clay Collection 152
coffin 19
coin hoards 17
Colt Hoare, Richard 41
Coneybury Anomaly 13, 14, 19, 155, 167
ConeyburyHenge 155
Coneybury Hill 155
consumption to regeneration ratio 51–54, 64
coppicing 48, 64
Corallian Ridge 100
core 120
Cornwall 159
Cothill Fen 100
Coulerach 125
Countess Farm 21, 148, 160–165
Countess Roundabout 185
cow 177, 186
crab apples 188
cranesbill 42
Crathes 40
Cuckoo Stone 13, 20, 23, 29
Culverwell 136
Cunetio 25
Cybele 23, 25, 43

daisy 125
dandelion 125
Danebury 205
Danubian longhouses 39
Darrent, river 151
debitage 98, 120, 132
Devon 178
DiodorusSiculus 11
Dionysus 43
Dobe 89
dog 203
Doggerland 181, 191
Downton 122, 143, 144–152, 158, 164, 175
druids 9
Durrington Walls 12–13, 23–26, 35, 64, 144, 155–156, 175, 179
dye 43

eagle head staff 25
Earl's Farm Down 15, 20, 26, 31
Easter Island 44, 50
elk 176
elm 43, 49, 100, 182
Elsloo 40
English Heritage 55–56, 59, 174
equinox 43, 104
ethnography 71, 81, 85

Fargo plantation 198
feasting 37, 159–161
Figbury Ring 13, 19, 27
Figheldean 12
firemaking 49, 100

fishing 100
Flag Fen 114
flint 50, 94, 103, 113, 178
 axe 54
 blades 149
 burnt 122–123, 158
 pink 96–99
 tools 76, 99
 unworked 96
flintknapping 17, 18, 95, 111, 159
footprints 188
forest clearance 179
FRAGSUS 50
France, Northern 38, 39
Funnel Beaker Culture 39

Garvald Burn 129
gender 72, 101, 113
Geoffrey of Monmouth 43
goat 177
Goldcliff 188
grass 42, 43
Greenland 72
Grimes Graves 50
Grooved ware 47
Gulf Stream 45
Gwithian 45

Hades 23
Hadrian's Wall 7
Hadza 101
hare 176
HauaFteah 189
hazel 37, 40–42, 49, 100, 187
 coppiced 47, 53
hearth 138
 drop zone 129
 toss zone 129
Heidegger, Martin 82, 84
herbivore 173–177
hermeneutics 82–83
Herxheim 40
High Post 12, 26
Hildenbrandiarivularis 97, 135, 150, 178
Historic Environments Records 10, 25, 152
hobnail boot phenomenon 29
Hockwold-cum-Wilton 45
holly 49
Holmegaard 182, 192
hornbeam 49
Hornstadt-Hornle 53
horse 203
Horsham point 159, 161, 178
Horton 40
Howick 129, 178
hunting 192
 intercept strategy 192–194
 pits 193
 strategies 173–177
hurdles 49

Index

incense 43
insect fossils 42
Inuit 182
Iping Common 187
Ireland 40, 43
Iron Age 17, 22, 27, 40, 43
 coins 8
 pottery 201
Islay 125
Isle of Man 40
Isle of Wight 181, 191

Jaktorow 180
Jones, Inigo 5
Ju/'hoansi 81, 89

Kennet, river 151, 152
Kennet Valley 144
Killaloe 136
King Barrow Ridge 13–14, 19–21, 152, 156, 185, 193
Knapp of Howar 44

La HougueBie 40
Lake 148, 160, 163, 167
Latvia 94
lead curse 8, 20
lime 49, 100
Linearbandkeramik 38, 53–54
Lingby II 183
Lismore Fields 40
Little Cheney 45
Llandygai 40
longevity 181
Lough Allen 136
Ludwinowo 7 39

Madagascar 74
March Hill 129
Marlborough Downs 145
marriage 93
marrow 204
meadow 42
Mesolithic home-base 157
microlith 120, 158
midden deposit 201
migratory route 121
Mikea 74
milk 205
Mokracz 129
mors inmatura 23
Mother Earth 31
mouse 112
Murngin 89
Mursalevo 47

Nadder Valley 145, 159, 184
National Trust 179
Neolithic 17
Neolithic houses 35–69
Neolithic Houses Project 35, 45–46, 56

Netheravon 12
New Covert 8, 16, 18
New King Barrows 14
Nuniamuit 81

oak 37, 40, 43, 44, 49, 100
Oakhanger 129
Oerlinghausen 40
Ogbury Camp 13, 19, 27
Old King Barrows 14
Old Sarum 35, 45, 55
orchid 42
Øresund 94
Orkney 44, 45
ovicaprids 203
oxeye 42

Palaeolithic 148, 182–183
Parc Archeologique Asnapio 40
pastoralism, mobile 36, 49, 63, 204–205
pasture 42
periglacial feature 183
Petersfinger Bridge 147, 163
Pewsey 147
phenomenology 11, 12, 15–16, 71, 80–82
pig 37, 112, 157, 176–177, 203–205
pine 37, 39, 43–44, 100
pine cone 43
Pine Tree Riot 48
Pliny the Elder 23
Poland 39
pollen 37, 42, 48, 55, 113, 145, 180, 188
Pomo 89
Portable Antiquities Scheme 10
Portland 136
pottery, Roman 18
Prejlerup bog 192–194

rabbit 177
rampion 42
raspberries 188
reconstruction 46
red deer 112, 176, 178, 190, 203
reed beds 188
Rhineland 38
ritual landscape 8
Robin Hood's Ball 19, 145
roe deer 176
Roman 5–33
 amulet 17
 army 7
 brooch 17
 cemetery 19
 glass 17
 kiln 17, 18
 spindle whorl 17
 villa 25
Romanisation 5, 7
roof, pitched 41
rope 43

Ruffey-sur-Seille 129
Russia 102

Salisbury District Council 43
Salisbury Museum 147
Salisbury Plain 17, 24, 41, 159–161, 184–185
 imperial estate 5–7
salmon 112
scabious 42
Scotland 36, 38, 40, 43, 191
sedge 42, 43
Serengeti 181
Sesklo 47
settlements, Mesolithic 149
Severn Estuary 188
Sharcot 147
sheep 27, 177, 203
Siriono 89
Skara Brae 44, 46, 50
Skateholm 94, 192
slate 128, 159–161
Somerset Levels 40, 48, 49, 52, 63
sorrel 125
Sorviodunum 25
spear 182, 195
spirits 22
spring 128
Star Carr 82, 115, 176, 180–181, 188–189
Starveall Plantation 152
Stockport Bottom 16
Stonehenge 6, 20, 57
 Bottom 169175, 184–187, 193, 197
 Cursus 13, 14, 28, 42, 57, 154, 159, 165, 180, 184, 190, 196–197
 Environs Project 155, 174
 Hidden Landscapes Project 174–197
 postholes 116, 143, 153, 159, 161, 175, 185
 Riverside Project 35, 46, 179
 sequence 116
 Visitor Centre 44, 59
Stour, river 151
Stroked Pottery Culture 39
strontium isotope 191
structuration theory 77
Sumer 73
Sweden 94
Sweet Track 42, 49

tannin 49
Tanzania 101
tar 43
Thames, river 100, 136
Thatcham 159
Theoretical Archaeology Group 75
thistle 125
Till, river 41, 184
timber, dating 38

Time Team 51
Tiwi 89
toad 112
tooth wear 204
tree felling 36
Trelystan Long Mountain 45
trout 112
Tubney Wood 71, 88
TybrindVig 180–182, 188–189, 192–194

ungulates 37

valerian 125
Vedbæk-Bøgebakken 94
vegetable flannel 43
Vespasian's Camp 13–15, 76, 96–97, 127, 160, 176, 201
viewsheds 11, 196–197
Vinca-Belo Brdo 47
vole 112

Wales 40, 45
Walton Track 49
Washo 89
Wawcott 135
weapons 105
weather 15
Welsh Marches 156, 159
Wessex 149, 205
Wessex Linear Ditches 15, 18, 21, 27
West Amesbury 145, 151, 179
Wey, river 151
wheat 42
Wheeler Grid System 114
White Horse Stone 40
willow 44, 49, 100
Wilsford 147
Winter, Luke 43
Winterbourne Stoke 13, 153–159, 165, 196
wolf 177
Woodhenge 13, 22–23, 27, 41, 45, 50, 184, 195
woodland management 48–9, 53
Woolaston 180, 188, 189
Wylye 145, 184

Yanomami 39
Yarnton 40
Yorkshire Dales 45
Yucunas 39
Yukaghir 89
yurt 46

zooarchaeology 206
ZooMS 177
Zvejniecki 94

!Kung 81

STUDIES IN THE BRITISH MESOLITHIC AND NEOLITHIC

Series Editors
David Jacques and Graeme Davis

Studies in the British Mesolithic and Neolithic presents the results of fieldwork and excavation as well as works of interpretation from all perspectives on the British Neolithic revolution. Archaeological methodology is augmented where appropriate with interdisciplinary techniques, reflecting contemporary practice in the discipline. Throughout the emphasis is on work which makes new contributions to the debate about the transition between hunter gatherer and farming cultures during this pivotal stage in British prehistory.

The series supports the archaeological community both in providing an appropriate forum for research reports as well as supporting interpretative work including cross-disciplinary research. It takes its inspiration from the work of the University of Buckingham's excavations at Blick Mead in the Stonehenge World Heritage Site.

Studies in the British Mesolithic and Neolithic is based at the Humanities Research Institute, University of Buckingham.

Volume 1 Blick Mead: Exploring the 'First Place' in the Stonehenge Landscape.
 David Jacques, Tom Phillips and Tom Lyons
 260 pages. 2018. 978-1-78707-096-7.

Volume 2 Stonehenge: A landscape through time.
 David Jacques and Graeme Davis.
 260 pages. 2018. 978-1-906165-85-7.